Bunker-Hellmich

W9-BZP-789

Enabling Environments

Measuring the Impact of Environment
on Disability and Rehabilitation

Plenum Series in Rehabilitation and Health

SERIES EDITORS

Michael Feuerstein
Uniformed Services University of the Health Sciences (USUHS)
Bethesda, Maryland

and

Anthony J. Goreczny
Chatham College
Pittsburgh, Pennsylvania

ENABLING ENVIRONMENTS: Measuring the Impact of Environment on
Disability and Rehabilitation
Edited by Edward Steinfeld and G. Scott Danford

HANDBOOK OF HEALTH AND REHABILITATION PSYCHOLOGY
Edited by Anthony J. Goreczny

INTERACTIVE STAFF TRAINING: Rehabilitation Teams that Work
Patrick W. Corrigan and Stanley G. McCracken

SOURCEBOOK OF OCCUPATIONAL REHABILITATION
Edited by Phyllis M. King

A Continuation Order Plan is available for this series. A continuation order will bring delivery of each new volume immediately upon publication. Volumes are billed only upon actual shipment. For further information please contact the publisher.

Enabling Environments

Measuring the Impact of Environment
on Disability and Rehabilitation

Edited by

Edward Steinfeld and
G. Scott Danford

State University of New York at Buffalo
Buffalo, New York

Kluwer Academic / Plenum Publishers
New York, Boston, Dordrecht, London, Moscow

Library of Congress Cataloging-in-Publication Data

Enabling environments : measuring the impact of environment on
 disability and rehabilation / edited by Edward Steinfeld and G.
 Scott Danford.
 p. cm. -- (Plenum series in rehabilitation and health)
 Includes bibliographical references.
 ISBN 0-306-45891-8
 1. Architecture and the physically handicapped--United States.
 2. Dwellings--Access for the physically handicapped--United States.
 3. Physically handicapped--Rehabilitation--United States.
 4. Environmental psychology--United States. I. Steinfeld, Edward.
 II. Danford, G. Scott. III. Series.
 NA2545.P5E53 1999
 720'.87--dc21
 99-22525
 CIP

ISBN 0-306-45891-8

© 1999 Kluwer Academic / Plenum Publishers
233 Spring Street, New York, N.Y. 10013

10 9 8 7 6 5 4 3 2 1

A C.I.P. record for this book is available from the Library of Congress

Printed in the United States of America

Contributors

Julio Bermudez, Graduate School of Architecture, University of Utah, Salt Lake City, Utah 84112.

Bruce B. Blasch, Rehabilitation Research and Demonstration Center, Department of Veterans Affairs Medical Center, Decatur, Georgia 30033

Bettye Rose Connell, Formerly with the Center for Universal Design, North Carolina State University, Raleigh, North Carolina 27695

Franklyn K. Coombs, BEAR Consultants, Lilburn, Georgia 30076

Barbara Acheson Cooper, School of Rehabilitation Science, McMaster University, Hamilton, Ontario, Canada L85 4K1

G. Scott Danford, Department of Architecture, State University of New York at Buffalo, Buffalo, New York 14214

William R. De l'Aune, Rehabilitation Research and Demonstration Center, Department of Veterans Affairs Medical Center, Decatur, Georgia 30033

Patricia L. Falta, School of Architecture, Université de Montréal, Québec, Canada H3C 3J7

Gail Finkel, Design Consulting & Research, Winnipeg, Manitoba, Canada R3B 0R3

Margaret Haley, Department of Computing and Communications, University of Washington Educational Outreach, Seattle, Washington 98105

Ake Isacsson, Community Health Sciences Center, Lund University, Lund, Sweden S-22354

Susanne Iwarsson, Community Health Sciences Center, Lund University, Lund, Sweden S-22354

Louise Jones, Department of Interior Design, Eastern Michigan University, Ypsilanti, Michigan 48197

Migette Kaup, The Ken Ebert Design Group, Manhattan, Kansas 66502

David B. Lantrip, Cartia, Inc., 2040 Langley Street, Oxnard, California 93033

Mary Law, School of Rehabilitation Science, McMaster University, Hamilton, Ontario, Canada L85 4K1

M. Powell Lawton, Philadelphia Geriatric Center, Philadelphia, Pennsylvania 19141-2996

Lori Letts, School of Rehabilitation Science, McMaster University, Hamilton, Ontario, Canada L85 4K1

Mary Beth Megrew, Rehabilitation Research and Development Center, Atlanta Veterans Affairs Medical Center, Atlanta, Georgia 30306

Carolyn Norris-Baker, Center for Aging, Kansas State University, Manhattan, Kansas 66506-1102

Leon A. Pastalan, College of Architecture, University of Michigan, Ann Arbor, Michigan 48109

Gary P. Richmond, Cannon Design, Grand Island, New York 14072

Patricia Rigby, Department of Occupational Therapy, University of Toronto, Toronto, Ontario, Canada M5T 1W5

Julia W. Robinson, Department of Architecture, University of Minnesota, Minneapolis, Minnesota 55405

Jon A. Sanford, Center for Universal Design, North Carolina State University, Raleigh, North Carolina 27695

Ron Sekulski, Industrial Design, Suomi College, Hancock, Michigan 49930-1882.

Philip Sloane, Department of Family Medicine and Epidemiology, University of North Carolina, Chapel Hill, Chapel Hill, North Carolina 27599

Edward Steinfeld, Center for Inclusive Design and Environmental Access, State University of New York at Buffalo, Buffalo, New York 14214

Debra Stewart, School of Rehabilitation Science, McMaster University, Hamilton, Ontario, Canada L85 4K1

Susan Strong, School of Rehabilitation Science, McMaster University, Hamilton, Ontario, Canada, L85 4K1

Travis Thompson, John F. Kennedy Center for Research in Human Development, Vanderbilt University, Nashville, Tennessee 37203

Theo J. M. van der Voordt, Department of Architecture, Delft University of Technology, Delft, the Netherlands 2628CR

Gerald D. Weisman, Department of Architecture, University of Wisconsin, Milwaukee, Wisconsin 53201

Preface

This volume is the first effort to compile representative work in the emerging research area on the relationship of disability and physical environment since *Barrier-Free Environments*, edited by Michael Bednar, was published in 1977. Since that time, disability rights legislation like the Americans with Disabilities Act in the United States, the worldwide growth of the independent-living movement, rapid deinstitutionalization, and the maturation of functional assessment methodology have all had their impact on this research area. The impact has been most noticeable in two ways—fostering the integration of environmental variables in rehabilitation research and practice, and changing paradigms for environmental interventions.

As the contributions in this volume demonstrate, the relationship of disability and physical environment is no longer of interest primarily to designers and other professionals concerned with managing the resources of the built environment. The physical environment has always been recognized as an important variable affecting rehabilitation outcome. Until recently, however, concepts and tools were not available to measure its impact in clinical practice and outcomes research. In particular, lack of a theoretical foundation that integrated environment with the disablement process hampered development of both research and clinical methodology. Thus, the physical environment received little attention from the mainstream rehabilitation research community. However, this situation is changing rapidly. There is an increased emphasis on development of methods that can improve the reliability and validity of both research and clinical interventions; this will significantly accelerate the dissemination and application of methods in the health sciences. This volume, in contrast to Bednar's pioneering work, reflects these changes by including many contributions on theory, methodology, and applications to clinical rehabilitation practice.

A major shift is now occurring in the paradigm of environmental intervention for independent living. Although such interventions were first viewed as an extension of prosthetics, in the 1970s the paradigm expanded to public accom-

modation. In the 1990s a third paradigm emerged, the concept of universal design—products and environments that are designed to be accessible and usable by everyone rather than as special accommodations for people with impairments. The goals of universal design include increasing functional independence, increasing social participation, and decreasing stigma. This new paradigm expands the arena of environmental intervention and consequently environmental research. While individual and public accommodations are certainly still necessary and important, the larger context of mass-produced products and environments are now viewed as constraints and obstacles to individual adaptation and fulfillment of potential. Moreover, functional independence is now recognized as only the first step in social participation. Other outcomes, such as the appearance of objects and places, are now being recognized as significant variables as well. To accommodate this new paradigm, research has expanded beyond the narrow focus of physical accessibility to include the social impact of designed environments.

The contributions in this volume represent a new dialogue that is uniting several previously separate fields of inquiry and practice. We have attempted to bring together representative work emerging in the fields of environmental design research, rehabilitation research, clinical rehabilitation practice, mental health, and aging. We are grateful that the contributors saw the importance of this developing dialogue and wish to thank them for their interest and the effort they made in bringing this work to fulfillment.

Contents

7. Assessing Special Care Units for Dementia: The Professional Environmental Assessment Protocol 165

Carolyn Norris-Baker, Gerald D. Weisman, M. Powell Lawton, Philip Sloane, and Migette Kaup

8. Using Environmental Simulation to Test the Validity of Code Requirements 183

Jon A. Sanford and Mary Beth Megrew

III. NEW DIRECTIONS IN RESEARCH METHODS 207

9. A Day's Journey Through Life©: An Assessment Game 211

Ron Sekulski, Louise Jones, and Leon A. Pastalan

Enabling Environments

Measuring the Impact of Environment
on Disability and Rehabilitation

Introduction

Edward Steinfeld and G. Scott Danford

This book provides an overview of research on the relationship of the physical environment to the disablement process. The theme is how this interaction can be measured. The book was initially developed through a call for papers to present at a working conference where the authors engaged in intensive interaction and discussion. After the conference, revised drafts of the papers were submitted and some additional papers were added to increase the range of topics covered. The book covers a broad range of issues to expose the diversity of concerns and approaches that are currently being practiced. The contributions represent work from several countries: the United States, Canada, Sweden, and the Netherlands. They also represent many different disciplines: architecture, psychology, occupational therapy, orientation and mobility training, human factors, gerontology, and computer-aided design. These international and multi-disciplinary flavors have enriched the book significantly because each country and discipline has its own particular perspective on the issues.

We have arranged the chapters into four parts: "Theory," "Reliability and Validity," "New Directions in Research Methods," and "Measurement in Practice." The emphasis on measurement reflects our belief that there has not been enough attention to research methodology in this field of study. Most books and articles on the subject are focused on reporting findings, and there has been virtually no explicit attention in the published literature on the process of measurement.

Edward Steinfeld and G. Scott Danford • Center for Inclusive Design and Environmental Access, School of Architecture and Planning, State University of New York at Buffalo, Buffalo, New York 14214.

Enabling Environments: Measuring the Impact of Environment on Disability and Rehabilitation, edited by Edward Steinfeld and G. Scott Danford. Kluwer Academic/Plenum Publishers. 1999.

Methodology starts with theory; hence the first part, which presents a set of important issues underlying the formation of research objectives and approaches. The second part is concerned with research quality, with ensuring that methods of measurement used in research and practice actually do what they are supposed to do. The third part presents some examples of research methods that promise to move the field in new directions. The last part presents a cross-section of research that demonstrates how the measurement of interactions between physical environment and disablement can be used in practical applications. Each part begins with an introduction that provides an overview of the chapters in that part.

The major premise of this book is that the physical environment is a very important factor in determining an individual's degree of independent living and in defining the status of people with disabilities in society. Most people with impairments and the professionals who serve them recognize that the environment plays an important role in life with an impairment. Environmental barriers can actually thwart the best efforts of health professionals to restore or augment function. As a result, removing barriers to independence has been an important part of the disability rights movement from its start. People with impairments themselves have been successful in making accessible design a major aspect of civil rights legislation. Three good examples in the United States are the Rehabilitation Act, the Americans with Disabilities Act, and the Fair Housing Act. Even though individuals with impairments and professionals alike recognize the importance of the environment, the research community and policymakers have not given it the attention it deserves. Part of the problem may be that traditional rehabilitation theory has focused primarily on the person. Changes in theory, however, spurred by the experience of the independent-living movement, are putting much more emphasis on the environment. The most notable evidence of this shift are the proposed changes to the *International Classification of Impairments, Disabilities and Handicaps* (ICIDH) (World Health Organization [WHO], 1980).

The ICIDH is the most widely adopted conceptual framework for research, practice, and policy related to rehabilitation. It distinguishes between "impairments," or disturbances at the level of the organism; "disabilities," or limitations in activities; and "handicaps," or limitations in societal participation. The traditional view is that impairment, disability, and handicap act like a linear cause-and-effect process; that is, impairment causes disability and disability in turn leads to limitations in societal participation or "handicap" (Figure I.1). The current official version of the ICIDH does not include environmental factors in its schema. Both

Health Condition ⟶ Impairment ⟶ Disability ⟶ Handicap

Figure I.1. Traditional model of the disablement process.

social and physical environments, however, clearly play a role in the success of rehabilitation.

In the absence of a guiding paradigm, most of the research on the relationship of the physical environment to disablement has focused on the development of normative guidelines for ensuring access to the built environment (e.g., building regulations and design norms or standards). The objective has been to reduce handicap and consequently ensure societal participation through environmental design. This valuable activity in itself demonstrates the importance of environmental factors and a need to reconsider the WHO model.

Although environment has not been entirely neglected, the lack of attention to environment in the model has retarded the development of policy that would facilitate many other needed environmental interventions, such as home modification services and universal design. Since most design issues addressed by the norms have received little research attention, the degree to which the norms actually reflect an accurate understanding of all the needs is questionable. Even for those topics that have received research attention, there are questions about the reliability and validity of methods used since there has been so little scientific debate about measurement methodology and practically no theory to use for generating research questions and guiding research approaches.

In rehabilitation practice, the narrow focus of research on environmental factors has restricted the development of fundamental knowledge about the relationship of disability to environment that would help professionals assess individual needs and identify both optimal and cost-effective interventions for their clients. It has also limited our understanding of how environment contributes to disability as opposed to handicap. A major unanswered question is: To what degree and for whom can environmental interventions improve capacities for independent living? Finally, little research attention has been given to the effectiveness of the norms in actual rehabilitation outcomes, either improved daily function or increased social participation.

The ICIDH is now undergoing a review and revision process (Ustan, 1997). One of the most important proposed revisions is the recognition that the context of a person's life, that is, personal factors such as age and motivation and environmental factors such as physical facilities, consumer products, and family support, must be incorporated in the ICIDH to reflect real world conditions more accurately. This would also shift the emphasis from a traditional medical model that treats only the person to the view that interventions in the context of an individual's life may be just as important as medical care. A second important proposal recognizes that a linear relationship between impairment, disability, and handicap is an oversimplification. Health conditions do not necessarily result in an impairment, but they can result in functional limitations; a good example is pregnancy. Moreover, an impairment could result in limitations in social role participation even if it causes no functional limitation; an example here is the result of stigma associated with mental illness. A third major proposal is to move

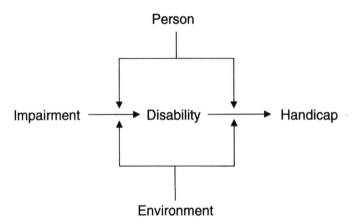

Figure I.2. New conception of the disablement process.

toward a more positive language for describing the relationship of disablement to environment. From this new perspective, the environment can be conceptualized as a mediating factor in both functional ability and social participation. Figure I.2 maps this new conception.

This new schema suggests major implications for rehabilitation practice. Putting more emphasis on the environment brings attention to the limitations in the context of daily life and deflects it from the limitations of the individual, who is clearly not to blame. No longer is it sufficient to evaluate an individual's functional ability to assess their level of independence; one must also consider who the person is, what their family resources are, and in what physical environment their everyday activities take place. No longer is it appropriate to discuss "disability" out of context. The new paradigm implies that we focus on abilities and how they are supported or limited by environment, either physical or social. It is clear that without good measurement techniques that take account of the effect of environmental variables, the ability to monitor outcomes is compromised.

With just a little imagination, one can see that the relationship between the functioning of a body or mind, abilities, social participation, environmental factors, and personal factors is very complex. The new conception suggests not only the need for giving more attention to environmental issues but also that these issues are multidisciplinary and of interest and importance to many different professionals. In particular, there is a need for more research to fully understand how the physical environment affects rehabilitation success. Granted, good practitioners already take a holistic view and give attention to these issues, but often they are operating on intuition, very limited information, and a lack of good measurement tools. Moreover, the resources devoted to making changes in the physical environment are often out of the practitioner's and individual's control.

Research can help demonstrate how important they really are and can provide data to make informed decisions about potentially costly and disruptive interventions. Such information is necessary to launch major new policy initiatives and to support changes in the management of resources.

An example helps to demonstrate the pressing need for more research on the mediating influence of the physical environment and better methods of measurement. The economics of health care are creating intense pressure to reduce the length of patient stays in acute care settings. Rehabilitation clients are therefore spending less and less time in inpatient facilities (Fielder & Granger, 1997) and more and more time in subacute facilities and at home (Beckley, 1996). In subacute and especially home locations, physical barriers in the near environment, such as stairs and bathroom design, have a significant effect on rehabilitation outcome as experienced by the individual in day-to-day life. Gain in function measured at discharge from inpatient facilities by current widely used outcome measures, such as the Functional Independence Measure (FIM™), may not be an accurate indicator of actual independence in the community. In pursuit of a pure measure of the individual's functional ability, effects of the physical environment are controlled out in the administration of the FIM™ instrument. In research described in more detail in Chapter 5, we document how the physical environment mediates functional ability and caregiver burden and demonstrate that those effects can be measured quantitatively. With new tools for measuring the impact of environment, it is now possible to measure the degree to which environmental interventions impact outcome in terms of functional independence (ability) and caregiver burden. Tying intervention to outcomes with a quantifiable measure can help rehabilitation practitioners, consumers, and insurers predict the impact of home modifications and use that knowledge to decide on the best mix of interventions for a particular household.

Although there is wide recognition that the physical environment is important, the resources devoted to environmental interventions in rehabilitation are insignificant compared to those devoted to other interventions, such as caregiver support or durable medical equipment. Despite the many laws mandating accessibility, there is a constant battle to fully implement those laws, and the social value of accessibility is continually questioned. The contributions in this book build a strong case for giving more attention to the environment in rehabilitation practice. Building on the emerging new model of disablement, theoretical issues are presented that will lead to many new approaches in research. The attention to research quality highlights the importance of high standards in development of measures and demonstrates a wide range of approaches to establishing research quality. The contributions include some exciting new approaches to research in this field that can be applied to study many different problems and issues, including the application of advanced computing technology. Finally, they demonstrate several approaches to using measurement of environmental effects in rehabilitation and design practice.

REFERENCES

Beckley, Nancy J. (1996). Marketing to referral sources. *REHAB Management* (October/November), *9*(6), 101–103.

Fielder, Roger C., & Granger, Carl V. (1997). Uniform data systems for medical rehabilitation: report of first admissions for 1995. *American Journal of Physical Medicine and Rehabilitation, 76*(1).

Ustun, Bedirhan. (1997). *ICDH Revisions.* Geneva, Switzerland: World Health Organization (published on the World Wide Web).

World Health Organization. (1980). *International Classification of Impairments, Disabilities and Handicaps.* Geneva, Switzerland: Author.

I

THEORY

All research has some theoretical foundation. However, too often research on enabling environments has not explicitly addressed theory. Rather, the theoretical ideas that guide the research are implied and often are revealed only by the beliefs, assumptions, and decisions imbedded in the selection of research methods and the interpretation of findings. In practice, theory takes even more of a hidden role. Norms of practice take precedence and guide decision making and action. But behind these norms are concepts, beliefs, and attitudes that are shaped by theory. As we discussed in the Introduction, the paradigms that have guided the fields of rehabilitation and disability studies in the past are changing. How might the new emerging paradigms affect the conduct of research on enabling environments? The chapters in Part I address this question in three different ways, but they are united in emphasizing the importance of theory as a transmitter of paradigms. These chapters also demonstrate how theory can help form a common ground for both practice and research.

Steinfeld and Danford, in Chapter 1, focus on the instrumental emphasis of most research and practice on enabling environments. The premise of enabling environments is that a good "fit" between person and environment is a desirable state of affairs. However, they point out that there are many ways that this state can be defined and many ways to measure it. The concept of fit used in most research and practice relies on design norms to establish an acceptable level of usability. This approach is not conceptually sophisticated enough to address the new model of the disablement process. Knowledge from both practice and research demonstrates that what is best for one person is not necessarily best for someone else. Using theoretical ideas from the field of environment–behavior studies and experience with the use of the Functional Independence Measure, the most widely used measure of disability in the world, the authors propose a transactional model of fit that better reflects the process through which individuals experience and adapt to the environment. Because these transactional processes are complex, the authors argue that multi- method research strategies

7

are needed to measure fit, methodologies that incorporate both professional and consumer perspectives and global and fine-grained measures. The authors propose that such methodologies can unite researchers by providing a widely accepted and more rigorous approach to research. Moreover, they can bridge the gap between research and practice by providing a uniform set of measures for many different kinds of activities. Three new methods under development that support the transactional multimethod approach are introduced in the chapter.

In Chapter 2, Connell and Sanford address the emerging new concept of universal design and its impact on research. Universal designs are products and places that are usable by people with a wide variety of capabilities and those whose capabilities may change over time. Although the term is often used as a synonym for accessible design, it is actually very different in a fundamental way. The target population for universal design includes both people with and people without impairments. Not only do universal designs have to be usable by people with impairments, but they also have to be convenient and attractive to those without impairments. This difference raises questions about how well both the findings of research on accessibility and the techniques for measuring enabling environments can be generalized to universal design research and practice. The authors argue that the shift of paradigms demands new conceptual and theoretical frameworks. In particular, the target populations for sampling need to be reconsidered, and relevant outcome measures and evaluative criteria need to be devised. This will allow research to identify the needs of the broader population as well as those with impairments. A critical need is for research to back up the claims that universal design has concrete benefits for everyone. In addition, the authors discuss emerging opportunities in the focus and direction of research that are suggested by the change of emphasis.

Van der Voordt's contribution (Chapter 3) examines the results of research leading to the revision of *The Call for Admittance*, a manual that is widely used as a guide for the accessible design and construction of buildings in the Netherlands. While preparing a new edition of this manual, van der Voordt and his associates reviewed and compared the existing empirical research findings on space requirements for accessibility from studies completed in different countries. They also completed a series of computer simulations on the space requirements of wheelchair users, in particular the use of toilets and doors. Initially the objective was to identify the consensus of research findings and validate and clarify consensus norms through the simulations, but the results of the study demonstrated that there was considerable divergence in findings and recommendations. A comparison of research approaches identified many differences in methodology and interpretation of results, especially recommendations for design norms. The findings have considerable significance for the theory of enabling environments. First, they demonstrate that cultural and professional values and attitudes play a significant role in the development of norms. What is acceptable

in one country or by one group of professionals may not be acceptable in another country or by other professionals. Theory must take this variability into consideration. Second, they demonstrate the importance of consistent methodology. Without consistency, replication of results is virtually impossible and the development of theory is thwarted.

1

Theory as a Basis for Research on Enabling Environments

Edward Steinfeld and G. Scott Danford

INTRODUCTION

Since the mid-1970s, there has been a growing body of research and practice on accessibility of the environment for people with impairments. Some of the research has found its way into codes, standards, and design guidelines. The norms and recommendations based on this research are used on a daily basis all over the world to make major decisions in design practice and social policy. Occupational therapists, physicians, and other rehabilitation service providers also use this knowledge base to plan interventions in the home and work environment in seeking to promote more independence for their clients.

Although much of the content in the design norms is based on research, much is still based primarily on the opinion of professionals, consumer advocates, and industry representatives serving on the committees who develop the norms. There is a need for much more research to validate those norms that derive more from opinion than fact. Moreover, detailed comparisons of even

Edward Steinfeld and G. Scott Danford • Center for Inclusive Design and Environmental Access, School of Architecture and Planning, State University of New York at Buffalo, Buffalo, New York 14214.

Enabling Environments: Measuring the Impact of Environment on Disability and Rehabilitation, edited by Edward Steinfeld and G. Scott Danford. Kluwer Academic/Plenum Publishers. 1999.

research-based norms and research recommendations (see Chapter 3 by van der Voordt, this volume) reveal many differences, which also suggests a need to standardize research methods. Yet, despite its importance, little attention has been given to investigating the reliability and validity of research methods used in this field. In particular, there has been no attempt to develop guidelines that would help to avoid bias and threats to validity and reliability in future research. The lack of a critical perspective and measures to ensure research quality brings into question the validity of many design norms and the practices of the design and rehabilitation professions.

Research on accessibility has been focused on the design of newly constructed buildings or on major renovations where entire buildings are brought into code compliance. However, the independent-living movement and the philosophy of mainstreaming have generated new information needs in this field. On one hand, there is now a need for information that can be used on a case-by-case basis as part of rehabilitation interventions. To justify third-party reimbursement for home and office modifications, for example, we need reliable methods to determine the specific needs of a person in a specific place. We need techniques that will help evaluate how an intervention contributes to maintaining independence. On the other hand, we need information that can help evaluate the impact of disability rights policies. Legislation like the Americans with Disabilities Act (ADA) in the United States, with its emphasis on "reasonable accommodation," raises many questions about the definition of an acceptable level of accessibility. What is "reasonable?" Under what conditions will someone's civil rights be violated because of architectural barriers? In fact, the widespread impact of disability rights legislation has made design norms a political battleground, as various interest groups lobby for and against specific criteria. The politicization of these norms demands higher quality information. Without it, there is no way to evaluate the positions of opposing interest groups. We also need a way to evaluate the impact of the design norms themselves. Specifically, we need instruments that measure the degree to which a physical environment disables or enables an individual or group. This information can help measure the effectiveness of norms used to enforce legislation.

Underlying all of these concerns is the lack of adequate theory. Most accessibility research and norms have not been based on an explicit theoretical foundation. Assumptions about human behavior and its relationship to the environment have been made in the conception and interpretation of this work, but these assumptions are not substantiated even by general observations of the relationship between human behavior and the physical environment. Poor theory has significant implications for validity, experimental bias, reliability, and generalizability. The most common assumption found in the existing research and norms is that an accessible environment is one in which an individual with an impairment can "function independently." Another assumption is that there is

some level of function that can be called "minimally acceptable." We believe that these assumptions have substituted for theory and, because of their vagueness, have limited progress in empirical research. They have also allowed policy-makers to ignore or slight the importance of research, relying instead on unsubstantiated opinion or using research results only when they conveniently support a particular opinion.

For example, a common rule in accessibility codes is that a ramp should not be steeper than a 1:12 slope. Yet, research by one of the authors indicates that only about 60% of 56 wheelchair users tested could manage such a slope for distances greater than 30 feet (Steinfeld, Schroeder, & Bishop, 1979b). Moreover, another study has demonstrated that wheelchair users can negotiate steeper slopes than 1:12 if the ramp is not too long (Templer, 1979). Knowledge of basic theory in statics and mechanics explains these divergent findings about slope. The energy required to move an object up an incline can be the same for a long shallow ramp and a short steep ramp. Theory in statics and mechanics suggests that there are likely to be other important factors to consider. One that has never been studied, for example, is the frictional resistance of the floor surface.

Of course, using a ramp is not simply a physical event; it is a physiological and behavioral one as well. Factors such as stamina and motivation come into play, as does pure physics. Behavioral issues are of particular concern in the development of regulations because ultimately a decision has to be made about the definitions of terms such as "accessible" or "reasonable accommodation." Thus, to study even such a seemingly simple issue as ramp design requires a relatively complex theoretical framework in order to understand the phenomenon fully and to make valid recommendations about policy from the results.

There is, however, a body of theory in the field of rehabilitation and disability studies and in environment–behavior studies that can provide a sound theoretical basis for this research. From this foundation, it is possible to develop improved research methods and better applications of research findings. Furthermore, good theory helps expose bias in professional, industry, and consumer opinion. Thus, developing a theoretical foundation for accessibility can both promote the cause of research and demonstrate the dangers of using unsubstantiated opinion as the primary source of knowledge for design criteria.

REHABILITATION AND DISABILITY STUDIES

Conceptual models of disability make an explicit or implicit distinction between "handicap" and "disability" (see, e.g., National Institute of Child Health and Human Development [NICHHD], 1992). Disability is viewed as an inability or limitation in performing a task and has a locus in the individual; handicap, or the positive and easier to measure term "participation," is an outcome of the inter-

action between the person and the sociophysical environment. It has a locus in the environment. A disability is viewed as the functional limitation caused by an impairment, whereas lack of participation is caused by the response of a culture to disability. For example, prejudice toward hiring people with disabilities restricts participation in the labor force; a walking limitation does not inherently have such an impact. The physical environment certainly plays a role in participation. An inaccessible job site, for instance, is a culturally imposed limitation, but the physical environment also mediates between impairment and human performance and thus plays a role in disability as well. For example, it may not be possible for a person with limited walking ability to use a bathtub without grab bars without assistance. Adding the grab bar changes the relationship between the person and the environment so that independent use is possible. The ability of the person, defined by level of independence in a functional task, has improved through environmental intervention. The physical environment, then, is linked to both participation and disability. It can enable both.

In their critique of research on disability, Fine and Asch (1988) argue that a focus on the person to the exclusion of environment reinforces the stereotype of helplessness associated with disability. This focus assumes that disability is a given. A focus on environment as a mediating variable, on the other hand, recognizes the powerful role environment plays in the social construction of disability. Such research can help uncover how environmental design (both social and physical) can break down stereotypes and redefine disability itself. Scott Campbell Brown (1992) reflected on the difficulties of measuring progress toward equality of opportunity, full participation, independent living and economic self-sufficiency as follows: "[T]he nation's progress toward meeting these four goals is dependent on successful policy interventions in a highly interactive process between environment and persons with disabilities; yet, objective measures of interactive processes are difficult to obtain" (p. 1).

The social construction model of disability defines the environment as a disabling or enabling context. Although restrictions on participation may be caused by social barriers such as policies and attitudes that lead to inaccessible places, the physical environment can also be viewed as part of the disability because it has a direct relationship to functional performance. Environmental "barriers" at home, at work, or in community settings can mask the abilities of individuals. They can even negate the impact of rehabilitation or thwart its progress. Although there is a growing body of human factors research focused on developing an empirical knowledge base on accessibility (Margulis, 1981; Steinfeld et al., 1979b; Woods, 1980), there is not, as yet, a way to understand the interactive relationship of environment and impairment that results in disability. Although the existing knowledge base can be used to assess the "accessibility" of buildings, as defined by a design norm, it cannot easily be used to assess the degree to which environments actually enable from the perspective of individuals or groups with impairments.

The Functional Independence Measure

To assess the mediating role of an environment, methods to measure functional ability must be found that are sensitive to changes in environment. There are several functional assessment measures used to assess the impact of rehabilitation interventions. The method in most widespread use in the North America is the Functional Independence Measure, or FIM™ (Uniform Data Systems [UDS] Project, 1993). We will focus this discussion on the FIM™ instrument because of its popularity in practice. The FIM™ instrument is a series of subscales that measure basic functional abilities of an individual. Each subscale uses a 7-point scale from complete dependence to complete independence. The FIM™ instrument has been used in over 1 million assessments and is in daily use at over 1000 rehabilitation settings throughout the world. A database has been developed of information obtained through FIM™ assessments. This database is managed by the UDS Project at the State University of New York (SUNY) at Buffalo. Through careful development and extensive experience, the UDS team has developed a training method for ensuring reliable administration of the FIM™ instrument. Figure 1.1 is a page from the training manual that shows, in the form of a flowchart, how the FIM™ subscale score for bathing is determined.

The FIM™ instrument measures disability in terms of functional limitation. It is based on the theory that disability can be measured separately from the influence of environment. Thus, environmental factors are purposely neutralized. For example, individuals can obtain the top score of 7 on a subscale if they bathe themselves without assistance. It does not matter where they bathe themselves. It can be in a tub, in the shower, or as a sponge bath. This measure of function, then, is theoretically independent of environment. Controlling out environmental influences is very important when measuring the success of rehabilitation in a health care setting since the environment is not part of the care program. The neutralization of environmental variables, however, presents some serious limitations for its use as a measure of rehabilitation success outside the health care setting.

The first limitation is related to quality-of-life issues. For example, an individual who uses a wheelchair may score 7 on the FIM™ bathing subscale prior to discharge from a hospital-based rehabilitation program. At the hospital, the individual may be showering independently using a shower stall in a fully accessible bathroom. At home, however, she may only have a bathtub located inside an inaccessible bathroom. As measured by the FIM™ instrument, her abilities would not change when she returns home as long as she can give herself a sponge bath from the kitchen sink. But there can be little argument that something has changed. She cannot take a bath in a culturally acceptable manner.

Although the FIM™ instrument has avoided the conceptual trap of equating disability and restricted participation (handicap), it does not take into consideration the mediating role of the environment. If used alone, it may put undue

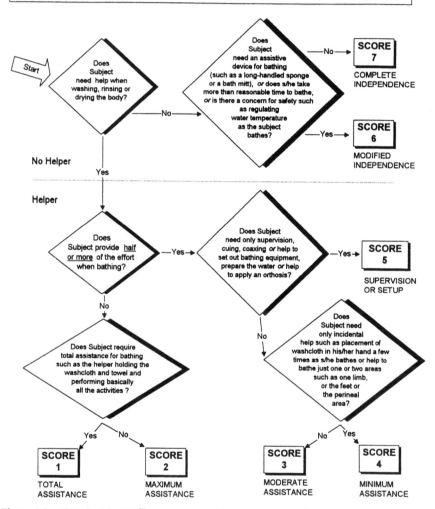

Figure 1.1. Flowchart for FIM™ subscale on bathing. (Reprinted with permission from the *Guide for the Uniform Data Set for Medical Rehabilitation (Adult FIM™)*, Version 4.0, effective January 1, 1994. Copyright© 1993 Uniform Data System for Medical Rehabilitation. UB Foundation Activities Inc.)

emphasis on the individual and thus, as Fine and Asch (1988) observed, reinforce the stereotypes associated with disability. In particular, the FIM™ instrument does not provide any information on the *acceptability* of living conditions, and so relying on the FIM™ instrument to address quality-of-life issues is not acceptable. In fact, such an approach to measuring the outcome of rehabilitation ignores the issue of participation. Lifestyles that are not culturally normative, even if functional independence is obtained, reflect limitations on participation. It should be noted that these criticisms do not negate the value of using the FIM™ instrument in studies of participation. A measure of functional independence that controls environmental influences is very useful for comparison purposes. For example, in the first example given here, an FIM™ score of 7 could be compared to how the individual actually takes a bath. Dependence on others or inability to use the bathroom would glaringly demonstrate the impact of inaccessibility. The FIM™ score would demonstrate that she is *capable* of bathing independently, but the environment severely restricts *how* she must do it.

A second limitation of the FIM™ instrument is that it has restrictions on content. The subscales omit many activities of daily living that depend on environmental design for success. For example, although there is a walking subscale, that scale does not include the use of doors, which can be major barriers to circulation in buildings and are especially important in education or work environments. While there is a subscale for eating, there is no subscale for food preparation, another critical task of independent living. The lack of such subscales limits the application of the FIM™ score as a dependent variable in research seeking to understand the relationship of environment to functional ability.

Aside from these two limitations, the complete independence of the FIM™ instrument from environmental influence is questionable. For example, a score of 6 is usually assigned when a subject uses an "assistive device." This has implications when comparing environments. For example, an ambulant individual may not need any assistive devices to use a shower stall at the health care setting; however, to use the tub in his home, he may require the use of a bathing chair. The use of the chair would reduce his score on bathing even though his actual physical ability has not changed. Further, interpretation is often necessary to define "assistive devices." For example, is a seating platform built into the corner of a shower stall an assistive device, or is it part of the shower? Furthermore, limitations on access to resources needed to complete a task, such as running water and supplies kept in storage, may also have an indirect influence on the FIM™ score. These limitations are environmentally determined, for example, the location of the faucet, towel bar, or soap dish. Inaccessible locations require assistance to complete the task. Thus, the FIM™ score can be *indirectly* influenced by the features of an environment. If those features require that the individual use an assistive device, are interpreted as if the person did, or require that the person be assisted, the score will be distorted.

This discussion demonstrates that the FIM™ score, if used alone, can obscure reality. Although an individual may score high on the FIM™ instrument, the quality of her life may be low in comparison to her potential. There are many aspects of community living not measured by the FIM™ instrument. Furthermore, even given the attempts to control out environmental influences, there are indirect effects that may distort the score itself when comparing performance in different environments. The contemporary policy emphasis on independent living and mainstreaming clearly demands a more sophisticated approach to measuring functional ability in community settings.

In summary, rehabilitation practitioners use measures such as the FIM™ instrument successfully to measure *rehabilitation outcomes*. However, the deemphasis on environment raises questions about their validity in generalizing the success of independent living or mainstreaming. In the real world, the environment may block access to the support needed to fulfill the potential of rehabilitation. In fact, through lack of environmental support, functional ability may deteriorate. There is also the issue of predictive validity. Without additional information, measures such as the FIM™ instrument are not useful to predict the ability of an individual (or group) to function in a particular environment (or class of environments like assisted living facilities or group homes). To do this, empirical relationships between FIM™ scores and usability of environments need to be established.

ENVIRONMENT–BEHAVIOR PERSPECTIVES

Environment-behavior studies provide a theoretical perspective to address the limited role environment has played in rehabilitation theory. Alexander (1970) and others have proposed that successful design is a close fit between the environment and the people by whom it is intended to be used. The concept of fit is an analogy from everyday life—for example, "clothes that fit." Research on design of environments for people with disabilities is usually implicitly or explicitly based on the idea that some state of fit is definable and achievable. In most of this research, fit has been conceptualized as an accessible or usable environment, one that matches the abilities of the individual or group with an appropriate level of support. Although the idea of finding a close match between environment and abilities is conceptually simple, measuring the degree to which a match is achieved is not. There are many ways that fit and environment can be defined and many ways to measure it (see, e.g., Danford, 1983). Moreover, the concept of matching abilities with support is an overly simplified representation of the actual relationships between individuals and their environment. An analysis and critique of definitions and methods of measurement used in accessibility research from the perspective of environment-behavior theory can provide insight for establishing a theoretical basis of this research.

Accessibility and usability are usually defined in terms of observed task performance (see, e.g., Bails, 1983; Brattgard 1967-1974; Steinfeld et al., 1979b;

Templer, 1979). Task performance has been taken to have a high level of face validity as a measure of fit. For example, a study might identify a space clearance, ramp slope, or reach limit that is usable by a large proportion of the study sample. But observed performance is only part of the total picture. Accessibility cannot be measured solely by observed performance because an acceptable level of usability is based on individual interpretations and social norms. By comparing architectural design standards for space sizes in different countries, Rapaport and Watson (1972) demonstrated convincingly that standards are not necessarily based solely on anthropometrics. Different cultures and subcultural groups hold different beliefs about tolerances between body size or body movements and the space envelopes in which they occur and the postures that are appropriate for specific activities. Much research has demonstrated the impact of individual and group difference on spatial behavior as well (e.g., Altman, 1975).

The clothing analogy can be used to illustrate the cultural and social aspects of fit. Some individuals will insist on wearing clothes that are clearly too small rather than admitting to themselves that they need to adjust their wardrobe to a changing body size. Others will wear clothes that are larger than they have to be because they feel more comfortable in them. In some cases, the degree to which clothes fit the body represents identification with a group. There are fashion periods where short and tight is considered aesthetically superior and others in which long and loose is the paradigm. In the former periods, those who aspire to the latest styles adjust their expectations for freedom of movement; in the latter they tolerate excess material to drag around and constantly adjust.

In the context of accessibility, several psychosocial factors clearly impinge on the definition of fit. These include self-image, motivation, social pressure, and expectations. As with clothing, individuals interpret and evaluate the degree to which the environment restricts and supports the satisfaction of their goals and desires. Observing task performance alone will not uncover the interpretative and normative dimensions of fit. In fact, the performance observed may in fact be influenced by factors that obscure an individual's true abilities. The wording of instructions, the expressions on the faces of research staff as they observe a subject in action, and the emotional state of individuals can easily alter performance in a task by setting up social expectations (see, e.g., Webb, Campbell, Schwartz, & Sechrest, 1969).

Although many causes of experimental bias can be controlled by careful research design and sample selection, the small budgets of most studies make such control difficult. Moreover, there have been no purely methodological studies that systematically investigate the impact of these variables. How does the wording of instructions affect performance? What difference will result from instructing someone to "apply the most force you can" compared to "apply a comfortable amount of force?" The instructions used, in fact, operationally define fit for each study.

We can also raise methodological concerns about the interpretation of research results. Statistical definitions of fit are often used to make recommenda-

tions from research data. In human factors research, the 5th and 95th percentile in performance are often used to define the boundaries of acceptable fit for the population at large. Steinfeld et al. (1979b) used a less stringent criterion to make recommendations based on task performance among a group of people with disabilities. They argued that the abilities of people with disabilities are already at the extremes of the population. Therefore the 5/95 rule should be relaxed to make more allowances for "outliers." Wherever a recommendation based on the performance of 100% of their sample would have cost implications, they fell back to the level achieved by 80% of their sample as a basis for recommendations. Woods (1980) used a 25/75 rule to establish recommendations. Some researchers have used the mean performance level and others have used the extremes of the range. The limitation of the statistical approach is that its generalizability depends on the degree to which the sample is representative of the target population. The degree of representativeness is often not defined by the researchers and is even less likely to be of concern to the policymakers that apply the results of the research.

Another definition of fit is to assign an arbitrary observable performance criterion, usually task completion. For example, Johnson (1981) used the criterion of being able to open and pass through a door to establish the amount of force allowable for doors with self-closing devices. It did not matter to him whether the task was difficult or easy, as long as an individual was able to pass through. This definition is based on the assumption that, for accessibility purposes, the bottom line is completion of the task. Yet, this definition ignores the influence of interpretation in the conduct of everyday life. To illustrate this influence, let us look at data from an unpublished study of our own. Table 1.1 shows data on the time it took for several individuals to simulate use of a bath-

Table 1.1. Data on Simulated Use of Bathroom

Subject	Time (s)	Convenience rating[a]
1	330	5
2	261	9
3	140	12
4	236	8
5	154	9
6	154	11
7	171	7
8	413	10
Means	232	8.9

[a]14-point scale as developed by Pitrella and Kappler (1988).

room. Subject 8 took almost twice as long as the mean time for the group. Obviously, the mean time would be substantially lower if her time was not included. Even though this individual was able to complete the task, it is questionable as to whether she would always use a bathroom independently. The convenience ratings (14-point scale) demonstrate that some subjects who had short times (7 and 5) rated the bathroom more difficult than or equivalent to subjects who had longer times (8 and 2). Two subjects with identical times gave it different ratings (5 and 6).

As the findings of accessibility research begin to be applied at the international level, the impact of cultural norms becomes critical. These norms are based not only on differences in body sizes but also on cultural differences in the use of space and level of economic/technological development. The idea that standards based on research in the United States can be applied in China or even Canada must be given serious critical attention. How can research data on human performance be applied most appropriately across cultural borders? Within a country, who decides on the degree to which standards accommodate the needs of the population as a whole? How can the findings from research with small samples be generalized to the population as a whole? How can the validity of standards as a prescription for fit be evaluated?

These questions raise important issues. Their answers shape research methodology and the interpretation of research findings. Theory establishes a framework for research that can answer these questions. A model of environment–behavior relationships is a first step toward theory. Our model of the environment–behavior relationship is influenced by many sources. Steinfeld (1981) and Danford (1983) have presented more elaborate descriptions of the key ideas.

How a person behaves in a particular situation is not a simple property of either the person or that person's environment but rather the interaction between the two (Cronberg, 1975; Mead, 1934). This view on the nature of person–behavior–environment relations is the defining characteristic of what has come to be known as a transactional perspective (Altman & Rogoff, 1987; Moore, 1976; Stokols, 1981; Wandersman, Murday, & Wadsworth, 1979). We propose that the transactional model can be very useful in practice. In particular, it can be operationalized in functional assessment to provide tools for measuring the impact of environmental design on functional performance.

Virtually all transactional models of person–behavior–environment relations are at least partially grounded in Kurt Lewin's (1951) classic concept of "Life Space," which is defined by the equation $B = f(PE)$. Simply stated, Lewin conceived of behavior as being a function of the interaction of personality and individual factors and the perceived environment of the individual. Contemporary transactional models are typically more complex. These models either continue the emphasis on mental processes, for example, perception, or emphasize outwardly observed behavior. Nevertheless, they generally acknowledge that behavior is a manifestation of the person–environment interaction rather

than determined by either intrapersonal factors or the environment alone. Both perspectives have their value and both can be incorporated in transactional models.

The Environmental Docility Hypothesis is an example of a transactional model. It demonstrates the focus on the relationship of person to environment and introduces the concept of "environmental demand." Based on the concept of stress, this model postulates that environment exerts a "press" upon the person, either supportive or challenging. The consequences of that environmental press depend upon the "competence" of the person encountering that environment (Nahemow & Lawton, 1973). Nahemow and Lawton argue that mismatches between the press of an environment, on the one hand, and the functional capabilities that person may possess, on the other hand, can lead to situations in which the person's functional independence and performance could be seriously compromised. This may occur not only with conditions of "overload," where press exceeds the coping capacity of an individual, but also in conditions of deprivation, where challenges are well below an individual's capacity.

Another concept often reflected in transactional models is captured by Albert Bandura's (1978) formulation of "reciprocal determinism." Bandura's model emphasizes the reciprocity that exists between person, behavior, and environment—each influencing the other two and, in return, being influenced by the consequences of its own effects. Transactional models typically take this reciprocity as a given and proceed to focus on defining the dynamic nature of the relationships between person, behavior and environment. One such contemporary model is Dynamic Reciprocal Determinism (Danford, 1983). This model melds the three aforementioned concepts and defines the dynamics of the relationships in terms that can explain widely divergent outcomes in the same setting. It seeks to explain how the environment's influence can seem at one time to be negligible and at another time to be the primary or even sole determinant of the outcomes resulting from a specific situation (see Figure 1.2). That is, the environment may in some cases heavily influence behavior and in others only have a negligible influence.

A key factor in the Dynamic Reciprocal Determinism model is a monitoring mechanism. Danford proposes that the person or group "monitors" the ongoing (or anticipated) behavior–environment transaction and typically submits to the influence of the environment. As long as the environmental press does not violate certain "tolerance thresholds" (i.e., does not violate the person's values, expectations, or capabilities) sufficiently to prompt an attempt to "override" or change the situation, the environment effectively determines the outcomes. The consequence is that "most of the time, most people behave in ways that are compatible with or adaptive to the settings they occupy" (Wicker, 1974, p. 599).

Symbolic interactionists (see Mead, 1934) propose that self-identity is a key factor in human behavior. The concept of self can be useful in explaining the monitoring process. As long as the situation matches one's conception of self or a

Figure 1.2. Dynamic Reciprocal Determinism model of person-behavior-environment transactions.

group's shared understanding about how things should be, then no action to change a relationship with the environment would be taken. If, however, the bounds of an appropriate match are broken, then some sort of action would occur, like protesting intolerable conditions, moving to a new place that is more appropriate, renovation of the existing environment, or construction of a new environment. Looking at the person-environment relationship in this way introduces two new dimensions. The resultant action could be entirely mental rather than physical, a change in values and expectations, that is, psychological adjustment to the situation. An example is the adjustment from "stranger" to "resident" documented by Matthews (1979) in housing for the elderly. It also has an important social component in that social interaction heavily defines what is considered appropriate and how an individual or group will respond. In essence, the interactionist view adds the dimensions of internal adjustment and social construction.

How successful a person or group might be in attempting to overcome an inappropriate situation is determined by the person's "mastery level" (similar to what Moos [1975] calls "capabilities"). Those with low levels of "mastery" may find that their attempts to change the situation are ineffective or even mal-

adaptive. In this case they may stop trying to change their perception of self, accepting the situation as a reflection of a new identity. An example is the prisoner who stops trying to resist control and becomes docile and compliant, that is, helpless. As the Environmental Docility Hypothesis proposes, if the demands of the environment are so great that mastery is impossible, even for individuals or groups with a high level of competency, there may be no mental or physical adjustment at all; they may simply succumb to insurmountable stress. This was the case, for example, in the recent demise of expert climbers on Mt. Everest. In general, these examples illustrate the importance of separating out adaptive behaviors from the person and environment. This helps clarify the relationship and analyze differences between one situation and another.

Nahemow and Lawton (1973) defined "fit" as a sort of equilibrium where an individual's capabilities are in balance with the press of environment. In their model, equilibrium is not a specific pivot point but rather a "zone of adaptation" within which individuals are sufficiently challenged to ensure continued ability to adapt yet not so challenged or deprived that they are under pathological stress. In other words, fit can be defined as a relationship that is tolerated by the person. The person concludes that the situation is at least satisfactory, or that the benefits to be derived from changing an inappropriate situation are simply not worth the costs in terms of the effort necessary to effect the requisite changes, or that the changes are not even possible due to the magnitude of the mismatch between the person's mastery level and the environment's demand character. Fit can also be defined socially as a situation that represents congruence between the desired presentation of self and the reflected self as perceived and affirmed by others. All of these conceptions are valid and are not mutually exclusive. In effect, fit can be defined by some objective performance criterion by an outside observer, by the individual, or by one's social world.

Obviously, the concept of fit covers a broad range of person-behavior-environment outcomes. It could be achieved by insulating an individual from challenge as mastery level declines, such as in baseball when a declining player is sent to the minors or when a frail older person is relocated to a nursing home. However, it could also be achieved by maintaining a high exposure to challenge and taking a different social role, such as a designated hitter or care recipient. In contemporary rehabilitation practice, with its emphasis on independent living, a common intervention would be to provide environmental support to achieve or maintain competence in the face of stress. However much the professional observer concludes that fit has been achieved, the individual may not, and vice versa. The transactional model provides a broader awareness of the situation that can assist a practitioner to make informed decisions and to understand the highly variable responses of clients. For example, it can help explain why people may have very different responses to the same modified environment. Some may be willing and able to learn new patterns of living, but others may refuse to deal with even a limited challenge and adapt by restricting their range of movement and/or

social roles. Moreover, it can help explain why some households make modifications to the environment and others do not. Each has a different definition of "fit" and different tolerance thresholds.

OPERATIONALIZING THE MEASUREMENT OF FIT

Ideally, a model of fit for rehabilitation practice should be useful for predictive as well as explanatory purposes. Therefore, two types of observational measures are needed to operationalize such a model. The first should measure functional ability at a finer level than the FIM™ and should be sensitive to environmental differences. Without this type of measure, it is impossible to link specific environmental features with performance. The second is a global measure of independence similar to the FIM™ that does not attempt to control the influence of environment and has a broader scope to include important environmental behaviors. Such a measure can serve as an outcome variable to demonstrate overall conditions of "fit" or "misfit." Our theoretical perspective indicates that the individual's own subjective assessment of usability is necessary to make judgments about person–environment fit. For example, the extremes of the reach range define the upper and lower limits of possibility. However, within the range of abilities, what constitutes an appropriate level of ease for a particular task? A subjective measure such as comfort, convenience, or difficulty is needed to answer that question. Such an evaluation of usability may be made by a third party, but one that is grounded in the perspective of the intended user is more appropriate when it will be used to make decisions about that individual's well-being. Cultural norms for both actual performance and usability ratings can be established from representative samples of the population.

It is important to note that fit may vary considerably from one time and/or place to another because of the changing context and interpretations of the individual. What is acceptable in one situation may not be acceptable in another. For example, subject 8 in Table 1.1 may be willing to tolerate very long transfer times in her own home but not in a public restroom. In other words, her expectations may be adjusted to the context. The ability to test many different situations and conditions is usually beyond the scope of most research budgets. Thus, for reasons of economy, we need precise and simple ways to describe environmental demand and usability. If these measures can be correlated with observer measures of functional ability, then it might be possible to rely solely on subjective rating scales that can be deployed at a much lower cost than observational measures. If we had such measures, we could study larger samples, a wide range of environments, and systematic patterns of relationships. This would allow us to construct predictive models.

We completed a 4-year research program to explore the theoretical and methodological issues described in this chapter. The long-range goal, beyond

even the initial 4-year program, was to develop and test methods to operational-
ize a model of fit grounded in our theoretical framework. For the short term,
over the 4 years, we sought to develop and test three instruments of the types
described here. By examining the relationship between these measures we
hope to develop a fuller understanding of person–environment fit for people
with impairments and to confirm our theoretical model. The methods and
models are intended to be used by both researchers and practitioners throughout
the world. By systematically developing a database with these and other data
collection methods we hope to establish a reliable source of information on
accessibility for use by policymakers, designers, and industry. The rest of this
chapter introduces the methods we developed and discusses the significance of
the research program.

Usability Rating Scale™

The Usability Rating Scale (URS™) provides a means to evaluate the level of
demand from the perspective of the person with an impairment. By completing a
rating with the scale, the individual gives an opinion on the difficulty/ease of
doing a task in an environment. For example, showering might be rated "very
difficult" in a tub, while it may be "easy" in a shower stall. Or, forward reach up
to 48 in. or down to 9 in. may be rated very difficult, while reach to 36 in. may be
rated very easy.

The subjective rating task is a human factors problem. A rating method for
use by people with little training must be easy to learn. For reliable use in research
it must be brief to administer, since it may have to be used in an extended set of
tasks within a relatively short time frame (e.g., walk-through evaluation of a
building). A program at the Research Institute for Human Engineering in Ger-
many studies subjective rating scales from the human factors perspective (Pitrella
& Kappler, 1988). Through an extensive literature review, they were able to
develop guidelines for design of such scales. A prototype scale was developed to
meet these guidelines. Pitrella and Kappler found it to be more reliable and
sensitive than other widely used scaling methods. We completed some prelimi-
nary studies using this scale and discovered several limitations in usability. We
then developed a new scale (the URS™) retaining some of the features of the
Pitrella–Kappler scale and including several differences. Key features of the
URS™ instrument include:

1. A two-step rating process that presents only a limited number of rating
 choices at a time.
2. Both numerical and descriptive anchor points to eliminate bias due to
 preferences and familiarity with either one or the other
3. Use of negative (difficult) and positive (easy) sides to reinforce the
 center point and the meaning of the two ends

4. Only three main anchor points in each direction to reduce the choices to an easily understood sequence

5. A horizontal vector approach to reduce the cultural bias of "higher is better"

The most obvious feature of the scale is the two-step sequential approach to focusing in on a rating. Pitrella and Kappler observed that scales with more anchor points were more sensitive but found that the more points, the more complex the rating task. The two-step "sequential judgment" task reduces the complexity of decision making without losing sensitivity. The URS™ instrument follows many of the recommendations proposed by Pitrella and Kappler, but we departed from their recommendations in several ways based on our own preliminary testing.[1]

Enviro-FIM™

We decided to use the FIM™ instrument as a basis for our observer rating scale on global performance. This allowed us to benefit from the accumulated knowledge on its administration. Moreover, it allowed us to develop a scale that is conceptually similar so that those experienced with the FIM™ instrument can readily understand and use the new scale. As described earlier, the FIM™ instrument has some serious limitations for understanding the fit between environment and individual. Although several of the subscales were not appropriate for issues of environmental fit, for example, the subscale on bladder control, 5 of the 18 subscales were: toileting, toilet transfer, bathing, bathing transfer, and grooming.

To ensure that the Enviro-FIM™ instrument was sensitive to environmental differences, we revised the way that the FIM™ instrument is administered. Thus, when using the FIM™ bathing subscale, the same scoring approach was used but the rating was based on use of a specific environment rather than on task performance independent of the environment. Each evaluation was based on performance within a specific setting. For example, an individual who received a top score in a shower stall might receive a lower score in a bathtub.

Finally, we expanded the range of scores from 7 points to 11 points. We did

[1]We reduced the number of main anchor points from 14 to 7 because our testing demonstrated that subjects had great difficulty making discriminations in the 14-point range. The differences between the written descriptors for 14 anchor points were difficult to discriminate. We settled on 7 points to maintain as much simplicity in language as possible. The URS™ instrument has no overlap between the three main parts of the range (easy, moderate, difficult). Our subjects found the overlap recommended by Pitrella and Kappler (1988) confusing. We also eliminated the extra "overrun" regions they propose at either side. Some subjects were willing to use that area and some were not based on personal comfort, i.e. "staying within the lines." We felt this introduced bias in the ratings and we had difficulty establishing the meaning of ratings and numerical scores that go beyond the extreme descriptors.

this because the FIM™ instrument's upper range is not sensitive enough to the different impacts of environmental features. For example, "additional time," "safety considerations," "modified environment" and "use of an assistive device" all result in a score of 6. However, a specific environment may result in one of these outcomes but not another. We therefore expanded the scale to account for the differences. This required deciding on the degree of independence each of these four points represented.

Because of these modifications, we call the new scale the Enviro-FIM™ instrument to distinguish it from the standard FIM™ instrument. Part of our work was to examine the relationship, if any, between Enviro-FIM™ scores and standard FIM™ scores.

Functional Performance Measure

The Functional Performance Measure (FPM™) employs two observer rating scales to score the *level of effort* expended by the subject toward task performance and the *level of assistance* provided by a caregiver. Both are 8-point ordinal scales, with the highest number indicating the highest level of effort and assistance. Thus there is an inverse relationship between independence and scores on these scales.

There are several important differences between the Enviro-FIM™ and FPM™ instruments. First, the FPM™ instrument makes no assumptions about independence based on the use of assistive technology. With the Enviro-FIM™ instrument, like the FIM™ instrument, use of an assistive device reduces the total possible score, regardless of how quickly or easily an individual performs a task. The FPM™ instrument, on the other hand, is oblivious to assistive devices; all that matters is the degree of effort expended. Thus, theoretically a person using a wheelchair or walking aid can score as high as someone who does not use such a device. Second, the Enviro-FIM™ instrument implies a continuum between degree of independence and assistance. In the FPM™ scales, separating the measurement of individual performance from assistance recognizes that caregiver burden may vary independently from the effort of an individual receiving care, particularly if the environment hinders the involvement of caregivers in a task. Third, whereas the Enviro-FIM™ instrument provides a single outcome measure for an activity, the FPM™ instrument has several identical ordinal subscales for each component of an activity under study. For example, the activity of bathing includes eight task components, using faucet, adjusting shower, etc., and each one is scored separately for both effort and assistance (a total of 16 ratings for the activity as a whole).

The different approach used in the FPM™ instrument clarifies the relationship between individual and environment. A supportive environment is not masked by the use of an assistive device. The impact of environment on caregiver burden is measurable, and the instrument can be used in a diagnostic mode to

examine the relationship between specific features in the environment and task performance.

Use of the Three Measures

The URS™ instrument enables one to examine subjects' perceptions of the relative ease or difficulty of performing certain activities of daily living in different physical environmental contexts, thereby demonstrating how perceptions of ease or difficulty can be influenced not only by the individual's functional capabilities but also by prior experiences, expectations, and so on. The URS™ instrument also enjoys the advantages of most such survey instruments, that is, low costs of administration compared to observer ratings. And when used to assess the perceptions of individual subjects, the URS™ instrument enables measurement of individual differences that may be significant correlates of subsequent functional independence and performance.

The Enviro-FIM™ instrument provides a means for evaluating design artifacts in terms of their impact on the functional independence of an individual or a group (e.g., assessing effects of alternative door configurations on the functional independence of wheelchair users). The Enviro-FIM™ instrument also enables a global assessment of fit between subjects and designed physical environments. This outcome measure is a way to determine if a mismatch exists between an environment's demand character and a subject's mastery level. The Enviro-FIM™ instrument requires a trained observer, but it can be used to make real time assessments.

The FPM™ instrument provides direct measurement of caregiver burden through its level of assistance scale and, thereby, a means of assessing how that burden is affected by changes in specific environments' demand character. The FPM™ instrument also permits the identification of specific design characteristics in physical environments responsible for problems in performance by either individuals or groups. Consequently, the FPM™ instrument can be used to identify needed design changes in specific task environments that will improve subsequent task (and therefore activity) performance, enabling one to fine-tune designed environments to facilitate specific outcome changes in the functional independence and performance of either individuals or groups. The FPM™ instrument also requires a trained observer for use, but it cannot be used in a real time mode, as currently configured. Videotaped records are needed to do the detailed analysis required.

The three measures can be very effective when used together. The URS™ instrument can be used to quickly flag potential problems in an environment and identify for whom they are most serious. The Enviro-FIM™ instrument can then be used to determine the impact of those problems on various aspects of independent function. Once a problem is identified and the impact on behavior is known, the FPM™ instrument can then be used for fine-grain analysis and

identification of solutions. This "focusing approach" reduces the need for expensive and time-consuming analysis of environment–person fit where no problem is perceived by the individual. The FPM™ instrument is not needed when the objective is simply to assess the impact of an environment on an individual or group, but it can be brought to bear on the specific activities that seem to be problematic when the objective of an assessment or research is to identify solutions to problems already identified by the other measures.

CONCLUSION

A critical analysis of accessibility research suggests that the field suffers from the lack of a strong theoretical foundation. New initiatives in independent living, mainstreaming, and civil rights have significantly widened the use of knowledge bases on accessibility and have concomitantly increased their importance. There is a need for better quality information, yet the shortcomings of existing research have led to confusion in policymaking, design, and rehabilitation practice. Assumptions about human behavior and its relationship to the physical environment have substituted for theory. Without good theory, the importance of research is neglected and policymakers rely too heavily on opinion, which is highly subject to politicization. Developing adequate theory will promote the cause of research and will demonstrate the inadequacies of reliance on opinion. Two sources of relevant theoretical ideas are the fields of disability studies and environment–behavior studies.

Authors in the field of disability studies have advanced the concept that participation (handicap) is a social construction that must be distinguished from disability. This has led to the measurement of functional ability independent of environment to avoid the bias of sociocultural factors that cause limitations in participation, for example, building design practices. However, measures of functional ability that focus solely on the person deny the importance of the physical environment in mediating the impact of disability. They perpetuate a negative stereotype of disability that becomes embodied in the research itself. The role of environment in fostering independence can easily be overlooked unless it is operationalized through assessment methods. Furthermore, without incorporating environmental variables, assessment methods will be weak predictors of outcome in independent living, mainstreaming, and subacute facilities where daily life involves intense interaction between individuals and their physical surroundings.

The definition of an accessible environment is typically based on the idea of fit between and individual's abilities and environmental features. Most accessibility research is based upon a rudimentary concept of fit and thus fails to take into consideration some important variables. This research relies primarily on observable measures of use. However, our analysis suggests that observed behav-

ior alone provides a very misleading view of function within an environment. Environment-behavior theory provides several useful insights into the concept of fit. Fit, like participation, is a cultural construct that has a major interpretive dimension. Environmental context, individual factors, and sociocultural values and attitudes all play a role in the definition of fit. It is proposed that a multi-method approach to understanding fit would be more useful and appropriate.

Our proposed model of fit can be concisely, albeit simplistically, summarized as follows. The standard FIM™ instrument controls for perception and environment. It measures behavior (independence) as a function of observed capabilities:

$$I = f(C)$$

Where I = functional independence and C = observed capabilities. We propose that independence as experienced in specific environments is a complex function of perceptions, environmental demands and observed capabilities:

$$I = f(P,E,C)$$

where I = functional independence (e.g., Enviro-FIM™ instrument), P = perceptions of difficulty (e.g., URS™ instrument), E = environment demands, and C = observed capabilities (e.g., FPM™ instrument).

Through the development of techniques to measure these variables, we will be able to understand the relationships between them. The findings of such research will have direct practical application in several areas. They will be useful in rehabilitation practice for predicting successful adaptation in the real world of home, workplace, and community. They will give rehabilitation practitioners a means to assess the contribution of the physical environment to handicap. Data on abilities of individuals to perform common component tasks within a range of settings will be useful in the development of better design standards and ideas for universal design of new products. It can also be useful for identifying priorities for barrier removal or for reviewing designs in progress. Finally, subjective perspective will introduce the perspective of people who have impairments themselves into the assessment of adaptation, evaluation of the environment, and policy development.

The three measures we have developed are described in more detail in Chapter 5. They represent one effort to operationalize the theoretical concepts advanced here. This is not to say that these are the only methods needed, but they do provide a step forward in the tools available to both practitioners and researchers.

ACKNOWLEDGMENT. The work on this chapter was supported through the Rehabilitation Research and Training Center on Functional Assessment and Evaluation of Rehabilitation Outcomes at the State University of New York at Buffalo. The Rehabilitation Research and Training Center was funded by a grant from the

National Institute on Disability and Rehabilitation Research, U.S. Department of Education.

REFERENCES

Alexander, C. (1970). The goodness of fit and its source. In H. M. Proshanky, W. H. Ittleson and L. G. Rivlin (Eds.), *Environmental psychology*. New York: Holt, Rinehart and Winston.

Altman, I. (1975). *The environment and social behavior*. Monterey, CA: Brooks/Cole.

Altman, I., & Rogoff, B. (1987). World views in psychology: Trait, interactional, organismic and transactional perspectives. In D. Stokols & I. Altman (Eds.), *Handbook of environmental psychology* (Vol. I, pp. 7-40). New York: Wiley.

Bails, J. (1983). *Project report on the field testing of the Australian standard 1428-1977*. Adelaide, South Australia: Public Buildings Department.

Brattgard, S. O. (1967-1974). Unpublished research on accessibility. Goteborg, Sweden: University of Goteborg.

Brown, S. C. (1992). *Bringing "handicap" into disability research: Developing tools for assessment of progress towards improving the quality of life for people with disabilities*. Paper presented to the Annual Meeting of the American Public Health Association.

Cronberg, T. (1975). Performance requirements for building—A study based on user activities. Sweden: Swedish Council for Building Research.

Danford, S. (1983). Dynamic reciprocal determinism: A synthetic transactional model of person-behavior-environment relations. In D. X. Amedeo, J. Griffin, and J. Potter (Eds.), *EDRA 1983: Proceedings of the Fourteenth International Conference of the Environmental Design Research Association* (pp. 19-28). Lincoln, NE: Environmental Design Research Association.

Fine, M., & Asch, A. (1988). Disability beyond stigma: Social interaction, discrimination and activism. *Journal of Social Issues, 44*(1).

Johnson, B. M. (1981). *Door use study*. Ottawa, Canada: Division of Building Research.

Lewin, K. (1951). *Field theory in social science*. New York: Harper & Row.

Margulis, S. T. (1981). *Building accessibility in relation to door hardware, door users and door use*. Washington, DC: National Bureau of Standards.

Matthews, S. H. (1979). *The social world of older women*. Beverly Hills, CA: Sage.

Mead, G. (1934). *Mind, self and society*. Chicago: University of Chicago Press.

Moore, G. (1976). Theory and research on the development of environmental knowing. In G. Moore & R. Golledge (Eds.), *Environmental knowing: Theories, research, and methods* (pp. 138-164). Stroudsburg, PA: Dowden, Hutchinson & Ross.

Moos, R. (1975). Synthesizing major perspectives on environmental impact: A Social ecological approach. In B. Honikman (Ed.), *Responding to social change* (pp. 211-222). Stroudsburg, PA: Dowden, Hutchinson & Ross.

Nahemow, L, & Lawton, M. (1973). Toward an ecological theory of adaptation and aging. In W. Preiser (Ed.), *Environmental design research* (Vol. I, pp. 24-32). Stroudsburg, PA: Dowden, Hutchinson & Ross.

Nahemow, L., & Lawton, M. P. (1973). Ecology and the aging process. In C. Eisdorfer & M. P. Lawton (Eds.), *Psychology of adult development and aging* (pp. 24-32). Washington, DC: American Psychological Association.

National Institute of Child Health and Human Development. (1992). *Report and Plan for Medical Rehabilitation Research (Draft V)*. Bethesda, MD: National Institute of Health.

Pitrella, F. D., & Kappler, W. (1988). *Identification and evaluation of scale design principles in the development of the Extend Range Sequential Judgment Scale*. Wachtberg, Germany: Research Institute for Human Engineering.

Rapaport, A., & Watson, N. (1972). Cultural variability in physical standards. In Gutman, R (Ed.), *People and buildings*. New York: Basic Books.

Steinfeld, E. (1981). The place of old age. The meaning of housing for old people. In J. Duncan (Ed.), *Housing and identity* (pp. 198–246). London: Croom Helm.

Steinfeld, E., Schroeder, S., & Bishop, M. (1979b). *Accessibility for people with ambulatory and reaching impairments*. Washington, DC: U.S. Department of Housing and urban Development.

Stokols, D. (1981). Group × place transactions: Some neglected issues in psychological research on setting. In D. Magnusson (Ed.), *Toward a psychology of situations: An interactional perspective* (pp. 393–415). Hillsdale, NJ: Erlbaum.

Templer, J. (1979). *Provisions for elderly and handicapped pedestrians*. Washington, DC: U.S. Department of Education, Federal Highway Administration.

Wandersman, A., Murday, D., & Wadsworth, J. (1979). The environment–behavior–personal relationship—implications for research. In A. Seidel &S. Danford (Eds.), *Environmental design: Research, theory and application* (pp. 162–174). Washington, DC: Environmental Design Research Association.

Webb, E. J., Campbell, D., Schwartz, R. D., & Sechrest, L. (1969). *Unobtrusive measures*. Chicago: Rand McNally.

Wicker, A. (1974). Processes which mediate behavior–environment congruence. In R. Moos & P. Insel (Eds.), *Issues in social ecology: Human milieus* (pp. 598–615). Palo Alto, CA: National Press Books.

Woods, W. (1980). *Disability and building codes: A quantitative study*. Tucson: Southwest Arthritis Center, University of Arizona.

Uniform Data Systems Project. (1993). *Guide for the Uniform Data Set for medical rehabilitation*. Buffalo, NY: University of Buffalo Foundation.

2

Research Implications of Universal Design

Bettye Rose Connell and Jon A. Sanford

INTRODUCTION

Over the last few years there has been growing interest in universal design—designing in such a way that people with and without disabilities can use the same products and building elements. Universal design is not a euphemism for familiar conceptions of accessibility. Rather, it involves a fundamental shift in thinking about design, particularly with regard to designing for people with disabilities.

Traditional design approaches *add* accessibility to otherwise inaccessible objects and standard designs. Consequently, traditional approaches to achieving accessibility tend to promote two sets of designs: specialized accessible designs and their inaccessible counterparts. This dualism has existed for a number of reasons, including the belief that access is a regulatory or clinical issue, only benefiting people with disabilities (Steinfeld, 1996). Pragmatically, traditional approaches have been the easiest approaches because the "gold standards" for dimensioning objects and spaces (i.e., *Architectural Graphic Standards* and *Humanscale*) do not integrate anthropometric and biomechanical information for people with disabilities with that for people without disabilities. Although

Bettye Rose Connell • Formerly with the Center for Universal Design, North Carolina State University, Raleigh, North Carolina 27695. **Jon A. Sanford** • Center for Universal Design, North Carolina State University, Raleigh, North Carolina 27695.

Enabling Environments: Measuring the Impact of Environment on Disability and Rehabilitation, edited by Edward Steinfeld and G. Scott Danford. Kluwer Academic/Plenum Publishers. 1999.

specialized designs may work well to compensate for functional losses experienced by people with disabilities, the fact that they are different from the spaces and products used by others makes them a potential instrument of the stigma and stereotyping experienced by people with disabilities.

In contrast, universal design seeks to *infuse* accessibility into the design of objects and spaces marketed to the general public. The hypothesis is that this will produce a number of desirable benefits for people with and without disabilities. For example, it is presumed that universal design will enable people with disabilities to use the same objects and spaces as those used by people without disabilities, both increasing the prevalence of accessibility and enhancing opportunities for the integration and participation of people with disabilities in society. For people without disabilities, universal design will enable, for example, children, parents pushing strollers, individuals temporarily disabled due to a broken leg, and individuals aging in place to safely and efficiently use the objects and spaces they encounter. Product manufacturers and the building industry also are expected to benefit through the enhanced consumer appeal expected of universal designs.

Much of the effort devoted to universal design so far has focused on promoting the concept in design education and among product manufacturers, developers, contractors, and others who are responsible for providing the objects and spaces that are available to consumers. A national educational program has worked with university design faculty to promote universal design in postsecondary curricula and to increase the number of new professionals skilled in designing universally (Welch, 1995). "Principles" of universal design have been developed to provide guidance to designers as well as to promote the concept (Center for Universal Design, 1997). Case studies of universally designed household products have provided insights about strategies that are potentially useful in persuading manufacturers to adopt universal design approaches (Center for Universal Design, 1997).

By comparison, virtually no attention has been given to the research implications of the universal design movement. Widespread adoption of a universal design approach will require new technical information and systematic compilation of existing information to inform design. Anthropometric and biomechanical information describing people with disabilities specifically will need to be obtained (or existing information identified) and integrated into mainstream dimensional standards used in routine design practice. In addition to research implications related to the "supply" of universal design, the discourse promoting universal design includes promises of a number of benefits for people with disabilities. These promises are no less than untested hypotheses about the effects of universally designed objects and spaces and the more widespread accessibility they are expected to create on personally and socially important outcomes.

This chapter explores the research implications of the universal design movement. Two distinct areas of research are examined: anthropometric and

biomechanical research to inform design and outcomes research to assess the impact of universal design on the functioning and well-being of people with disabilities.

WHAT IS UNIVERSAL DESIGN?

In the short history of accessible design, people with disabilities have been viewed as being different from the nondisabled population, requiring buildings and products that are designed differently from those produced through routine design practices. Universal design, essentially, does away with the "them" and "us" distinctions inherent in conventional approaches. Universal design is based on the premise that buildings and products can and should be designed to be usable by a broader segment of the population. As a result, universal design promotes accessibility on a broader scale than do conventional approaches to accessibility.

The appeal of universal design is very much in the eye of the beholder. For designers, developers, manufacturers, and others who determine what objects and spaces are available to consumers, universal design represents a means to capture a market among the large and growing population of people with disabilities and older people. From the perspective of consumers, universal design is expected to increase the overall prevalence of accessibility and usability in the built environment and to enhance opportunities for routine participation and social integration of people with disabilities in everyday life (Mace, Hardie, & Place, 1990).

Several examples will help to clarify the differences between conventional designs that are inaccessible and unusable by people with disabilities, accessible designs that are usable but still differ from conventional designs, and universal designs that are usable by a wide range of people.

A common accessibility problem in buildings is the absence of an entry at ground level. Sloping the path upward to the entry is a common solution to this problem. Figure 2.1 shows a home with a conventional entry with steps to which a ramp has been added to provide access for an individual in a wheelchair. The ramp is obviously an afterthought and looks out of place at this house and in the neighborhood. It is constructed from different materials than those originally on the exterior of the home and is steep enough that a railing is needed to ensure that those walking and wheeling up or down the ramp do not fall off. Figure 2.2 shows a different approach to adding an accessible entry to a house of similar age and style as the house in Figure 2.1. Here a second pathway to the front door was added to the right and around the side of the porch. The top of the pathway is level with the porch. The slope of the path is shallow, and grading prevents a drop-off on the sides of the sloped path, negating the need for a railing. In contrast to the house shown in Figure 2.1, this approach preserves the integrity of the design of the older home, and the new path is integrated with the exterior

Figure 2.1. A typical retrofit entry ramp replacing steps on an older home. (Bettye Rose Connell)

Figure 2.2. The sloped path looks as if it were part of the original design and preserves the appearance of the front entry. (Center for Universal Design, "Accessible Home Modification Slide Show")

design of the home. The home in Figure 2.3 was designed with a bridge and berm entry, rather than a conventional ramp, to provide easy access to an above-grade deck and entry. In this example, a limited amount of grading to recontour the area of the path resulted in a gently sloping berm up to the level of the entry. A level deck and bridge were constructed between the high point of the berm and the entry. The berm is kept away from the house to avoid drainage problems, resulting in a sheltered planting area visible from lower level basement windows. The bridge and berm is considered to be more "universal" because the single route in and out of this entry to the house is usable by everyone and because it is integrated with the home and looks appropriate in the neighborhood. From a distance, the berm looks like the natural contour of the site. The slope of the berm is very shallow (i.e., slope < 1:20) and does not necessitate a handrail, thus making this path look more like those at other houses in the neighborhood.

Many people with hand and upper body impairments have difficulty grasping and turning conventional door handles (Figure 2.4). Unlike the conventional handle in Figure 2.4, the lever door handle in Figure 2.5 (Lido style lever door handle) can be operated without grasping and turning. It also requires minimum strength and little fine motor control to operate. In addition to meeting the

Figure 2.3. In new construction, sitework can negate the need for a ramp and stairs as well as enhance the appearance of a home. (Center for Universal Design, "Accessible Home Modification Slide Show")

Figure 2.4. A conventional around door knob is often difficult to grasp and turn. (Jon A. Sanford)

needs of people with some types of hand and upper body impairments, lever-styled hardware allows people who find themselves in situations where they cannot manipulate the handle (e.g., hands are full) to open the door with an elbow, forearm, or back of the hand. These types of door handles not only have been widely adopted in nonresidential construction, where they meet accessibility requirements, but also in residential construction not regulated by these requirements. In contrast, adaptive lever handles that fit over conventional round knobs (Figure 2.6), can be used to make conventional knobs easier to operate. Although such devices offer an alternative to replacing door hardware, they look like the specialized product they are and cost about the same as more universally designed hardware.

In sports facilities with assembly seating, such as baseball parks, indoor arenas, and football stadiums, the quality of audience experience for people

Figure 2.5. A lever door handle is easier to operate than a round knob as it does not require grasping and turning. (Center for Universal Design, "Accessible Home Modification Slide Show")

with disabilities is often dependent on the choices provided to people about where to sit, with whom they will sit and interact, and what they will see. One strategy is to provide flexibility in seating arrangements through use of adjustable seating. Introduced at Camden Yards in Baltimore, these seating arrangements are often called Camden seats (Figure 2.7). Camden seats enable any patron, whether ambulatory or nonambulatory, to use the same seating space by rotating the seat out of the way to create a wheelchair space or leaving it in place as a conventional seat. This type of seating also works well for families with small children in strollers as well as tall individuals and other fans (e.g., an individual with a straight leg cast) who see the extra leg room as a luxury (Figure 2.8). Adjustable seating allows for infinite combinations of wheelchair spaces and seats, enabling groups of different size and composition to purchase seating

Figure 2.6. An adaptive lever handle can be used to make a conventional door knob easier to operate. (Center for Universal Design, "Accessible Home Modification Slide Show")

space together. The use of these seats effectively avoid the unfinished look of a wheelchair "corral" because there are no gaps in seating rows. Those who need a wheelchair space know what the adjustable seats are; to others they look like seats that provide extra leg room. In contrast, seating configurations that use individual fixed companion seats with open wheelchair spaces clearly differentiate wheelchair spaces from other seating, particularly when these spaces are unoccupied (Figure 2.9). Moreover, the rigid configuration of alternating wheelchair spaces and fixed seats builds in limitations on group composition and the ability of wheelchair users to sit together.

In summary, universally designed objects and spaces are usable by a wider range of people than are conventional designs. They offer convenience and ease of use options to users without disabilities as well as access to users with dis-

Figure 2.7. Camden seats are intended to be used to seat patrons who are ambulatory or can be rotated out of the way to accommodate patrons who use a wheeled mobility device. (Jon A. Sanford)

Figure 2.8. Camden seats work well for groups of different sizes and composition, such as multiple patrons who use wheelchairs, and look similar to conventional seats. (Jon A. Sanford)

Figure 2.9. Wheelchair spaces with fixed seats for ambulatory companions not only differentiate wheelchair spaces from conventional seats but also limit group size and composition. (Jon A. Sanford)

abilities. Universal design can be incorporated into renovations as well as new construction projects and in residential and nonresidential settings.

ANTHROPOMETRICS AND BIOMECHANICAL RESEARCH

Anthropometry is the measure of physical features of humans (Diffrient, Tilley, & Harman, 1981a), including body size and shape. Biomechanics is the measure of body movement and strength, including range of movement, speed, strength, and endurance (McCormick, 1970). Both of these human constructs are important to the design and engineering professions to maximize the fit between people and the design of products and spaces that they use. For example, anthropometry is an important consideration in determining requirements for the size of door openings, the height of counters, and the diameter of grab bars. Similarly, biomechanical data are critical in determining requirements for operating forces for appliance controls and door hardware, reach ranges related to shelf height, and energy expended traversing ramps and stairs.

Universal design requires that an inclusive and pluralistic model be adopted in which design for differences is a key strategy (Steinfeld, 1996). Practically, universal design is predicated on the availability of information that describes

the anthropometric and biomechanical characteristics of the population as a whole. Thus, it raises questions about the data that designers use that summarize the anthropometric and biomechanical characteristics of the population. To the extent that relevant information describing people who are not able-bodied adults is not available, excluded, or poorly integrated, universal design will be more difficult to achieve in any broad-based way.

The most comprehensive as well as valid and reliable anthropometric and biomechanical databases have been developed from surveys undertaken by NASA (ARP Associates, 1978) and the Army (Gordon et al., 1989). These databases are the basis for most design standards, including the three volumes of *Humanscale* (Diffrient, Tilley, & Bardagjy, 1974; Diffrient, Tilley, & Harman, 1981a,b). In addition to the military and NASA data, *Humanscale* has been corrected for population growth rates and is supplemented by data on vision, strength, and endurance that have been provided by human factors specialists (Diffrient et al., 1981b). *Humanscale* is arguably the most comprehensive and widely used source of human factors data in the design and engineering communities and, as such, is illustrative of the types of anthropometric and biomechanical measurements routinely used in design practice.

To enable designers to determine the percentage of people who will be included or excluded by a specific design, *Humanscale* divides the total range of anthropometric and biomechanical values of able-bodied males and females into percentiles. Diffrient et al. (1974) suggested that typical designs should accommodate the 95% of the population of able-bodied men and women who fall between the 2.5 and 97.5 percentiles. Although McCormick (1970) argued that design should incorporate dimensions at the extremes in order to accommodate all individuals in the user population, Diffrient et al. (1974) maintained that including the extremes of able-bodied men and women (e.g., largest and smallest people) not only would impose excessive requirements, making designs impractical, complicated, or too expensive, but would also jeopardize the comfort, efficiency, or safety of the majority. Thus, even though there are those who advocate designing for the widest range of the user population, conventional design practice typically includes only 95% of the able-bodied population.

Designing for 95% of the able-bodied population has obvious implications for people with disabilities. Specifically, it raises the question: If design practice routinely excludes persons who lie at the edges of the bell curve of the able-bodied population, how can one expect the needs and capabilities of people with disabilities, which are likely to fall beyond the extremes of the able-bodied population on many anthropometric and biomechanical measures, to be accommodated in the design of objects and spaces?

Information about able-bodied children and adults in *Humanscale* includes anthropometric information about body size, circumference, and grip size, as well as biomechanical information about movement angles, strength, and endurance. Each of these broad anthropometric and biomechanical categories

includes measures of a number of different components. For example, body size includes a variety of measurements related to the length, height, circumferences, centers of gravity, weight, and width of each body part (i.e., head, neck, trunk, upper arm, forearm, hand, thigh, leg and foot). Body movements includes measurements related to reach, strength, and visual field.

Humanscale summarizes anthropometric and biomechanical information about the able-bodied population on a number of pictorial selectors. Information presented about older adults and people with disabilities is presented separately from that for the general population and covers fewer categories of measures than those presented for the general population. The absence of information and lack of integration are two important issues that must be considered if anthropometric and biomechanical databases, like *Humanscale*, are to inform the practice of universal design.

First, in some cases, the absence of information about specific measures for older people and people with disabilities means that there are no expected differences between the population of older people and people with disabilities and the population of able-bodied people. For example, length of arms or size of hands of the population of people with disabilities would not be expected to differ from those of the able-bodied population, and information about such measures on the pictorial displays for the able-bodied population is probably generalizable to other population groups. In other cases, the absence of information about specific measures (e.g., strength, angular body movements, and endurance) means that data are not available (or not incorporated) for older adults and people with disabilities, even though one would expect differences on these measures between the population of older people and people with disabilities and the population of able-bodied people.

Importantly, the latter group of missing data often represent those anthropometric and biomechanical categories that are most likely to be impacted by impairment and must be considered in designing universally. Thus, although there is no reason to expect that all anthropometric and biomechanical measures for all people with disabilities will differ from the general population, there is every reason to expect that some critical measures (particularly those related to strength and body movements associated with specific disabilities) will fall outside the extremes for the able-bodied population. For example, the upward and forward reach of individuals with shoulder impairments would be expected to be more limited than that of the able-bodied population. As a consequence, the reach of some portion of the population of those with shoulder impairments would fall outside the lower end of the range of reaches of those without shoulder impairment.

A second issue relates to the presentations of anthropometric and biomechanical data for older adults and people with disabilities in design standards. In *Humanscale* data pertinent to designing for older people and people with disabilities are not well integrated with data for able-bodied people in the

pictorial summaries of population data. This practice reinforces the perception that people with disabilities are different and the idea that accessibility can be added after an object has been designed to accommodate some portion of the able-bodied population. In contrast, *Humanscale 8*, which integrates space planning data for people with and without disabilities into one pictorial selector, illustrates that it is feasible to develop similar integrated displays for each anthropometric measure.

Design practitioners rely on summaries of anthropometric and biomechanical information. The convention is to design for the 95% of the population that falls between the 2.5 and 97.5 percentiles with regard to specific anthropometric and biomechanical measures. Although some anthropometric and biomechanical data are available for older people and people with disabilities, the extent of these data are limited in comparison to those available to describe the able-bodied population. Importantly, at least some the anthropometric and biomechanical factors for which data are not available are precisely those aspects of body size and human performance that would be expected to be impacted by impairment. Finally, available information that describes the anthropometric and biomechanical characteristics of older people and people with disabilities is not well integrated with comparable information describing the able-bodied population.

Research Strategies

It is clear that anthropometric and biomechanical research related to people with disabilities is needed. Three key issues to be resolved in planning to conduct this research are discussed here.

First, the anthropometric and biomechanical domains in which research is needed must be established. Some anthropometric and biomechanical data already have been generated in conjunction with studies of human performance (e.g., upward and forward reach) as well as from studies of task-specific design features (e.g., use of door hardware and ramps). For example, studies have measured circumference and body size (Floyd, Guttman, Wycliffe-Noble, Parkes, & Ward, 1966; Stoudt, 1981); posture and gait (Perry, Mulroy, & Renwick, 1993; Waters, Yakura, & Askins, 1993); strength (Lauback, Glaser, & Suryaprasad, 1981); stamina, energy expenditure, and exertion (Fisher & Patterson, 1981; Hunter, 1987; Sanford, Story, & Jones, 1997; Waters & Lunsford, 1985; Waters, Torbum, & Mulroy, 1992); and grip size and strength and reach ranges for people with hand and arm impairments (Bails & Seeger, 1988; Czaja & Steinfeld, 1980; Steinfeld, Sanford, & Shiro, 1986; Steinfeld, Schroeder, & Bishop, 1979; Woods, 1980). Reviews of this research are needed. Existing reviews are dated (cf., Czaja, 1984; Steinfeld et al., 1979) and do not reflect research findings from the past decade. In addition, Czaja's review focused only on people with hand and arm impairments. Recognizing the need to undertake such a study, the Access Board, which is responsible for writing the Americans with Disabilities Act Accessibility Guide-

lines, recently sponsored a project to conduct a review of anthropometric literature specific to "seated adult wheelchair users." Similar reviews are needed for other populations of people with disabilities to determine the anthropometric and biomechanical data that are available, the population subgroups for whom it is representative, validity and reliability, and the potential for integrating these existing data into general population databases. It is important to underscore the need to rigorously assess the adequacy of existing data. Data obtained from small samples and samples of convenience are subject to a number of threats to their accuracy and generalizability. In these cases, decisions will have to be made if the results of prior studies are adequate, need to be supplemented, or are unusable. The latter two categories would indicate a need for additional research.

Second, the anthropometric and biomechanical data to be collected through additional research efforts should be prioritized in terms of their relative importance. As discussed earlier, the absence of anthropometric and biomechanical information describing people with disabilities is not necessarily a good indicator of a research priority. Rather, priority should be given to those anthropometric and biomechanical measures on which the population of people with disabilities would be expected to differ from the able-bodied population. Effort needs to be devoted to identifying priorities for such research. Important issues include the groups/perspectives to be included and the criteria for determining priority. For example, people with disabilities as well as designers and researchers all have valuable and valid perspectives on the issue of anthropometric and biomechanical research priorities. Additionally, there are different approaches, each with strengths and weaknesses, to ranking priority, such as those anthropometric and biomechanical issues that impact the largest number of daily activities, the activities that are most central to independent functioning, or even those that are most easily researched.

Third, data obtained for people with disabilities must be reliably and meaningfully integrated into existing population data. A critical issue is likely to be the methods and measures used to obtain different data sets. Traditional methods of obtaining measurements of some anthropometric and biomechanical factors, such as angular body movements, may not be feasible for people who use mobility aids. In such cases, new measurement techniques may need to be developed that yield data compatible with existing data for the able-bodied population.

In summary, the absence of anthropometric and biomechanical information describing the population as a whole, including people with and without disabilities, is a barrier to the adoption of universal design approaches by the design community. Designers of specialized accessibility products and environments often deal with this problem by relying on their own insights, personal experiences, and interactions with people with disabilities to develop new designs for a target population (cf., Bostrom, Malassigné, & Sanford, 1984). To be more inclusive of people of varying sizes and abilities, however, universal designers cannot be so reliant on personal experience and insights. The need to assemble

basic anthropometric and biomechanical data on the capabilities and limitations of people with disabilities and integrate this data with data for the population in general formats familiar to designers is critical to the practice of universal design.

OUTCOMES RESEARCH

Outcomes research is the second type of research that is suggested by the universal design movement. Outcomes research related to universal design differs in important ways from prior research that has evaluated accessible objects and spaces produced as specialized designs. Specialized design has focused on the production of objects and spaces that are usable by people with disabilities, and the majority of accessibility research has focused on evaluating their usability. The results have provided feedback on the effectiveness of the resulting objects and spaces in compensating for functional and sensory impairments. This research also has provided insights about the accuracy of regulatory requirements and design processes that produced designs. In general, these studies have addressed questions of "fit" and levels of independence and safety in activity performance achieved with designs (cf., Connell, Sanford, Moore, Bostrom, & Ostroff, 1994; Steinfeld & Shea, 1993). Importantly, accessibility advocates have made few claims about specialized design, other than those related to independent functioning. Little research has viewed the usability of specialized designs as a "means" to other "ends," for example, the differences that the availability of accessible objects and spaces have made in the lives of people with disabilities.

In contrast, the discourse on universal design routinely implies that universally designed objects and spaces are means to more than just greater independence in functioning. Universally designed objects and spaces are seen as a means to directly and indirectly enhance the life experiences of people with disabilities, such as through greater social integration and age-normal role access and participation, and to do so in ways and to an extent that specialized designs cannot. In addition, the discourse on universal design assumes that it is possible to design objects and spaces such that they are usable (and will be used) by a broad range of the population, including but not limited to people with disabilities. Thus, the concept of usability in universal design is significantly different from that which is at the heart of specialized design. The usability, in a functional sense, of universally designed objects and spaces by people with disabilities is almost taken for granted. Claims about the usability of universally designed objects and spaces really focus on people without disabilities and concern general consumer acceptance of universally designed objects and spaces. The acceptance of universally designed objects and spaces is an important part of the strategy of universal design as an instrument of social change.

In summary, there are two broad, presumptive, but untested, beliefs about the consequences of universal design that are imbedded in the discourse advocat-

ing universal design. One belief, which focuses on its consequences for "producers" (e.g., product manufacturers, developers, facility owners and managers, designers), is that universally designed objects and spaces will appeal to the general public as well as people with disabilities, thereby opening up larger and different markets from those currently being accessed and creating commensurate opportunities for selling more units of product, whether those units are carrot peelers or new homes. The second belief, which focuses on the impact of universal design on "consumers" or "users," particularly those with disabilities, is that it will enhance psychosocial factors important in the life experiences of people with disabilities *and* that the psychosocial benefits associated with universal design will be of greater magnitude than those associated with specialized design. If these beliefs are viewed as untested hypotheses, the first suggests the need for a program of marketing research and the second a program of outcomes research. The primary emphasis here is on issues involved in developing a program of outcomes research.

Accessibility has historically had strong clinical and regulatory linkages. Access, in virtually all settings except single family housing, is viewed an unconditional civil right of individuals with clinically defined impairments (Scotch, 1988). In this view access is a categorical construct—either it is or is not achieved, frequently with technical and scoping requirements from accessibility codes and standards functioning as criteria for evaluation. Although some early advocates clearly expected mandated accessibility to have broad-ranging consequences for the acceptance and integration of people with disabilities (DeJong & Lifchez, 1983), these outcomes have not been a central concern in accessibility research. In contrast, civil rights are less of an issue with universal design, and other rationales for its adoption by producers and acceptance by consumers with and without disabilities are needed. Although some producers have indicated that the need to comply with regulatory requirements has been part of organizational decisions to adopt a universal design approach, compliance is, at best, one of a number of reasons for producer adoption (Center for Universal Design, 1997).

Research is needed to evaluate claims about the benefits of universal design for people with disabilities and its acceptance by people without disabilities. Such research is not an esoteric exercise. A primary motivation for examining the effects of universal design is to develop a knowledge base for answering hard questions about how much difference and what kind of difference universal design makes in the quality of people's lives. If the claims are supported by research findings, the argument of those who advocate for universal design would be strengthened. Research results also could provide greater leverage for adoption of a universal design approach in design education and the building industry as well as among accessibility regulatory bodies. On the other hand, if the claims are not supported by research or are supported in a more limited way, such information would be useful in more accurately characterizing expected outcomes of universal design and reducing the potential for false expectations

about psychosocial benefits among consumers with disabilities or about consumer demand by the population as a whole among producers.

There are three issues to be addressed by a program of research focused on the effects of universal design on psychosocial outcomes. First, do universally designed objects and spaces make a difference in important psychosocial outcomes, such as integration, participation, and life satisfaction? Second, if universal design makes a difference, what is the magnitude of that difference and how does universal design compare to other known sources of variation in the outcomes? If universal design accounts for differences in the outcomes of interest, in all probability these differences will be small in comparison to other sources of variability (i.e., amount of additional variance explained by universal design), but real (i.e., statistically significant). For example, a number of external factors, such as social/family resources and role obligations, have been found to account for significant differences in the life satisfaction (Fuhrer, Rintala, Hart, Clearman, & Young, 1992) and mobility "handicap" (McDonough, Badley, & Tennant, 1995) experienced by people with disabilities. Would the (non)use of universal designs further explain differences in life satisfaction? The third issue is more interpretive and value-based. Are statistically significant differences in psychosocial outcomes that are accounted for by universal design, particularly if they are small differences, in some sense meaningful? Small differences are potentially important because the physical environment may be a comparatively more realistic target for change than are other factors that influence outcomes, even if other factors, for example disability itself, represent larger sources of variability in outcomes of interest. In contrast, small differences may be practically unimportant when difficulty or cost of implementation are compared with the size of potential gains in life experiences.

Key Research Design Issues

Several key issues need to be considered in planning research on the effects of universal design. The first is the formulation of research questions and how they shape the data that are collected, the rigor of the evidence that is obtained, and the "fit" between results and the context for application. At a minimum, there are two broad research questions that should be addressed by early research on the psychosocial effects of universal design. More sophisticated questions, which are dependent on more knowledge of the issues, may come later.

One of these questions is whether or not there is a relationship between universal design and psychosocial outcomes and, if so, what the strength of the relationship is. In its simplest iteration, this research question might take the form of: "Is use of/access to universal design related to ..." community integration, for example. This question could be logically pursued by collecting data on the community integration of people with disabilities, including individuals with and without access to universally designed objects and spaces, and comparing

the relationship between presence of universal design and community integration scores. If the claims for universal design are true, one would expect the presence of universal design to be related to higher integration scores, and differences between the two groups' integration would provide some insight about how much of an impact universal design makes in the community integration of people with disabilities.

A second and more complex question, but one more central to the universal design movement, concerns the comparative effects of specialized and universally designed objects and spaces on functional *and* psychosocial outcomes. Universal designs are presumed to work as well or better than specialized designs in compensating for functional loss due to impairments as well as in having a more positive impact on psychosocial outcomes. Thus, the general research question might take the form of: "What are the differences in the functional independence and community integration of people who use universally designed objects and spaces and those who use specially designed objects and spaces?" If universal design has the expected relationships to functioning and integration, one would expect equivalent or higher independence scores and higher integration scores. Differences between the scores of those who use universal designs and those who use special designs would provide some insight about how much difference universal design makes. Because this question pays attention to the nature of the accessible objects and spaces that the comparison group uses, it might be expected to yield "cleaner" data on the effects of universal design than questions with less clearly defined comparison group experiences. However, it also places more stringent and potentially unrealistic demands on the types of environments (independent variable) with which participants are experienced. Ideally, the universal design group would only use universally designed objects and spaces, and the specialized design group would only use specialty designs. Research design mechanisms for controlling experiences with the independent variable are probably incompatible with the dependent variables of interest. For example, conducting studies in laboratory settings would enable researchers to control the types of designs (e.g., universal versus specialized design) experienced by study participants, at least for the duration of their time in the laboratory. However, measures of dependent variables, such as social integration and participation, that could be obtained under laboratory conditions may not be good predictors of real world experiences. For researchers, there may be problems of generalizability, for nonresearchers, measures and results may lack "face validity" and credibility. Field research that capitalizes on situations that create "naturally occurring experiments" may help overcome some of these problems.

The second key issue follows from the first. There is a need to identify the key outcomes or dependent variables to be examined—the behaviors and experiences that universal design is hypothesized to impact. At one level, these outcomes may seem self-evident. The discourse on universal design as well as the disability studies literature and research on the disablement process suggest a

number of outcomes, or perhaps more accurately domains of outcomes, that universal design might be expected to affect, including the social integration of people with disabilities and their participation in roles normal for an individual's age at home, school/work, leisure, in community settings, and so on (Dawson & Chipman, 1995; DeJong, 1991; Fuhrer et al., 1992; Hahn, 1988; Heumann, 1993; Long, 1995; Mace et al., 1990; McDonough et al., 1995; Racino & Taylor, 1993; Smith, 1994; Ville, Ravaud, Marchal, Paicheler, & Fardeau, 1992; Welch, 1995). Universal design also may be an important vehicle in reducing stigma and stereotyping associated with the use of designs that are visibly different from those used by others (Romeis, 1990).

At another level, a great deal of work is needed to specify and elaborate outcomes in such a way that they are measurable. There are two conceptually distinct considerations that at some point must be integrated. First, as has been noted with regard to outcomes measurement in the field of assistive technology, outcomes domains are often multidimensional (i.e., they have an impact on clinical status, functional status, quality of life, satisfaction, cost), and specific dimensions are differentially important to different audiences (DeRuyter, 1995). Research carefully structured with regard to distinctions of functional limitation, disability, and handicap/social limitation (cf. Gitlin & Corcoran, 1996) also make it clear that environmental interventions can be assessed in terms of different levels and types of outcomes. The emphasis here has been on quality of life and related psychosocial outcomes, issues that probably are of greatest importance to people with disabilities and their families. However, producers may be more interested in issues such as costs of universal design in comparison to usual practices and customer satisfaction with universal designs, especially among customers who are not disabled. Policymakers and advocates who want to determine if and for whom universally designed, in contrast to conventional specialized design, "interventions" are eligible for third-party reimbursements may be more interested in clinical and functional outcomes associated with universal design. The second consideration is the process by which the broad domains and more detailed components of outcomes will be elaborated. There are a number of options, including empirical and expert- and consumer-based consensual approaches; probably the least preferable strategy is to rely solely on one approach and the perspective of one group. Over and beyond this more conceptual work of specifying and defining dimensions of outcomes to be assessed, there is a need to identify existing instruments or to develop and validate new ones for measuring outcomes as dependent variables.

CONCLUSIONS

Widespread interest is rapidly moving universal design from concept to practice—from idea to actuality of tangible objects and spaces. An important ramification of this shift is that universal design will be subjected to different

kinds of scrutiny in the world of practice than it has been in the world of ideas. An obvious and apparent shortcoming in the existing discourse on universal design is the absence of a relevant knowledge base about universal design. This chapter has identified two such gaps: (1) the need for population-based anthropometric and biomechanical norms and the integration of those data with existing norms for the general population and (2) the need to initiate outcomes research to determine the effects of universal design. These gaps, unless addressed by the research community, will likely become serious barriers to the shift from concept to practice with the potential that gains already achieved cannot be sustained.

Several action steps have been identified to initiate programs of anthropometric/biomechanical and outcomes research related to universal design. For anthropometric/biomechanical research, domains in which research is needed must be identified and prioritized. Some anthropometric/biomechanical data for people with disabilities exist, but their appropriateness as a basis for population norms is dependent on evaluation using scientific criteria. Data obtained from small, nonrandom samples will be of limited utility, and additional research is called for. Where no data exist, additional research is warranted. Research should proceed in some rational order with highest priority given to anthropometric and biomechanical measures that are most closely related to impairment and that denote functions that affect use of conventional designs by people with disabilities. Finally, information on anthropometric/biomechanical norms, whether obtained from existing or new research, needs to be integrated in a very literal sense with existing standards used by designers. If we want designers to design for everyone, then it is incumbent on us to ensure that data on everyone are available in the same place and in the same way.

With regard to developing a program of outcomes research, perhaps the most pressing issue is identifying and elaborating outcomes of interest. The discourse on universal design emphasizes psychosocial variables that impact the nature and quality-of-life experiences of people with disabilities, such as independence in daily activities, social and community integration, role access and participation, and equality/nondiscrimination. The domain of psychosocial outcomes is probably of greatest interest to people with disabilities. However, there are other audiences and affected groups who may have different interests. For example, producers may be interested in customer satisfaction, especially in relation to costs, and policy groups may be interested in functional outcomes, in comparison to specialized alternatives. A critical issue is the process by which outcomes are specified. It is not appropriate for the target domains for research or their operational definitions to be determined by any one group, including but not limited to people with disabilities, producers, or policy professionals. We initially need to plan how to plan outcomes research.

The primary motivation in asking questions about the effects of universal design is to understand how much difference and what kind of difference it

makes in the lives of people. Moreover, we need to use good science to address these questions. We need answers that are defensible to skeptics—those whose values, practices, and agendas predispose them to view universal design as too costly, relevant to only a few people, and something to be dealt with only to the extent required by law. A recent editorial on disability research in geriatrics (Branch, 1996) addresses a number of issues that can be extrapolated to accessibility research. Branch argues that much of what is known (or believed to be known) about the benefits of many interventions to prevent, delay, or mitigate the effects of age-related disability may be convincing to those who believe in these interventions, but is unlikely to be rigorous enough to counter the doubts of skeptics. In an era in which common sense is increasingly measured in dollars and cents, we must be prepared to offer defensible evidence of our beliefs.

REFERENCES

ARP Associates. (1978). *Anthropometric source book: Anthropometry for designers* (NASA Reference Publication 1024). Washington, DC: National Aeronautics and Space Administration.

Bails, J. H., & Seeger, B. R. (1988). *Ergonomic design for physically disabled children. Part I.* Adelaide, South Australia: South Australian Department of Housing and Construction.

Bostrom, J. A., Malassigné, P. M., & Sanford, J. A. (1984). Development and evaluation of four shower prototypes. *Proceedings of the Second International Conference on Rehabilitation Engineering, 4*, 91-92.

Branch, L. (1996). Research on disability: Where is it leading? *Journal of Gerontology, 51B*, S171-S172.

Center for Universal Design. (1997, June). *Studies to further the development of universal design.* Final report to the National Institute of Disability and Rehabilitation Research.

Connell, B. R., Sanford, J. A., Moore, R., Bostrom, J., & Ostroff, E. (1994). Accessibility standards for children's environments. In M. Binion (Ed.), *Proceedings of the RESNA '94 Annual Conference* (pp. 48-50). Arlington, VA: RESNA Press.

Czaja, S. (1984). *Hand anthropometrics.* Technical paper prepared for the U.S. Architectural and Transportation Barriers Compliance Board.

Czaja, S., & Steinfeld, E. (1980). *Human factors research with disabled children.* Buffalo, NY: People's Center for Housing Change.

Dawson, D. R., & Chipman, M. (1995). The disablement experienced by traumatically brain-injured adults living in the community. *Brain Injury, 9*, 339-353.

DeJong, G. (1981). *Environmental accessibility and independent living outcomes. Directions for disability policy and research.* East Lansing: University Center for International Rehabilitation, Michigan State University.

DeJong, G., & Lifchez, R. (1983). Physical disability and public policy. *Scientific American, 248*(6), 40-49.

DeRuyter, F. (1995). Evaluating outcomes in assistive technology: Do we understand the commitment? *Assistive Technology, 7*, 3-16.

Diffrient, N., Tilley, A. R., & Bardagjy, J. C. (1974). *Humanscale 1/2/3.* Cambridge, MA: MIT Press.

Diffrient, N., Tilley, A. R., & Harman, D. (1981a). *Humanscale 4/5/6.* Cambridge, MA: MIT Press.

Diffrient, N., Tilley, A. R., and Harman, D. (1981b). *Humanscale 7/8/9.* Cambridge, MA: MIT Press.

Fisher, S. V., & Patterson, R. P. (1981). Energy cost of ambulation with crutches. *Archives of Physical Medicine and Rehabilitation, 62*, 250-256.

Floyd, W. F., Guttman, L., Wycliffe-Noble, C., Parkes, M. A., & Ward, B. A. (1966). A study of the space requirements of wheelchair users. *Paraplegia, 4*(1), 24-37.

Fuhrer, M. J., Rintala, D. H., Hart, K. A., Clearman, R., & Young, M. E. (1992). Relationship of life satisfaction to impairment, disability, and handicap among persons with spinal cord injury living in the community. *Archives of Physical Medicine and Rehabilitation, 73*, 552-557.

Gordon, C. C., Bradtmiller, B., Churchill, T., Clauser, C. E., McConville, J. T., Tebbetts, I., & Walker, R. A. (1989). *1988 anthropometric survey of U.S. Army personnel: Methods and summary statistics* (Technical Report NATICK/TR-89/044, U.S. Army). Natick, MA: Natick Research Development and Engineering Center.

Hahn, H. (1988). The politics of physical differences: Disability and discrimination. *Journal of Social Issues, 44*, 39-47.

Heumann, J. E. (1993). A disabled woman's reflections: Myths and realities of integration. In J. A. Racino, P. Walker, S. O'Connor, & S. J. Taylor (Eds.), *Housing, support, and community* (Vol. 2, pp. 230-250). Baltimore: Paul H. Brookes.

Hunter, J. (1987). Energy costs of wheelchair propulsion by elderly and disabled people. *International Journal of Rehabilitation Research, 10*(4), 50-54.

Lauback, L., Glaser, R., & Suryaprasad, A. (1981). Anthropometry of aged male wheelchair-dependent patients. *Annals of Human Biology, 8*(1), 25-29.

Long, R. G. (1995). Housing design and persons with visual impairment: Report of focus-group discussions. *Journal of Vision Impairment and Blindness, 89*(1), 59-69.

Mace, R. L., Hardie, G. J., & Place, J. P. (1996). Accessible environments: Toward universal design. Center for Universal Design, North Carolina State University, Raleigh, NC.

McCormick, E. J. (1970). *Human factors engineering* (3rd ed.). New York: McGraw-Hill.

McDonough, P. A., Badley, E. M., & Tennant, A. (1995). Disability, resources, role demand and mobility handicap. *Disability and Rehabilitation, 17*(3/4), 159-168).

Perry, J., Mulroy, S. J., & Renwick, S. E. (1993). The relationship of lower extremity strength and gait parameters in patients with post-polio syndrome. *Architecture-Psychology-Medical Rehabilitation, 74*(2), 165-169.

Racino, J. A., & Taylor, S. J. (1993). Introduction. In J. A. Racino, P. Walker, S. O'Connor, S. J. Taylor (Eds.), *Housing, support, and community* (Vol. 2, pp. 1-30). Baltimore: Paul H. Brookes.

Sanford, J. A., Story, M. F., & Jones, M. L. (1997). An analysis of the effects of ramp slope on people with mobility impairments. *Assistive Technology, 9*(1), 22-33.

Scotch, R. K. (1988). Disability as the basis for a social movement: Advocacy and the politics of definition. *Journal of Social Issues, 44*, 159-172.

Smith, E. (1994). Visitability. *Mainstream, 18*(10), 28-34.

Steinfeld, E. (1996). *Universal design as innovation.* Occasional paper, Center for Inclusive Design and Environmental Access, University at Buffalo.

Steinfeld, E., & Shea, S. (1993). Enabling home environments. Identifying barriers to independence. *Technology and Disability, 2*(4), 69-79.

Steinfeld, E., Schroeder, S., & Bishop, M. (1979). *Accessible buildings for people with walking and reaching limitations.* Washington, DC: U.S. Department of Housing and Urban Development, U.S. Government Printing Office.

Steinfeld, E., Sanford, J., & Shiro, G. (1986). *Hands on architecture.* Final report submitted to the Architectural and Transportation Barriers Compliance Board.

Stoudt, H. W. (1981). The anthropometry of the elderly. *Human Factors, 23*, 29-37.

Ville, I., Ravaud, J.-F., Marchal, F., Paicheler, H., & Fardeau, M. (1992). Social identify and the International Classification of Handicaps: An evaluation of the consequences of facioscapulohumeral muscular dystrophy. *Disability and Rehabilitation, 14*(4), 168-175.

Waters, R. L.,& Lunsford, B. R. (1985). Energy cost of paraplegic locomotion. *Journal of Bone-Joint Surgery, 67*(8), 1245-1250.

Waters, R., Torbum, L., & Mulroy, S. (1992). Energy expenditure in elderly patients using assistive devices. *Topics in Geriatric Rehabilitation, 8*(2), 12-19.

Waters, R. L., Yakura, J. S., & Askins, R. H. (1993). Gait performance after spinal cord injury. *Clinical Orthopedics*, 87-96.

Welch, P. (Ed.). (1995). *Strategies for teaching universal design*. Boston: Adaptive Environments Center.

Woods, W. (1980). *Disability and building codes: A quantitative study*. Tucson: University of Arizona, Health Sciences Center, Biomedical Division.

3

Space Requirements for Accessibility

Cross-Cultural Comparisons

Theo J. M. van der Voordt

AIM OF THE RESEARCH

Toward a New Edition of *Call for Admittance*

Considerable attention is paid in the Netherlands to the dissemination of information on the accessibility of the built environment. A standard work in this field is *Call for Admittance* [Geboden Toegang], published by the Dutch Council for the Disabled [Federatie Nederlandse Gehandicaptenraad]. The first edition of this manual appeared in 1973. It had been based largely on existing publications and empirical knowledge of experts, supplemented by small-scale studies on space requirements at a rehabilitation center. The eleventh edition of this work appeared in 1993. *Geboden Toegang* has by now become a household word in the Netherlands. The manual is cited regularly by developers, designers, and those responsible for reviewing plans and developing legislation.

Although new insights and research data from the last two decades have been included in later editions, the eleventh edition is outdated. Current trends such as building adaptable housing (Voordt, 1990, 1992) and organizing informa-

Theo J. M. van der Voordt • Faculty of Architecture, Delft University of Technology, Delft, The Netherlands 2628CR.

Enabling Environments: Measuring the Impact of Environment on Disability and Rehabilitation, edited by Edward Steinfeld and G. Scott Danford. Kluwer Academic/Plenum Publishers. 1999.

tion according to the different stages in the design process are not addressed well. Scoping (i.e., the degree of accessibility in connection with the application area) is barely mentioned at all. Another concern is the shift away from individual adaptations and categorical provisions toward "design for all," also referred to as "universal design" or "universal access." In the Netherlands we use the term "integral accessibility." This concept means that everyone should be able to use the built environment, without assistance, if at all possible (Wijk, 1992). Therefore, dimensional criteria should be based on the principle that people differ in size and physical ability. For instance, if the clear width of a doorway is set at 850 mm, it would allow a fairly large and heterogeneous group to pass through, including people with personal aids or belongings (e.g., wheelchair, crutch, luggage, baby carriage), with the exclusion of some "outliers" (e.g., very wide wheelchairs, hospital beds). So actually, "everyone" means every person whose space requirements fall within the dimensional criteria of the so-called "wider than average." Within the framework of a European Concept for Accessibility, experts have developed international standards (CCPT, 1995). The new edition of *Call for Admittance*, which appeared at the end of 1995 with the title *Manual on Accessibility*, incorporates such recent developments (Wijk, 1995).

The primary aim of the present research was to gather and compare data from previous empirical research as a scientific base for the measurements in the new edition of *Call for Admittance*.

METHODS

Delft University of Technology and the National Housing Council completed an inventory of publications on space requirements for accessibility. Sixty-two organizations worldwide were sent requests for information, and various databases were referenced. We next reviewed completed empirical research on space requirements for accessibility. No more than 40 studies were identified (see the list of references and bibliography at the end of this chapter), half of which were either not relevant or outdated. In some studies the number of test subjects was too small. Others (e.g., from Finland or Sweden) had not been translated, or the original research report was unavailable. Nineteen publications were selected for in-depth analysis with respect to their usefulness for establishing building standards for integral accessibility (Voordt, Jong, Drenth, Nolte, & Sanders, 1993). Most of these studies had made use of full-scale models. Some studies used fixed constructions with various dimensions (e.g., Ownsworth, Gaylor, & Feeney, 1974; Steinfeld, Schroeder, & Bishop, 1979; Werkgroep Bouwen voor Iedereen, 1979). Others used movable partitions to vary the measurements (e.g., Walter, 1971; Steinfeld et al., 1979; Werkgroep Bouwen voor Iedereen, 1983). A few studies were executed in real life situations, for instance, at the

homes of research subjects (Howie, 1967) or in public buildings (Steinfeld, Schroeder, & Bishop, 1986).

In addition to the review of completed empirical research, a series of simulation studies were made of the space requirements of wheelchair users (Voordt et al., 1993). These simulation studies examined the subactivities from which an activity is built up, their sequence, and their space requirements, both when performed separately and as an integrated part of an activity. Variations were considered, such as activities with or without assistance, and different transfer techniques. The use of the toilet is an example of an integral activity. It can be broken down into opening and closing the door, transfers to and from the toilet, using the toilet, washing hands, and leaving the bathroom.

The space required for each subactivity was analyzed with computer-generated drawings of movements. These drawings were executed with the help of the computer program AutoCAD version 12, a very popular computer-aided design (CAD) program. Within AutoCAD we also used the program MARIONET, developed by Eindhoven Technical University (Boekholt, 1987). This program contains two-dimensional drawings of human figures, including a person in a wheelchair. The figures consist of separate parts that can be connected through nodes to form a human shape. MARIO is a male figure 175.5 cm tall. NET is a female figure 162.5 cm tall. The measurements of the figure that we chose for the present research were adapted to recent anthropometric data (i.e., 1800 mm) as the present average height of a Dutch man.

Information on the movements required for computer simulations were found in publications and in discussions with an expert from the Community Medical Service (responsible for person–environment adaptations) and an experienced occupational therapist, supplemented where needed with wheelchair experiments of the activities by the researchers themselves. The simulation studies were confined to the use of toilet, shower, and wash basin; vertical transport by lift; and opening and closing doors. The Appendix illustrates various simulation studies on the use of the toilet and opening a door toward the user.

RESULTS

First, we will describe some methodological issues identified by comparing the reports. Second, some results of the completed empirical research are discussed, in combination with the results from the simulation studies.

Methodological Issues

Several reports failed to explicate the assumptions of the study (e.g., independent versus assisted use of space), the dimensions and constraints of the

wheelchairs used by subjects, or the intended type of application (adaptable or adapted housing, universal accessible public buildings, nursing homes). Many reports only mentioned in passing the degree of variation in space use. Often only the minimum requirements are reported. Therefore, the effect of many variables on space use remains unclear, for example:

- Familiarity with spatial layouts or facilities
- Type and degree of disability, e.g., full useability of arms and hands as opposed to partial or complete loss of these functions
- Type of aids, such as a wheelchair as opposed to a support cane or walker or no use of aids at all, and the type of wheelchair (manual or powered, narrow or wide, large or small turning radius)
- Familiarity with aids, e.g., experienced vs. nonexperienced wheelchair users
- Type of approach and transfer (lateral, frontal, oblique)

As far back as 1966, a study by Nichols, Morgan, and Goble clearly demonstrated the importance of the type of wheelchair. The study showed that 50% of the variation in space use was caused by the different sizes of wheelchairs. In this respect it is important to notice that, for instance, in Brättgard's research of 1974 many subjects used front-wheel-drive wheelchairs. Such wheelchairs are practically nonexistent in the United States. Their maneuvering characteristics are very different than rear-wheel-drive chairs. In some studies wheelchairs were used that are now outdated. This makes it difficult to extrapolate the results to the present situation with reliability.

Another concern was the wide diversity within the study sample. Earlier studies usually recruited their subjects from rehabilitation centers (Nichols et al., 1966; Floyd, 1966; Walter, 1971). Later, subjects were recruited through appeals in the media (Steinfeld, 1979) or at an information market for people with disabilities (Werkgroep Bouwen voor Iedereen, 1983). Different sampling selections lead to considerable differences in the subjects' ability to cope.

A third important issue is the interpretation of "fit" between the environment and the people by whom it is intended to be used. As Steinfeld and Danford show elsewhere in this book (Chapter 1), standards developed from observed task performance may differ according to whether the criterion is simply the ability to perform the task at all versus task performance within reasonable limits of time and effort. They also point out that there are social and cultural differences in tolerances between body size, body movements, and the space envelope in which they occur. These differences were observed by Rapoport and Watson (1972) with respect to many types of space norms.

As most samples were not selected at random, it is hard to determine what percentiles are excluded from consideration by recommendations from the studies. However, a rough estimation could be made. In most studies, the dimensions within which 80%–90% of the sample could perform a task were used as the

basis for recommendations. Several studies added a margin of around 5% to the minimum dimensions based on this criterion. It could be concluded that some 90% of the populations studied are included within the dimensional criteria based on these studies. Wheelchair users, who constitute a minority within the disabled population, require more space than other disabled people. So the actual proportion of people with disabilities that fit within the recommended dimensions is even higher.

Use of Space in the Bathroom

Empirical research into the use of bathrooms was conducted by McLelland (1972), Ownsworth et al. (1974), and Steinfeld et al. (1979). McLelland studied only the design of a grab bar next to the bath. He demonstrated the usefulness of such a device and recommended a bar diameter of 30–40 mm with a space between bar and wall of 50–65 mm. Without a grab bar, 12 out of 21 participants could not get into or out of the bathtub without assistance, but only 4 people could not manage it with the bar in place. The other studies gave attention to the bathroom as a whole as well as to separate elements. Let us discuss the elements one by one.

Bath

The bathtub tested by Ownsworth et al. (1974) is 710 mm wide, 1680 mm long, and 560 mm high. Out of 36 subjects (all wheelchair users), 2 were unable to make a transfer. Eight persons used a frontal transfer, 20 an oblique transfer, and 6 a lateral transfer. Eight subjects were able to use an alternative method of transfer to the one they used during the experiment. So in places used by a variety of people with disabilities, the design should provide space around the bath for both lateral, frontal, and oblique transfers. With individual adaptations (e.g., at home), the design can be adjusted to the user's personal preference. A majority of the study subjects (24 persons) chose to use a "bath aid." This aid consisted of a horizontal stand next to the bathtub that was used to shift one's body into the water. A lifting apparatus was required for 3 people. The remaining 7 subjects transferred to the bath unaided. An occupational therapist assisted 21 of the subjects. The 95th percentile for the use of space required perpendicular to the bath appeared to be 1400 mm across the full length of the bath and, at the location of the bath aid, 80 mm by 25 mm next to the bath (Figure 3.1).

Steinfeld et al. (1979) used a bathtub measuring 760 mm by 1520 mm. A lateral transfer appeared to require a minimum space of 760 mm in front of the bath, a frontal transfer 1220 mm. A space of 1220 mm by 1220 mm made both kinds of transfer possible. Horizontal grab bars were placed around the bath at 760, 835, and 910 mm above the floor, with a fourth grab bar at 230 mm above the upper edge of the bath (610 mm from the floor). Three vertical grab bars were

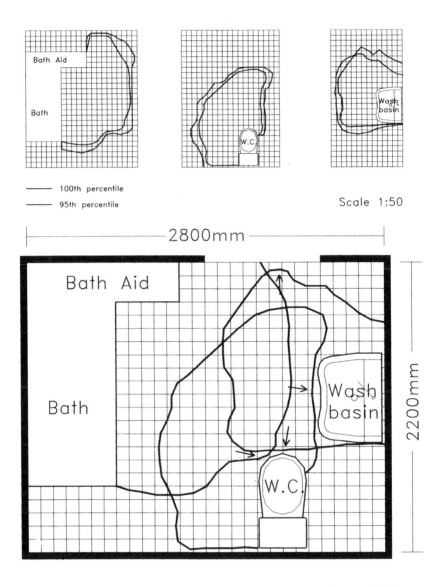

Scale 1:20

Figure 3.1. Space requirements for use of a bathroom by a wheelchair user (Ownsworth et al., 1974). Arrows indicate critical boundaries by aggregating the activity areas determined in the first experiment.

also installed, two on the side walls and one (movable) bar on the front edge of the bath. The bars most frequently used were the horizontal ones placed at 910 mm above the floor and at 230 mm above the edge of the bath. The bars at the head and foot ends of the bath were used mainly to get across the edge and for stabilization; the bar set into the side was used to lower oneself into the bath or rise from it. The part of the vertical bar used the most lay between 610 and 1220 mm.

Toilet

Ownsworth et al. (1974) tested a wall-hung toilet with a depth of 760 mm and a width of 240 mm. The extra floor space gained by using a wall-hung toilet was considered more important than the extra costs compared to a pedestal toilet. The following transfer techniques were tested: frontal transfer (15 respondents), oblique transfer (7 respondents), lateral transfer (12 respondents). Two subjects were unable to make the transfer, and 7 subjects experienced difficulties. Eight people required assistance. Twenty-nine subjects approved of the distance between the front of the toilet bowl and the supporting wall (760 mm), but for 5 people it constituted a problem (too far). The space required at the transfer side for the 95th percentile was 1000 mm in width (measured from the center of the toilet bowl) and a depth of 1800 mm (including toilet bowl). One-quarter of the subjects benefited from the space beneath the bowl when making the transfer.

Steinfeld et al. (1979) studied the use of a wall-hung toilet by 58 wheelchair users and 11 able-bodied people. Apart from the space requirements, the study was aimed at determining the optimum heights of the toilet bowl (430–480 mm) and horizontal grab bars (840–910 mm). It appeared that the toilet transfer depended as much on training as on disability. Nearly 1 in 3 wheelchair users was unable to perform a toilet transfer without assistance, no matter how wide the stall. For 9 out of 40 wheelchair users, a toilet stall width of 1220 mm was too narrow. When they were brought back for a second test, they were able to transfer in stalls that narrow but they had to use a transfer technique that was different and sometimes more difficult than that which they typically used. Everyone who could transfer was able to use the 1220 mm stall. On the basis of this research the researchers recommended toilet dimensions of 1220 mm wide and 1680 mm deep, with the center of the toilet bowl located at 760 mm from one side wall. This is considerably less than the dimensions recommended in the study by Ownsworth et al. (1974) or in various other publications (Table 3.1).

When the results from the study by Steinfeld et al. (1979) are compared with the results from the simulation studies (Table 3.2 and Appendix), it seems that with Steinfeld's dimensions, a side transfer (lateral shift, parallel to the toilet) and transfers with assistance are hardly possible. The user space recommended by Ownsworth et al. (1974) is more adequate but still too narrow for assisted lateral

Table 3.1. Recommended Dimensions of Toilet Stalls

Reference	a	a + b	c + d	net m²
Ownsworth et al. (1974)	450	1450	1800	2.6
Goldsmith (1976)				
Small-sized toilet	400	1400	1700	2.4
Standard toilet	500	1500	2000	3.0
Fokus (1976)				
Public buildings	1100	2200	2200	4.8
Steinfeld et al. (1979)	460	1220	1680	2.1
ANSI 117,1 (1986)	460	1525	1420	2.2
Depending on direction of approach	460	1220	1775	2.2
and method of transfer	460	1220	1420	1.7
	460	915	1675	1.6
European Manual (1990)				
Integral accessibiity		1650	1800	3.0
Limited accessibility		900	1500	1.4
Suitability for visiting	450	1000	1200	1.2
Wijk (1992)				
Testing integral accessibility	450	1650	2200	3.6
Call for Admittance (1993)				
Multifunctional toilet	1100	2200	2500	5.5
Assisted use of toilet	700	1800	2200	4.0
Minimum dimensions toilet	550	1650	2200	3.6

transfers and only marginally adequate for oblique transfers (too shallow). Various studies show that lateral and oblique transfers are used quite often, by 10%–20% and 25%–30%, respectively, of the wheelchair users (British Department of the Environment, 1992; Groot, 1988; Standards Association of Australia, 1993). The popularity of different transfer techniques appears to vary from country to country. A 90° lateral transfer, for example, is used in the Netherlands by around 40% of wheelchair users, while in an Australian study it was only 9%. A side transfer (parallel to the toilet bowl or with a slight angle to it) seems to be more

popular in Australia than it is in the Netherlands (36% vs. 18%). An important issue for further research is whether or not more standardized training methods could limit the diversity in transfer techniques and, consequently, the diversity in space requirements.

Wash Basin

Ownsworth et al. (1974) studied a wash basin 635 mm wide and 485 mm deep, fixed at a height of 825 mm from the floor (hardly the same measure as the 815 mm recommended by Steinfeld et al., 1979). The transfer methods were distributed as follows: 26 tests of frontal transfer, 8 oblique transfers and 2 lateral transfers. Thirteen people considered the wash basin too high, whereas 22 were satisfied with its position. Four people could not reach the taps. Nine persons were unable to wash their hair. Arm rests and foot supports were sometimes in the way, or elbows had to be supported uncomfortably high. For the required space in front of the wash basin, the 95th percentile amounted to 1250 mm by 700 mm (with the latter measured from the front of the basin). This was slightly less than the outcome of our simulation study for washing hands, where the user space measured 1200 mm by 900 mm. A more elaborate wash-up (including face and back) required 1200 mm by 1250 mm.

Shower

Ownsworth et al. (1974) did not complete research into the use of a shower, but Steinfeld et al. (1979) did. They compared the usability of a wheel-in shower (no curb, no seat) to a conventional shower stall, and the transfer to a shower seat in a stall with the curb (100 mm high) in place and with the curb removed. Furthermore, a full-scale model was tested with a toilet (430 mm high) or a wash basin (810 mm high and 460 mm deep) next to he shower stall, at distances of 760 mm and 910 mm, respectively. The shower stall tested had a depth of 1520 mm and a variable width. The doorway was 860 mm wide. All subjects had problems coping with the curbs, although these did not stop anyone from making the transfer. Most people considered a maneuvering space of 1220 mm by 760 mm adequate. A larger space of 1520 mm by 1070 mm was required in cases where it was necessary to make an L-turn before entering a wheel-in shower, but the position of the toilet left no knee-room next to the stall. The simulation study showed that a lateral transfer from wheelchair to shower seat required even more space: around 1600 mm by 1300 mm.

Bathroom

Ownsworth et al. (1974) had 33 wheelchair users test a bathroom measuring 2220 mm by 2800 mm and fitted with a bath, wash basin, and toilet (Figure 3.1). Except for one person, every one considered this layout quite adequate. Almost

Table 3.2. Space Requirements for Toilet Transfers According to Simulation Studies (van der Voordt et al., 1993)

Transfer		Distance to well	Width × depth	m²
Lateral transfer (90°)		a = 400 b = 900 c = 600	1300 × 1300	1.7
Idem, assisted		a = 500 b = 1150 c = 950	1650 × 1650	2.7
Oblique transfer		a = 400 b = 900 c = 1300	1300 × 2000	2.6
Idem, assisted		a = 700 b = 900 c = 1300	1600 × 2000	3.2
Frontal transfer		a = 400 b = 400 c = 1150	800 × 1850	1.5
Backward shift, assisted		a = 650 b = 650 c = 1100	1300 × 1800	2.4
Lateral shift parallel or under 45°		a = 400 b = 1000 c = 700	1400 × 1400	2.0
Folding down support bars		a = 400 b = 1000 c = 1300	1400 × 2000	2.8

a = Distance from center of toilet bowl to wall on one side
b = Idem, to side of transfer
c = Distance from front of toilet bowl to wall
d = Depth of toilet bowl (700 mm)

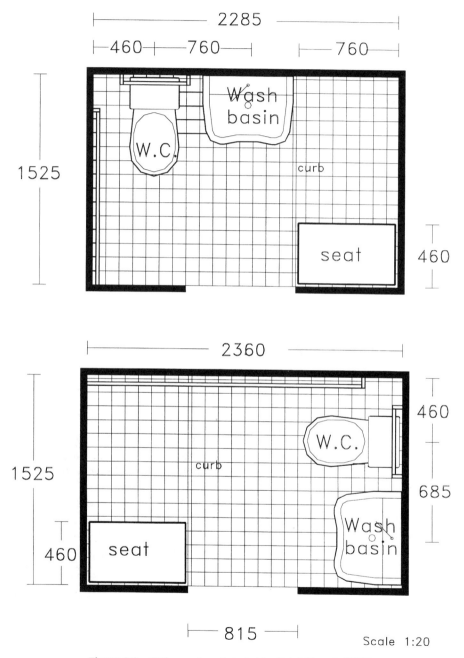

Figure 3.2. Bathroom layouts tested by Steinfeld et al. (1979).

all subjects were able to turn 360°. Only a few subjects had problems maneuvering. One person in a wheelchair with foot supports folded out was unable to make a 360° turn. The majority of wheelchair users needed to use the area underneath the toilet and wash basin for turning.

Steinfeld et al. (1979) studied two minimum-sized bathroom layouts with a toilet, wash basin, and shower (Figure 3.2). Each bathroom was tested with a wheel-in shower stall and a conventional shower stall with a seat. The rooms measured 2280 mm by 1520 mm and 2350 mm by 1520 mm, respectively, with doorway widths of 810 mm. These dimensions are considerably below the minimum measurements of 2150 mm by 2150 mm recommended in *Call for Admittance*. Nevertheless, both bathrooms were usable, provided they were fitted with a wheel-in shower stall, an entrance at the longer side, and doors that pivoted out. The layout with a shower located opposite the toilet and wash basin proved to be less practical, as it did not provide the users with enough maneuvering space. Another problem was that a shower stall with a raised curb only allowed a parallel transfer to the shower seat, which required a space of 305 mm to the side of the shower. Such a shower could not be used by anyone unable to make a lateral or oblique transfer. Also, the door could only be closed if there was a space of 760 mm next to the toilet.

User Space Required for the Opening and Closing of Doors

The space requirements for the opening and closing of doors have been studied by several investigators (Brättgard et al., 1974; Nichols et al., 1996; Ownsworth et al., 1974; Steinfeld et al., 1979; Walter, 1971; Werkgroep Bouwen voor Iedereen, 1983). The dimensions recommended in these studies and other publications were widely divergent (Table 3.3). For instance, the space needed to open a door approached from the hinge side toward the user (A1 in Table 3), amounted to 1200 mm by 2000 mm in a study by Brättgard (1974), but should be 1485 mm by 2220 mm according to the current Australian Standard AS 1428.1-1993. Unfortunately, the study on which these Australian standards were based has never been published, so no explanation for these differences can be given.

The scope of the studies also varied widely. Several publications paid scant attention to the space required to close a door and the effect of the direction of approach. The simulation studies on the opening and closing of doors confirmed the notion that the direction of approach of the wheelchair and rotation of the door determined to a large extent the amounts of space needed for maneuvering (Table 3.3 and Appendix).

The required amount of space parallel to the door and perpendicular to the door were also closely related: The larger the space in front of the door, the less space needed on both sides of the doorway. This made it hard to determine the measurements of one integral user space. It may also explain why the various

studies resulted in such diverse measurements. Only a few published standards (e.g., the Australian Standard) list requirements based on the direction of approach, door rotation, and door width. This is of particular importance in residential construction, where every quarter of an inch counts. Nevertheless, we tried to summarize the results of empirical research and simulation studies in a limited number of recommended measures (Table 3.4).

The measures in Table 3.4 refer to net maneuvering space from a fixed start position (a person in a wheelchair gripping the latch to open the door) to a fixed end position (the person letting go of the latch after closing the door). The required space for approaching or leaving should be added to this maneuvering space. The recommended measures are minimum measures for adaptable housing. For public buildings a bit more space is recommended, both because people are less accustomed with the situation and in view of the use of electric wheelchairs. The space required to close a door while leaving at the hinge side (Table 3.4) is very large. Therefore it is recommended to avoid such situations. For instance, in the case of a bathroom door opening into a corridor, it would be better to reverse the hinge side and latch side.

CONCLUDING OBSERVATIONS

Although accessibility for people with disabilities has been a focus of research for over 30 years, no consensus on the minimum dimensions required has been reached as yet. As indicated in this chapter, the measurements recommended in various studies, standards, and design guides are widely divergent. The major explanations for these variations appear to be:

- Different assumptions on which the studies are founded: For instance, it makes a great deal of difference whether the design of an integral accessible toilet incorporates all methods of transfer or disregards certain transfer techniques.
- Different samples: In some studies subjects were selected at random from the disabled population; in others they were all recruited from one rehabilitation center, leading to dissimilar abilities in coping with physical barriers.
- Different types of wheelchairs: Some studies only include manual wheelchairs, other ones include electric wheelchairs and push chairs; in several cases the wheelchairs used are obsolete.
- Social and cultural differences: This includes anthropometric tolerances, transfer techniques (e.g., by different training methods), and the relationship of fixtures; for example, while the arrangement of a toilet, washbasin, and bathtub at three different walls (as studied by Owns-

Table 3.3A. Space Requirements for Opening and Closing of Doors by Wheelchair Users (Measured in mm), with Door Opening toward the User

Situation	Research	a	b	c	d	e	m²
	Walter (1971)	—	—	—	—	—	2.4
	Brätgard (1974)	1200	2000	1100	780	—	2.8
		1400					2.8
	Steinfeld (1979)	1525	—	1065	760	—	2.6
	ANSI A 117.1 (1986)	1525	—	915	815	—	2.5
		(1365)		(1065)	(815)		2.3
	DIN 18025 (1989)	1500	1500	—	900	—	2.8
	NEN 1814 (1989)	—	—	—	—	—	
	Geboden Toegang (1990)	1950	1450	500	850	—	3.3
	Australia AS 1428.1 (1993)	1485	2220	850	760	610	3.6
		(1570)	(2270)	(810)	(850)	(610)	2.3
	Simulation studies,	1500	1500	600	850	0	2.3
	van der Voordt et al. (1993)	(1250)	(1800)	(900)	(850)	(0)	2.6
		[1250]	[2100]	[1200]	[850]	[0]	3.6
		([1250])	([2900])	([0])	([850])	([2000])	
	Walter (1971)	2070	1420	300	800	320	2.9
		[1870]	[2300]	[750]	[800]	[750]	4.3
	Brätgard (1974)	1200	2000	300	780	—	2.4
		1250					2.5
	Steinfeld (1979)	1525	—	610	760	—	2.1
	ANSI A 117.1 (1986)	1525	—	455	815	—	1.3
				610			2.2
	DIN 18025 (1989)	1500	1500	—	900	—	2.3
	NEN 1814 (1989)	1500	1500	500	850	—	2.3
	Geboden Toegang (1990)	1450	1450	500	850	—	2.1
	Australia AS 1428.1 (1993)	1350	1350	480	760	110	1.8
		(1350)	(1420)	(460)	(850)	(110)	1.9
	Simulation studies,	1800	1250	350	850	0	2.3
	van der Voordt et al. (1993)	(1500)	(1500)	(600)	(850)	(0)	2.3

Source	a	b	c	d	e	
Walter (1971)	1270 [1350]	— [2540]	— [970]	800 [800]	550 [770]	3.4
Brättgard (1974)	1000 *1250*	2200	—	780	—	2.2 2.5
Steinfeld (1979)	1220	—	0	760	—	0.9
ANSI A 117.1 (1986)	1220	—	610	815	—	1.7
With door closer	1370					2.0
DIN 18025 (1989)	1500	1500	—	900	—	2.3
NEN 1814 (1989)	—	—	—	850	—	2.3
Geboden Toegang (1990)	1100	2100	1200	850	110	2.6
Australia AS 1428.1 (1993)	1485 (1570)	1720 (1770)	850 (810)	760 (850)	(110)	2.8
Simulation studies, van der Voordt et al. (1993)	1800 (1500)	1500 (2150)	600 (900)	850 (850)	0 (0)	2.3 2.3

Maneuvering space excluding space for approach
999 = required space for opening of doors
(999) = alternative (depending on way of approach)
999 = preferred space for opening of doors
[999] = required space for closing of doors
— = no data available

Table 3.3B. Space Requirements for Opening and Closing of Doors by Wheelchair Users (Measured in mm), with Door Opening Away from the User

Situation	Research	a	b	c	d	e	m²
	Walter (1971)	1200	1500	400	800	300	1.8
		[1970]	[3010]	[1120]	[800]	[1050]	5.9
	Brättgard (1974)	1000	1500	—	780	—	1.5
		1200					1.8
	Steinfeld (1979)	1065	—	0	810	—	0.9
	ANSI A 117.1 (1986)	1065	1370	—	815	—	1.5
	With door closer	1220					1.7
	DIN 18025 (1989)	1500	1500	—	900	100	2.3
	NEN 1814 (1989)	—	—	—	—	850	2.2
	Geboden Toegang (1990)	1100	2000	500	850	—	2.1
	Australia AS 1428.1 (1993)	1240	1660	290	760	610	1.8
		1120	1650	190	850	610	1.3
	Simulation studies, van der Voordt et al. (1993)	1100	1200	0	850	300	
	Walter (1971)	[2250]	[1830]	[370]	[800]	[650]	4.1
	Brättgard (1974)	1200	2000	200	780	—	1.3
			1150				1.3
	Steinfeld (1979)	1525	—	305	760	—	1.6
	ANSI A 117.1 (1986)	1220	—	—	815	—	1.0
	With door closer			305			1.4
	DIN 18025 (1989)	1500	1500	—	900	—	2.3
	NEN 1814 (1989)	1500	1500	500	850	—	2.3
	Geboden Toegang (1990)	1150	1450	500	850	—	1.7
	Australia AS 1428.1 (1993)	1350	1240	480	760	0	1.7
		(1350)	(1310)	(460)	(850)	(0)	1.8
	Simulation studies, van der Voordt et al. (1993)	1200	900	0	850	0	1.1

	a	b	c	d	e	m²
Walter (1971)	1200 [1970]	1500 [3010]	400 [1120]	800 [800]	300 [1050]	1.8 5.9
Brättgard (1974)	1000 *1100*	1550	—	780	—	1.6 *1.7*
Steinfeld (1979)	1065	—	0	810	—	0.9
ANSI A 117.1 (1986)	1065	—	610	815	—	1.5
with door closer	1220	1500	—	900	—	1.7
DIN 18025 (1989)	1500	—	—	—	—	2.3
NEN 1814 (1989)	—	1600	700	850	—	1.8
Geboden Toegang (1990)	1100	1660	610	760	290	2.1
Australia AS 1428.1 (1993)	1285 (1140)	(1550)	(610)	(850)	(95)	1.8
Simulation studies, van der Voordt et al. (1993)	1100	1200	300	850	0	1.3

Maneuvering space excluding space for approach
999 = required space for opening of doors
(999) = alternative (depending on way of approach)
999 = preferred space for opening of doors
[999] = required space for closing of doors
— = no data available

Table 3.4A. Recommended Minimum Measures for Opening and Closing of Doors, with Door Opening toward the User

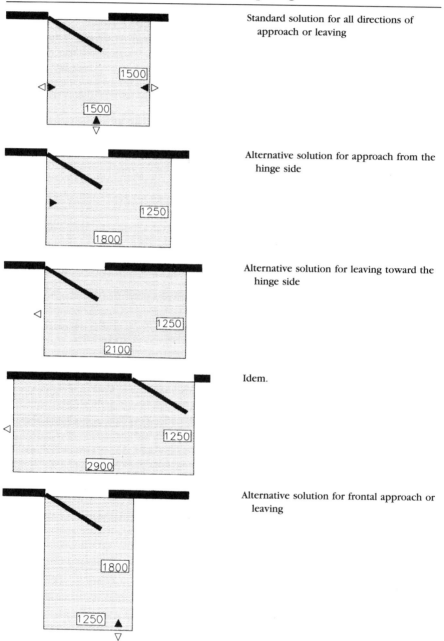

Standard solution for all directions of approach or leaving

Alternative solution for approach from the hinge side

Alternative solution for leaving toward the hinge side

Idem.

Alternative solution for frontal approach or leaving

Table 3.4A. (*Continued*)

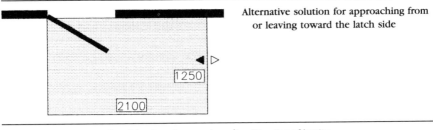

Alternative solution for approaching from or leaving toward the latch side

▶ = Direction of approach ▷ = Direction of leaving

Conditions:
 Wheelchairs propelled manually by the user
 Space between doorframe = 900 mm; clear opening = 850 mm
 No thresholds

worth et al., 1974; see Figure 3.1) might be acceptable in the United Kingdom, in the United States all the fixtures are usually located along one or two walls (as studied by Steinfeld et al., 1979; see Figure 3.2).

• Research methods: the presence of partitions, whether movable or fixed, causes people to "shy away" for fear of bumping into them, which will slightly increase the space required compared to studies with no partitions; another example is the use of controlled laboratory settings as opposed to real life situations.

• Interfering recommendations from research data: Some recommendations were based on minimum dimensions required by 80% of the sample; others were based on the criterion that 95% of the sample should be able to perform the task.

It is urgently recommended that researchers provide clear information on their basic assumptions, research protocols, subjects, equipment, and so on. For reasons of comparability, standards for the description of subjects and wheelchairs are important. The same holds true for research protocols and recommendations inferred from research data. For instance, Ownsworth et al. (1974) were seeking optimal dimensions without regard to economy, while Steinfeld et al. (1979) tried to work from the opposite direction, starting with the norms of conventional practice and identifying minimum changes needed to accommodate most people with disabilities. As a consequence, in the former study subjects were asked to do the task in the way they preferred, while in the latter they were asked to adapt to different environmental conditions. Developing standardized consensus-based protocols could remove this source of bias (just as standard tests do for flame spread or noise transmission).

A second observation concerns the use of the computer. Computer-generated drawings can be used as:

**Table 3.4B. Recommended Minimum Measures for Opening
and Closing of Doors, with Door Opening Away from the User**

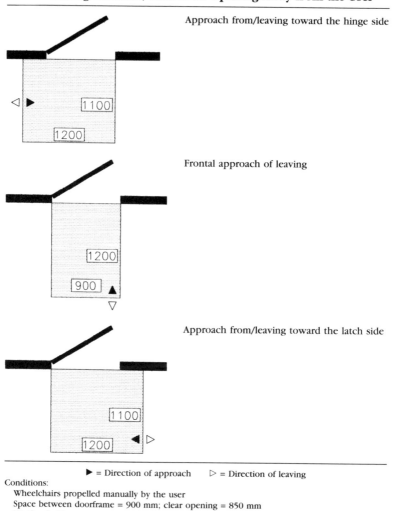

Approach from/leaving toward the hinge side

Frontal approach of leaving

Approach from/leaving toward the latch side

▶ = Direction of approach ▷ = Direction of leaving

Conditions:
 Wheelchairs propelled manually by the user
 Space between doorframe = 900 mm; clear opening = 850 mm
 No thresholds

- A research tool to analyze space requirements, movements, and use of space
- A tool to present research data graphically, taking into account the dynamics of task performance by presenting various subactivities
- A design tool, enabling a designer to include pictures in his design drawings to assess accessibility issues in various design options

It must be emphasized that simulation studies cannot completely replace empirical research, but should be used in combination with literature reviews, experts' opinions, and empirical research in laboratory settings or real life situations. One must have a very clear understanding of how tasks are performed in real life. Simulations can be easily biased by assumptions about the smoothness of movement. In real life, people are used to making a lot of adjustments (e.g., moving back and forth to fit into a small space). They often bump into things but tolerate such an inconvenience, provided that the inconvenience is not too strong and the activity does not need to occur too often. Simulations may exaggerate the minimum space needed if they are based on smooth movements without such adjustments. Another issue is the tolerance that should be added for the distance that people keep between themselves and walls. Simulation studies can, however, reduce the need for costly and time-consuming empirical research in full-scale models. They can be used to compare the influence of different wheelchair sizes on space requirements or the influence of different maneuvering methods. For example, in case of a hinge side approach and a door that opens toward the user, a wheelchair user has two options for opening and moving through the doorway (see Appendix):

- Passing by the door entirely (parallel to the door), turning backward (perpendicular to the door) while opening the door until one is in front of the doorway, moving forward and passing through the doorway
- Turning in front of the closed door, moving backward while opening the door, moving forward and passing through the doorway

The latter option requires less space at the latch side and more in front of the door. When the simulation studies are used to analyze the influence of these variables, field experiments can concentrate on testing design options by people with different disabilities and types of aids.

Recommendations for Future Research

In addition to the need for standardization of research protocols, there is a need for improvement of simulation studies. The disadvantage of the present two-dimensional version is that the projection of movements of the arms and body onto a flat surface is a complex process. The simulations can be improved by using three-dimensional figures. A next step is conversion of a three-dimensional figure into a computerized "robot." This will allow conversion of specific motor handicaps to a spatial model, which, for example, could be applied to measurement studies for individual adaptations of an existing home or workplace.

The review of completed empirical research and the simulation studies have indicated that more data are needed on the following issues:

- Space requirements for use of bedrooms and bathrooms, particularly when supports/hoisting equipment are needed
- Space requirements for people of exceptionally tall or short stature
- Space requirements for people using new types of electric mobility devices (e.g., scooters)
- Space requirements for people with very severe disabilities, for instance, people without hand/arm functions
- Space requirements for opening and closing doors, including measurements on the hinge side and the latch side of the doorway
- Popularity of different transfer techniques and the feasibility of alternatives
- Application of technological innovations and the consequences for the measurement of buildings and outdoor spaces

Knowledge of space requirements for people with different types of disabilities is extremely important when renovating existing housing to be accessible. If adaptability to the level of wheelchair use is not possible at all, one needs to know for which groups of people with disabilities adaptability is still feasible.

Apart from empirical research through full-scale models and movement studies with the use of computer simulations, the study of real life situations (e.g., in adapted or adaptable housing) should not be neglected. Such research will yield invaluable information as to how people with disabilities cope with the reality of available space and appliances.

Finally, it is important to improve the international exchange of knowledge, research data, guidelines, and standards. By establishing international databases, journals, and books such as this one, exchanges of knowledge occur that create not only a better understanding but also a greater consensus and more reliability of both research data and design guidelines or standards.

APPENDIX: MOVEMENT STUDIES

Oblique Transfer, Unassisted

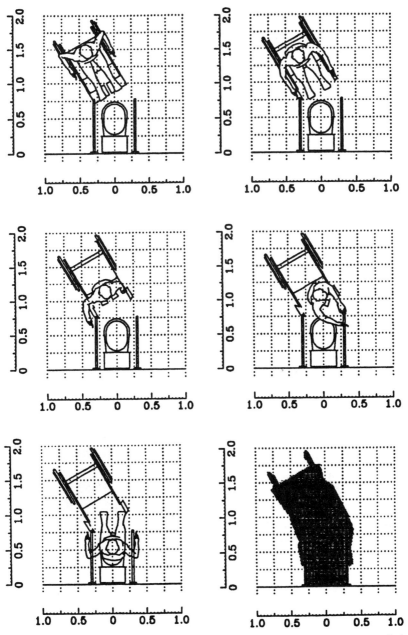

Scale: 1:50

Oblique Transfer, Assisted

Scale: 1:50

Frontal Transfer, Unassisted

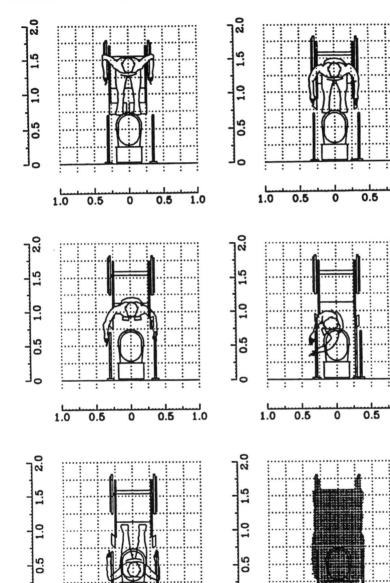

Scale: 1:50
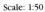

Lateral Shift, Unassisted

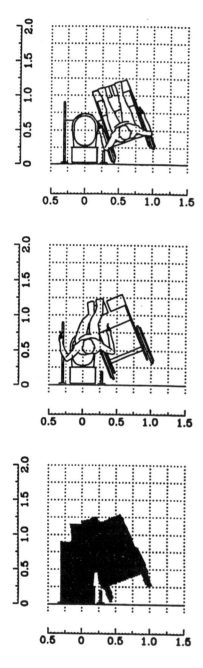

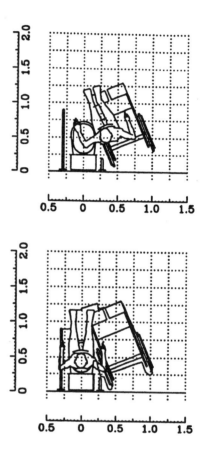

Scale: 1:50

Transfer from Wheel Chair to Shower Seat

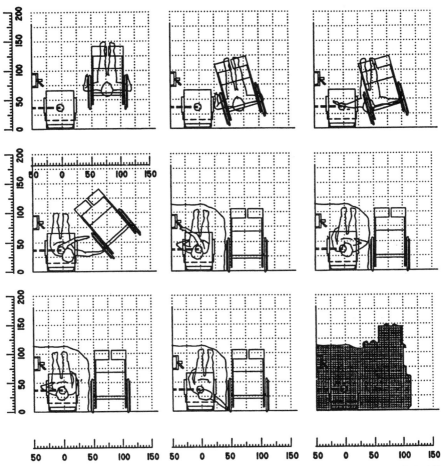

Scale: 1:50

Opening of Door toward the User, Lateral Approach
from the Hinge Side

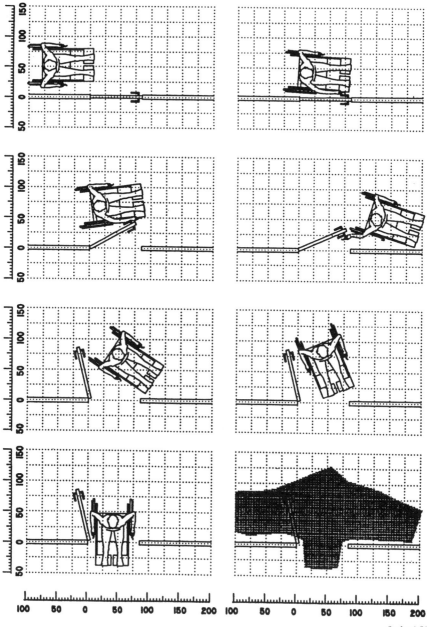

Scale: 1:50

Closing of Door toward the User, Exiting in the Direction of the Hinge Side

Scale: 1:50

REFERENCES AND BIBLIOGRAPHY

American National Standards Institute. (1986). *A117.1, Specifications for making buildings and facilities accessible to, and usable by, physically handicapped people*. New York: Author.

Boekholt, J. T. (1987). *MARIONET*. Eindhoven, The Netherlands: Technical University, Faculty of Architecture.

Brättgard, S. (1974). *Maneuvering space for indoor wheelchairs*. Goteborg, Sweden: University of Goteborg, Department of Handicap Research.

British Department of the Environment. (1992). *Sanitary provision for people with special needs*. Middlesex, England: Author.

CCPT. (1990). *European concept for accessibility*. Rijswijk, The Netherlands: Author.

Deutsches Institut für Normung. (1989). *DIN 18 025: Wohnungen für Menschen mit Behinderungen*. Berlin: Author.

Federatie Nederlandse Gehandicaptenraad. (1993). *Geboden Toegang [Call for Admittance.]* Utrecht, The Netherlands: Author.

Floyd, W. F. (1966). *A study of the space requirements of wheelchair users*, 6(7), 24-37.

Goldsmith, S. (1976). *Designing for the disabled*. London: RIBA Publication.

Groot, J. J. (1988). *Ruimte voor toiletgebruik. [Space Requirements for Use of a Toilet]*. Amsterdam: Gemeenschappelijke Medische Dienst.

Howie, P. M. (1967). A pilot study of disabled housewives in their kitchens. London: Disabled Living Foundation.

McLelland, I. (1972). *Bath aids for the disabled*. Loughborough, UK: University of Technology, Institute for Consumer Ergonomics.

Nederlands Normalisatie Instituut. (1989). *NEN 1814, Toegankelijkheid van gebouwen en buitenruimten [Dutch Standard on Accessible Buildings and Outdoor Areas]*. Delft, The Netherlands: Author.

Nichols, P. J. R., Morgan, R. W., & Goble, R. E. A. (1966). Wheelchair-users. A study in variation of disability. *Ergonomics*, 9(2), 131-139.

Ownsworth, A., & Feeney, R. J. (1973). *Housing for the disabled. Part 1, An ergonomic study of the space requirements of wheelchair users for doorways and corridors*. Loughborough, UK: University of Technology, Institute for Consumer Ergonomics.

Ownsworth, A., Galer, M., & Feeney, R. J. (1974). *Housing for the disabled. Part 2. An ergonomic study of the space requirements of wheelchair users for bathrooms*. Loughborough, UK: University of Technology, Institute for Consumer Ergonomics.

Rapoport, A., & Watson, N. (1972). Cultural variability in physical standards. In A. Gutman (Ed.), *People and building*. New York: Basic Books.

Standards Association of Australia. (1993). *AS 1428.1-1993: Design for access and mobility*. New South Wales, Australia: Author.

Steinfeld, E., Schroeder, S., & Bishop, M. (1979). *Accessible buildings for people with walking and reaching limitations*. Washington, DC: U.S. Department of Housing and Urban Development.

Steinfeld, E. (1986). *Hands on architecture. Vol. 3, Executive summary and recommended design guidelines*. Washington, DC: U.S. Architectural and Transportation Barriers Compliance Board.

Stichting Fokus (1976). *Toegankelijke gebouwen en bruikbare woningen [Accessible Buildings and Usable Hosues]*. Fokusreeks no. 2. Ten Boer, The Netherlands: Author.

Voordt, D. J. M. van der. (1990). Building adaptable housing: From theory to practice. *Architecture and Behaviour*, 6(1), 257-269.

Voordt, D. J. M. van der. (1992). Design for all—building adaptable housing. In M. Aristides & K. Cleopatra (Eds.), *Metamorphoses, Proceedings of IAPS 12*. Marmaras, Greece: University of Thessloniki. Aristotle.

Voordt, D. J. M. van der, Jong, G. E. de, Drenth, J. G., Nolte, E. A. H., & Sanders, L. (1993). *Ruimte voor toegankelijkheid [Space Requirements for Accessibility]*. Delft, The Netherlands: Technical University, Faculty of Architecture.

Walter, F. (1971). *Four architectural movement studies for the wheelchair and ambulant disabled*. London: Disabled Living Foundation.

Werkgroep Bouwen voor Iedereen. (1979). *Gebruik van hellingbanen [Use of Ramps]*. Delft, The Netherlands: Technical University, Faculty of Architecture.

Werkgroep Bouwen voor Iedereen. (1983). *Interimrapport deurenonderzoek [Use of Doors]*. Delft, The Netherlands: Technical University, Faculty of Architecture.

Wijk, M. (1992). *Integrale toegankelijkheid van bestaande rijkshuisvesting [Integral Accessibility of Governmental Buildings]*. Dordrecht, The Netherlands: EGM Onderzoek.

II

RELIABILITY AND VALIDITY

Reliability and validity are the *sine qua non* of measurement. To be reliable, a measure must produce consistent results; to be valid, it must measure what it is meant to measure. Without reliability and validity, a measure's data are useless.

Reliability is connected to the accuracy of the measure. If the measure lacks precision or is otherwise inconsistent in what it records, it is not reliable. "[T]he consistency of the responses [also] provides some limited measure of validity … [t]he less consistent, the less likely the validity" (Robinson, Baer, Banerjee, & Flachsbart, 1975, p. 112).

Issues of validity are typically broken down into two types: internal and external. A measure whose results can be explained away as an artifact of the way the measurement was performed lacks internal validity. A measure whose results are not generalizable to situations other than those in which the measurement was performed lacks external validity (Webb, Campbell, Schwartz, & Sechrest, 1972). Without internal validity, concern about a measure's external validity becomes a moot point. And of course, without reliability, all questions about a measure's validity become pretty much academic.

Measurement of the environment's influence on the disablement process is far too critical a matter to pursue without concern for methodological rigor. Especially in light of the approaching "age wave" associated with the graying of the "baby boom" generation (Dychtwald & Flower, 1989), we can expect that the reliable and valid measurement of the environment's influences on the disablement process will become a matter of some urgency. Without an accurate understanding of the environment's influence on the lives of people with impairments, society faces the very real possibility of being overwhelmed by the sheer magnitude of the incoming age wave (Danford & Steinfeld, 1997). The chapters in this part address issues of reliable and valid measurement. They demonstrate, in several contexts, how such measurements can be ensured.

Chapter 4 by Iwarsson and Isacsson focuses on the need within health care services for functional assessment measures that acknowledge the role of envi-

ronment on the functional abilities of an impaired person. The authors report two studies on one such measure, the Swedish revision to "The Enabler." These studies provide data on the interrater reliability of this instrument that are sufficient to warrant their recommending its use not only for research but also in clinical settings.

Chapter 5 by Danford and Steinfeld introduces three instruments they designed to be used in various combinations to measure both perceptual and behavioral dimensions of "transactions" between people with impairments and their physical environments. The authors present data on the reliability and validity of these measures that demonstrate their utility not only to diagnose the adequacy of such transactions but also to prescribe remedial, individualized, and appropriately accommodating environmental design interventions when required.

Chapter 6 by Lantrip defines environments that constrain or otherwise interfere with the physical performance of desired activities by their inhabitants as "handicapping." The ISOKIN measures that he developed are general, computer-based methods for identifying constraints and interferences. Lantrip first discusses both theoretical and methodological issues in the ISOKIN measures and then illustrates their application. Data are provided to show how computer analysis allows complex interactions between inhabitants and environment to be not only visualized but also quantified, thereby providing an unambiguous and replicable tool for measuring how environments influence the behavioral performance of people both with and without physical impairments.

Chapter 7 by Norris-Baker, Weisman, Lawton, Sloane, and Kaup, reports on the development of the Professional Environmental Assessment Protocol and its use in evaluating 20 special care units for people with Alzheimer's disease and related dementias. The reported measure evaluates such settings on eight dimensions of "the environment as experienced" — encompassing not only the physical environment but also the philosophy of care and program, level of resident capability, constraints of regulations and budget, and other organizational, policy, and social contexts. Data are presented to indicate that this measure can be used reliably to examine the therapeutic potential of the environmental milieu for people with dementia by trained raters who have some level of sophistication in person–environment concepts and long-term care.

Chapter 8, the final chapter in this part, by Sanford and Megrew, demonstrates the importance of developing reliable and valid measures for assessing current code requirements for the design of environments for people with impairments. The authors present the methodology and findings of a research study that evaluated current code requirements for the design of grab bars and demonstrated their ineffectiveness and/or unnecessary restrictiveness in attempting to help older people maintain independent use of toilets. Moreover, the authors demonstrate the utility of such an assessment methodology for changing and improving existing codes and design norms.

REFERENCES

Danford, G., & Steinfeld, E. (1997). Environmental design: Enabling technology for an aging society. In G. Gutman (Ed.), *Technology innovation for an aging society: Blending research, public and private sectors* (pp. 83–110). Ottawa, Canada: Division of Aging and Seniors, Health Canada.

Dychtwald, K., & Flower, J. (1989). *Age wave: The challenges and opportunities of an aging America*. Los Angeles: Tarcher.

Robinson, I., Baer, W., Banerjee, T., & Flachsbart, P. (1975). Trade-off games. In Michelson (Ed.), *Behavioral research methods in environmental design* (pp. 79–118). Stroudsburg, PA: Hutchinson Ross.

Webb, E., Campbell, D., Schwartz, R., & Sechrest, L. (1972). *Unobtrusive measures: Nonreactive research in the social sciences*. Chicago: Rand McNally.

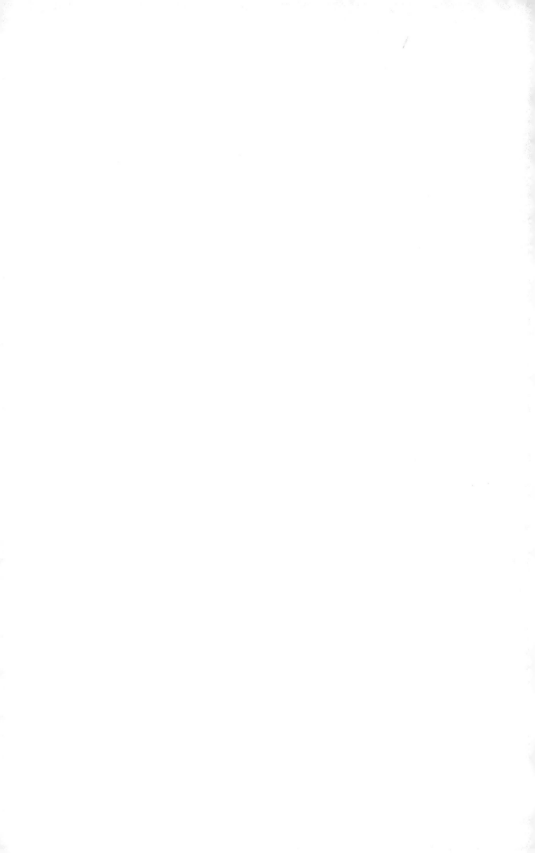

4

"The Enabler" Applied to Occupational Therapy
Reliability of a Usability Rating Scale

Susanne Iwarsson and Åke Isacsson

INTRODUCTION

Within the health care services, functional assessments covering different aspects of a client's situation are essential. These assessments should not only include the individual's intrinsic factors, for example, diagnosis, biological and behavioral aspects, and aspects of care, but should also consider environmental factors (Kane, 1993). To understand performance problems it is important to give equal attention to person and to environment. Disabilities and handicaps occur because of gaps between the individual and the environment and are not inherent in the person (Verbrugge & Jette, 1994).

Occupational therapists have, through their experiences from work with the provision of assistive devices and the planning of housing adaptations (Iwarsson & Isaacson, 1993; Parker & Thorslund, 1991), practical knowledge of the fact that details in the physical environment are crucial to promote everyday activity for impaired individuals (Lawton, 1980). To reduce disability and handicap, assessment of the physical environment of housing and its close surround-

Susanne Iwarsson and Åke Isacsson • Department of Clinical Neuroscience, Division of Occupational Therapy, P. O. Box 157, S-22100 Lund, Sweden.

Enabling Environments: Measuring the Impact of Environment on Disability and Rehabilitation, edited by Edward Steinfeld and G. Scott Danford. Kluwer Academic/Plenum Publishers. 1999.

ings in relation to the functional abilities of the individual is essential. Usually, different home evaluation and home safety checklists are used for environmental assessments. Only a few of the environmental assessment instruments available have been developed as applications of theory, and many have not undergone psychometric testing or scientific review (Cooper, Cohen, & Hasselkus, 1991; Letts et al., 1994). Development of more objective guidelines are required to improve occupational therapists' home assessments (Clemson, Roland, & Cumming, 1992).

"The Enabler" (Steinfeld et al., 1979) was originally published as an ideogram, with the aim of making a problem analysis possible by focusing on what impact environmental barriers have on people with various functional limitations/ dependence on assistive devices for mobility. It consisted of two separate parts that, when combined, conceptualized the degree of accessibility of a certain physical environment in relation to a certain individual. The major issues for access to buildings were summarized by juxtaposing environmental barriers against the functional abilities of an individual. In the first part, 15 different functional limitations/dependence on assistive devices for mobility that should be considered in design were defined, as concerns of mental functioning, the senses, internal body regulation, and motor impairment (Figure 4.1). In the second part, 13 matrices listed different environmental barriers which might be problems to users of buildings and facilities. The matrices concerned different aspects of buildings: outdoor circulation paths, parking, curb ramps and intersections, built-in landscape furniture, entrances, exits and doorways, interior

A	Difficulty interpreting information
B1	Severe loss of sight
B2	Complete loss of sight
C	Severe loss of hearing
D	Prevalence of poor balance
E	Incoordination
F	Limitations of stamina
G	Difficulty in moving head
H	Difficulty in reaching with arms
I	Difficulty in handling and fingering
J	Loss of upper extremity skills
K	Difficulty bending, kneeling, etc.
L	Reliance on wlking aids
M	Inability to use lower extremities
N	Extremes of size and weight

Figure 4.1. The functional limitations/dependence on assistive devices for mobility as defined in the original "Enabler" (Steinfeld et al., 1979, p. 75).

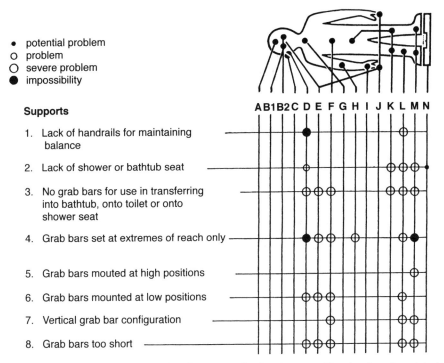

Figure 4.2. Example of a problem identification matrix of environmental barriers from the original "Enabler" (Steinfeld et al., 1979, p. 89).

circulation paths, vertical circulation, storage and work surfaces, space clearances, supports, controls and operable hardware, plumbing fixtures, and communications. The accessibility problems thus identified were, based on current knowledge and expertise, coded as: potential problem, problem, severe problem or impossibility (Figure 4.2).

The instrument had not been further developed by occupational therapists (B. A. Cooper, personal communication, Oct. 13, 1992). Our purpose was to introduce and develop "The Enabler" into a useful and reliable instrument for assessment of the physical environment of housing and its close surroundings.

METHODS

Procedure

"The Enabler" was translated into Swedish and supplemented by a form containing data on the individual and the current type of housing. The first part of

the instrument, on functional limitations/dependence on assistive devices for mobility of the individual, was supplemented with more accurate definitions. As in the original version (Steinfeld et al., 1979), this section included 15 different functional limitations/dependence on assistive devices for mobility items (Figure 4.1).

Some of the environmental barriers listed in the 13 matrices of the original ideogram focused on public areas of buildings. Since our purpose was to develop an instrument for home evaluation, we excluded the environmental barriers that were not relevant. Changes were made in the order of the conditions listed to follow the procedure of a site visit by an occupational therapist, divided into four subparts: outdoor conditions, entrances, indoor conditions, and communication. The revised instrument comprised 144 different environmental barriers. For precise definitions of environmental barriers, there was a reference to norms for accessible housing that was well known and commonly used by Swedish occupational therapists (Handikappinstitutet, 1989). We also assigned scores, 1–4, to the problem codings of the original matrices: (1) potential problem, (2) problem, (3) severe problem, or (4) impossibility (Figure 4.3). These scores made it possible to calculate a total score of "predictive physical environmental demand" as a global result of the assessment.

The assessment was to be administered in three steps, described in an infor-

First mark the functional limitations and dependence on assistive devices for mobility in the individual (Figure 4.1) that have been observed. Then copy the crosses to all the rating forms for environmental barriers.

A. OUTDOOR ENVIRONMENT General	A	B1	B2	C	D	E	F	G	H	I	J	K	L	M	N	
1. Narrow paths (less than 1.3m).						3	3							3	3	1
✗ Irregular walking surface (includes irregular joins, sloping sections, etc.).		2	3			(1)	1		3				(3)	3		
3. Unstable walking surface (loose gravel, sand, clay, etc.).		2	3			3	3	2					3	4		

Mark the observed environmental barriers with a cross. Then put a circle around the scores (1 - 4) in the squares at the intersections of functional limitations and environmental barriers. The total of the scores is a measure of the degree of accessibility problems.

Legend to scores: 1) potential problem
2) problem
3) severe problem
4) impossibility

Figure 4.3. Example of a problem identification matrix of environmental barriers from the Swedish revised version of "The Enabler" (Iwarsson, 1995, p. 17) retranslated into English, including legends to the three-step administration procedure.

mation sheet with instructions. In the first step, the individual was examined/interyiewed to analyze if any of the 15 functional limitations/dependence on assistive devices for mobility, A–N, listed in the instrument were present. The letters representing the limitations identified were then marked on each environmental barriers matrix. Second, the home environment and its close surroundings were examined. The environmental barriers found were marked on the matrices. In the third step, the functional limitations/dependence on assistive devices for mobility found were juxtaposed against the environmental barriers marked as present, and the predefined scores 1–4 found at intersections in the matrices were marked. Finally, these scores were added into a total "predictive physical environmental demand" score (Figure 4.3).

If the individual does not have any functional limitations and is not dependent on assistive devices for mobility, the score is 0. Consequently, the maximum score obtainable is different for each individual, since it depends on the number of functional limitations/dependence on assistive devices for mobility found. Scores may theoretically range from 0 to above 900 points, but a maximum score is not likely to occur since it would indicate an individual with all of the 15 functional limitations/dependence on assistive devices for mobility present and an unbelievably extreme environment, overloaded with all the barriers described in the matrices. In practice, the part assessing environmental barriers could be used separately, defining only the obstacles and the nature of the obstacle, to underlie decisions for compensatory interventions.

First Study—First Version of "The Enabler"

The first version of the revised instrument and a questionnaire were distributed to 10 occupational therapists in one Swedish primary health care district, with the purpose of testing the instrument in practice. We asked each of them to use it when assessing a patient's home for accessibility, fill in the matrices, and return them. In the questionnaire we asked for their comments on various aspects of the instrument and their interpretations of specific terms used, leading us to make further revisions increasing face and content validity of the instrument.

We then asked another 16 occupational therapists from the same primary health care district to use only the part of environmental barriers for assessment of the same building. The house assessed was an old, but recently renovated, one-family private house in the Swedish countryside. The raters were given a short verbal introduction to the administration procedure in advance. Their assessments were conducted simultaneously but independently and took approximately 1 hr to complete.

As the next step, "The Enabler" was distributed to occupational therapists in different primary health care districts all over Sweden. They were asked to use the complete instrument in a real clinical situation for an assessment of acces-

sibility in a patient's home, as part of an ordinary site visit. To test the interrater reliability of the instrument, they asked a colleague to use it to assess the same patient and environment as soon as possible after the first visit.

Twenty of the therapists asked had patients available and were able to participate in the study along with a colleague. In all, 26 patients of different ages and with different diagnoses were assessed in their home environments by two independent raters. The total number of raters was 40.

Second Study—Second Version of "The Enabler"

The first Swedish version of "The Enabler" was revised, taking into consideration the experiences from the first study. The definitions of the 15 functional limitations/dependence on assistive devices for mobility items were revised to make them even more precise. The environmental barriers items were examined as well, since some items were found irrelevant and others needed to be re-defined. A detailed analysis of the items with less agreement between the two raters of each patient showed that several of them had "mixed" definitions, that is, several aspects were defined within the same item, or several other items were much alike. The raters of the first study had also identified additional environmental barriers that they suggested should be added to the instrument, for example, items concerning the accessibility of terraces/balconies. Several groups of items, for example, an assessment of stairs that occurred only once in the first version of the instrument, had to be repeated for several parts of a building. After the revisions described, we counted 188 environmental barriers items, 105 identical to the environmental barriers items of the first version. Exact definitions from the Swedish norms for accessible housing (Handikappinstitutet, 1989) were transferred into the matrices, since the raters of the pilot study had found it difficult to define the environmental barriers by heart or by use of the referred book. Limits for measurements and definitions were either written in the matrices or were page-referenced to the book given (Handikappinstitutet, 1989) (Figure 4.3). We wrote a manual as well, adapted to recent Swedish building legislation, to standardize the administration procedure (Iwarsson, 1995). The purpose of the second study was to further develop and test "The Enabler."

The sample of raters of the second study were 32 experienced occupational therapists undergoing postgraduate training. The group of raters was pretaught during four lessons. They were taught generally about the development and use of instruments for assessment and specifically on the use of "The Enabler." Since two of the occupational therapists were absent when the group of raters was taught, we were left with a sample of 30 raters.

The raters were asked to choose one case each from their current records of patients. Patients lived in ordinary housing, were of the age of 20 or older, and had come up for occupational therapy treatment during the last 12 months ($n = 30$). The patients represented a wide range of diagnoses, since evidence of instrument

reliability must be demonstrated for different populations for which the test will be used (Deitz, Tovar, Thorn, & Beeman, 1990). Excluded were demented patients, patients mentally retarded, and those terminally ill or entirely bed-ridden.

Data Collection. The 30 patients enrolled were assessed in their homes independently by pairs of raters, using the second Swedish revised version of "The Enabler" (Iwarsson, 1995).

Data Analysis

Functional Limitations/Dependence on Assistive Devices for Mobility. Agreement between the two raters of the same patient concerning functional limitations/dependence on assistive devices for mobility was examined. The simplest approach to assessing interrater reliability is simply to observe the proportion of exact agreements between raters and calculate percent agreement. A major weakness of this approach is that some amount of the observed agreement is due to chance. However, the kappa statistic is a strict measure of reliability that corrects for agreement between raters due to chance. It is calculated as follows:

$$\kappa = (p_0 - p_c)/(1 - p_c)$$

Kappa has a maximum of 1.00 when agreement is perfect; a value of 0 indicates no agreement better than chance. Negative values indicate worse than chance agreement (Altman, 1991; Bartko & Carpenter, 1976; Cohen, 1960). We evaluated interrater reliability by the use of kappa, κ. Mean kappa values, κ, were calculated for groups of items. The values obtained were interpreted following the guidelines of Altman (1991): κ values between 0.81 and 1.00 indicated very good agreement, between 0.61 and 0.80 good, 0.41 and 0.60 moderate, while values between 0.21 and 0.40 indicated fair agreement and below 0.20 was poor. κ values generated from different populations are not comparable (Svensson, 1993), so it is not possible to calculate if changes in results between different studies are significant.

Environmental Barriers. For the first study, agreement between the 16 raters was examined by comparisons concerning which environmental barriers they had marked or not marked during their assessments. We decided to consider agreement on a certain barrier to be acceptable when 13 raters, that is, 80% agreed on the assessment.

For the succeeding parts of the study, agreement between the two raters of the same patient's environment was evaluated using kappa statistics, following the same procedure described earlier. Mean kappa values, κ, were calculated for the whole group of environmental barriers as well as for each of its subsections.

Scores. For each rater and each patient total scores were calculated following the earlier described scoring procedure (Figure 4.3). Total median score differences and ranges of differences were calculated between the two total scores obtained for each patient/environment assessed by two raters. These calculations were also performed for subsets of data. To visualize the degree of agreement between raters, data were plotted against the line of identity (Altman, 1991; Altman & Bland, 1983; Bartko & Carpenter, 1976).

RESULTS

Functional Limitations/Dependence on Assistive Devices for Mobility

First Study

In 9 of the 26 cases the two raters assessing the same patient and environment agreed totally on the functional limitations/dependence on assistive devices for mobility of the individual. In the rest of the cases the raters disagreed on 1–4 items, median value (Md) = 1. In 11 of the 17 cases with differences the first rater identified more functional limitations/dependence on assistive devices for mobility in the individual than did the second rater.

Mean kappa for the 15 functional limitations/dependence on assistive devices for mobility items was $\kappa = 0.76$ (Table 4.1), indicating good agreement. A detailed analysis of the individual κ values indicated that agreement was very good for 6 of the items, good for 7 and fair for 1. For the item "complete loss of sight," κ was indefinable, since no patient assessed was blind.

Second Study

In 16 of the 30 cases the two raters assessing the same patient and environment agreed totally on the functional limitations/dependence on assistive devices for mobility of the individual. In the rest of the cases the raters disagreed on 1–4 items, Md = 1.

Mean kappa for the functional limitations/dependence on assistive devices for mobility items was $\kappa = 0.87$, indicating very good agreement (Table 4.1). A detailed analysis of the individual κ values indicated that agreement was very good for 11 of the items and good for 3. As in the first study, for the item "complete loss of sight," κ was indefinable. The results of the second study have been reported in detail elsewhere (Iwarsson & Isacsson, 1996).

Mean kappa for this section was 0.76 in the first study and 0.87 in the second (Table 4.1), that is, agreement was good or very good, respectively. For 12 of the 15 separate items, the κ values of the second study were higher.

Table 4.1. Mean Kappa Values, κ, Measuring Interrater Agreement
Concerning Functional Limitations/Dependence on Assistive Devices
for Mobility in the Individual and Environmental Barriers in the Home[a]

Items	Number of definable kappa	Mean kappa, κ
First study; n n = 26		
Environmental barriers; n = 144	130	0.55
Outdoor; n = 33	31	0.54
Entrance; n = 49	39	0.57
Indoor; n = 100	57	0.56
Communication; n = 6	3	0.12
Functional limitations/dependence on assistive devices for mobility; n = 15	14	0.76
Second study; n = 30		
Environmental barriers; n = 188	173	0.68
Outdoor	32	0.69
Entrance	43	0.74
Indoor	92	0.60
Communication	6	0.68
Functional limitations/dependence on assistive devices for mobility; n = 15	14	0.87

Environmental Barriers

First Study

For assessment of the same building (n = 16), the raters found "The Enabler" possible to use, but stated that its construction was so uncommon that it demanded much concentration and practice to be "handy."

The number of observed environmental barriers marked by each rater ranged from 26 to 53, Md = 44. The 16 raters agreed totally on 66 of the 144 (46%) environmental barriers assessed. For the rest of the items the degree of agreement varied (Table 4.2). Items of the subsection "entrances" showed the greatest part of the total items (88%) at a level of acceptable agreement, as defined earlier.

For assessment of 26 patients/environments in pairs of raters, the mean kappa for the 144 environmental barriers items was κ = 0.55 (Table 4.1), indicating moderate agreement. For 14 of the 144 items κ was indefinable since none of the 40 raters had marked any of them as present. A detailed analysis of the individual κ values defined indicated that agreement was very good to good for 48% of the items, good to moderate for 34%, and poor for 18%.

In none of the 26 cases did the two raters of the same patient agree totally on the environmental barriers observed. The raters disagreed on 1–39 items, Md = 14.

**Table 4.2. Degree of Agreement on 144 Environmental
Barriers among 16 Raters, Expressed as Distribution of Answers**

Distribution of answers among raters[a]	Environmental barrier items			
	Outdoor ($n = 32$)	Entrances ($n = 41$)	Indoor ($n = 65$)	Communication ($n = 6$)
16–0	14	26	22	4
15–1	2	4	10	0
14–2	2	4	6	0
13–3	3	2	6	0
12–4	1	1	8	0
11–5	1	0	4	0
10–6	3	1	5	1
9–7	5	3	3	0
8–8	1	0	1	1

[a]16–0, maximum agreement between raters on answers "yes" or "no"; 8–8, minimum agreement between raters on answers "yes" or "no."

Second Study

Mean kappa for the environmental barriers items was $\kappa = 0.68$ (Table 4.1), indicating good reliability. The κ values for the individual items indicated that agreement was very good to good for 59% of the items, moderate for 20%, fair for 4%, and poor for 9%. Details have been reported elsewhere (Iwarsson & Isacsson, 1996).

Mean kappa for this section was 0.55 in the first study and 0.68 in the second (Table 4.1), that is, agreement was moderate in the first study and good in the second. For 56% of the 105 environmental barrier items that were identical in both studies, the individual κ values were higher in the second study. One item, "Location of grab bars obstructs use of equipment or fixture or circulation around it," remained undefined in both materials because no rater had identified it.

In the first study 3 of the items of the subsection "communication" remained undefined, and $\kappa = 0.12$ for the 3 items defined. In the second study all the items were defined, generating a κ value of 0.68, that is, agreement was good (Table 4.1).

Scores

First Study

Among the 26 cases, sample A1, the highest individual "predictive physical environmental demand score" obtained was 432 points, and the lowest was 5 points. The total scores of the 26 assessments differed between the two raters of

**Table 4.3. Total Score
Differences between Raters**

Sample[a]	Median difference	Range of differences
First study		
A1	36	3-159
B1	29	4-70
C1	40	3-159
Second study		
A2	24	1-172
B2	13	1-70
C2	76	9-172

[a]A1: $n = 30$, all raters. B1: $n = 16$, the raters in complete agreement on functional limitations of the individual. C1: $n = 14$, the raters not in complete agreement on functional limitations of the individual. A2: $n = 30$, all raters. B2: $n = 16$, the raters in complete agreement on functional limitations/dependence on assistive devices for mobility of the individual. C2: $n = 14$, the raters not in complete agreement on functional limitations/dependence on assistive devices for mobility of the individual.

each patient, with a median of 36 points (Table 4.3). The degree of agreement concerning total scores between raters is illustrated in Figure 4.4.

Second Study

Among the 30 assessments the highest individual "predictive physical environmental demand score" obtained was 606 points, and the lowest was 44 points. The total scores of the 30 assessments differed among the two raters of each patient with a median of 24 points. For the 16 raters who agreed completely on the functional limitations of the individual assessed, sample A2, the median difference was 13 points (Table 4.3). The degree of agreement concerning total scores between raters is illustrated in Figure 4.4.

This study was conducted under real clinical circumstances, with many raters involved. The results demonstrate that "The Enabler" is a useful and reliable tool. Many instruments tested yield reliable results only under very special test circumstances, and occupational therapists often afterwards adjust instruments to fit clinical reality (Managh & Cook, 1993). Thus it is important to test instruments in real, not idealized, situations.

Since the instrument is descriptive and evaluative, one of the most important types of reliability to be tested is interrater reliability (Law, 1987). Further revisions of the Swedish version of "The Enabler" and training of occupational therapy raters resulted in increased agreement compared with previous results.

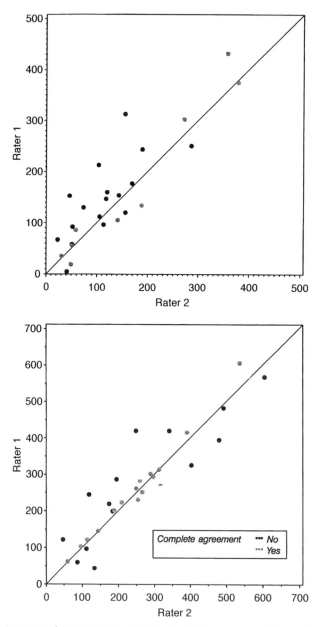

Figure 4.4. Agreement between raters, total scores (first study: sample A1, $n = 26$; second study: sample A2, $n = 30$).

For the second revised version of the instrument, it was very good to good, using Altman's (1991) strict interpretation of κ values.

Kappa, a strict measure preferable for gauging agreement, has been recommended for use for reliability analyses in therapeutic research (Ottenbacher & Tomchek, 1993). After reanalysis of a sample of already published data using κ instead of the common percentage agreement method, the results showed that 50%–75% of the data would have been judged as having unacceptably low reliability (Suen & Lee, 1989). In our first study, the percentage agreement concerning judgment of functional limitations/dependence on assistive devices for mobility, $n = 26$, was 93%, but κ = 0.76.

In studies similar to this (Hamilton, Laughlin, Fiedler, & Granger, 1994) computations of intraclass correlation coefficients (ICC) between the total scores of two raters have been frequently used to establish reliability. ICC give an estimation of the level of association between raters, but because "The Enabler" scores were generated from nominal and ordinal data, the use of the ICC is questionable (Bartko & Carpenter, 1976). Illustrating agreement between raters by plotting data against the line of identity gives a good visual assessment of the relationship (Altman, 1991; Altman & Bland, 1983; Bartko & Carpenter, 1976). Agreement between the two raters of each case concerning total scores appeared visually higher in the second study (Figure 4.1). This was true especially among the raters who agreed completely on the impairments in the individuals assessed. ICC also increased from 0.86 in the first study to 0.92 in the second.

The reduction of data to a single number obtained after statistical analysis always requires an examination of frequencies. Many different agreement patterns among raters will yield similar values of κ (Altman, 1991). A very important result from the first study, not affecting statistical reliability, was that raters did not reach consensus in assessing functional limitations/dependence on assistive devices for mobility in an individual, or in assessing environmental barriers. This may not be due to weaknesses of the instrument only; it is also a serious problem connected with the question of competence among occupational therapists and the validity of their clinical judgments. We were surprised that the raters agreed in only 9 of the 26 cases of the first study, on the functional limitations/dependence on assistive devices for mobility of the individual. The fact that the results indicated that first raters defined more functional limitations/dependence on assistive devices for mobility than did second raters was unexpected, leading to several possible explanations. It could be connected to the question of "patient responsibility," that is, if the occupational therapist actually responsible for treatment performed a more thorough assessment. Another reason might be that first raters had prior knowledge of their patients, even if a formal home assessment had not been performed. An item that caused some confusion among raters was "Inability to use lower extremities, i.e., dependency on a wheelchair for mobility" since some individuals could use lower extremities in one part of the environment but not in another. It is common for patients to use a wheelchair for

outdoor transportation, but not indoors. When calculating total scores, compensations must be made for this difference. Solutions were presented in the manual for the instrument (Iwarsson, 1995), but all raters might not have paid enough attention to it. Some of the differences of judgments between raters might be connected with the actual situation of assessment. In our revised version of the instrument, the data-gathering process was a combination of interview and observation. It is common for occupational therapists to use both methods simultaneously during a clinical assessment, which we recommended for the use of "The Enabler," striving for a realistic, not idealized, situation. There are always problems connected with self-reporting through interviews, and observations of performance are preferable (Guralnik, Branch, Cummings, & Curb, 1989).

An important condition to be met during assessment using "The Enabler" is that judgment of functional limitations/dependence on assistive devices for mobility must be correct. The total score ends up arbitrary if it is not, which explains some of the differences among resulting total scores (Figure 4.4; Table 4.3). In the second study the definitions in the manual were improved and the raters were taught in advance to adhere strictly to them. There were relatively more raters in complete agreement on the functional limitations of the individuals in the second study than in the first one, 16 out of 30.

The functional limitations/dependence on assistive devices for mobility section of "The Enabler" is an easy and quick way to administer a reliable, although coarse, descriptive assessment of an individual, especially appropriate for occupational therapy services in primary health care. When more detailed, graded information on functional limitations/dependence on assistive devices for mobility is warranted, another instrument should be used.

We learned that when assessing environmental barriers, the rater has to be very accurate and familiar with the existing norms and definitions. Most occupational therapists are familiar with the assessment of entrances and indoor conditions, but are perhaps less accustomed to performing assessments of lighting conditions and tactile warnings for visually impaired individuals, which may explain some of the results of the first study (Table 4.2). Development of more objective guidelines are required to improve occupational therapists' home assessments (Clemson et al., 1992), and the introduction and development of "The Enabler" was an important step toward ensuring the quality of analyses underlying clinical decisions in primary health care occupational therapy services.

If the instrument is used in clinical practice as a descriptive tool, underlying decisions for treatment, scores do not matter. Since two patients could end up with similar scores, generated by totally different patterns of difficulties, the therapist always has to examine the results, item for item (Law & Letts, 1989). If used for evaluation or for research purposes, scores are useful for a global rating of accessibility.

Face and content validity of the Swedish occupational therapy version of

"The Enabler" (Iwarsson, 1995) has been increased after the second revision, since several environmental barriers items have been added according to the experiences of the former raters. In evaluative measures, one important construct is that the instrument is sensitive to changes in the cases assessed (Law & Letts, 1989). This is obvious within "The Enabler," since the total scores will decrease if one functional limitation or environmental barrier item is no longer found. If an individual does not have any of the functional limitations, the total score will be 0. The validity of an instrument can only be estimated, not directly measured. Establishing validity is an ongoing process, never accomplished by a few research studies (Law, 1987).

Health care perspectives and the knowledge of specific diseases and disabilities of lifespan development and how these processes influence function and activity are important knowledge needs for the multidisciplinary team (Cooper et al., 1991). Both medical and technical competence is required to be able to make correct judgments. In a previous study, we found that there were communication problems between occupational therapists and other actors in the building process (Iwarsson & Isacsson, 1993). Perhaps one reason for this was that different occupational therapists had different opinions on problems connected with barrier-free design, resulting in misunderstandings. We suggest that validity issues need to be discussed when preparing active participation in the building process. The differences are serious matters of quality among occupational therapists' clinical judgments, and the lack of a clearly defined conceptual base presents a primary obstacle to further professional development (Cooper et al., 1991).

Environmental aspects have to be emphasized when discussing the issue of disablement. The person-centered perspective persists strongly in medical science, often neglecting the demanding features of the environment that are influencing the capacity of the individual. The importance and measurement of environmental demand, independent from the individual, needs to be considered (Verbrugge & Jette, 1994; Wade, 1994). "Person–environment fit" models, such as the Docility Hypothesis (Lawton, 1980), help researchers and clinicians view disability and handicaps as relationships to environments, instead of personal characteristics (Verbrugge & Jette, 1994). The structure of "The Enabler" is congruent with such a perspective, since the assessment of environmental barriers is performed generally. It is very useful when defining the demands inherent in the physical environment of housing and its close surroundings. The relationship with the individual's functional limitations/dependence on assistive devices for mobility is performed afterwards as a separate step. The assessment gives important information on the conditions in which an individual can be independent or dependent in a specific physical environment.

In conclusion, "The Enabler" is congruent with a functional orientation in assessment. It is useful for the assessment of physical aspects of housing and its close surroundings and could identify some of the conditions in which an

individual can and cannot be independent in a specific physical environment. "The Enabler" was found to be very useful, and the Swedish revised version is a reliable tool, not only for research but also for use in real clinical circumstances.

REFERENCES

Altman, D. G. (1991). *Practical statistics for medical research*. London: Chapman & Hall.

Altman, D. G., & Bland, J. M. (1983). Measurement in medicine: The analysis of method comparison studies. *Statist, 32*, 307–317.

Bartko, J. J., & Carpenter, W. T. (1976). On the methods and theory of reliability. *Journal of Nervous and Mental Disease, 163*(5), 307–317.

Clemson, L., Roland, M., & Cumming, R. (1992). Occupational therapy assessment of hazards in the homes of elderly people: An inter-rater reliability study. *Aust Occupational Therapy Journal, 39*(3), 23–26.

Cohen, J. A. (1960). A coefficient of agreement for nominal scales. *Educational and Psychological Measurement, 20*, 37–46.

Cooper, B. A., Cohen, U., & Hasselkus, B. R. (1991). Barrier-free design: A review and critique of the occupational therapy perspective. *American Journal of Occupational Therapy, 45*(4), 344–350.

Deitz, J. C., Tovar, V. S., Thorn, D. W., & Beeman, C. (1990). The Test of Orientation for Rehabilitation Patients: Inter-rater reliability. *American Journal of Occupational Therapy, 44*(9), 784–790.

Guralnik, J. M., Branch, L. G., Cummings, S. R., & Curb, J. D. (1989). Physical performance measures in aging research. *Journal of Gerontology, 44*(5), M141–146.

Hamilton, B. B., Laughlin, J. A., Fiedler, R. C., & Granger, C. V. (1994). Interrater reliability of the 7-level Functional Independence Measure (FIM). *Scandinavian Journal of Rehabilitation Medicine, 26*, 115–119.

Handikappinstitutet. (1989). *Bygg ikapp handikapp* [*Building to overcome handicap*]. Stockholm, Sweden: Author.

Iwarsson, S. (1995). *"The Enabler." Manual och bedömmingsformulär. Svensk reviderad version anpassad till arbetsterapi* [*"The Enabler." Manual and assessment form. The Swedish revised occupational therapy version*]. Unpublished manuscript, Lund University, Sweden.

Iwarsson, S., & Isacsson, Å. (1993). Basic accessibility in modern housing—a key to the problems of care in the domestic setting. *Scandinavian Journal of Caring Sciences, 7*(3), 155–159.

Iwarsson, S., & Isacsson, Å. (1996). Development of a novel instrument for occupational therapy assessment of the physical environment in the home—a methodologic study on "The Enabler." *Occupational Therapy Journal Research, 16*(4), 227–244.

Kane, R. L. (1993). The implications of assessment. *Journal of Gerontology, 48*, 27–31.

Law, M. (1987). Measurement in occupational therapy: Scientific criteria for evaluation. *Canadian Journal of Occupational Therapy, 54*(3), 133–138.

Law, M., & Letts, L. (1989). A critical review of scales of activities of daily living. *American Journal of Occupational Therapy, 43*(8), 522–528.

Lawton, P. (1980). *Environment and aging*. Los Angeles: Brooks/Cole.

Letts, L., Law, M., Rigby, P., Cooper, B., Stewart, D., & Strong, S. (1994). Person–environment assessments in occupational therapy. *American Journal of Occupational Therapy, 48*(7), 608–618.

Managh, M. F., & Cook, J. V. (1993). The use of standardized assessment in occupational therapy: The BaFPE-R as an example. *American Journal of Occupational Therapy, 47*(10), 877–884.

Ottenbacher, K. J., & Tomcheck, S. D. (1993). Reliability analysis in therapeutic research: Practice and procedures. *American Journal of Occupational Therapy, 47*(1), 10–16.

Parker, M. G., & Thorslund, M. (1991). The use of technical aids among community-based elderly. *American Journal of Occupational Therapy, 45*(8), 712–717.

Steinfeld, E., Schroeder, S., Duncan, J., Faste, R., Chollet, D., Bishop, M., Wirth, P., & Cardell, P. (1979). *Access to the built environments: A review of the literature.* Washington, DC: Government Printing Office.

Suen, H. K., & Lee, P. S. C. (1989). Effect of the use of percentage agreement on behavioural observation reliabilities: A reassessment. *Journal of Psychopathology and Behavioral Assessment, 7,* 221–234.

Svensson, E. (1993). *Analysis of systematic and random differences between paired ordinal categorical data.* Gothenburg, Sweden: Almqvist & Wiksell International.

Verbrugge, L. M., & Jette, A. M. (1994). The disablement process. *Social Science Medicine, 38*(1), 1–14.

Wade, D. T. (1994). *Measurement in neurological rehabilitation.* Oxford: Oxford University Press.

5

Measuring the Influences of Physical Environments on the Behaviors of People with Impairments

G. Scott Danford and Edward Steinfeld

INTRODUCTION

Disease or disorder need not be present for an impairment to exist, impairment need not be present for a disability to exist, and disability need not be present for a handicap to exist. The physical environment alone is often sufficient to occasion any of those conditions—impairment, disability, or handicap.

Obviously, physical environments can cause "impairment" (i.e., any loss or abnormality of a psychological or anatomical structure or function (World Health Organization [WHO], 1980) by posing dangers to a person that result in injury. For example, a poorly illuminated staircase with uneven tread widths and riser heights occasions a person to stumble and fall, causing serious injury to both hands with the consequence that she can no longer grasp objects or rotate her wrists.

G. Scott Danford and Edward Steinfeld • Center for Inclusive Design and Environmental Access, School of Architecture and Planning, State University of New York at Buffalo, Buffalo, New York 14214.

Enabling Environments: Measuring the Impact of Environment on Disability and Rehabilitation, edited by Edward Steinfeld and G. Scott Danford. Kluwer Academic/Plenum Publishers. 1999.

Physical environments can also cause "disability" (i.e., any restriction or inability to perform an activity in the manner or within the range considered normal for a human being (WHO, 1980) by failing to provide those conditions a person requires to enable functional performance. For example, the aforementioned person with the injured hands now finds it impossible to drive a conventional automobile because she cannot hold or turn the steering wheel.

Physical environments can even bring about a "handicap" (i.e., any disadvantage for a given individual that limits or prevents the fulfillment of a role that is normal for that individual) (WHO, 1980) by constraining or even preventing a person's accustomed participation in society. For example, the aforementioned person with the injured hands now finds herself unable to live independently in her home because so many of the physical environment's features like doorknobs, drawer pulls, cabinet handles, household appliances, food preparation utensils, and personal grooming devices require the ability to grasp an object and/or rotate the wrists.

On the other hand, a physical environment that provides the conditions necessary to sustain functional independence can prevent the occurrence of a disability or a handicap whether or not impairment is present. The presence of impairment merely adds to the list of accommodations that physical environments must make to avoid creating a disabling or handicapping situation.

Interestingly, the success of enabling environments is typically contingent upon the accommodations provided being neither too little (i.e., underaccommodating) nor too much (i.e., overaccommodating) (Nahemow & Lawton, 1973).

Environmental Accommodation

Physical environments that are underaccommodating can trap people with impairments in demanding person–behavior–environment transactions that exacerbate the consequences of their impairments. For example, the failure to accommodate the nonfunctional legs of a job applicant by requiring the person to climb steps to reach the site of every employment interview not only turns that person's impairment into a disability by restricting her mobility but also extends that disability into a handicap by preventing that person from becoming a gainfully employed member of society.

Physical environments that are overaccommodating can also be problematic. They can engender premature dependence upon needlessly accommodating design features that accelerate the erosion of functional abilities. For example, a fully ambulatory but generally sedentary person's constant reliance upon the convenience of an elevator continues to the point that the stamina required for that person to climb stairs is degraded.

The challenge for environmental design research is to develop methods that will enable one to know not only when environmental accommodation is needed but also which environmental accommodations are appropriate (i.e., salient and

neither under- nor overaccommodating) to ensure habitable outcomes for the person with impairments. Meeting this challenge is complicated by the transactional nature of person-behavior-environment relationships.

Transactional Person–Behavior–Environment Relationships

Person-behavior-environment relations are by no means simple systems. How a person behaves in a particular situation is not a simple function of either the person or that person's environment but rather the interaction between the two (Cronberg, 1975; Lewin, 1951). This view on the nature of person-behavior-environment relationships is the defining characteristic of what has come to be known as a "transactional" perspective (Altman & Rogoff, 1987; Moore, 1976; Stokols, 1981, 1987; Wandersman, Murday, & Wadsworth, 1979).

Many transactional models posit some form of reciprocal relationship between three interrelated outcome determinants: person, behavior, and environment (Bandura, 1978). The reciprocity involves each determinant influencing the other two and, in return, being influenced by the consequences of its own effects on those other two. Those distinctions that can be made between such transactional models primarily involve their differing conceptions of the dynamics involved in defining those reciprocal relationships. In fact, the ability to reconcile what might seem to be a conflict between a transactional perspective on person-behavior-environment relationships and this chapter's opening argument that "the physical environment alone is often sufficient to occasion … impairment, disability or handicap" rests entirely upon how one defines the dynamics of those reciprocal relationships.

The program of research being reported in this chapter rests largely on the reciprocity defined by a transactional model called Dynamic Reciprocal Determinism (Danford, 1982, 1983, 1985). This model describes mechanisms by which the person "monitors" the ongoing behavior-environment relationship and typically submits to the pattern of behavior being cued and reinforced by the environment. It posits that as long as the behavior-environment relationship does not violate the individual's values, expectations, or abilities sufficiently to prompt an attempt to "override" that relationship, the environment will effectively dictate the outcome. Even in instances where the environment requires behavior that exceeds an individual's "tolerance threshold," a successful override is by no means assured. (For a broader discussion of Dynamic Reciprocal Determinism and other theoretical underpinnings of this research program, including the concept of "fit," see Chapter 1, in this volume).

When the transaction involves a person with an impairment and that person's attempt to override an unaccommodating behavior-environment relationship fails, disability ensues. The unaccommodating environment demands functional performance that is beyond the person's abilities, leaving the individual unable to function like others whose requirements for support are not as stringent.

Measuring Person–Behavior–Environment Transactions

The aforementioned interpretation of the transactional perspective and the difficulty of determining the appropriateness of a particular environmental design accommodation provide the underlying framework for a number of recent and current projects of the Center for Inclusive Design and Environmental Access (IDEA) at the State University of New York at Buffalo. With funding provided by the U.S. Department of Education's National Institute for Disability and Rehabilitation Research (NIDRR) through organizations such as the Rehabilitation Research and Training Center on Functional Assessment and Evaluation of Rehabilitation Outcomes and the Rehabilitation Engineering Research Center on Aging, the IDEA Center has made a long-term commitment to developing methods for measuring and analyzing the appropriateness of person–behavior–environment transactions for a wide range of people and environmental contexts.

In the program of research being reported in this chapter, the IDEA Center is developing methods to measure the influences of the near physical environment on functional independence and performance of people within impairments. These measures examine how physical environments can disable individuals and, conversely, enable or even enhance functional independence and performance.

The focus of this program of research has thus far been primarily on the development, testing, and refinement of outcome measures as complements to the widely employed Functional Independence Measure instrument (Granger, Hamilton, Kuth, Zielezny, & Sherman, 1986)—more popularly referred to as the FIM™ instrument. (For further discussion of the FIM™ instrument, see Chapter 1 in this volume.) The new measures not only help identify when environmental accommodations are actually needed but also which accommodations are appropriate.

Outcome measures were sought that would accomplish five goals:

1. Obtain self-reports on the ease or difficulty of a person's functional performance of selected activities
2. Assess a person's functional independence during performance of these activities
3. Assess a person's level of effort expended toward functional performance of selected activities
4. Assess a caregiver's burden in assisting the person when independent function is compromised
5. Distinguish differences across environments with varying conditions of environmental demand

Three outcome measures were developed:

1. The Usability Rating Scale (URS™), which has a person rate the perceived ease or difficulty of performing selected activities
2. The Environmental Functional Independence Measure (Enviro-FIM™),

which scores the person's functional independence while performing selected activities in a specified environment.

3. The Functional Performance Measure (FPM™), which scores not only the person's level of effort expended toward functional performance of selected activities' task components but also any caregiver's level of assistance provided to that person.

RESEARCH DESIGN

The initial testing and refinement of these three outcome measures was performed by studying the functional performance of selected activities by people with impairments in physical environments whose demand characters were systematically varied. The research design for this testing and refinement phase involved asking 24 female subjects with mobility impairments (i.e., 12 wheelchair users and 12 walking aid users) to simulate the performance of selected activities of daily living in three full-scale mock-ups of bathrooms. In these three bathrooms, five sets of design attributes typically addressed by accessibility standards and guidelines were systematically varied to provide three distinct levels of environmental demand:

1. Size of the open floor area inside the room
2. Entry door features
3. Lavatory/vanity features
4. Toilet features
5. Bathtub/shower features

There was a "challenging" bathroom (i.e., a full-scale bathroom not in compliance with any current accessibility standards) (see Figure 5.1), a "supportive" bathroom (i.e., a full-scale bathroom in full compliance with current accessibility standards) (see Figure 5.2), and an "intermediate" bathroom (i.e., a full-scale bathroom only partially in compliance with current accessibility standards) (see Figure 5.3.).

In addition, the 24 subjects were asked to negotiate their way through some 26 distinct door configurations, including entering and existing door configurations for each of the three bathrooms. These door configurations varied systematically in terms of:

1. Door width
2. Direction of door swing
3. Latch type
4. Handle type
5. Latch side clearance
6. Force required to open
7. Interior/exterior projections

Figure 5.1. The challenging bathroom configuration.

The defining features of each of the three bathrooms and their door configurations are displayed in Table 5.1.

The bathroom and door trials were counterbalanced to control for possible order effect, and standardized instructions were provided for each activity to be performed (e.g., simulating use of the tub/shower), including each activity's task components (e.g., turning on the faucet). At the end of each activity, each subject was then asked to rate how easy or difficult it had been to perform the requested

Figure 5.2. The supportive bathroom configuration.

activity in that environment (see "Usability Rating Scale" section). Each subject's performance of each of the requested activities in each bathroom environment was also videotaped to permit subsequent analysis of other matters (see "Environmental Functional Independence Measure" and "Functional Performance Measure" sections).

Usability Rating Scale (URS™)

The Usability Rating Scale (URS™) is an adaptation of a previously developed, tested, and published sequential 13-point judgment scale (Pitrella & Kappler, 1988) that ultimately was simplified to a sequential 7-point bipolar rating scale. (See Chapter 1 in this volume.) The URS™ instrument is designed to elicit subjective responses to an individual's experience during the functional perfor-

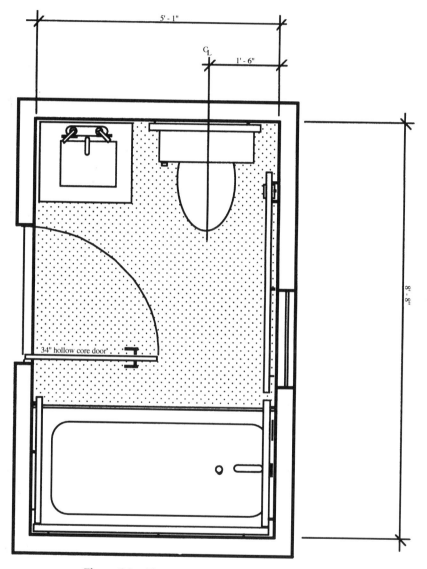

Figure 5.3. The intermediate bathroom configuration.

Table 5.1. Defining Features of the Three Bathrooms

	Bathrooms		
Features	Challenging	Intermediate	Supportive
Maneuvering area	15 square feet	20 square feet	25 square feet
Interior dimensions	5 ft. 1 in. by 7 ft. 8 in.	5 ft. 1 in. by 8 ft. 8 in.	7 ft. 1 in. by 8 ft. 8 in.
Door width	32 in.[a]	34 in.[a]	34 in.[a]
Door handle	Knobs	Levers	Levers and towel rack for pull
Door swing	Inward	Inward[b]	Outward
Vanity width	20 in.	24 in.	30 in.
Knee space	Closed	Open	Open
Faucet	Dual knob	Dual lever	Single lever
Cabinet height	47 in.	47 in.	40 in.
Mirror	On cabinet only	On cabinet plus adjustable	On cabinet plus adjustable
Toilet height	16 in.	16 in.	18 in.
Toilet grab bars	None	Wall	Toilet seat and wall
Tub/shower	15 in. tub	15 in. tub	Roll-in shower
Shower head	Fixed	Handheld, fixed position	Handheld, adjustable height
Bath grab bars	None	Wall	Wall
Shower controls	Single knob	Single lever, on-center	Single level, off-center

[a]Clear opening was about 1.75 in. smaller.
[b]Door removed if necessary ("modified environment").

mance of activities in physical environments through a two-step process (see Figure 5.4). The first step asks the person to make an initial choice between "difficult," "moderate," and "easy" judgments of their functional performance of an activity. The second step then asks the person to focus that judgment at a specific position on the relevant subsection of the 7-point scale. A person's self-report about the relative ease or difficulty of performing an activity in a particular physical environment was hypothesized to be a global response to that environment's influence on their functional performance during simulation of the requested activity.

Examination of the URS™ ratings of the three bathrooms by the 24 subjects (see Figure 5.5) supported our hypotheses about these environments' relative enabling and handicapping influences. Particularly noteworthy were the wheelchair users' perceptions indicating that they were substantially more enabled by the design features of the supportive bathroom and substantially more disabled by design features in the intermediate and challenging bathrooms than were their counterparts who used walking aids.

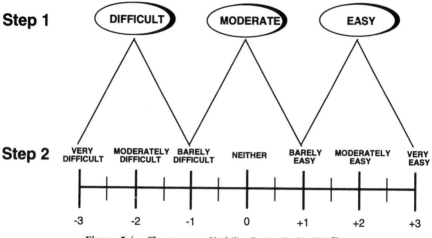

Figure 5.4. The two-step Usability Rating Scale (URS™).

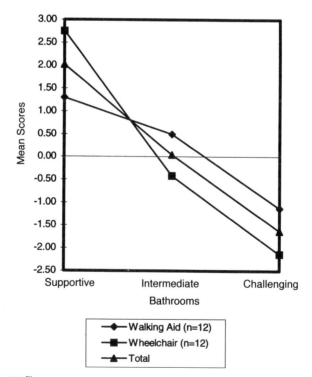

Figure 5.5. URS™ mean scores for the supportive, intermediate, and challenging bathrooms.

Environmental Functional Independence Measure (Enviro-FIM™)

The Environmental Functional Independence Measure (Enviro-FIM™) is a derivative of the 7-point FIM™ instrument that is widely employed in rehabilitation medicine (see Figure 5.6). (See Chapter 1 in this volume.) The Enviro-FIM™ instrument effectively duplicates the FIM™'s scores of 1, 2, 3, 4, 5 and 7, adds a score of 0, and expands the FIM™ score of 6 into four scores to create 11-point measurement scale (see Figure 5.7).

Which of the 11 Enviro-FIM™ scores a person receives is determined by:

1. Whether the activity is completed by the person
2. Whether additional time is required for the person to complete the activity

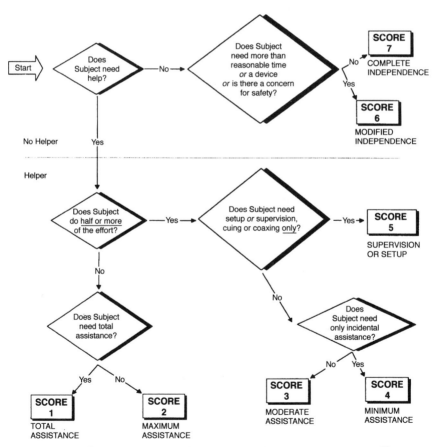

Figure 5.6. Decision tree for the Functional Independence Measure (FIM™).

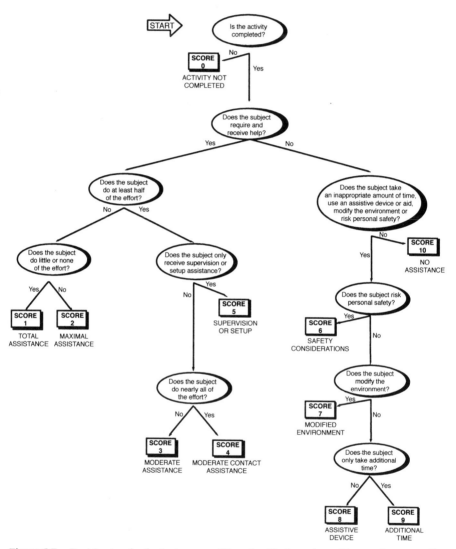

Figure 5.7. Decision tree for the Environmental Functional Independence Measure (Enviro-FIM™).

3. Whether an assistive device (i.e., specialized equipment, tool, or aid) is used by the person to complete the activity
4. Whether a modification of the environment (e.g., introduction of a bench or chair) is necessary for the person to complete the activity
5. Whether a risk to personal safety or well-being is experienced while the person completes the activity
6. Whether the assistance of another person is required and received while the person completes the activity
7. Whether the assistance received involves only noncontact supervision (e.g., standby, cueing, or coaxing) or setup (e.g., laying out items for later use) such that the person still expends 100% of the effort required to complete the activity
8. Whether the assistance received involves minimal contact assistance (e.g., touching) such that the person still expands 75%–99% of the effort required to complete the activity
9. Whether the assistance received involves moderate assistance such that the person still expends 50%–74% of the effort required to complete the activity
10. Whether the assistance received involves maximum assistance such that the person expends only 25%–49% of the effort required to complete the activity
11. Whether the assistance received involves total assistance such that the person expends less than 25% of the effort required to complete the activity

The Enviro-FIM™ instrument was designed to be used to identify, at a global level, enabling and disabling influences of physical environments on the functional independence of a person with an impairment during performance of an activity under varying conditions of environmental demand.

Tests of both interrater and intrarater reliabilities (see Table 5.2) demonstrated relatively high levels of complete agreement in use of the Enviro-FIM™ instrument that were only marginally affected by the passage of time (i.e., 2 weeks with no exposure to the Enviro-FIM™ instrument).

FIM™ ratings were also assigned to the 24 subjects by a certified FIM™ scorer who was instructed to evaluate each subject's performance in each bathroom as a separate case study. These data demonstrated that FIM™ scores do indeed have the potential to be impacted by the physical environment in which they are assigned (see Figure 5.8). The FIM™ mean scores of the wheelchair users, for example, were markedly affected by the differing physical environments in which they performed the directed activities.

Examination of the Enviro-FIM™ scores of these same 24 subjects in the three bathrooms (see Figure 5.9) demonstrated the anticipated differential ef-

Table 5.2. Environ-FIM™ Reliabilities

| | Enviro-FIM™ | |
Type of reliability	n	Agreement
Interrater, initial trial	164	96%
Interrater, second trial, 2 weeks later	164	87%
Intrarater, initial trial	164	92%
Intrarater, second trial, 2 weeks later	164	89%

fects of the three simulated bathrooms on the subjects' functional independence with, again, the wheelchair-users being the more dramatically affected—particularly in the challenging bathroom.

Comparison of the FIM™ and Enviro-FIM™ scores (see Figure 5.10) demonstrates similar effects of the three environments on the subjects' functional

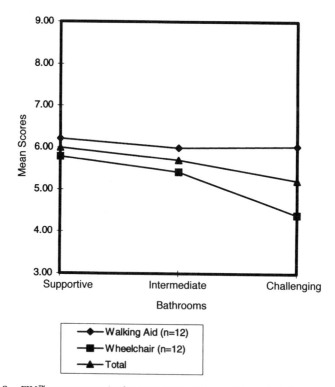

Figure 5.8. FIM™ mean scores in the supportive, intermediate, and challenging bathrooms.

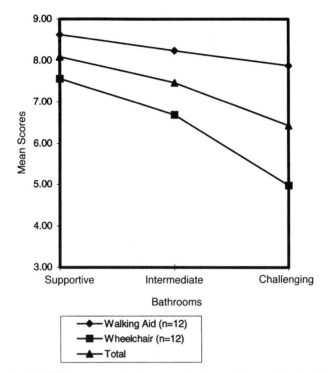

Figure 5.9. Enviro-FIM™ mean scores in the supportive-intermediate, and challenging bathrooms.

independence scores. In fact, when the 11-point Enviro-FIM™ scale is collapsed back into a 7-point scale comparable to the FIM™'s 7-point scale, the two sets of scores fall so remarkably close to one another as to be virtually indistinguishable in the figure.

Functional Performance Measure

The third outcome measure, the FPM™ instrument, employs two 9-point rating scales to score the Level of Effort expended by the subject toward performance of an activity's task components and the Level of Assistance provided by the caregiver during such task performance in the several bathroom and door environments tested. (See Chapter 1 in this volume.) Instead of rating the levels of effort and assistance observed throughout an entire activity like "bathing," the FPM™ rates the effort expended and the assistance provided for every task component of that activity—for example, transferring into the bathtub, operating the faucet, and so on.

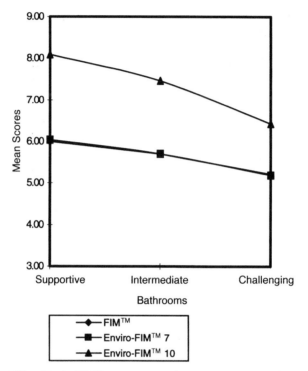

Figure 5.10. FIM™ and Enviro-FIM™ mean scores in the supportive, intermediate, and challenging bathrooms.

Which of the nine Level of Effort scores the individual receives (see Figure 5.11) is determined by:

1. Whether task performance is observable
2. Whether task performance is required for completion of the activity
3. Whether the task is self-performing
4. Whether the ability to perform the task is thwarted
5. Whether the opportunity to perform the task is refused
6. Whether the task is completed and, if so, by whom
7. The frequency of complaint as an expression of aggravation, inconvenience, or anxiety during task performance
8. The frequency of interruption in the continuity of task performance
9. The amount of time taken for task performance
10. The number of attempts made toward task performance

Which of the nine Level of Assistance scores the caregiver receives (see Figure 5.12) is determined by:

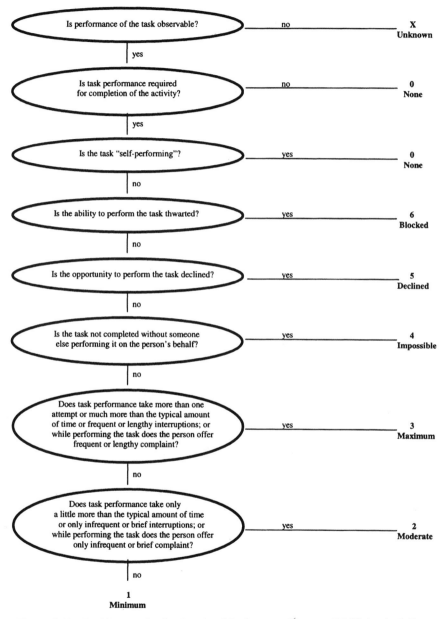

Figure 5.11. Decision tree for the Functional Performance Measure (FPM™) level of effort.

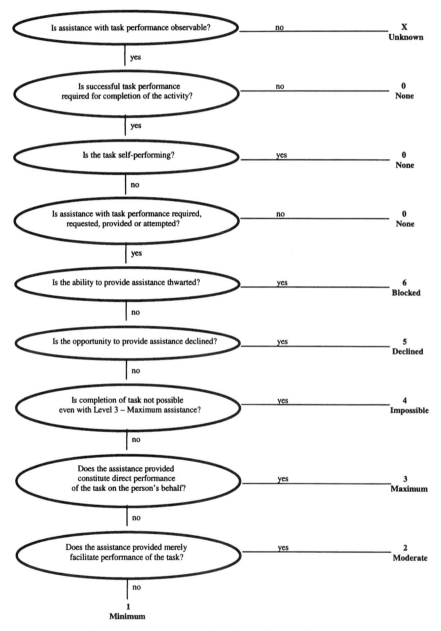

Figure 5.12. Decision tree for the FPM™ level of assistance.

1. Whether task performance is observable
2. Whether task performance is required for completion of the activity
3. Whether the task is self-performing
4. Whether assistance is required, requested, provided, or attempted
5. Whether the ability to assist task performance is thwarted
6. Whether the opportunity to assist task performance is refused
7. Whether the task is completed and, if so, by whom
8. Whether the assistance provided effectively constitutes direct performance of the task, merely facilitates performance of the task, or is only incidental to performance of the task

Of the 24 subjects analyzed using the FPM™ Level of Effort and Level of Assistance scales, four (i.e., two wheelchair users and two walking aid users) were rescored to permit both interrater and intrarater reliabilities to be examined. This involved rescoring each of the 283 component tasks performed by every subject in the three bathrooms and all 26 doors—a total of 1132 Level of Effort judgments and 1132 Level of Assistance judgments.

The intrarater reliability analysis examined the consistency with which one rater scored the 283 tasks for each of the four subjects. The results (see Table 5.3) showed exact score matches on the 9-point Level of Effort scale of 97% and exact score matches on the 9-point Level of Assistance scale of 99%.

Interrater reliability analysis examined the agreement between two raters who scored the 283 tasks for each of the four subjects. These results (see Table 5.3) showed exact score matches on the 9-point Level of Effort scale of 84% and exact score matches on the 9-point Level of Assistance scale of 96%. Of the 16% exact score Level of Effort mismatches, only 1.5% of the mismatched scores differed by more than 1 point on the 9-point scale—which is remarkable since this was achieved without benefit of a formal training program or a written user manual detailing all of the coding conventions during this testing and development phase.

Examination of the Level of Effort scores (see Figure 5.13) for the 24 subjects in the three bathrooms (excluding the bathrooms' door trials, which were analyzed separately) shows the walking aid users expending a relatively constant

Table 5.3. FPM™ Reliabilities

Type of reliability	Level of effort		Level of assistance	
	n	Agreement	*n*	Agreement
Interrater[a]	1132	84%	1132	96%
Intrarater	1132	97%	1132	99%

[a]Level of effort scale interrater agreement variance: 1 point off = 14.5%; >1 point off = 1.5%.

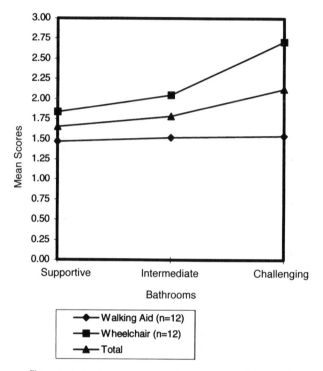

Figure 5.13. FPM™ level of effort mean scores in the supportive, intermediate, and challenging bathrooms.

Level of Effort across the three bathrooms but the wheelchair users expending a progressively increasing Level of Effort as they moved from the supportive to the intermediate to the challenging bathrooms.

Examination of the Level of Assistance scores (see Figure 5.14) for the 24 subjects in the three bathrooms (again, excluding the bathrooms' door trials) shows the walking aid users receiving negligible assistance in any of the bathrooms but the wheelchair users receiving a progressively increasing Level of Assistance as they moved from the supportive to the intermediate to the challenging bathrooms.

Plotting mean Level of Effort and Level of Assistance scores across all 24 subjects in all three bathrooms (see Figure 5.15) clearly shows the effects of environment not only on the effort required from the individual but also on the assistance required from the caregiver as they moved from the supportive to the intermediate to the challenging bathrooms.

Plotting the mean Level of Effort scores for all grooming, toileting, and bathing tasks performed by all 24 subjects versus their comparable FIM™ instrument subscales' scores (i.e., grooming, toilet transfer, tub transfer, and bathing)

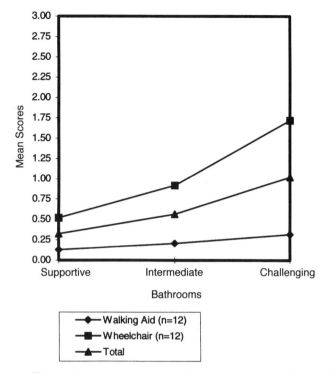

Figure 5.14. FPM™ level of assistance mean scores in the supportive, intermediate, and challenging bathrooms.

in the challenging bathroom (see Figure 5.16) shows the anticipated strong inverse relationship between the two measures. The lower the subject's FIM™ score, the higher the Level of Effort typically required to perform the tasks; the higher the subject's FIM™ score, the lower the Level of Effort typically required to perform the tasks.

UTILITY OF OUTCOME MEASURES

The initial motivation for the development, testing, and refinement of these three measures was for their use as complements to the FIM™ instrument—tapping into information about environmental influences on the individual's functional independence and performance that the FIM™ instrument theoretically ignores.

The URS™ instrument enables one to examine a person's perceptions of the relative ease or difficulty of performing certain activities of daily living associated with the FIM™ instrument in different physical environmental contexts, thereby

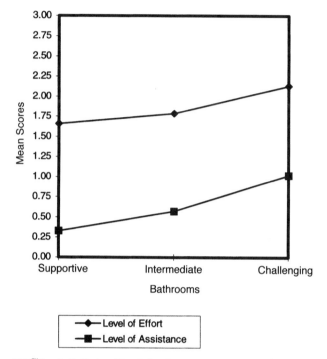

Figure 5.15. FPM™ level of effort and level of assistance mean scores in the supportive, intermediate, and challenging bathrooms.

demonstrating how perceptions of ease or difficulty can be influenced not only by the individual's functional abilities but also by prior experiences, expectations, and so on. The URS™ instrument also enjoys the cost advantages of most such survey instruments (e.g., lower cost of administration compared to the FIM™ instrument). And when used to assess the perceptions of individuals, the URS™ instrument enables measurement of individual differences in perception that may be independent of observed performance—for example, an individual with a low Enviro-FIM™ score may still rate an environment easy to use or vice versa. Such data are important when evaluating the acceptability of an environment to the user.

The Enviro-FIM™ instrument provides a means for evaluating environmental features in terms of their impact on the functional independence of an individual or a group (e.g., assessing effects of alternative door configurations on the functional independence of wheelchair users). The Enviro-FIM™ instrument also enables a global assessment of the fit between people with impairments and their physical environments. This outcome measure provides a means for determining if a mismatch exists between an environment's demand character and a subject's mastery level.

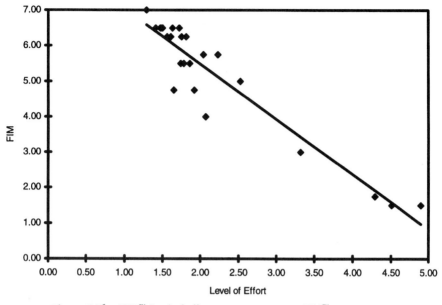

Figure 5.16. FPM™ level of effort mean scores versus FIM™ mean scores.

The FPM™ instrument provides a direct measurement of caregiver burden through its level of assistance scale and, thereby, a means to assess how that burden is affected by physical environments' varying demand character. The FPM™ instrument also permits the identification of specific design characteristics in physical environments responsible for problematic task performance by either individuals or groups. Consequently, the FPM™ instrument can be used to identify needed design changes in specific task environments that will improve subsequent task (and therefore activity) performance. The FPM™ instrument thereby enables one to fine-tune designed environments to facilitate specific outcome changes in the functional independence and performance of either individuals or groups.

DEMONSTRATION OF OUTCOME MEASURES IN USE

A quick demonstration of how these measures are employed to these ends is helpful to understand their usefulness. Table 5.4 shows mean URS™ and Enviro-FIM™ scores for door use in each of the three bathrooms. Door configuration characteristics encountered while entering and exiting the supportive bathroom (i.e., doors D1S2 and D4S1, respectively) are clearly perceived as being easy to use by the 24 subjects. The mean Enviro-FIM™ scores also substantiate this. In contrast, the door configuration characteristics encountered while entering and

Table 5.4. Utility of URS™ and Enviro-FIM™
Scores for Identifying Problems

Door	Approach and swing	Demand	Enviro-FIM™[a]	URS™[b]
D1S2	Enter and out	Supportive	7.83	2.38
D4S1	Exit and out	Supportive	8.08	2.83
D5I1	Enter and in	Intermediate	7.04	0.88
D8I2	Exit and in	Intermediate	7.67	1.19
D9CI1	Enter and in	Challenging	6.04	−0.40
D12CI2	Exit and in	Challenging	6.04	−0.04

[a]Enviro-FIM™ scale: 1-10, 10 = complete independence.
[b]URS™ scale: −3 to +3, +3 = very easy.

exiting the challenging bathroom (i.e., doors D9CI1 and D12CI2, respectively) are just as clearly perceived as being more difficult to use by these same 24 subjects—actually moving into the negative half of the bipolar URS™ scale. And again, Enviro-FIM™ scores substantiate this with overall mean scores for functional independence during door use that are barely above the level (even with the walking aid users' much higher scores included) where help would typically be required. Clearly, the wheelchair users are being disabled by the demand character present in these door configurations.

Examining the FPM™ average Level of Effort and Level of Assistance scores (see Table 5.5) on just the first of those two door configurations for the challenging bathroom (i.e., door D9CI1, entering the challenging bathroom) for wheelchair users versus walking aid users quickly enables us to focus on the specific component tasks that are causing the problems indicated by the URS™ and Enviro-FIM™ scores. Maneuvering to close the door (i.e., "closing maneuver")

Table 5.5 Utility of FPM™ Level of Effort
and Level of Assistance Scores for Identifying Causes of Problems

Door no. D9CI1 Task	Level of effort[a]			Level of assistance[b]		
	Wheelchair	Walking aid	Total	Wheelchair	Walking aid	Total
Approach	1.33	1.25	1.29	0.00	0.00	0.00
Opening maneuver	1.00	1.42	1.21	0.00	0.00	0.00
Latch use	1.58	1.25	1.42	0.25	0.00	0.13
Opening	2.42	1.83	2.13	0.00	0.00	0.00
Through passage	2.17	1.83	2.00	0.00	0.00	0.00
Closing maneuver	3.67	1.86	2.77	2.25	0.00	1.13
Closing	4.25	1.86	3.06	2.58	0.29	1.44

[a]Level of effort: 0-6, 0 = no effort required.
[b]Level of assistance: 0-6, 0 = no assistance required.

and then actually closing the door after entering the room (i.e., "closing") are tasks that the wheelchair users but not the walking aid users found virtually impossible to perform. (Recall that a Level of Effort score of 3 means "maximum" effort was required and a Level of Effort score of 4 means that task performance was "impossible" even with maximum effort.)

By next examining the design characteristics of the challenging bathroom that are related to these tasks, it becomes readily apparent that two specific design characteristics have combined to disable the wheelchair users. The "open floor space" inside the bathroom is only 15 square ft. (refer to Table 5.1) and the door's interior projection of 32 in. sweeps into the bathroom and across large portions of that 15 square ft. when opened (refer back to Figure 5.1). This combination leaves insufficient space for the subjects to maneuver their wheelchairs out of the way so that the door can be closed once they are inside the room.

CONCLUSION

Poorly designed physical environments can impair, disable, and handicap anyone. People with existing impairments are particularly at risk. A major contributing factor placing such persons at risk is that most classifications of impairments, disabilities, and handicaps overlook the physical environment as an outcome determinant. A major implication of the program of research reported in this chapter is the urgent need to revise current classification of impairments, disabilities, and handicaps to acknowledge appropriately accommodating environmental design as an effective form of interdiction into person–behavior–environment relationships for people with impairments. Well-designed physical environments can prevent injuries that would typically translate into impairments, can prevent disabilities that would otherwise follow from impairments, and can prevent handicaps that would otherwise come about from disabilities. They are unlikely to do so with any regularity, however, until classifications of impairments, disabilities, and handicaps are revised to incorporate the physical environment as an outcome determinant.

This research program demonstrates the value of a transactional perspective. It also has significant implications for the measurement of person–behavior–environment relationships—especially for those interested in managing preferred outcomes for people with impairments. The reciprocity between person, behavior, and environment demands the inclusion of both subjective and objective measures of outcomes. The abandonment of either in favor of the other results in oversimplification and, most likely, misrepresentation of the reciprocal interdependencies operating between the several outcome determinants in such transactional systems.

Yet another implication of the reported program of research is the importance of validating current accessibility codes and standards that are often used to

define appropriate person-behavior-environment relationships for people with impairments. By subjecting such codes and standards to validation using outcome measures that reflect a transactional perspective on person-behavior-environment relationships, empirical assessments of the outcomes actually experienced as a result of compliance (or noncompliance) with current accessibility codes and standards can be possible. This should help define "reasonable accommodation" provisions of accessibility regulations by enabling comparison of the costs of modifications against the outcomes actually realized by people with impairments as a result of those modifications. The application of outcomes measures like those developed by this program of research should therefore make it possible to replace much of the current "guess-timating" about what is or is not "reasonable."

A final (and perhaps the most important) implication of the reported program of research is the emerging ability to diagnose existing person-behavior-environment transactions and then prescribe individualized, appropriate design interventions. In contrast to a reliance on accessibility codes and standards that are typically more useful for determining minimum legal guidelines based on a consensus process, the employment of measures like those developed in this program of research can maximize the functional independence and performance of people with impairments based upon an empirical process.

Measurement of the mediating influence of environments on the behavior of people with impairments can enable the diagnosis of disabling and handicapping person-behavior-environment relationships. This diagnosis can be accomplished in sufficient detail to permit the individualized prescription of appropriate design interventions. Environmental design can then become a more effective form of intervention as part of rehabilitation practice. Disability need not be the inevitable consequence of impairment and handicap need not be the inevitable consequence of disability unless physical environments make it so. The program of research reported in this chapter demonstrates how the designed environment has an intimate relationship to the disablement process.

ACKNOWLEDGMENT. The work on this chapter was supported through the Rehabilitation Research and Training Center on Functional Assessment and Rehabilitation Outcomes at the State University of New York at Buffalo. The Rehabilitation Research and Training Center was funded by a grant from the National Institute on Disability and Rehabilitation Research, U.S. Department of Education.

REFERENCES

Altman, I., & Rogoff, B. (1987). World views in psychology: Trait, interactional, organismic and transactional perspectives. In D. Stokols & I. Altman (Eds.), *Handbook of environmental psychology* (Vol. 1, pp. 7-40). New York: Wiley.

Bandura, A. (1978). The self system in reciprocal determinism. *American Psychologist, 33*(4), 344-358.

Cronberg, T. (1975). *Performance requirements for building—a study based on user activities.* Stockholm, Sweden: Swedish Council for Building Research.

Danford, S. (1982). Therapeutic design for the aging. In A. Horton (Ed.), *Mental health interventions for the aging* (pp. 155-171). New York: Praeger.

Danford, S. (1983). Dynamic Reciprocal Determinism: A synthetic transactional model of person-environment relations. In D. Amedeo, J. Griffin, & J. Potter (Eds.), *EDRA 19: Proceedings of the Fourteenth International Conference of the Environmental Design Research Association* (pp. 19-28). Lincoln, NE: Environmental Design Research Association.

Danford, S. (1985). The reciprocal roles of settings and behavior. In R. Johnson, D. Bershader, & L. Leifer (Eds.), *Autonomy and the human element in space* (pp. 60-70). Washington, DC: National Aeronautics and Space Administration.

Granger, C., Hamilton, B., Keith, R., Zielezny, M., & Sherman, F. (1986). Advances in functional assessment for medical rehabilitation. *Topics in Geriatric Rehabilitation, 1*(3), 59-74.

Lewin, K. (1951). *Field theory in social science.* New York: Harper & Row.

Moore, G. (1976). Theory and research on the development of environmental knowing. In G. Moore & R. Golledge (Eds.), *Environmental knowing: Theories, research, and methods* (pp. 138-164). Stroudsburg, PA: Dowden, Hutchinson & Ross.

Nahemow, L., & Lawton, M. (1973). Toward an ecological theory of adaptation and aging. In W. Preiser (Ed.), *Environmental design research* (Vol. 1, pp. 12-32). Stroudsburg, PA: Dowden, Hutchinson & Ross.

Pitrella, F., & Kappler, W. (1988). *Identification and evaluation of scale design principles in the development of the Extended Range Sequential Judgment Scale.* Wachtberg, Germany: Research Institute for Human Engineering.

Stokols, D. (1981). Group x place transactions: Some neglected issues in psychological research on setting. In D. Magnusson (Ed.), *Toward a psychology of situations: An interactional perspective* (pp. 393-415). Hillsdale, NJ: Erlbaum.

Stokols, D. (1987). Conceptual strategies of environmental psychology. In D. Stokols & I. Altman (Eds.), *Handbook of environmental psychology* (Vol. 1, pp. 41-70). New York: Wiley.

Wandersman, A., Murday, D., & Wadsworth, J. (1979). The environment-behavior-person relationship: Implications for research. In A. Seidel & S. Danford (Eds.), *Environmental design: Research, theory and application* (pp. 162-174). Washington, DC: Environmental Design Research Association.

World Health Organization (1980). *International classification of impairments, disabilities, and handicaps manual of classification relating to the consequences of disease.* Geneva, Switzerland: Author.

6

Measuring Constraints to Inhabitant Activities

David B. Lantrip

INTRODUCTION

The nature of the relationship between human behavior and proximate environment rules out any simple definition of "physical disability" or "good design." A person's physical disability is given meaning and value only when it is found to interfere with some desired activity. Furthermore, an environment may be said to handicap each of its inhabitants regardless of physical ability, to the extent that it interferes with desired activities. To understand the widespread potential of environmental handicapping one need look only as far as the modern kitchen, where most able-bodied women are significantly handicapped in reaching over-the-counter kitchen cabinets. Neither clinical definitions of physical ability nor architectural jury pronouncements offer useful measures of the handicapping potentialities of an environment–behavior interaction.

Environmental quality must be assessed in terms of how well an environment accommodates physical and behavioral diversity in performance of activities. By viewing environmental performance in terms of how well needs for space and other qualities are satisfied, it is possible to shift emphasis away from both environmental and individual characteristics toward measures of their relationship. This is the essence of the transactional view of environment–

David B. Lantrip • Cartia, Inc., 2040 Langley Street, Oxnard, California 93033.

Enabling Environments: Measuring the Impact of Environment on Disability and Rehabilitation, edited by Edward Steinfeld and G. Scott Danford. Kluwer Academic/Plenum Publishers. 1999.

behavior research (Altman & Rogoff, 1987) and the philosophical foundation of the analytical approach described in this chapter.

The transactional view calls for a new unit of analysis, the environment–behavior entity, that has both physical and psychological attributes. For example, the attribute of spaciousness (a perceptual quality) must be measured relative to the inhabitant's need for space, that is, the psychological and behavioral spatial requirements for planned activities and visual expansiveness. Neither simple measures of available space nor studies of spatial behavior will suffice. Measures that offer insight and design guidance must relate both of these aspects of the environment–behavior relationship.

This chapter describes how transactional measures of the environment–behavior relationship can be defined and operationalized using computer-aided analysis techniques. Illustrations show how the computer allows complex interactions between inhabitant and environment to be visualized and quantified, thereby providing for an unambiguous and replicable assessment of environmental performance. The approach makes no assumptions concerning the physical abilities of inhabitants. As a result, the methods are not only applicable to special populations, but may be particularly cogent where often overlooked features of the environment have serious handicapping consequences.

ENVIRONMENTAL ASSESSMENT

Background and Theory of Environmental Measurement

Environmental researchers have traditionally used many measurement methods borrowed from the social and behavioral sciences. This is partly because gathering environmental data is complex, but it also reflects a general tendency within the field to rely on multiple methods to improve reliability and validity of results. Subjective measures have been widely used for building evaluations for two reasons. First, the theory and methods of psychometrics have been well documented and, second, surveys are an efficient way to get responses from a large population of users concerning various environmental issues. For example, recent efforts to create a standard survey for evaluating facilities include questions concerning background information (i.e., demographics, job description, and work conditions), suggested environmental changes, ratings of environmental characteristics and changes, task chronology and work flow, work-related experiences, and color preferences (Stokols, 1986). Broader use of comprehensive survey instruments such as this would help establish a national database, increase the comparability of data across different studies, and improve the estimation of measure validity, reliability, and model generalizability. However, subjective measures have several well-documented shortcomings (e.g., Fowler, 1988; Popham, 1978), such as "response sets," where respondents tend to

answer questions from a particular perspective rather than provide answers directly related to the questions. The "social desirability" response, for example, produces results that tend toward what is generally considered the "desired" or "correct" response. For this reason it would not be surprising to see respondents indicate that a larger workspace with windows would help them perform their work. Other potential problems with subjective measures concern respondent errors of judgment or memory, ambivalent or biased questions, and inaccurate response scales. These problems tend to increase the "fog" or overall unclarity of the relationships in the data and often lead to difficulties in interpreting the results.

These methodological problems have encouraged social scientists to use physical evidence when possible to extend the validity of questionnaire data. For example, it is reasonable to measure floor area, rather than rely solely on inhabitant's estimates of workspace size. Also, the influence of the architecture and building industries, as well as more "hard" science fields such as engineering, can be seen in the desire to relate directly to perceptions of environmental quality such physical quantities as floor area, light intensity, sound pressure, and temperature.

Although the recognition of the need to include physical evidence in environment–behavior models is, in general, a positive development, there has been a concomitant tendency to subscribe to an oversimplified behavioral model. In the simplified stimulus-response model, there is an assumed optimum level, or at least a range of acceptable values, for physical environmental stimuli that will produce positive behavioral outcomes in inhabitants, such as increased productivity. Laboratory studies investigating the relationship between specific environmental characteristics, such as physical density, to perceived crowding are good examples of this approach (Baum & Epstein, 1978; Baum & Paulus, 1987). Other examples are studies that have reported the direct relationship of workspace floor area, enclosure, lighting, color, and windows (among other characteristics) to environmental satisfaction and productivity (Brill, Margulis, & Konar, 1984; Flynn & Spencer, 1977; Marans & Yan, 1989; Oldham, 1988; Spreckelmeyer, 1993; Sundstrom & Altman, 1989; Wohlwill, 1974). However these investigations have often led to inconclusive and contradictory findings.

The key to understanding these difficulties lies in viewing environment–behavior relationships in transactional and organismic terms. Altman and Rogoff (1987) define a transactional approach as "the study of the changing relations among psychological and environmental aspects of holistic unities." They describe an organismic approach as "the study of dynamic and holistic psychological systems in which person and environment components exhibit complex, reciprocal, and mutual relationships and influences." The ecological (Brunswik, 1956, Gibson, 1979) and systems approaches to environment–behavior research are good examples of each. Both these approaches emphasize that the fundamental unit of analysis is not one or more discrete characteristics of the environment

or individual inhabitants, but rather a system that includes many environmental characteristics and inhabitants.

The human–environment system is a construct with both objective (physical) and subjective (perceptual) aspects. The system also has unique attributes related to its purpose: the goals of the inhabitant(s) and the "affordances" of the environment. Affordances are what the environment offers inhabitants in terms of resources to fulfill needs and goals (Gibson, 1979). In other words, affordances are what an inhabitant perceives as useful or constraining about the environment. It is an artifact of the human–environment relationship and does not exist independently of a sentient inhabitant. For example, the size of a workspace (i.e., measured floor area) has been shown to be a generally poor predictor of environmental satisfaction (Brill et al., 1984; Marans & Yan, 1989). This is because the floor area has no intrinsic value until the needs of a particular inhabitant are considered. Then, the relationship of the floor area to subjective assessment and behavioral outcomes may be understood in terms of how its size and shape accommodate or constrain the desired activities of the inhabitant. A given floor area may have very different affordances to a wheelchair-bound adult as compared to an able-bodied child.

Recent efforts have been made at the University of California at Irvine to develop transactional environment–behavior measures that are predictive of inhabitant perceptions of privacy (Churchman, Stokols, Scharf, & Nishimoto, 1990). These new measures describe the workspace in terms of expanding circles of "buffer space" around the primary vantage point of an inhabitant. The measures embody a transactional approach by attempting to describe the environment in terms of its affordance of visual and acoustic privacy. Empirical studies indicate that the buffer measures exceed the predictive and explanatory power of other simple measures of enclosure. Improvements to these measures are possible by using descriptions of buffer surfaces that are more reliably related to inhabitant perceptions. For example, the height of a visual buffer may not be as strongly linked to visual privacy as the percentage of visual field occluded by the buffer. The subtle difference is that a shorter partition may conceivably have more privacy value than a taller partition if it is located closer, whereas the percentage of visual field occluded is constant for a given inhabitant vantage point.

The Irvine efforts underscore the important role that human perceptual processes play in the assessment of environments. The functioning of human perception defines what can be perceived and what is important and relevant about the environment. For example, useful measures of lighting will be predictive of perceived lighting quality for primarily two reasons. First, because they measure light from the point of view of the inhabitant and, second, because they measure whether satisfactory light is available where it is needed. Useful measures must capture the difference between what is needed by an inhabitant and what is provided by the environment.

MEASURING ENVIRONMENTAL CONSTRAINT

Perception of overall environmental quality by an inhabitant depends in part on the provision of sufficient space for desired activities.[1] When insufficient space is provided, inhabitants often feel cramped or crowded, are dissatisfied, and respond with nonproductive coping behaviors. This section discusses how environments constrain inhabitant activities and introduces a method for measuring these spatial insufficiencies. The relationship between inhabitant goals and resulting activities is addressed first. Inhabitant activities are then used as templates for assessing an objective spatial requirement, referred to as the "body-motion envelop" (BME). Finally, the BME is used to define several measures that quantify the difference between the space objectively required for inhabitant activities and what is provided by an environment, that is, the sufficiency or insufficiency of space. This approach to measuring environmental performance differs from prior investigations by capturing transactional qualities of the environment–behavior relationship that are highly perceivable by inhabitants.

Goals Are the Source of Space Requirements

To design "good" environments, it is first important to clearly understand the goals of inhabitants and then interpret these goals in terms of the physical space required for their fulfillment. Judgments of good or bad only have meaning when considered in terms of how well an environment is meeting the needs of its users. Heimsath (1977) states: "The question of goals and their fulfillment cannot be divorced from the environment, for the environment can create a positive support for goal seeking or it can work negatively against the individual's goals. The concept of 'quality of life' suggests both the goals of the individual and the setting for those goals" (p. 57). Perin (1970) shares a similar view: "[W]e are able to perceive criticisms of environments as expressions of the level to which people's purposes have been hindered from fulfillment—that is, the person's expectations of the behaviors the environment would allow or enable him to engage in were not met at all or were not met adequately" (p. 75). Thus, people perceive environments that interfere more with their goal-directed activities as lower in quality and less satisfying.

The Activity

Observable goal-achieving behavior includes the body motions of people as they go about their daily activities. So it follows from the previous discussion that environments that are perceived by inhabitants to interfere with their body motions will be less preferred. How an environment interferes with the body

[1]Lantrip (1993) provides a comprehensive discussion of contributors to perceived environmental quality.

motions of its inhabitants is a good starting point for developing quantitative measures of environmental performance. However, before quantitative measures can be considered, it is necessary to describe body motions so they can be interpreted in terms of physical space requirements. This section proposes a taxonomy of body motions and the next section characterizes body motions in terms the amount of space they require.

Body motions that are logically or habitually related and have a reasonably well-defined starting and ending point define an activity. Activities are differentiated from the more basic body motions that shape them, called *actones* (Thiel, forthcoming), as well as the sequences of activities that shape larger patterns of behavior, called *tasks*. For example, when retrieving a file from a workstation file cabinet a worker may push back and turn the office chair, stand and turn toward the desired cabinet, walk across the office floor, open the cabinet and select the file, turn toward the desk, walk back, sit down, turn the chair, and move it back into position at the desk. It is easy to describe the task of retrieving a file as being composed of several distinct subtasks such as pushing back and turning the chair. These subtasks are activities. Similarly, the activities are composed of other, subtle body motions such as head, arm, hand, and leg movements that are actones.[2]

Actones, activities, and tasks have other distinctions that help differentiate them. Tasks are more obviously related to inhabitant goals than are either actones or activities. Examples for an office environment include using the copy machine, fax, or other resource; walking; using facilities such as the restroom or water fountain; and meeting with other co-workers. Activities may have a function, such as reaching for the phone, bending over to pick up something on the floor, and so on, but generally require the presence of other linked activities to be understood in terms of overall goals. Actones tend to be simple manipulations of body parts that are linked to form recognizable activities. As such, their relationship to goals is not always easily identified when viewed in isolation. Exceptions are writing, typing, talking, or other activities that require minimal body motion. Actones are also normally localized to a single place—that is, they are body centered—whereas activities and tasks often involve movement of the body to a new place and can be best described by an external reference system. For example, walking involves moving arms and legs in a coordinated and repetitive cycle. The arm and leg motions, when observed from the perspective of the body, appear simply repetitive and without a clear association to activities, tasks, or goals. These localized and isolated motions are actones. However, when observed from a stationary position outside the body, the arms and leg motions clearly have the purpose of moving the body and together define the "walking" activity.

[2]See also Perin (1970) for a detailed discussion of behavioral analysis in terms of behavioral circuits and actions and the implications for environmental design.

This taxonomy of body motion provides a convenient way to describe complex goal-achieving behavior in terms of less complex components. Similarly, the space required to accomplish a task can be determined by the space required for constituent activities.

The Body-Motion Envelope

Every human activity sweeps out a volume of space, no matter how simple or complex the body motions. This volume of space is called the BME. One way of visualizing what the BME might look like is to imagine that an activity is performed inside a semirigid plastic bag (with breathing holes, of course). As the activity progresses, a person stretches the plastic bag just enough to allow room for the most extreme body motions. When the activity is completed, the plastic bag retains its shape and provides a permanent record of the minimum space required for this particular sequence of body movements. Figure 6.1 shows how the plastic BME might look surrounding two activities: a man putting on a coat and a woman turning in her office chair.

If an individual performed an activity exactly the same way and in the same location and position every time, then the BME would perfectly define the shape and volume of a minimum enclosure for that activity. Of course this is never the case, and to be useful the BME must be able to account for variations in the size, shape, and behavior of people.

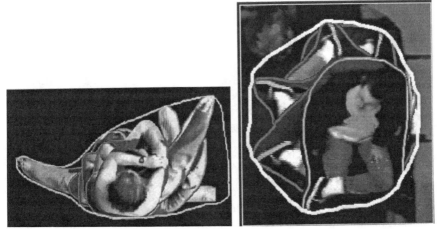

Man Putting on Coat Women Turning 180° in Chair

Figure 6.1. Estimating a body-motion-envelope (BME).

HUMAN VARIABILITY VERSUS ENVIRONMENTAL CONSTRAINT

> Most naturally occurring systems exhibit extreme variability—seemingly to the point
> of randomness. Yet despite the irregularities, natural systems are clearly constrained to
> ordering principles that reflect the fundamental limitations of physical dimensionality.
> (West & Goldberger, 1987, p. 354)

There is significant variability in how people go about their daily activities, yet there is an understandable pattern to these movements when the behavioral goals and setting are considered. For example, we expect to see variation in the patterns of motion when observing a worker leave his or her desk in an office setting. The person might spin the chair around before standing one time, push back the chair before turning it the next time, or push back and stand up without turning the chair at another time. If we knew nothing about the purpose for the body motions that we were observing and the physical constraints of the setting, then these variations might appear to belong to different activities or even be random. However, our knowledge concerning the worker's goals, associated behavior patterns, and the setting for those patterns allows us to recognize that the motions belong to classes of goal-directed behavior that we call tasks, such as "getting up to retrieve a file." Knowing this we can begin to classify the constituent activities that make up each task and make note of the variations in movement that are observed. This process of observation and classification soon results in a finite set of variations for each activity observed, as described in the example given here.

Variations in human movement belong to one of four types (see Figure 6.2). Each of these types is called a "degree of freedom." There may be variations in the location and angular orientation (hereafter referred to as "position") of an activity, the way in which the activity is performed, or the size and shape of person performing the activity. The different ways that activities are performed are referred to as behavioral variability, and the different sizes and shapes of people are referred to as anthropometric variability. If an individual performs an activity exactly the same way and in the same location and position every time, then there would be no degrees of freedom exercised. The BME in this case would be the minimum possible, as illustrated in Figure 6.1.

As different people are observed performing an activity, the behavioral and anthropometric variations combine to modify a minimum body motion envelope according to a probability function. The probability function is a statistical distribution of the space taken by the population observed. Figure 6.3 shows the activities from Figure 6.1 again with a series of shaded envelopes added. Each of these differently shaded envelopes represents the shape and size of BME that would be expected for different quintiles of an observed population. Greater observed variation in body size and behavioral variation is represented by larger envelopes. Conversely, areas where nearly all members of the observed population may be found while performing an activity are represented by the darkest,

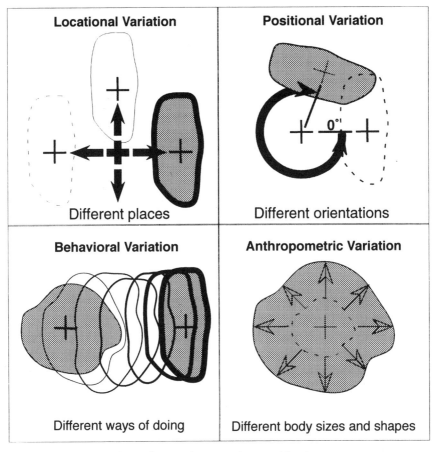

Figure 6.2. Body-motion degrees of freedom.

central envelopes. The BME and its associated probability "shells" provide a concise representation of the space required to accommodate an activity with all of its observed variations.

The environment can constrain our activities by restricting our freedoms of locational, positional, anthropometric, and behavioral variety. This is illustrated in Figure 6.4, where the setting is too small for a typical activity. Initially there is no position or location that will allow the BME to fit within the space available for it. However, the BME may be made to fit by one or more geometric manipulations. For example, the BME can be reduced in size without changing its shape until it fits. This size change corresponds to decreasing the size of the person that will be accommodated by the space when performing the activity without

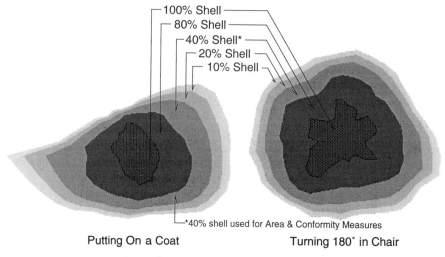

Figure 6.3. BMEs with probability shells.

requiring behavioral adaptation. Alternatively, the BME can be deformed in several ways to fit the available space. These shape changes correspond to reducing the behavioral variety of the larger quintile of potential inhabitants; that is, the activity can now only be performed in ways that conform to the narrow space. Typically, some combination of these constraints would be observed, depending on the characteristics and preferences of the inhabitant. For example, a small person would be required to adapt less than a larger person.

A space that does not accommodate the BMEs of the activities for which it is designed will constrain one or more degrees of freedom of its inhabitants. A method of analysis, called ISOKIN,[3] has been developed to quantify the essential tradeoff demanded in the design of potentially constraining spaces intended for human activity. It is a tradeoff between environmental constraint and human variability. The ISOKIN model proposes that inhabitants will prefer environments that accommodate desirable levels of human variability. Table 6.1 includes a more detailed listing of the propositions underlying the development of ISOKIN.

With ISOKIN analysis we can begin to predict the probability that a particular environmental design will allow for desirable levels of human variability. In this way ISOKIN may be thought of as less a "theory of fit" between inhabitant(s) and environment and more a theory of environmental affordance. For

[3]The name ISOKIN is derived from the Greek *iso*, meaning equal, and *kine*, to move. Together they refer to the contours of equal valued movement represented by probability shells (see Figure 6.3).

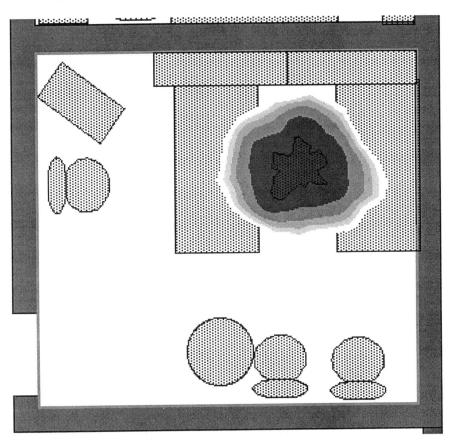

Figure 6.4. Little space to turn a chair.

example, a space may be adequately designed to fit normative architectural standards for certain kinds of use (e.g., workspace, restroom stall, building entry, etc.), yet badly fail to support or tolerate common variances from this mean. The dysfunction of some environments for "large" or "small" people and those with "disabilities" is a common example. However, much less obvious examples can also be important sources of irritation, such as placement of copy machines in main circulation corridors, workspaces that double as access paths to shared resources, and furnishings that won't allow chairs to be pulled up close to worksurfaces without interference with armrests. The ISOKIN measures introduced in the next section quantify how well an environment accommodates the diverse nature of human activities and thereby predict how changes in the arrangement of space may impact the inhabitant's sense of environmental quality.

Table 6.1. Propositions of the ISOKIN Model

1. A space is more habitable if it allows an activity or set of activities to be performed in alternative positions (i.e., orientation) and locations within the space without haptic-kinesthetic interference. These degrees of freedom represent enhanced positional and locational variety.
2. A space is more habitable if it allows an activity or set of activities to be performed in alternative ways without haptic-kinesthetic interference (including the use of wheelchairs, crutches, or other physical aid). This freedom represents enhanced behavioral variety.
3. A space is more habitable if it is as accommodating to the largest inhabitant as it is to the smallest inhabitant. That is, if a space fails to accommodate the activities of the largest member of an inhabiting population without haptic-kinesthetic interference, then the space is considered less habitable than one that does. This degree of freedom represents enhanced anthropometric variety.
4. A space is more habitable if it is experienced as having quantitatively less haptic-kinesthetic interference and qualitatively less severe haptic-kinesthetic interference.
5. The behavioral and anthropometric degrees of variety freedom combine to modify an absolute minimum habitable space requirement (in terms of shape and volume) according to a probability function; this function is uniquely defined for every set of human activities in terms of expanding regions of decreasing probability of interference.
6. A space that is perceived as more habitable will be preferred over others.
7. A direct relationship exists between the computed level of habitability of a space and a user's self-reported level of satisfaction with the space.
8. A direct relationship exists between the computed level of habitability and a user's self-reported level of task-related productivity within a space.

PROPOSED QUANTITATIVE MEASURES

A Sectional Approach to Three-Dimensional Analysis

As previously described, BMEs are complex surfaces in three-dimensional space that just enclose the space needed to perform an activity. ISOKIN analysis seeks to quantify how well interior space accommodates a set of BMEs. This section describes how this complex three-dimensional analytical problem can be reduced to a simpler two-dimensional problem.

Computing surface measures of three-dimensional objects is too complex and time-consuming for manual methods or even most personal computers. Lantrip (1988) describes several approaches used by various authors to mathematically characterize such enclosing surfaces. However, a section-by-section analysis of the BME and enclosing volumes (e.g., like slicing a hard-boiled egg) allows the use of simplified two-dimensional measures at each section level. The results of all sectional analyses can then be integrated to form unified volumetric measures. The number of "Z-sections" (i.e., horizontal slices through the volumes) analyzed is a function of the desired accuracy of the results. If a greater level of accuracy is desired, then more, thinner, sections can be sliced through the volumes. If less detail is required, then a projection of all the Z-sections onto a

horizontal plane (i.e., as if looking from the ceiling) provides a two-dimensional approximation of the three-dimensional problem. The two-dimensional approximation provides identical results to the three-dimensional analysis in the case where all environmental objects and BMEs are uniform in cross-section over the entire height of the space. However, generally the two dimensional (projection) analysis results in lower estimates of how much space is available for specific activities, as compared with a three-dimensional analysis, which would compute measures over sections at several heights and then average the results. The magnitude of underestimation depends primarily on the number of furnishings that have activity space above or below them. Figure 6.5 illustrates the concept of sectional analysis for a hypothetical BME and enclosure.

Types of ISOKIN Measures

ISOKIN measures belong to one of the three categories depending on whether they focus on (1) the area available for activities, (2) the shape of space available, or (3) direct environmental interference with activities. Area measures are sensitive to the difference between the amount of floor area required for activities and furnishings and the area that is available. Assuming there is enough space to accommodate an activity in at least one location and position, the

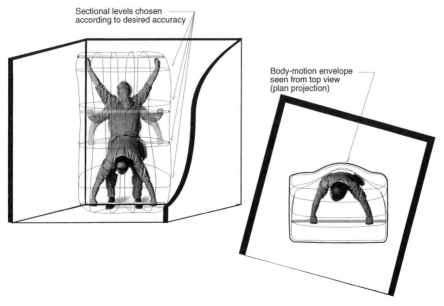

Figure 6.5. Three-dimensional view and plan projection of BME and enclosure.

area measures indicate the amount of variability in activity location and position that is possible in a space without interference and resulting behavioral adaptation. The measures concerned with differences in the shape between BME and enclosure are called conformity measures. The conformity index is particularly useful when space is "tight" and indicates if BME and enclosure can "nest" together efficiently because they are similarly elongated. Interference measures are most useful when there is some restriction to the positional variation of an activity in a desirable location. The interference measures then help assess the degree of potential inference to activities by furnishings or the activities of other inhabitants.

Each of the three categories of measures may be applied to individual spaces or to various groupings of spaces. The purpose for grouping spaces is to allow one group to be compared with another. For example, several alternative layouts for a hospital wing may be compared by using the means of measures computed for the various patient, staff, and public spaces. Special measures are defined for cases where multiple inhabitants are concurrently using a space. A more detailed description of these measures and their application is available in Lantrip (1986, 1988, 1990, 1993). Table 6.2 includes the definitions of the major ISOKIN measures by category.

COMPUTER ANALYSIS OF ENVIRONMENTAL CONSTRAINT

A computer program, called MacISOKIN, has been developed to compute ISOKIN measures. Figure 6.6 shows what is seen on the computer monitor when using MacISOKIN. The steps needed to set up and complete an analysis using MacISOKIN are summarized in the following example:

Step 1: Define Floor Plans

The first step is to define the space to be analyzed. With MacISOKIN this is done by either importing the floorplan from a computer-aided design (CAD) file or by drawing it on the computer screen with the drawing tools provided in the program. All or part of the floorplan may be analyzed. A zone line is added to specify the boundary of the interior space to be analyzed. Figure 6.7 shows two floorplans with gray zone lines that are ready to be analyzed.

Step 2: Consider Type of Analysis

The second step is to consider the kinds of analyses to be performed on the space. There are three types of analysis possible, and each type includes a different set of possible activities and ISOKIN measures.

Type I analysis addresses how the environment constrains activities that

Table 6.2. Summary of ISOKIN Measures

Area measures: Comparing how much space is needed with how much is provided

1. Total Enclosed Area (TEA): What is often called "floor area" in architectural literature; the total floor area enclosed by the walls or other space-defining elements (e.g., doorways, columns).
2. Gross-Free Area (GFA): The total enclosed area *minus* the area required for a specific activity (i.e., a body-motion envelope, or BME) and furnishings or other space occupying elements in the TEA.
3. Gross-Free Area Ratio (GFAR):[a] The dimensionless ratio of gross-free area to total enclosed area; GFAR = (GFA/TEA) × 100
4. Interference-Free Area (IFA): The *usable* area within an enclosure *for a specific activity* defined by an envelope of unrestricted movement. Area that is not accessible to the BME without deformation (i.e., without behavioral adaptation by user) is not included; IFA = GFA − unusable area
5. Interference-Free Area Ratio (IFAR):[a] A measure of spatial economy. The percentage of space *usable* for a specific activity relative to the total enclosed area; IFAR = (IFA/TEA) × 100

Conformity measures: Comparing the shape of space needed with the shape of space provided

6. Form Factor (FF): A ratio of the greatest linear distance between any two points within a BME or enclosure GFA to the diameter of a circle with the same area as the BME or enclosure. *Magnitude of shape elongation* is indicated relative to a circular standard; increasing L/d = greater elongation

$$FF_{BME} = L_{BME}/d_{BME} \text{ and } FF_{encl} = L_{encl}/d_{encl}; FF \geq 1.0$$

7. Conformity Index (CI):[a] The difference between enclosure and BME form factors; indicates similarity of BME and enclosure *shape* in terms of their elongation; CI = $FF_{encl} - FF_{BME}$

Interference measures: Assessing the potential impact of spatial constraint on activities

8. Radial Interference Margin (RIM): A measure of positional constraint or "margin of accommodation." The magnitude of separation (+) or overlap (−) of the maximum *radial* of a preferentially located BME with the minimum radial of an envelope; RIM = $R_{min}(enc) - R_{max}$ (BME)
9. Percentage of radial interference margin (PRIM):[a] A relative measure of radial interference, adjusted for BME size; PRIM = (RIM/$R_{BME,max}$) × 100
10. Total Angular Interference (TAI): A measure of positional constraint; degrees through which contact is observed between a rotating preferentially located BME and an enclosure.
11. Percentage of Angular Interference (PAI): The dimensionless form of TAI; PAI = (TAI/360) × 100
12. Adaptation Index (AI): The magnitude of radial and angular interference. The mean area of a preferentially located BME that overlaps the enclosure boundary as it changes position; AI = $(A_{out}/A)_{BME}$
13. Probability of Interference (POI):[a] Statistics and graphics indicating the probability that two or more activities will interfere due to space and scheduling constraints. POIR = POI/TEA

[a]Included in the ISOKIN Index of overall spatial constraint.

are highly variable in location and position. Turning around while standing or sitting or putting on one's coat are examples of these kinds of mobile activities. ISOKIN area and conformity measures, such as Gross Free Area, Interference-Free Area, and Conformity Index, are best at assessing the level of constraint on these activities. Results of Type I analysis indicate the affordance of the space for the full set of planned activities and range of degrees of freedom.

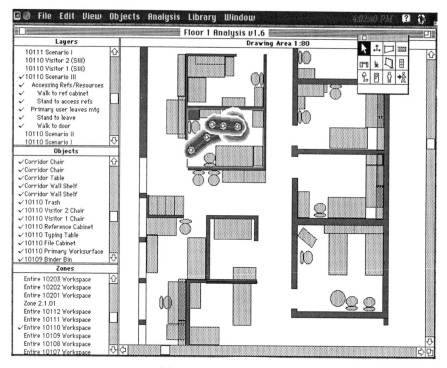

Figure 6.6. MacISOKIN computer program.

Type II analysis addresses how the environment constrains activities that are more likely to be performed in certain known locations than those in Type I analyses. Examples are activities associated with stationary resources such as desks, keyboards, counters, and copiers. The ISOKIN interference measures, such as Radial Interference Margin, Total Angle of Interference, Adaptation Index, and Probability of Interference, are best at assessing potential constraint to these activities due to proximate environmental surfaces. Results of Type II analyses indicate the extent of interference that is likely between included activities and proximate surfaces.

Type III analysis addresses the situation where several inhabitants are performing activities in the same space and at the same time. A typical office scenario used for this type of analysis is where the primary user leaves the workspace or accesses a reference cabinet while a visitor is sitting in the space. The Probability of Interference measure is used to provide a graphical and numerical indication of the extent of probable interference among concurrent activities.

These three types of ISOKIN analyses provide a rationale for selecting the

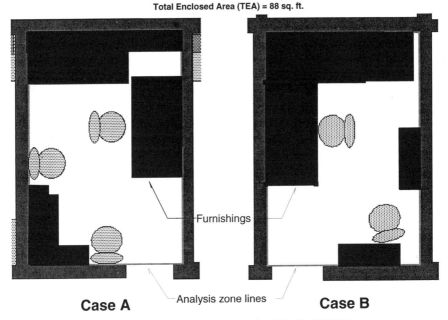

Figure 6.7. Floorplans to be analyzed by MacISOKIN.

activities and measures to be included in a study. Table 6.3 summarizes the activities and measures associated with each analysis type. For the current example, all three types of analysis will be demonstrated with the activities and measures listed in Table 6.3.

Step 3: Select Activities

Activities to be included in the analysis are selected in this step. These should be the activities most likely to be performed by the inhabitant(s) based on their roles and known behavioral goals. The space will be rated based on the mean level of constraint and/or interference that is probable for all included activities. MacISOKIN includes a library of BMEs that have been defined for the most frequently observed office activities. These BME shapes are selected one at a time from a list on the computer screen (see Figure 6.8) and then inserted into the floorplan and arranged into the place and position that is most likely to be observed for the activity. Figure 6.9 shows what the first BME for a Type I analysis look like after it has been placed in the floorplan. This procedure is repeated for activities in each of the three types of analysis until all BMEs for all participants are in place on the floorplan. Figure 6.10 shows the placement of all

Table 6.3. Three Types of Activities and ISOKIN Measures

Activities	Description	Measures
Type I: Single, mobile activities		
Standing turn, 90° Standing turn, 180° Sitting turn, 90° Sitting turn, 180° Don/doff clothing, purse, backpack, etc.	Activities included in this scenario are highly variable in location and position. ISOKIN area and conformity measures are best at assessing the level of constraint on this type of activity. Results indicate the tolerance of the space for the full set of planned activities and range of degrees of freedom.	TEA, GFA/GFAR, IFA/IFAR, CI
Type II: Single activities with preferred locations and/or positions		
Accessing files, standing Accessing files, sitting Leaning back in chair Standing up and sitting down at desk, 90° Standing up and sitting down at desk, 180° Opening desk top drawer Walk around chair Don/doff clothing, purse, backpack, etc. Sitting turn, 90° Sitting turn, 180°	Activities included in this type analysis are more likely to be performed in certain known locations than those in Type II. The ISOKIN interference measures are best at assessing potential constraint to activities due to proximate environmental surfaces. Results indicate the extent of interference that is likely between included activities and proximate surfaces.	RIM/PRIIM, TAI/ PAI, AI, POL/ POIR
Type III: Multiple activities		
Primary user leaves meeting (standing up with walking, and visitor and co-user sitting) Accessing references/ resources during meeting (standing up with walking, and visitor and co-user sitting)	Type III addresses the situation when several people are performing activities in the same space and at the same time. The POI measure provides a graphical and numerical indication of the extent of probable interference among concurrent activities. The activities of the primary user in the presence of sitting visitors and co-user are considered.	POR/POIR

Figure 6.8. MacISOKIN library of BMEs.

activities for a Type III scenario. MacISOKIN has the capability to keep track of which inhabitant performs which activity so that only activities done by different inhabitants will interfere with each other. Any activity, however, can be interfered with by environmental surfaces or boundaries.

Step 4: Select Measures

In step four, the desired measures must be selected from a list in MacISOKIN and computed. Only measures belonging to one analysis type are computed at a time. Each selected measure is computed for every activity included in the analysis type category.

Step 5: Interpret Results

When the computer computations are complete, a report is displayed that lists the measure values and their means for all activities and zones included in the analysis. Figure 6.11 shows excerpts from the report for Type I, II, and III analyses of the example space.

Graphic output is also provided that illustrates the results of Type I and III analyses. Figure 6.12 shows the graphics results for the Type I analysis. The

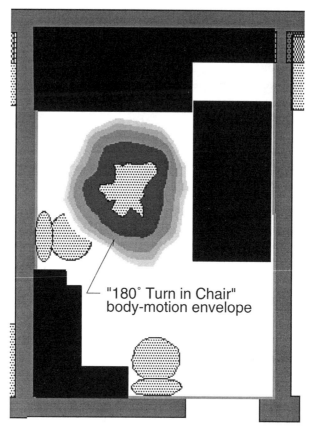

"180° Turn in Chair"
body-motion envelope

Figure 6.9. First BME placed at preferred location in floorplan.

lightest shade indicates the area that is interference-free for the "standing turn" Type I activity. Graphics of this type can be used to quickly learn where space is not accessible to inhabitants for the activities they perform (that is, without behavioral adaptation). Figure 6.13 shows the graphics results for the Type III analysis. This graphic shows the pattern of probable interference between concurrent activities in the space; the darkest areas represent the areas of highest probable interference.[4] Reference to Figure 6.10 shows that for Case A, the darkest areas correspond to interference between "standing up" and "walking" BMEs of the primary inhabitant and the "sitting" BME of a visitor. In Case B, the major interference is between the inhabitant accessing a reference cabinet and a

[4]The computer display is color-coded so that areas of greatest probable interference are more easily distinguished than with gray shades.

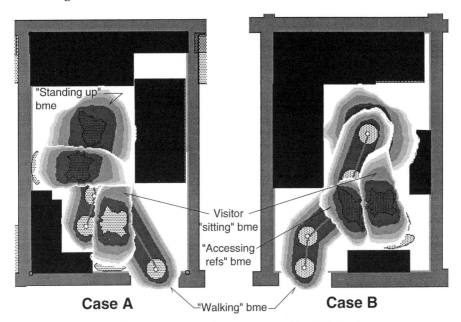

Figure 6.10. Floorplan with concurrent activity BMEs in place.

sitting visitor. In both cases the graphic results clearly illustrate how the layout of the workspace has constrained the placement of a visitor to locations and positions that will interfere with likely activities of the inhabitant.

The results of ISOKIN analysis can be interpreted using three different approaches. Graphics results retain the spatial nature of the problem and can be easily interpreted in terms of helpful design interventions. As shown in Figures 6.12 and 6.13, it is not difficult to identify where the placements of certain furnishings or overall space dimensions are causing unnecessary constraint on inhabitants. An iterative process of design improvement is possible using only Type I and III graphics output. However, when all of the obvious interventions have been considered a second approach is to refer to the numerical results.

The most useful numerical results are the mean measure values. These are mean values computed for all activities included in an analysis. For some analyses particular measures, such as the interference-free area or probability of interference, are sufficient to get a quick idea of where to make design improvements. When a more thorough analysis is desired, as in the later stages of design or when an environmental evaluation is being performed, a composite measure can be computed that includes the contributions of several ISOKIN measures. The following overall ISOKIN index was derived from an empirical study designed to test the relationship of ISOKIN measures to perceived quality of and satisfac-

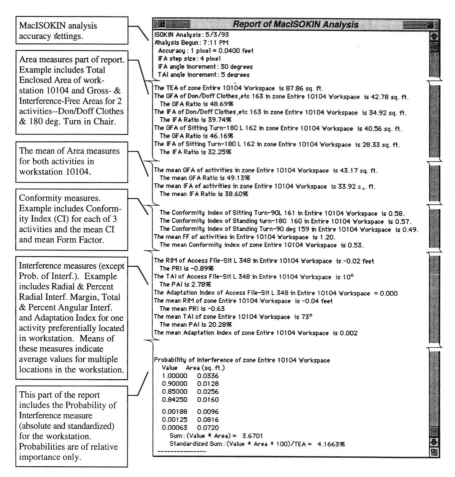

Figure 6.11. Excerpts of a MacISOKIN report.

tion with environments (Lantrip, 1993). Selected measures are weighted so that each contributes an equal amount of variance to the index (i.e., the index and measures are standardized).[5] Note that conformity and probability of interference measures are negatively weighted because their increasing value must decrease the ISOKIN Index of environment performance.

[5]Only those measures that (1) contribute to a high Cronbach alpha (reliability) and (2) show a strong predictive relationship to perceived environmental quality by office inhabitants are included in the ISOKIN Index equation. GFAR, IFAR, PRIM, and POIR are the dimensionless forms of GFA, IFA, RIM, and POI. Table 6.2 includes the definitions of these ISOKIN measures.

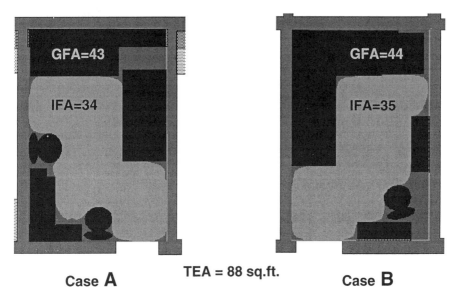

Figure 6.12. Graphic results of Type I MacISOKIN analysis. GFA, gross-free area; IFA, interference-free area.

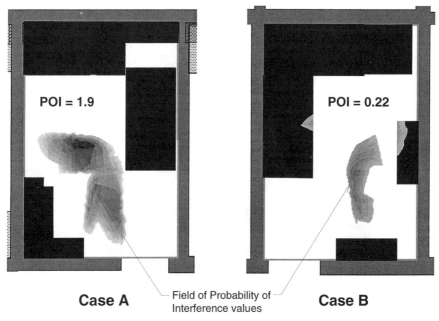

Figure 6.13. Graphic results of Type III MacISOKIN Analysis. POI, probability of interference.

ISOKIN Index = 0.10 GFAR + 0.08 IFAR − 7.29 CI + 0.05 PRIM − 3.43 POIR1 − 1.82 POIR2 − 2.33

The empirical study showed that the ISOKIN Index is a significant indicator of the perceived environmental quality and environmental satisfaction of work-space inhabitants. This relationship is reflected in Figure 6.14 where the ISOKIN Index of environmental quality varies systematically with measures of perceived quality and satisfaction in the expected direction. Accordingly, this index may be useful in deciding which design changes are most likely to improve an inhabitant's assessment of environmental quality.

A third way of interpreting the results of ISOKIN analysis data is to use the ISOKIN Index as an absolute indicator of habitability, that is, to assess the "goodness" of a space design based on the Index value alone. Empirically based measures of this type tend to be reliable only for a narrow range of situations where thorough testing has validated them. Hence, use of the Index as a general indicator of environmental quality will likely yield unpredictable results.

CONCLUSION

The theory and methods described here hold promise for improving the quality of our built environments and our lives. None of us is immune to the handicapping influences of our environment, although there are obvious differences in the abilities of some people to adapt both their environment and their

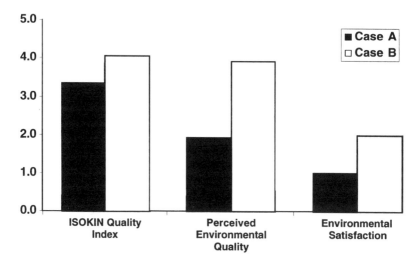

Figure 6.14. ISOKIN index of quality as a predictor of environmental quality and satisfaction.

behavior to reduce the negative effects. Clearly the less able-bodied of us will benefit the most from environments that accommodate a diversity of human needs and abilities. This work offers a theoretical and methodological framework for creating more of these high-quality environments, as well as a means for quantifying and visualizing the handicapping influences of less satisfactory environments. The theory presented here is important because it clarifies the often muddy role of environmental research and gives it the power to usefully inform design. The methods are important because they operationalize the integrative, transactional view of environment–behavior phenomena. Together, the theory and methods are tools for creating environments that fully enable, rather than handicap, their inhabitants.

REFERENCES

Altman, I., & Rogoff, B. (1987). World views in psychology: Trait, interactional, organismic, and transactional perspectives. In D. Stokols & I. Altman (Eds.), *Handbook of environmental psychology* (pp. 7–40). New York: Wiley.

Baum, A., & Epstein, Y. M. (1978). *Human response to crowding.* Hillsdale, NJ: Erlbaum.

Baum, A., & Paulus, P. B. (1987). Crowding. In D. Stokols & I. Altman (Eds.), *Handbook of environmental psychology* (pp. 533–570). New York: Wiley.

Brill, M., Margulis, S., & Konar, E. (1984). *Using office design to increase productivity.* Buffalo, NY: Workplace Design and Productivity.

Brunswik, E. (1956). *Perception and the representative design of experiments (2nd ed.).* Berkeley: University of California Press.

Churchman, A., Stokols, D., Scharf, T., & Nishimoto, R. (1990, July). *Measuring environmental change in the office: A contextual approach.* Paper presented at the 22nd International Congress of Applied Psychology, Kyoto, Japan.

Flynn, J. E., & Spencer, T. J. (1977, April). The effects of light source color on user impression and satisfaction. *Journal of the Illumination Engineering Society,* 167–179.

Fowler, Jr., & Floyd, J. (1988). Survey research methods. Newbury Park, CA: Sage.

Gibson, J. J. (1979). *The ecological approach to visual perception.* Boston: Houghton-Mifflin.

Heimsath, C. (1977). *Behavioral architecture.* New York: McGraw-Hill.

Lantrip, D. B. (1986). ISOKIN: A quantitative model of the kinesthetic aspects of spatial habitability. In *Proceedings of Human Factors Society 30th Annual Meeting, 1* (pp. 33–37). Dayton, OH: Human Factors Society.

Lantrip, D. B. (1988). *The design and analysis of space for haptic and kinesthetic habitability.* Unpublished masters thesis, University of Washington.

Lantrip, D. B. (1990). The built environment as a constraint to human freedom: An activity-based stochastic model. In R. I. Selby, K. H. Anthony, J. Choi, & B. Orland (Ed.), *Proceedings of 21st Annual Conference of the Environmental Design Research Association (EDRA)* (pp. 52–63). Denver, CO: EDRA.

Lantrip, D. B. (1993). *Environmental constraint of human movement: A case study of the effects on office worker environmental satisfaction and self-rated productivity.* Ph.D. dissertation, University of Michigan.

Marans, R. W., & Yan, X. (1989). Lighting quality and environmental satisfaction in open and enclosed offices. *Journal of Architectural and Planning Research, 6*(2), 118–131.

Oldham, G. R. (1988). Effects of changes in workspace partitions and spatial density on employee reactions: A quasi-experiment. *Journal of Applied Psychology, 73*(2), 253–258.

Perin, C. (1970). *With man in mind: An interdisciplinary prospectus for environmental design.* Cambridge, MA: MIT Press.

Pophan, W. J. (1979). *Criterion-referenced measurement.* Englewood Cliffs, NJ: Prentice-Hall.

Spreckelmeyer, K. F. (1993). Office relocation and environmental change: A case study. *Environment and Behavior, 25*(2), 181–204.

Stokols, D. (1986). New tools for evaluating facilities design and productivity. In *7th Annual Conference of the International Facility Management Association.* Chicago: IFMA.

Sundstrom, E., & Altman, I. (1989). Physical environments and work-group effectiveness. *Research in Organizational Behavior, 11*, 175–209.

Thiel, P. (forthcoming). *The stream of experience: Notations for an experienciable envirotecture.* Seattle: College of Architecture and Urban Planning, University of Washington.

West, B. J., & Goldberger, A. L. (1987, July–August). Physiology in fractal dimensions. *American Scientist, 75*, 354–365.

Wohlwill, J. F. (1974). Human response to levels of environmental stimulation. *Human Ecology, 2*, 127–147.

7

Assessing Special Care Units for Dementia

The Professional Environmental Assessment Protocol

Carolyn Norris-Baker, Gerald D. Weisman, M. Powell Lawton, Philip Sloane, and Migette Kaup

INTRODUCTION

Although much effort has been devoted to developing conceptually based approaches for measuring environment, tools for assessing physical environments remain relatively underdeveloped, and instruments to assess environments designed to care for people with dementia reflect this situation. The Professional Environmental Assessment Protocol (PEAP) has been developed to provide a standardized method of expert evaluation of special care units (SCUs) for people with dementing illnesses such as Alzheimer's disease and related disorders.

Carolyn Norris-Baker • Center for Aging, Kansas State University, Manhattan, Kansas 66506-1102. **Gerald D. Weisman** • Department of Architecture, University of Wisconsin, Milwaukee, Wisconsin 53201. **M. Powell Lawton** • Philadelphia Geriatric Center, Philadelphia, Pennsylvania 19141-2996. **Philip Sloane** • Department of Family Medicine and Epidemiology, University of North Carolina, Chapel Hill, Chapel Hill, North Carolina 27599. **Migette Kaup** • The Ken Ebert Design Group, Manhattan, Kansas 66502.

Enabling Environments: Measuring the Impact of Environment on Disability and Rehabilitation, edited by Edward Steinfeld and G. Scott Danford. Kluwer Academic/Plenum Publishers. 1999.

Although the primary focus of the PEAP is the physical setting, the assessment is conducted within an understanding of the larger context of the social, organizational, and policy environment. This chapter reviews the conceptual and methodological foundations of the PEAP, describes its scales, provides information about its reliability, and illustrates its applications in comparing settings and in monitoring change within a single specialized care setting.

The environmental contexts of care for people with Alzheimer's disease and related dementing illnesses, as well as the potentially therapeutic role of physical, social, and organizational dimensions of the environment, have received increasing attention in recent years (Carp, 1994; Weisman et al., 1994). Systematic research, and consequently the measurements of these environments, is a recent phenomenon. Clinical knowledge of populations experiencing dementia gained during the 1970s and 1980s, provided a foundation for proposing aspects of the environment that might be therapeutic for people with dementia (Weisman, Calkins, & Sloane, 1994). Modifications to the caregiving environment and the creation of SCUs followed from these experiences. Although research to date suggests the therapeutic importance of environment in caring for people with dementia (Ohta & Ohta, 1988; Teresi, Lawton, Ory, & Holmes, 1994; U.S. Congress, 1992), the tools used to assess these environments, such as SCUs, and the conceptual foundations of such measurements have been diverse. Grant's (1994) recent commentary on conceptualizing and measuring physical environments in SCUs concluded that this area of research needs better conceptualization of the relationship between environment and outcomes among residents with dementing illnesses, better instruments to assess both SCUs and other long-term care environments, and better identification of the most salient environmental factors for residents experiencing different stages and subtypes of dementia. A major research initiative under the auspices of the National Institute on Aging (NIA) has been responding to these issues through its emphasis on the development of a set of common core measures, including the physical environment, among ten separate but coordinated research projects (Holmes, Ory, & Teresi, 1994).

Defining and measuring quality of SCU environments is challenging because the target population is diverse. While progressive dementias such as Alzheimer's disease produce profound changes over time, a single individual will differ widely in abilities and needs over the course of the illness, and disease expression will vary markedly between individuals. As a result, the therapeutic dimensions of an environment that serves persons with dementia need to support the varying consequences of dementia. In addition, since persons with dementia tend to be elderly, they also experience the varying consequences of aging and a high prevalence of conditions such as visual impairment, hearing impairment, and arthritis. For example, devices to assist orientation and wayfinding, such as signs indicating the presence and location of a bathroom, depend on the ability to read and comprehend symbols. These devices may be useful only in the early and middle stages of dementia, before language comprehension is lost. To be effec-

tive, such cues must be seen easily by aging eyes and be relevant to the individual's past experience. In rural Kansas, for example, staff members in one SCU reported that the most helpful symbol for older male residents was a pictograph of an outhouse placed on the bathroom door. In late dementia, direct visualization by having the toilet within the line of sight may be the most effective method of orienting residents (Namazi & Johnson, 1991a,b). Although measurement problems associated with individuals' changing abilities are critical, the PEAP focuses on the therapeutic environment as a whole, rather than on individual residents, and does not address this issue in its assessments.

CONCEPTUAL AND METHODOLOGICAL FOUNDATIONS

The assessment of environments for special care of people with dementing illnesses should include strategies that yield a comprehensive view of the varied impacts of the environmental context, including ways to document process as well as outcomes and identify unexpected as well as expected results. Such research is a complex task. Analyses completed by the Office of Technology Assessment (OTA) in 1992 concluded that "many of the potentially important characteristics of the units … are conceptually vague, difficult to define operationally, and difficult to measure" (U.S. Congress, 1992, p. 31). Paths researchers have taken toward developing measurement strategies for SCU environments reflect these challenges. Starting points have included (1) the socioecological approach developed by Moos and his colleagues, using assessments such as the Multidimensional Environmental Assessment Procedure (MEAP) (Moos & Lemke, 1979, 1988); (2) the individual competence–environmental press approach to environment and aging developed by Lawton and his colleagues (Lawton, 1986; Lawton & Nahemow, 1973); and (3) approaches based on the needs of people with dementing illnesses. This third approach relies on knowledge of the needs of this target population to guide informal conceptual analyses of the environment and aging literature to identify dimensions that express human needs and for which environmental facilitators for meeting the needs are evident.

The MEAP, which was developed to evaluate supportive residential environments for older people ranging from nursing facilities to congregate housing, focuses at the level of the facility. It includes dimensions of the organizational policy/program and aggregate resident and staff characteristics and a physical and architectural features checklist. Moos (1993) and his colleagues derived the physical environmental dimensions from his social ecological model: physical amenities, social-recreational aids, prosthetic aids, orientational aids, safety features, architectural choice, space availability, staff facilities, and community accessibility. While the MEAP is valuable for assessing many types of environments, its use for SCUs is problematic. Its global focus on the facility and its aggregate populations and its lack of targeting on dimensions most relevant to

dementing illnesses do not yield sufficiently focused and specific information about the SCU (Grant, 1994).

The second starting point for development—Lawton's ecological model of environment and aging—characterizes the environment in terms of its personal, group, suprapersonal, social, and physical dimensions. The model provides a conceptual framework through which to integrate the complex factors involved in dementing illnesses. In addition, the Environmental Docility Hypothesis derived from this model suggests that more vulnerable people are more easily affected by the qualities of their environment. Thus, people with dementing illnesses may both be more highly sensitive to universal needs, such as privacy or facilitation of social contact, and may also have unique environmental needs related to their dementia. This conceptual framework not only provides a framework for assessing multiple aspects of the environment, but also accommodates assessing needs that are relatively universal to all older people and needs that are unique to people with dementing illnesses.

Researchers who have contributed to the third strategy are numerous and represent both environment–aging and health care perspectives. Teresi et al. (1994) illustrate this approach in their discussion of the role of the physical environment in providing a safe, secure setting that supports the functioning of people with dementing illnesses (Calkins, 1988; Cohen & Day, 1993; Cohen & Weisman, 1991; Coons, 1985, 1991; Grant, 1994; Hyde, 1989; Lawton, Fulcomer, & Kleban, 1984; Sloane & Mathew, 1990, 1991; Weisman, Cohen, Ray, & Day, 1991; Zeisel, Hyde, & Levkoff, 1994). They concluded that minimum environmental assessments should include items evaluating awareness and orientation, environmental stimulation and challenge, support of functional ability, safety and security, positive social milieu, privacy and control, healthy and familiar environment, and general comfort. They also noted the continuing need to examine the reliability and validity of assessment instruments and the greater reliability achieved by measuring objective environmental domains such as safety and security in contrast to subjective ones such as general comfort. The therapeutic qualities of SCUs also have been described in terms of their differences from comparison units, as well as in typologies of units and variations in physical aspects of different unit types (Gold, Sloane, Mathew, Bleats, & Konanc, 1991; Grant, 1994; Holmes, Teresi, & Monaco, 1992; Sloane & Mathew, 1991).

A variety of measures have been employed to obtain information on SCU environments. Weisman et al.'s (1994) analysis of past research identified three key issues related to the conceptualization and measurement of the SCU environment: the level of conceptualization (global/macro or discrete/micro), the specific dimensions in which the environment is defined (including relationships among those dimensions), and elements and properties of the SCU environment. The PEAP uses a midrange level of conceptualization, between the entire SCU as treatment and the discrete approach of measuring observable environmental characteristics. The instrument used most widely to assess SCU environments,

the Therapeutic Environmental Screening Scale (TESS) (Sloane & Mathew, 1990, 1991), uses a discrete conceptualization of environment. Its expanded version, the TESS 2+, was developed as part of the NIA collaborative projects and is being used as part of the common data set (Weisman et al., 1994). It consists of questions, ratings, and checklists completed by a trained observer conducting a walk-through of the SCU. Other scales include the Nursing Unit Rating Scale proposed by Grant (1994) and the Homelike Evaluation Scale proposed by Pastalan and his colleagues (1992).

PROFESSIONAL ENVIRONMENTAL ASSESSMENT PROTOCOL

PEAP has been developed to provide a standardized method of expert evaluation of SCUs for people with Alzheimer's disease and related dementias. It was conceptualized as an assessment that would require in-depth knowledge and professional expertise in person–environment relationships and design and would generate an independent criterion against which other instruments such as the TESS 2+ could be compared. It evaluates SCU settings with respect to eight dimensions of the "environment as experienced" that have been judged by consensus among a group of experts to be therapeutic with respect to the care of persons with dementia. These dimensions are similar to those identified by Teresi et al. (1994) and are listed and defined in Table 7.1.

The focus of the PEAP is the environment as experienced, encompassing not only the physical setting but also the philosophy of care and program, level of resident capability, constraints of regulations and budget, and other organizational, policy, and social contexts. Both an interview with administrative staff and approximately 2 hours of participant observation in the SCU are required to complete the assessment. The PEAP goes beyond simple documentation of objective properties of the setting as a whole (e.g., enumeration of spaces, calculation of square footage) to provide a more global set of evaluations of the environmental milieu for dementia care.

Three levels of the physical setting are considered in completing a PEAP. *Fixed or structural features* include those such as overall unit area and floor plan, or the presence or absence of windows. *Semi-fixed features* include less permanent architectural elements, such as the presence or absence of handrails and the type and condition of wall and floor surfaces. *Non-fixed features* include the presence of wall hangings, activity supplies, and endless other "props" that can play a critical role in the life of a setting.

Observers use field notes from their interview and observations to prepare a narrative description and evaluation of the SCU for each of the eight dimensions of environmental quality and to generate numerical ratings based on a 5-point scale for each dimension. In this study, the 20 SCU environments also were ranked-ordered in terms of a global judgment of the eight dimensions considered

Table 7.1. Professional Environmental Assessment Protocol (PEAP): A Standardized Method of Expert Evaluation of Dementia Care Units

I. *Maximize safety and security*: The extent to which the environment both minimizes threats to resident safety and security and maximizes sense of security of residents, staff, and family members

II. *Maximize awareness and orientation*: The extent to which users (often staff and visitors as well as residents) can effectively orient themselves to physical, social, and temporal dimensions of the environment

III. *Support functional abilities*: The extent to which the environment and the rules regarding the use of the environment support both the practice and continued use of everyday skills. These skills can be divided into activities of daily living (ambulation, grooming, bathing and toileting, eating, etc.) and independent activities of daily living, which will vary with stage of the disease

IV. *Facilitation of social contact*: The extent to which the physical environment and rules governing its use support social contact and interaction among residents

V. *Provision of privacy*: The extent to which input from (e.g., noise) and output to (e.g., confidential conversations) the larger environment are regulated

VI. *Opportunities for personal control*: The extent to which the physical environment and the rules regarding the use of the environment provide residents with opportunities consistent with level of acuity, for exercise of personal preference, choice, and independent initiative to determine what they will do and when it is done

VII. *Regulation and quality of stimulation*: People with dementia have decreased ability to deal with potentially conflicting stimuli and have greater difficulty distinguishing between foreground and background stimulation. Therefore, the environment must be sensitive to both the *quality* of stimulation and its *regulation* (assessed separately in this study). The goal is stimulation without stress

VIII. *Continuity of the self*: The extent to which the environment and the rules regarding its use attempt to preserve continuity between present and past environments and the self of past and present. This can be expressed in two different ways: through presence of personal items belonging to the individual and by creation of a noninstitutional ambiance

as a whole. The scale points for each dimension are (points in parentheses): exceptionally high support (5), high support (4), moderate support (3), low support (2), unusually limited or low support (1). When determining ratings, observers may note whether the unit seems high or low within the standardized definition, although examples of these data are not included here. Examples of the anchor point definitions for dimensions of safeguarding safety and security and of continuity of the self are described in the next sections.

Safety and Security

Unusually Low Level (1)

Exits to unsecured areas are neither controlled nor easily observed. Basic elements such as handrails may be ill placed or absent. Residents have easy access to potentially hazardous areas or elements. Flooring may be irregular or slippery.

Bath and/or toilet areas are cramped, compromising ability of staff to render assistance.

Exceptionally High Level (5)

Staff can easily and unobtrusively monitor residents' locations and activities. Problems of elopement are handled in a dignified and noninstitutional fashion. Traditional safety elements are well positioned and integrated into building design. There may even be handrails in the bedrooms for low-functioning residents, and few barriers to use these supports. Adequate floor area is provided for staff to assist with bathing and toileting, and equipment is nonthreatening to residents. Features that support competence but are potentially hazardous (e.g., stoves) are adequately secured.

Continuity of Self

Unusually Low Level (1)

Few or no efforts are made to respond to issues of individualization or ties to objects or patterns of daily activity associated with the past. Markers of institutional character are also present. Sameness, dullness, gloss, and deprivation may appear to be the rule.

Unusually High Level (5)

The only units warranting this rating will be those where most resident rooms include both article(s) of personal furniture and other items of personalization. In addition to extensive personalization, elements of a noninstitutional environment and continuity of familiar behavior patterns and lifestyle will be present. Examples include use of street clothes by staff; lack of visibility of institutional equipment; provisions for continuity of familiar behavior patterns, such as gardening; and naming events such as meals by customary terms (in rural Kansas, "dinner" is served at noon).

Since the PEAP assesses multiple aspects of the environment through both direct observation and interviews, it is possible to assess dimensions in which the physical setting and organizational context may be dissimilar. Thus, an SCU may be policy-strong or policy-weak, the physical environmental may be strong or weak, or an SCU may be relatively balanced on the physical and policy aspects of each dimension. For example, the assessment of a limited provision of privacy would require that privacy is compromised in one or two critical ways, which could result from rooms with more than two residents or no options for social spaces, but also might result from facility policy and staff activity that ignores residents' needs for privacy in a setting that provides for moderate levels of physical environmental privacy.

METHOD

After pretesting the PEAP at several sites in Milwaukee, additional raters were trained in Kansas. The training included reading information about dementia and the design of environments for people experiencing dementia, viewing videotapes of SCUs that described the therapeutic goals of the environments, observing SCUs to gain familiarity with assessing such settings, and practicing using the PEAP in facilities not included in the study, with extensive discussion after each practice assessment. After training was completed, raters used the PEAP to assess 20 SCUs in Kansas that ranged widely in size (8–64 residents) and staffing ratios, urban/suburban or rural town/small city locations (10 each), and included both purpose-built units and those that were adapted from existing construction in long-term care facilities. All units sampled had been participants in the portion of the NIA collaborative studies conducted in Kansas. Data were collected between January and June 1994. As part of the assessment protocol, administrators were asked to rate the therapeutic importance of each of the PEAP dimensions for their SCU. For 12 of the 20 units, two raters completed PEAP assessments simultaneously but independently to provide data for assessment of reliability. Data to answer questions of test/retest reliability over time were not obtained.

RELIABILITY

Although the sample for assessing reliability is small, results suggest that the PEAP has good potential for yielding reliable information among different raters. Interrater agreement between these assessments was evaluated in three ways, as shown in Table 7.2. First, percentage agreement, indicating the percentage of ratings for which both raters had the same score for each category, was deter-

Table 7.2. PEAP Interrater Agreement

Dimension	Percentage agreement	Spearman's rho	Weighted kappa
Safety and security	91.7	0.85	0.83
Awareness and orientation	66.7	0.75	0.74
Functional ability	75.0	0.83	0.83
Facilitation of social contact	58.3	0.76	0.69
Provision of privacy	75.0	0.69	0.71
Personal control	83.3	0.82	0.80
Regulation of stimulation	66.7	0.81	0.79
Quality of stimulation	66.7	0.76	0.76
Continuity of self	66.7	0.88	0.85

mined. It ranged from 91.7% for safety and security to 58.3% for facilitation of social contact. These results support the observation of Teresi et al. (1994) that more objective environmental domains are more reliably measured. Despite the low percentage agreement in some cases, the ratings never differed by greater than 1 point on the scale, which is reflected in the higher Spearman rho correlation coefficients and the weighted kappas. The Spearman's rho ranged from a high of .88 for continuity of self to a low of .69 for provision of privacy, although all dimensions except privacy reached or exceeded .75, and the majority exceeded .80. Finally, when kappas were calculated, the results ranged from .69 for facilitation of social contact to .85 for continuity of self. Generally, a kappa above .60 is considered good agreement, and a kappa above .80 is very good; thus, all PEAP dimensions demonstrated good or very good interrater agreement.

ILLUSTRATIVE PROFILES OF PEAP DATA

As Figure 7.1 demonstrates, the mean PEAP ratings centered around 3 for all 20 units. Very few units were judged to have scores of 1 or 5 on any dimension, suggesting a relative lack of variability among the units assessed. It is unclear whether this lack of variability is a product of the particular sample of SCUs or whether it indicates a limitation of the PEAP evaluation criteria. Figure 7.1 also highlights discrepancies between administrative goals and reality. The profile of mean administrative ratings suggests substantial gaps between the perception of the importance of particular dimensions by administrators and PEAP assessments of the units, with importance rated higher for all dimensions except awareness and orientation. However, the dimension of safety and security, most highly valued by administrators, was also the most consistently highly achieved dimension.

Figure 7.2 presents a subset of PEAP profiles across the eight dimensions that illustrate diversity as well as similarity among units. Data presented are from units at the top of each quartile of the ranking of SCUs by the global assessment of total therapeutic milieu (SCUs 1, 6, 11, 16) and the lowest-ranked unit (SCU 20). When mean ratings across the eight dimensions were calculated for each of the units, the five units ranked in the top quartile had a mean rating of 3.7; those in the next two quartiles had mean ratings of 3.4 and 2.9, respectively; and those in the lowest quartile had a mean rating of 2.1. Seldom did a unit score either 5 or 1 for any dimension. Some units, such as SCU 1, had relatively uniform ratings across the different dimensions, while others, such as SCU 20, were more varied. For safety and security, of greatest importance to administrators and most subject to regulations, the first, sixth, and eleventh ranked units all were judged to have high levels of support, which indicated that safety elements generally were present and well-handled, but that one or two less serious problems existed. In this sample, such problems frequently were the lack of adequate space in a bathing or

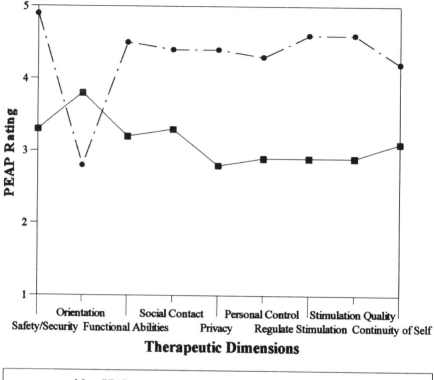

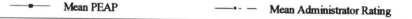

Figure 7.1. Mean PEAP and administrator ratings.

toileting area for staff to provide assistance easily, lack of high visibility for supervision of all exterior spaces, or hard, glossy flooring materials. The units ranked 16 and 20 both had moderate support, indicating that while exits were likely to be controlled and hazards minimized, staff surveillance of the unit was difficult and items such as handrails could have been provided in additional locations in areas such as bathing or toileting rooms.

The ratings for continuity of self reflect greater variance among the selected units. SCUs 1 and 6 provided high levels of support for continuity of self, including personalizationinresident rooms and a primarily noninstitutional appearance in common areas. Areas that support daily activities connected to the familiar past, such as kitchen or garden, were present but were limited in use by residents. SCU 11, providing moderate support, attempted to make the dominantly institutional environment more familiar by efforts to include personalization in resident rooms, with residential-style furnishing and variations in color and finishes. Raters concluded that SCU 16 offered only a low level of support for

Figure 7.2. Range of PEAP profiles for SCUs sampled.

continuity of self, with its distinctly institutional character and very limited, family-initiated attempts to personalize resident rooms. SCU 20 provided an example of a unit with unusually low levels of continuity, as described previously. However, it should be recognized that the PEAP intrinsically values preserving continuity through the use of objects that from a low-stimulation approach might be deemed inappropriate. SCU 20 adhered to such a reduced stimulation philosophy and thus would be expected to receive such a rating when assessed via the PEAP.

STIMULATING AND DOCUMENTING CHANGE IN AN SCU: A CASE STUDY

As a part of the assessment procedure, each unit was provided with recommendations for enhancing the therapeutic environment. These recommenda-

tions took the form of a three- or four-page document with suggestions specific to the particular unit. Ideas for possible modifications focused primarily on semi-fixed and nonfixed features that could be changed without major renovation. The recommendations were organized in terms of the therapeutic dimensions of the PEAP and were presented within the context of the current strengths and weaknesses of the SCU and the administrator's assessment of the relative importance of the eight therapeutic goals. The feedback was directed to both the administrator of the facility and the coordinator of the unit. Facilities were contacted to ensure that recommendations were received and to answer any questions that unit coordinators or administrators had about the recommendations.

An example from one SCU participating in the study illustrates ways in which the environmental information from the PEAP was used to stimulate modifications to the care environment. This SCU was ranked 10, in the midrange of those assessed, and is part of a not-for-profit Continuing Care Retirement Community (CCRC) on the edge of an urban area. The SCU had a rather institutional plan, with resident rooms opening off a double-loaded corridor and the dining, family, and kitchen areas grouped off a narrow hall near the entrance to the unit. The corridor contained several alcoves in the vicinity of the bathing area and ended in glass doors leading to an exterior space. The unit had 6 two-bedded rooms with wing wall separations and 4 single rooms, to accommodate a total of 16 residents. At the time of the initial PEAP assessment, the unit had recently added alarmed doors to reduce elopement, removed a door to increase its visibility from the family/activity area, and added some pictures in the corridor. Recent staffing and policy changes added mental health aides and a regular program of activities and eliminated restraints. Excerpts from observer field notes indicated that

> the unit still appears institutional in nature. Hard smooth surfaces dominate the interior spaces and the colors are cool blue pastels.... There are multiple seating options in both the hallway and the social areas. There is a kitchen area present, but it is used only for activities.... Residents on the unit seem very social [for this population]. They are relatively interactive, and contact and conversation with staff are frequent.

As Figure 7.3 shows, the initial assessment indicated that the unit was strongest in providing privacy, quality of stimulation, personal control, and social contact, although all the ratings were within a 1-point range. The unit was least effective in the areas of support for functional abilities, safety and security, and regulating stimulation. The recommendations provided after the initial assessment ranged from a variety of relatively inexpensive suggestions for the addition of props related to daily living to costly modification of the design of the unit to remove the narrow hall limiting visibility and access to the living, dining, kitchen, and patio area from the main corridor and resident rooms.

A second PEAP assessment was completed after 6 months. Although the same rater completed the PEAP, she did not review previous data or have

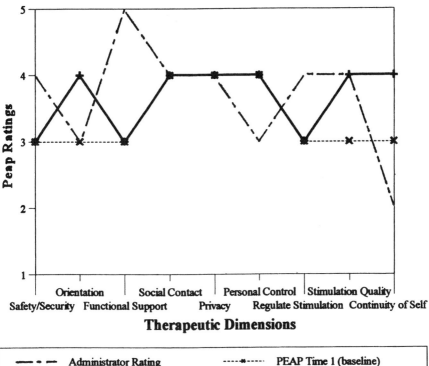

Figure 7.3. Case study of changes in PEAP ratings for SCU 10.

information about changes made. After the second PEAP was completed, an independent interview with staff was held and photographs documented changes made to the unit. The development of a secure outdoor patio, including tables and chairs and opportunities for gardening, was attributed to recommendations based on the initial PEAP. Since the second PEAP was completed in November, weather precluded residents from using the patio garden regularly. Changes in the main corridor included the addition of textured wall hangings, quilts, and Norman Rockwell prints and additional personalization at the doors to some resident rooms. In the dining area, round tables seating smaller numbers of residents had replaced larger, rectangular tables; more chairs were provided, and new curtains improved the control of glare. In the family and kitchen areas, many props had been added to increase the continuity with a homelike setting and the potential for maintaining or enhancing functional abilities. However, many of the kitchen area props, such as kitchen canisters, potholders and tea towels,

plastic utensils, and a coffee pot, were used primarily to enhance familiarity and orientation, rather than as part of daily activities in the unit.

The second PEAP (Figure 7.3) showed no change in dimensions where few modifications had been made, but modest changes in the dimensions that should have been influenced by the specific interventions. For example, no changes were identified in the rating for safety and security and no modifications had addressed the factors that had negatively influenced the original rating, such as hard, slick floor surfaces; glare resulting from daylight at the end of the main corridor; and limited visibility (and, consequently, difficult staff monitoring) between different activity areas in the unit. The hallways leading to the activities areas and the bathing area were too narrow to allow the installation of handrails. All of the modifications needed to improve safety and security were quite costly and had not been implemented at the second assessment. Changes identified through the pre- and postmodification PEAP (see Figure 7.3) included increases in ratings from moderate (3) to high (4) support of awareness and orientation, stimulation quality, and continuity of self. Ratings for support of functional abilities, facilitation of social contact, and regulation of stimulation did not change, but raters' field notes indicated small improvements insufficient to change the ratings for these dimensions.

Regulation and quality of stimulation provide examples of how specific modifications influenced PEAP ratings. Factors that contributed negatively to the rating of 3 (PEAP #1) for regulation of stimulation included the glare present due to flooring materials and corridor lighting, an unregulated public address (PA) system that introduced unpredictable noise, unregulated television noise, and the lack of sound absorption due to many hard surfaces. Problems with the quality of stimulation included lack of variation and contrast in colors; hard finishes that contributed to an institutional character; harsh, meaningless noise from the PA system; occasional institutional smells; lack of tactile variation and stimulation; and the lack of pleasant, homelike sources of stimulation such as props or smells. It is clear that the modifications listed earlier directly addressed some of these problems. The addition of the wall hangings and dining room remodeling mitigated some problems stemming from glare and noise. However, the persistence of unregulated PA and television noise, as well as continuing glare in the corridor, resulted in a continuing rating of moderate (3) for regulation of stimulation. At the same time, some of these same modifications contributed to improved ratings for awareness and orientation and for continuity of self. For example, the additions of wall hangings and quilts in the corridor provided both additional cues for orientation and greater continuity with residents' past lives. At the same time, addition of familiar props that helped enhance stimulation were not incorporated into residents' daily activities and programs, which might have resulted in increased support of functional abilities. As this example makes clear, modifications to the SCU environment may impact one or more of the PEAP

therapeutic dimensions or may have little impact at all, especially if the program and policy climate does not take advantage of all potential benefits.

SUMMARY

In summary, the PEAP employs the professional expertise of person–environment researchers and designers to carry out systematic, in-depth assessments of the environmental milieu of SCUs. It evaluates the environment as experienced in terms of the dimensions of maximizing safety and security, awareness, and orientation; supporting functional abilities; facilitating social contact; providing privacy; providing opportunities for personal control; providing appropriate stimulation that is both regulated and of quality; and preserving opportunities for continuity between past and present environments and past and present self. Each of these dimensions is based on a conceptual foundation that has inherent values associated with meeting basic or derived human needs. Unlike tools that enumerate objective components of the environment and are relatively value free, the PEAP includes integral evaluative aspects that reflect its conceptual origins. The research reported here suggests that trained raters using the PEAP independently generate assessments with acceptable levels of agreement. The relative lack of variability in the ratings generated for 20 SCUs, especially in terms of scores at the highest or lowest points of the scales, may be a function of this particular sample or may indicate potential problems with the PEAP scaling itself. Further studies of the instrument are needed to clarify this issue. The case study of one SCU suggests the potential of the PEAP to measure major environmental changes as well as stimulate modifications. The continued development and refinement of the PEAP, based on these initial data and concurrent research at other sites, should lead to a reliable tool that is a useful contribution to the developing arsenal of approaches for examining the complex issues associated with the therapeutic potential of the environmental milieu for people with dementing illnesses.

The PEAP should prove a valuable tool for both a freestanding evaluation and a component of a larger assessment battery. Although the PEAP dimensions were carefully chosen to represent those identified as most salient by the leading researchers in environmental assessment, that set must be viewed as potentially open-ended. It may well be that other investigators will profit by adding new dimensions should the evolution of design technology and conceptualization of service environments warrant such additions. Since the PEAP requires some level of sophistication in person–environment concepts and in long-term care, it might best be used by design professionals who have had experience in long-term care, by social researchers familiar with long-term care and person–environment concepts, or possibly by service professionals with sensitization to

both design and evaluation methods. It is very likely that most users will require a streamlined version of the type of training described in this chapter. Given this degree of training, PEAP ratings should be quite useful either as relatively abstract evaluation tools for research purposes or as clinical tools, as described in the case study. Further illumination regarding the PEAP's qualities will be forthcoming as its relationships to other measures such as the TESS become established. Analysis is underway (Sloane, in process) to identify shorter TESS item sets that can serve as relatively objective indicators of the more abstract PEAP dimensions. Future combined use of a shortened TESS and PEAP, performed independently by a research observer and trained professional respectively, should provide a richer and more cohesive picture than either tool used separately.

REFERENCES

Calkins, M. (1988). *Design for dementia: Planning environments for the elderly and confused.* Owings Mills, MD: National Health Publishing.

Carp, F. (1994). Assessing the environment. In M. P. Lawton & J. Teresi (Ed.), *Annual review of gerontology and geriatrics* (Vol. 14, pp. 324–352). New York: Springer.

Cohen, U., & Day, K. (1993). *Contemporary environments for people with dementia.* Baltimore: Johns Hopkins University Press.

Cohen, U., & Weisman, G. (1991). *Holding on to home: Designing environments for people with dementia.* Baltimore: John Hopkins University press.

Coons, D. (1985). Alive and well at Wesley Hall. *Quarterly: A Journal of Long Term Care, 21*(2), 10–14.

Coons, D. (1991). *Specialized dementia care units.* Baltimore: Johns Hopkins University Press.

Gold, D., Sloane, P., Mathew, L., Bleats, M., & Konanc, D. (1991). Special care units: A typology of care settings for memory-impaired older adults. *The Gerontologist, 31,* 4657–475.

Grant, L. (1994). Commentary: Conceptualizing and measuring social and physical environments in special care units. *Alzheimer's Disease and Associated Disorders, 8*(Suppl. 1), S321–S327.

Holmes, D., Teresi, J., & Monaco, C. (1992). Special care units in nursing homes: Prevalence in five states. *The Gerontologist, 32,* 191–196.

Holmes, D., Ory, M., & Teresi, J. (1994). Dementia special care: Overview of research policy and practice. *Alzheimer's Disease and Associated Disorders, 8*(Suppl. 1), S5–S13.

Hyde, J. (1989). The physical environment and the care of Alzheimer's patients: An experimental survey of Massachusetts's Alzheimer's units. *The American Journal of Alzheimer's Care and Related Disorders & Research, 4*(3), 36–44.

Lawton, M. P. (1986). *Environment and aging.* Albany, NY: Center for the Study of Aging.

Lawton, M. P., & Nahemow, L. (1973). Ecology and the aging process. In C. Eisdorfer & M. P. Lawton (Eds.), *The psychology of adult development and aging* (pp. 619–674). Washington, DC: American Psychological Association.

Lawton, M. P., Fulcomer, M., & Kleban, M. (1984). Architecture for the mentally impaired elderly. *Environment and Behavior, 16*(6), 730–757.

Moos, R. (1993). Conceptualizations of human environments. *American Psychologist, 28,* 652–655.

Moos, R., & Lemke, S. (1979). *Multiphasic Environmental Assessment Procedure (MEAP) manual.* Palo Alto, CA: Stanford University and VA Medical Center, Social Ecology Laboratory.

Moos, R., & Lemke, S. (1996). *Evaluating residential facilities: The Multiphasic Environmental Assessment Procedures.* Thousand Oak, CA: Sage.

Namazi, K., & Johnson, B. (1991a). Environmental effects on incontinence problems in Alzheimer's disease patients. *The American Journal of Alzheimer's Care and Related Disorders & Research, 6*, 16–21.

Namazi, K., & Johnson, B. (1991b). Physical environment cues to reduce the problems of incontinence in Alzheimer's disease units. *The American Journal of Alzheimer's Care and Related Disorders & Research, 6*, 22–28.

Ohta, R., & Ohta, B. (1988). Special care units for Alzheimer's disease patients: A critical look. *The Gerontologist, 28*, 803–808.

Pastalan, L., Sekulski, R., Jones, J., Schwarz, B., & Struble, L. (1992). *Homelike attributes of dementia Special Care Units.* Ann Arbor, MI: National Center on Housing and Living Arrangements for Older Americans, College of Architecture and Urban Planning, University of Michigan.

Sloane, P., & Mathew, L. (1990). The therapeutic environment screening scale. *The American Journal of Alzheimer's Care and Related Disorders & Research, 5*, 22–26.

Sloane, P., & Mathews, L. (1991). *Dementia units in long term care.* Baltimore: Johns Hopkins University Press.

Teresi, J., & Holmes, D. (1994). Overview of methodological issues in gerontological and geriatric research. In M. P. Lawton & J. Teresi (Ed.), *Annual review of gerontology and geriatrics* (Vol. 14, pp. 1–22). New York: Springer.

Teresi, J., Lawton, M. P., Ory, M., & Holmes, D. (1994). Measurement issues in chronic care populations: Dementia special care. *Alzheimer's Disease and Associated Disorders, 8* (Suppl. 1), S144–S183.

U.S. Congress, Office of Technology Assessment. (1992). *Special care units for people with Alzheimer's and other dementias: Consumer education, research, regulatory and reimbursement issues (OTA-H-543).* Washington, DC; U.S. Government Printing Office.

Weisman, G., Cohen, U., Ray, K., & Day, K. (1991). Architectural planning and design criteria for dementia care units. In D. Coons (Ed.), *Specialized dementia care units* (pp. 83–106). Baltimore: Johns Hopkins University Press.

Weisman, G., Calkins, M., & Sloane, P. (1994). The environmental context of special care. *Alzheimer's Disease and Associated Disorders, 8*(Suppl. 1), S308–S320.

Zeisel, J., Hyde, J., & Levkoff, S. (1994). Best practices: An environment–behavior (E-B) model for Alzheimer special care units. *American Journal of Alzheimer's Disease, 9*(2), 4–21.

8

Using Environmental Simulation to Test the Validity of Code Requirements

Jon A. Sanford and Mary Beth Megrew

INTRODUCTION

Environmental simulation is a means of matching the design of specific environmental features to human performance capabilities. When researchers systematically model realistic environments that people can move through and manipulate, subjects can comprehend both the level of effort required to use specific environmental features as well as the impact of size and proportions. Moreover, simulations permit observers to assess problems encountered with use and to identify limitations of the design directly, rather than having to rely on subjective evaluations of the user (Steinfeld, 1988). As a consequence, full-scale simulation affords the ability to evaluate the usability and safety of one or more environmental features under controlled conditions that are not available in the real world.

Jon A. Sanford and Mary Beth Megrew • Rehabilitation Research and Development Center, Atlanta Veterans Affairs Medical Center, Atlanta, Georgia 30306.

Enabling Environments: Measuring the Impact of Environment on Disability and Rehabilitation, edited by Edward Steinfeld and G. Scott Danford. Kluwer Academic/Plenum Publishers. 1999.

This is particularly useful in evaluating the performance and safety impacts of alternative environmental variables (Stokols, 1993).

Full-scale simulation has been used successfully in environmental design research, in facility planning, and in accessibility research (Bostrom, Malassigné, & Sanford, 1984; Clipson, 1993; Kuller & Mikellides, 1993; Lawrence, 1993; Marans, 1993). A variety of environments have been studied, including nursing home toilets, offices, and housing units. In each case, care was taken to simulate reality by reproducing a variety of elements that could be manipulated and examined under controlled conditions and in which individuals' varying behaviors under those conditions could be examined as well.

Full-scale simulation has been used quite frequently in accessibility research. Much of this work has focused on the development of new products (e.g., Bostrom et al., 1984; Sanford et al., 1994) for older individuals and people with disabilities and changes to accessibility codes and standards (e.g., Czaja & Steinfeld, 1980; Feuerstein, Steinfeld, Sanford, & Shiro, 1987; Johnson, 1981; Nichols, 1966; Sanford & Steinfeld, 1987; Steinfeld et al., 1979; Woods, 1980). This research approach has been highly effective in analyzing component tasks in the use of a particular environmental feature (e.g., reaching for a grab bar), identifying both general and unique needs of individuals and assessing how differences in environmental features (e.g., height and location of a grab bar) have an impact on the ability of individuals to complete routine tasks (e.g., get on and off a toilet). These data are particularly important when the intent of the research is to inform and provide guidance to design professionals on the design of environments that are more responsive to the needs of specific populations.

There is a growing body of evidence that older adults are one such population that could benefit from environments that are more responsive to their needs and capabilities. Chronic diseases often prevalent in older individuals can result in loss of mobility, agility, strength, and stamina. They have long-term effects on a person's capability to function independently in activities of daily living, jeopardize personal safety, and negatively affect quality of life.

The most common approach to providing environments that are responsive to older people, whether living in the community or in nursing homes, has been to adopt, by choice or law, environmental interventions based on the accessibility standards. Three major model codes regulate building accessibility in the public and private sectors.

- American National Standards Institute (ANSI) Standard (ANSI 117.1, 1992)
- Americans with Disabilities Act Accessibility Guidelines (ADAAG), promulgated by the Architectural and Transportation Barriers Compliance Board (Access Board) and with which buildings and facilities open to the general public must comply

- Uniform Federal Accessibility Standards, 1988 (UFAS), which meet the specifications in ADAAG and with which all construction by the federal government must comply

New construction and major renovation projects for nonresidential (e.g., health care facilities, including nursing homes) as well as some residential building types (e.g., apartments) must be in compliance with either ADAAG, UFAS, or local building codes (most of which are based on or reference ANSI A117.1) that meet or exceed ADAAG. Although one- and two-family residential buildings are typically exempted from accessibility regulations, most codes and standards specify minimum guidelines for the design of accessible bathrooms, kitchens, and entrances. Other code provisions that are relevant to housing (e.g., space and reach requirements) are also frequently used a guidelines for residential purposes. This use of accessibility codes as guidelines for residential construction is illustrated in a segment of the PBS series *This Old House* in which an addition was built according to accessibility guidelines in anticipation of the homeowner's aging mother moving in at some point in the future.

Despite efforts to mandate accessibility through laws and codes, Czaja (1984), Faletti (1984), Steinfeld and Shea (1993), and others have argued that accessible design features that are legally mandated are primarily based on the capabilities of young people, particularly those with mobility impairments (e.g., people with paraplegia) and may not always be appropriate for older individuals. Hiatt (1989) further noted that assistive devices, such as innovative grab bars, that would be responsive to the needs and capabilities of frail elderly, do not meet current accessibility requirements. The American Institute of Architects' publication on designing for older people (1985) states that portions of the ANSI standard are not recommended for general use by older individuals. Steinfeld and Shea (1993) suggest that "accessible designs" may do more to promote disability and dependence among older people than to ameliorate it. Thus, while the provision of accessible design features in buildings specifically designed for older people (e.g., nursing homes and independent living facilities) is legally mandated, there is concern that these features may not be responsive to their needs and capabilities.

The potential mismatch between functional ability and the responsiveness of accessible designs is particularly evident in the design of toilet facilities. Nonambulatory elderly individuals often experience difficulty transferring between a toilet and wheelchair. Many ambulatory older individuals have difficulty raising and lowering themselves on and off a toilet. Accessibility guidelines for grab bar placement in toilet rooms are based on an individual being able to pull himself or herself out of the wheelchair and across a toilet (Mace & Lasett, 1974). Whereas this design may be appropriate for young paraplegics with good upper body strength, there is no evidence that older people with common disorders

such as degenerative joint diseases and neuromuscular dysfunctions that affect strength, balance, mobility, and standing/stooping can use grab bars in the same manner. Thus, while the provision of accessible design features in buildings specifically designed for older people (e.g., nursing homes and independent living facilities) is legally mandated, the usefulness of these features for older individuals has not been adequately assessed.

In response to these concerns, this chapter reports the findings of a study that utilized environmental simulation to evaluate the effect of grab bar placement and toilet seat height on an older person's ability to toilet independently and safely. It was specifically hypothesized that different grab bar configurations (including those "built-to-code" as well as alternative designs that are intended to respond to the needs and capabilities of elderly people) have different impacts on the safety and independence of older people in toileting activities and that the safety and independence in toileting associated with different design configurations differ for ambulatory and nonambulatory older people. In addition, the chapter discusses the advantages and disadvantages of simulation as a research approach and the application of simulation to other types of environmental assessment.

METHODS

Research Design

This study addressed differences in safety and independence associated with two environmental features—grab bars and toilets—by varying the relationship between two characteristics—location and height. Specifically, a repeated measures design was used to evaluate four grab bar configurations, paired with two variations in toilet seat height.

Subjects

The research design called for a minimum of 100 participants, divided equally into two experimental groups—ambulatory and nonambulatory. Subjects had to be 60 years or older, able to transfer independently, and cognitively intact (to ensure comprehension of tasks and reliability of posttrial self-report data). Whereas most academic research has a readily available subject pool of college students, imposing restrictive criteria such as age limitations and disability creates a major problem in gaining access to subjects. In most cases, it is difficult and often expensive to locate and transport older individuals and those with disabilities to a laboratory site. The solution was to identify eldercare facilities that were willing to permit testing to occur on site, thus eliminating the need to find individual subjects and transport them to a single laboratory site.

One hundred sixteen subjects from the Atlanta Veterans Affairs Medical Center, two senior activity centers, an area adult daycare center, and three area long-term-care facilities in the Atlanta area, as well as at the C. J. Zablocki VA Hospital in Milwaukee, Wisconsin, and the Audie L. Murphy VA Hospitals in San Antonio, Texas, participated in the study. Sixty-six (56.9%) of the participants were ambulatory and 50 (43.1%) used wheelchairs. The ambulatory group was almost equally divided between males (51.5%) and females (48.5%), although males outnumbered the females by slightly more than 3:1 (76% versus 24%) in the nonambulatory group. This can be attributed to the largely male population of the three VA hospitals that were the source for most of the nonambulatory participants.

Equipment

Due to subject and site constrains, a portable, full-scale mockup of a toilet room that could be dismantled and transported, either locally by van or shipped across the United States, had to be constructed. To meet these specifications, the mockup had to be lightweight, yet able to support the weight of an individual during transfer. In addition, the unit had to be compact and free-standing to compensate for variations in spaces that were likely to be available for testing at participating sites. Metal partitions typically used in toilet rooms were selected. These partitions are constructed of 1/2-in. polystyrene sandwiched between two layers of metal, making them lightweight and able to safely accommodate grab bars. Moreover, because off-the-shelf components were used, the test unit could be easily modified for future research.

The mock-up had accommodations for two toilet seat heights (17 and 19 in.) and four grab bar configurations at two heights (33 and 36 in.), as well as for two cameras for videotaping the trials. Two 6-foot-long walls of the portable testing unit were set at right angles to each other and were marked with a 4-in. grid over their entire area (Figure 8.1). This grid was used in the analyses to indicate where the grab bars were grasped in each of the trials. To minimize time and effort to change test configurations, grab bars and toilet were mounted with standardized attachments and fastening systems that did not require tools to remove and affix (Figure 8.2). Finally, the unit was designed to permit the toilet and grab bars to be changed independently, thus creating flexibility to test different configurations and heights in future studies.

Specifications for the four grab bar configurations to be tested were based on common types of installations in VA nursing homes. These included one based on federal accessibility standards (which comply with ADAAG), two used in recently constructed VA nursing homes for which variances from the federal standards were granted (one that varied in length and placement of the grab bars and one using two side bars), and one that included a diagonal side bar (see Figures 8.3–8.10). The toilet heights tested (17 and 19 in.) and two grab bar heights (33 and 36

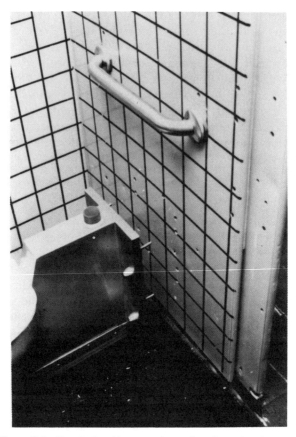

Figure 8.1. Four-inch grid over entire wall surface of testing unit.

in.) represented the minimum and maximum dimensions permitted by current standards.

Configuration 1 complied with ADAAG Section 4.16.4, Figure 29, for two horizontal grab bars placed perpendicular to each other (Figures 8.3 and 8.4). Although ADAAG Figure 29 specifies a 24-in. bar behind the toilet (water closet) for toilets not located in a stall and a 36-in. bar for toilets located in stalls. Configuration 1 consisted of a 20-in. grab bar positioned on the rear wall and centered on a toilet 18 in. (as specified in Figure 29) from the side wall. A longer, 44-in. bar (which exceeded ADAAG minimum of 42 in.) was posited on the side wall in compliance with ADAAG, beginning 12 in. from the rear wall and extending beyond the front of the toilet. Although the 20-in. bar did not meet ADAAG specifications, researchers considered that the 4-in. difference would permit the

Figure 8.2. Standardized attachments and fastening system used on test unit.

comparison of grab bar lengths below (20 in.) and above (44 in.) ADAAG requirements for both rear and side bars (see Configuration 2).

Configuration 2, like the first configuration, had grab bars placed at right angles on the side and rear walls. However, in this configuration the locations of the long and short grab bars were reversed (Figures 8.5 and 8.6). The longer grab bar (44 in.) was placed on the back wall, 8 in. from the side wall. The bar extended beyond the side of the toilet, located 18 in. on center from the side wall. The shorter grab bar (20 in.) was positioned on the side wall, beginning 12 in. from the back wall. This configuration was chosen because it had been used in retrofit designs in some VA nursing homes where the location of the existing bathroom door precluded the use of a longer bar beside the toilet.

Configuration 3 consisted of two European-designed grab bars that were not code compliant, but were intended to meet the needs of older individuals.

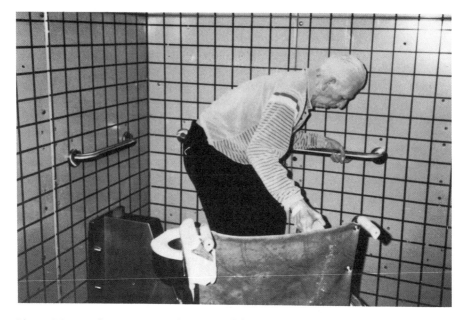

Figure 8.3. Configuration 1: typical ADAAG grab bar configuration for toilets not located in stalls.

Each grab bar was affixed to the rear wall (Figures 8.7 and 8.8) and extended 34 in. on either side of a toilet, located 48 in. on center from the side wall. No rear bar was provided. Both of the grab bars were hinged at the wall to swing up and out of the way when desired. The location of the toilet and the ability of the grab bars to pivot provided participants with opportunities to use one or both grab bars and to transfer onto the toilet from the front or from either side.

Configuration 4 added a third, diagonal bar to Configuration 2 (Figures 8.9 and 8.10). The 48-in. diagonal bar was placed at a 45° angle on the wall beside the toilet and in front of the shorter horizontal bar. The lower end of the diagonal bar was located 20 in. above the floor and 20 in. from the back wall. From the point, the bar angled up and outward, extending 72 in. above the floor and 72 in. from the back wall.

Procedures

After completion of the Folstein Mini-Mental Exam for cognitive screening and informed consent procedures, subjects were oriented to the experimental protocol. The protocol consisted of eight test trials (four grab bar configurations at two toilet heights) in which subjects were asked to approach and get on the toilet, stay seated for a few seconds, and get off. Participants were instructed to

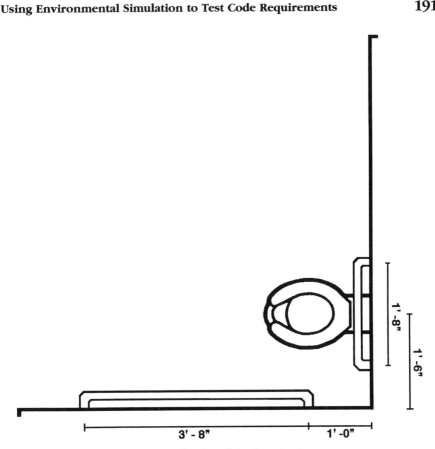

Figure 8.4. Plan of Configuration 1.

get on and off the toilet in any manner they could. Each trial was videotaped from the side by a tripod mounted camera and from overhead by a camera mounted on the test unit. After each trial, participants were asked to rate the safety, ease or difficulty of use, and helpfulness of the grab bars of each grab bar/ toilet configuration on a 5-point Likert scale. Upon completion of all trials, participants were given photographs of each configuration and asked to indicate which configuration they thought was the safest, least safe, easiest to use, and most difficult to use and which configuration was best for them.

Data Analysis

Each participant was tested on each of the four configurations twice, once in the high position and once in the low position, resulting in a total of 232 pos-

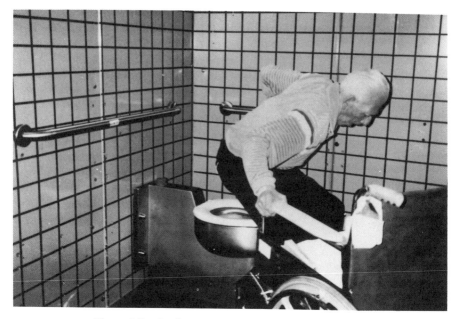

Figure 8.5. Configuration 2: reverse ADAAG configuration.

sible trials for each configuration. Videobased data of observed safety and independence was scored to identify the type and extent of usability problems (e.g., difficulty getting on the toilet), how and where grab bars were used, and time taken to perform each component task. Contingency tables and Chi-square analyses were used to identify differences between groups and the impact of design differences by determining the significance of self-report and video data, including ranking for safety, difficulty and helpfulness, frequency and location of grab bar use, and frequency of assistive device use.

RESULTS

Difficulty and Safety

As illustrated in Table 8.1, the nonambulatory group consistently rated Configuration 3 higher than any of the other configurations, preferred by more than twice as many participants as the second-rated configuration (Configuration 4). This was found for each category, including safest (54.8%), easiest (58.5%), and best (61.9%). In addition, the nonambulatory group consistently rated Con-

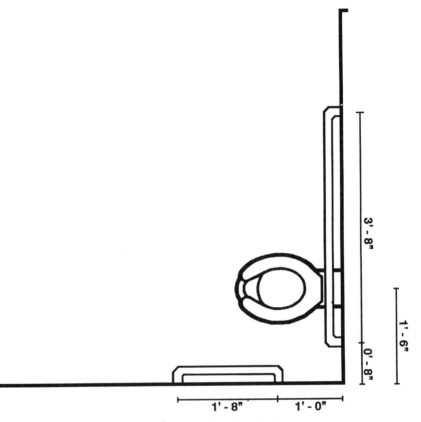

Figure 8.6. Plan of Configuration 2.

figuration 2 as least safe (45.7%) and most difficult (50.0%) to use. The ambulatory group also rated Configuration 3 as safest (45.8%) and easiest to use (46.6%), and Configuration 2 as the least safe (57.4%) and most difficult (58.0%). However, unlike the nonambulatory group, which clearly rated Configuration 3 higher, the ratings of ambulatory participants for safety and ease of use were bimodal, split almost equally between configuration 3 and Configuration 4. In fact, 52.6% of the ambulatory group rated Configuration 4 as the best, compared to the 31.6% who preferred Configuration 3. The code-compliant configuration, Configuration 1, ranked no higher than third in safety, ease, and preference.

In addition to posttrial and observation data, many participants made comments about the safety and difficulty that were recorded on the videotape archive. The most frequent comments by both ambulatory and nonambulatory

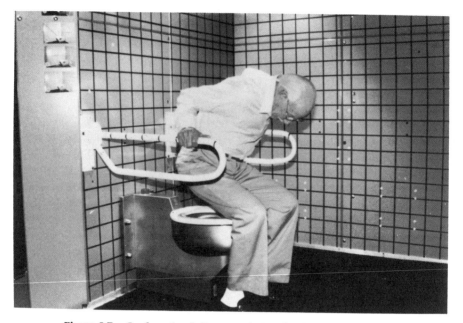

Figure 8.7. Configuration 3: European-designed grab bars that pivot up.

participants questioned the utility of the rear grab bar in Configurations 1, 2, and 4. In addition, the majority of nonambulatory participants who refused to attempt a trial cited the difficulty or lack of safety of the configuration as a reason.

Frequency of Grab Bar Use

Analysis of the videotape data revealed that grab bars were used for four component tasks: (1) pulling oneself out of a wheelchair or off the toilet, (2) stability while transferring, (3) pivoting, and (4) support when lowering oneself onto the toilet or wheelchair. Frequency of grab bar use was determined by adding the number of tasks for which a grab bar was used to either transfer on or off the toilet. In other words, a single grab bar could have had up to four uses in either transferring onto or off of the toilet. As a result, for 116 participants, there were a total of 928 possible uses for each grab bar.

Interestingly, grab bars that were the most radical departure from the accessibility standards (i.e., the two side bars in Configuration 3) were used more often ($p \leq .0001$) by both ambulatory and nonambulatory participants (Table 8.2), accounting for 40% of all grab bar uses (551 out of 1371). Moreover, when actual use is compared with possible use, Configuration 3 had a significantly higher percentage of grab bar use (59.4%) than any of the other configurations,

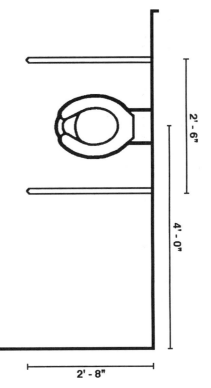

Figure 8.8. Plan of Configuration 3.

which ranged from only 27.7% to 33.5% (Table 8.3). Configuration 3 was also rated much higher for safety and ease by use by both nonambulatory (54.8% and 58.5%, respectively) and ambulatory (45.8% and 46.6%, respectively) participants. However, while 61.9% of the nonambulatory participants rated Configuration 3 the best, 57% of the ambulatory group rated Configuration 4 as the best.

In addition, the data indicate that the need for a rear grab bar is dubious. In comparison to the use of the side bars (Table 8.4), the use of rear grab bars was minimal for the nonambulatory group ($n = 70$) and virtually nonexistent for the ambulatory group ($n = 10$). On the one hand, it could be argued that rear grab bars were only used in three configurations (Configuration 3 did not include rear bars), although the use of the rear bar would be significantly lower than use of the side bars even if Configuration 3 were excluded ($n = 413$ and 327 for nonambulatory and ambulatory participants, respectively). On the other hand, the very fact that participants did not need rear grab bars on Configuration 3 can be interpreted as significant in itself, indicating that absence of a rear bar should be

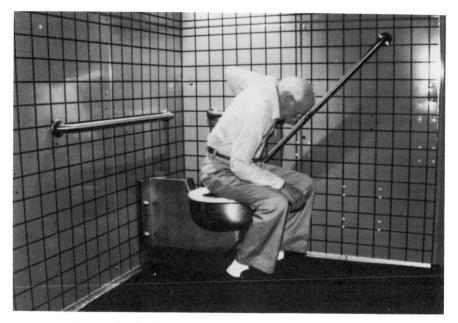

Figure 8.9. Configuration 4: diagonal bar added to Configuration 2.

construed as zero uses rather than merely as missing data. This interpretation magnifies the discrepancy between the side and rear grab bars as the total number of uses of side bars almost doubles ($n = 739$ and 552 for nonambulatory and ambulatory participants, respectively) without any change in the number of uses of the rear bar. Finally, the rear bar (i.e., Configuration 1) had the lowest frequency of use by nonambulatory participants of the three configurations with rear grab bars. In fact, when the longer grab bar was located in the rear in Configurations 2 and 4, it was used significantly more often ($p \leq .0001$) than when the shorter bar was in the rear. Based on an analysis of the videotape data, this pattern of use can be primarily attributed to the difficulty that participants had in reaching the rear grab bar, particularly the shorter bar, from either a seated or a standing position.

Frequency of Use of Mobility Aids as an Assist

The videotape analysis revealed that many subjects used their mobility aids (i.e., walkers and wheelchairs) in addition to, or in lieu of, grab bars to provide assistance in transferring on and off the toilet (Table 8.5). Although there were significant differences in the frequency of use of mobility aids by configuration

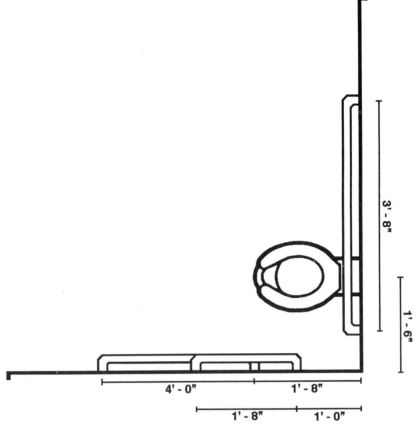

Figure 8.10. Plan of Configuration 4.

($p = .0021$) for transferring onto the toilet, there were no significant differences for transferring off the toilet. Moreover, there were no significant differences in the use of mobility aids between transfer on and transfer off for any configuration.

However, when frequency of use of mobility aids are compared to use of grab bars, a different pattern emerges. Whereas the use of mobility aids might be expected to increase as the use of grab bars decreases (i.e., mobility aids are used to compensate for inadequate placement of grab bars) this relationship only held true for Configuration 3 (Table 8.6). This relationship was not only apparent, but Configuration 3 was the only configuration in which the incidence of grab bar use exceeded the incidence of wheelchair use to assist in transferring onto the toilet ($p = .005$) and in transferring off (although not significant). In fact, the inverse

Table 8.1. Difficulty and Safety

	Rating									
	Safest		Least safe		Easiest		Most difficult		Best	
Group	n	%	n	%	n	%	n	%	n	%
Nonambulatory										
Configuration 1	6	14.3	6	17.1	5	12.2	7	19.4	7	16.7
Configuration 2	2	4.8	16	45.7	2	4.9	18	50.0	2	4.8
Configuration 3	23	54.8	7	20.0	24	58.5	5	13.9	26	61.9
Configuration 4	11	26.2	6	17.1	10	24.4	6	16.7	7	16.7
TOTAL	42	100.1	35	99.9	41	100.0	36	100.0	42	100.1
Chi-square	23.274		8.086		27.78		12.222		32.095	
p	≤.0001		.0443		≤.0001		.0067		≤.0001	
Ambulatory										
Configuration 1	6	10.2	6	11.1	3	5.2	5	10.0	5	8.8
Configuration 2	2	3.4	31	57.4	2	3.4	29	58.0	4	7.0
Configuration 3	27	45.8	9	16.7	27	46.6	8	16.0	18	31.6
Configuration 4	24	40.7	8	14.8	26	44.8	8	16.0	30	52.6
TOTAL	59	100.1	54	100.0	58	100.0	50	100.0	57	100.0
Chi-square	32.186		30.593		39.793		29.52		31.772	
p	≤.0001		≤.0001		≤.0001		≤.0001		≤.0001	

relationship was found in the other three configurations—mobility devices were used significantly more often than grab bars when transferring onto as well as off of the toilet.

CONCLUSIONS

The use of environmental simulation to conduct this study resulted in important and useful evaluative data on the usability of different grab bars by older individuals. Most importantly, the patterns of grab bar use observed in this study raise some important questions concerning the applicability of accessibility standards in providing designs that will promote independent toileting by older people with disabilities.

First, the data clearly indicate that grab bars that do not comply with accessibility codes are at least as effective for ambulatory (i.e., Configuration 3) and were more useful for nonambulatory (i.e., Configurations 3 and 4) older adults. Second, the utility of rear grab bars is questionable. The use of rear grab bars by ambulatory participants was virtually nonexistent ($n = 10$) for all configu-

Table 8.2. Frequency of Grab-Bar Use by Configuration

Group	Transfer on		Transfer off		Chi-square
	n	%	n	%	
Nonambulatory					
Configuration 1	75	17.05	65	17.60	ns
Configuration 2	91	20.68	69	18.70	ns
Configuration 3	170	38.64	156	42.30	ns
Configuration 4	104	23.64	79	21.10	ns
TOTAL	440		369		
Mean	8.8		7.4		
Chi-square	47.473		59.867		
p	≤.0001		≤.0001		
Ambulatory					
Configuration 1	56	21.20	56	18.80	ns
Configuration 2	44	16.70	53	17.80	ns
Configuration 3	98	37.10	127	42.70	ns
Configuration 4	66	25.00	62	20.80	ns
TOTAL	264		298		
Mean	4.0		4.5		
Chi-square	24.364		49.893		
p	≤.0001		≤.0001		

rations. Although the use of rear bars was somewhat greater among the nonambulatory participants, the frequency of rear grab bar use was significantly lower than that of side bar use in all three configurations in which rear grab bars were provided. Moreover, the use of all rear grab bars ($n = 70$) was less than 10% of the number of uses of side grab bars ($n = 819$) by nonambulatory participants. Most significantly, the rear bar that complied with the accessibility standards (i.e., Configuration 1) had the lowest frequency of use by nonambulatory participants of the three configurations with rear grab bars.

These findings indicate that functional distance in the direction of transfer

Table 8.3. Percentage of Total Possible Grab-Bar Use

	Actual number of uses	Percentage of possible use (928)
Configuration 1	252	27.2
Configuration 2	257	27.7
Configuration 3	551	59.4
Configuration 4	311	33.5

Table 8.4. Frequency of Use by Location of Grab Bars

	Nonambulatory		Ambulatory		
	n	%	*n*	%	*p*
Transfer on					
Side bars					
Configuration 1 Long	68	17.17	54	20.85	ns
Configuration 2 Short	64	16.16	42	16.22	.0326
Configuration 3 Left	82	20.71	45	17.37	.0220
Configuration 3 Right	88	22.22	53	20.46	.0346
Configuration 4 Short	34	8.59	8	3.09	.0274
Configuration 4 Diagonal	60	15.15	57	22.01	ns
Total	396	100.00	259	100.00	
p		.0004		≤.0001	
Rear bars					
Configuration 1 Short	7	15.91	2	40.00	ns
Configuration 2 Long	27	61.36	2	40.00	.0171
Configuration 4 Short	10	22.73	1	20.00	ns
Total	44	100.00	5	100.00	
p		≤.0001		≤.0001	
Transfer off					
Side bars					
Configuration 1 Long	62	18.08	55	18.77	ns
Configuration 2 Short	54	15.74	50	17.06	ns
Configuration 3 Left	78	22.74	65	22.18	ns
Configuration 3 Right	78	22.74	62	21.16	ns
Configuration 4 Short	17	4.96	6	2.05	ns
Configuration 4 Diagonal	54	15.74	55	18.77	ns
Total	343	100.00	293	99.99	
p		≤.0001		≤.0001	
Rear bars					
Configuration 1 Short	3	11.54	1	20.00	ns
Configuration 2 Long	15	57.69	3	60.00	ns
Configuration 4 Short	8	30.77	1	20.00	ns
Total	26	100.00	5	100.00	
p		.0151		≤.0001	

Table 8.5. Frequency of Device Use in Transfer
(Nonambulatory Subjects Only)

	Transfer on		Transfer off		
	n	%	*n*	%	*Chi-square*
Configuration 1	152	24.7	128	22.6	ns
Configuration 2	189	30.7	162	28.6	ns
Configuration 3	122	19.8	139	24.6	ns
Configuration 4	152	24.7	137	24.2	ns
TOTAL	615		566		
Chi-square	14.678		ns		
p	.0021				

between the user and the device appears to be the major determinant of use. In other words, people grab for whatever object is closer to them in the direction toward which they are moving. As a user's position changes, he or she will attempt to grab an object that is closer to the new position. This explains the high incidence of use of both side grab bars and wheelchairs and the almost nonexistent use of rear grab bars that were too far away for older subjects to reach. Most importantly, when grab bars were provided on both sides of the toilet (i.e., Configuration 3), such that subjects could use both hands to assist in the transfer, the frequency of grab bar use almost doubled and the incidence of wheelchair use declined. Therefore, minimizing functional distance between the user and stable, firmly affixed assistive devices (e.g., grab bars) at all points in the transfer

Table 8.6. Grab-Bar versus Device Use

			Chi-square	*p*
Transfer on				
Configuration 1	152	75	26.119	≤.0001
Configuration 2	189	91	34.30	≤.0001
Configuration 3	122	170	7.89	.005
Configuration 4	152	104	9.0	.0027
Transfer off				
Configuration 1	128	65	20.565	≤.0001
Configuration 2	162	69	37.442	≤.0001
Configuration 3	139	156	ns	
Configuration 4	137	79	15.574	≤.0001

process should promote their use and discourage use of other inappropriate devices.

This conclusion is based on the premise that the use of an assistive device is generally a prerequisite to an older person's ability to toilet safely and independently. It is imperative that older individuals, many of whom have problems with gait, balance, and mobility, have access to and use appropriate devices to assist them in transferring onto and off a toilet. Further, it is also imperative that any devices that are used to assist in transfer be stable and firmly affixed to a wall, floor or other immovable object. In other words, assistive devices, such as grab bars, that are provided, but not used do not enhance independent toileting. Conversely, those that are unstable or movable, such as wheelchairs, towel bars, and toilet seats, can potentially jeopardize safety. As a consequence, situations that increase use of appropriate assistive devices while decreasing use of walkers, wheelchairs, and other inappropriate objects of convenience to assist in transfer should promote safe and independent toileting among older individuals.

This study, like other simulation studies, was limited by the number of possible configurations and experimental groups that could be tested. However, unlike other studies, its major limitation was that it could not, due to the sensitive nature of some tasks, model all aspects of toileting behavior. For example, transfer was simulated, but disrobing was not. As a result, it was not possible to determine whether disrobing impacts grab bar use or whether grab bar configuration impacts the ability to remove one's clothes. Although simulations should ideally model the full extent of any particular activity, this simulation study clearly illustrates the effectiveness of simulation as a research methodology in assessing the fit between environments and older people. Moreover, it illustrates the conditions under which simulation studies are most useful. These include situations in which:

1. The component tasks associated with the environmental feature(s) of interest (e.g., grab bars and toilet) are finite and predictable (e.g., get out of a wheelchair, get onto a toilet)
2. There is little variation in the specific design characteristics (e.g., height of a toilet, location of grab bars) of the task-related environmental features and the context is small enough to be modeled and replicated (e.g., toilet room)
3. The nature of the activity is sensitive and evaluation of environments in use would be too invasive (e.g., toileting)
4. Sampling problems are anticipated

Component Tasks

Many activities that are difficult for older adults are simple, routine activities (e.g., getting on and off the toilet) that have a limited set of component tasks

that are generally performed in a predictable, predetermined order. In such instances, simulation studies permit subjects to perform an activity as they normally do, without having to be directed in a desired sequence of tasks. This permits a high degree of ecological validity as well as experimental control of environmental characteristics. In addition, because subjects perform the same component tasks, data are consistent across subjects, thus permitting the use of quantitative analyses. In contrast, direct comparison of subjects using quantitative analytic techniques are more difficult in studies that utilize naturalistic observations or simulation studies that involve activities in which tasks vary from person to person (e.g., cooking a meal). In such cases analyses are more likely to be qualitative and descriptive in nature.

Variability of Design Characteristics

Because the number of different characteristics of a particular design feature (e.g., height, size, and location of a grab bar) that can be manipulated and tested in a simulation is limited by time and cost constraints, simulation is useful when there is not likely to be much variation in the way the environment is designed. Such is often the case with accessibility standards that are applicable to most facilities for older adults (e.g., senior centers and nursing homes). Technical requirements for architectural accessibility are typically stated as prescriptive measures of minimum, maximum, or allowable ranges of height, location, depth, diameter, and so on. As a result, there is little variability in current technical requirements for accessible building features as specified in ANSI, ADAAG, or state building codes. Similarly, there is little variation in environmental characteristics of many accessible features (including both building components such as ramps and wider doorways as well as products such as toilets and grab bars), particularly in facilities utilized by older persons. As a consequence, simulation studies can accurately model and evaluate the impact of real world environments by incorporating actual building products without modification.

Sensitivity of Pertinent Behaviors

Simulations are advantageous when observation methods are potentially invasive, such as observations of toileting behavior. In such cases, prudence and local human investigations committees generally dictate alternatives to studies that involve naturalistic observations. Although simulations offer a viable alternative to naturally occurring behaviors, it is important to recognize that there are limitations in the simulation that can impact the validity of the research. For example, simulating a toilet transfer while dressed may be different than removing one's clothing in preparation to getting on and using a toilet, particularly for individuals who are impaired. However, even when simulation studies cannot replicate all component tasks associated with an activity, they nonetheless per-

mit many of the critical tasks to be observed. In contrast, it is unlikely that observational data on any of the critical tasks could be collected in a study of naturally occurring toileting behavior.

Sampling Problems

Simulations are viable when there are likely to be sampling problems due to the lack of appropriate sites for naturalistic observations or difficulty in recruiting subjects. In many cases, identifying one or more sites where the environmental features of interest are found naturally is difficult, particularly in studies where innovative alternatives are being evaluated. In addition, simulation studies facilitate obtaining statistically significant samples. This is a major obstacle in conducting studies with human subjects, particularly when subjects are older adults and/or individuals with disabilities, who are apt to be less mobile and less motivated (e.g., college students make good subjects because they are required to participate). The use of a lightweight, free standing, portable, full-scale mockup that can be brought to research subjects where they are (i.e., at senior centers or nursing homes) rather than bringing the subjects to a centrally located test site is generally cost-effective and helps ensure that a statistically significant sample can be obtained. In addition, this strategy makes testing more convenient and requires less of a commitment from subjects, two considerations that are extremely important with frail populations.

Stokols (1993) notes in his discussion of methodological concerns in environmental simulation research that two principles of simulation research help create both high internal and high external validity. The first principle is that, because the experimental components (e.g., height, location of grab bars) of the simulated environment are controlled, the subjects' responses and researchers' observations would be directly attributed to the experimental variables, producing high internal validity. The second principle is that the subjects' behavior and the environmental conditions can be reliably expected to occur in the same way outside the simulated environment, producing high external validity.

In summary, this study illustrates the effectiveness of simulation studies in comparing differences, under relatively controlled conditions, among a number of different characteristics (i.e., safety and independence) for a limited number of environmental features (i.e., grab bars and toilet seat height). In addition, this study illustrates the utility of simulation when sampling problems are anticipated (e.g., identifying sites and transporting subjects) or when the activity of interest (i.e., toileting) is too sensitive for naturalistic observations.

ACKNOWLEDGMENTS. This study was funded by the Department of Veterans Affairs, Rehabilitation Research and Development Service, Washington, DC, Project #E629-RA. The authors wish to acknowledge the contributions of the Project Team: Roger Bodenheimer, David Higginbotham, and Renee Jarvis, At-

lanta VAMC Rahab R&D Center, Decatur, Georgia; Pascal Malassigné and Sue Kartes, C. J. Zablocki VAMC, Milwaukee, Wisconsin; Mark Cors and Todd Hoehn, Milwaukee Institute of Art and Design; and Deanna Nelson and Jeff Rosenberg, Audie L. Murphy VA Hospital, San Antonio, Texas.

REFERENCES

Access Board. (1991). *American with disabilities act accessibility guidelines*. Washington, DC: Equal Employment Opportunity Commission and U.S. Department of Justice.

American Institute of Architects Foundation. (1985). *Design for aging: An architect's guide*. Washington, DC: Author.

American National Standards Institute. (1992). *Providing accessibility and usability for physically handicapped people, ANSI A117.1-1992* (revisions of ANSI A117.1-1980, 1986). New York: Author.

Bostrom, J. A., Malassigné, P. M., & Sanford, J. A. (1984). Development and evaluation of four shower prototypes. In *Proceedings of the Second International Conference on Rehabilitation Engineering* (Vol. 4, pp. 91-92). Arlington, VA: RESNA Press.

Clipson, C. (1993). Simulation for planning and design: A review of strategy and techniques. In R. W. Marans & D. Stokols (Eds.), *Environmental simulation—policy and research issues* (pp. 23-57). New York: Plenum.

Czaja, S. J. (1984). *Hand anthropometrics*. Technical paper for U.S. Architectural and Transportation Barriers Compliance Board. Washington, DC: U.S. Architectural and Transportation Barriers Compliance Board.

Czaja, S., & Steinfeld, E. (1980). *Human factors research with disabled children*. Buffalo, NY: People's Center for Housing Change.

Faletti, M. (1984). Technology to adapt environments. *Generations, 8*, 35-38.

Feuerstein, M., Steinfeld, E., Sanford, J., & Shiro, S. G. (1987). Hands on architecture: A typology for designers and researchers. In *EDRA 18, the Proceedings of the Eighteenth Annual Environmental Design Research Association Annual Conference* (pp. 115-120). Washington, DC: EDRA.

Hiatt, L. (1989, March). *Housing for the elderly workshop*. Paper presented at the meeting of American Society on Aging, Washington, DC.

Küller, R., & Mikellides, B. (1993). Simulated studies of color, arousal, and comfort. In R. W. Marans & D. Stokols (Eds.), *Environmental simulation: policy and research issues*. New York: Plenum.

Lawrence, R. J. (1993). Simulation and citizen participation: Theory, research, and practice. In R. W. Marans & D. Stokols (Eds.) *Environmental simulation: policy and research issues* (pp. 163-190). New York: Plenum.

Johnson, B. (1981). *Door-use study*. Ottawa: Division of Building Research, National Research Council, Canada.

Mace, R., & Lasett, B. (1974). *An illustrated handbook of the handicapped section of the North Carolina state building code*. Raleigh: North Carolina State Department of Insurance.

Marans, R. W. (1993). A multimodal approach to full-scale simulation: Evaluating hospital room designs. In R. W. Marans & D. Stokols (Eds.), *Environmental simulation: policy and research issues* (pp. 113-131). New York: Plenum.

Nichols, J. (1966). Door handles for the disabled. *Annals of Physical Medicine, 8*(5), 180-183.

Sanford, J. A., & Steinfeld, E. (1987). Designing for orientation and safety. In *Proceedings of the Annual Research Conference of the AIA/ACSA Council on Architectural Research*. Washington, DC: AIA/ACSA Council on Research.

Steinfeld, E. (1988). Full scale modeling in architecture. Presentation at the Architectural Research Centers Consortium 1988 Conference. Champaign, IL: ARCC.

Steinfeld, E., & Shea, S. (1993). Enabling home environments: Identifying barriers to independence. *Technology and Disability*, *2*(4), 69–79.

Steinfeld, E., Schroeder, S., Duncan, J., Faste, R., Chollet, D., Bishop, M., Wirth, P., & Cardell, P. (1979). *Accessible buildings for people with walking and reaching limitations*. Washington, DC: U.S. Government Printing Office.

Stokols, D. (1993). Strategies of environmental simulation: Theoretical, methodological, and policy issues. In R. W. Marans & D. Stokols (Eds.) *Environmental simulation: research and policy issues* (pp. 3–21). New York: Plenum.

Woods, W. (1980). *Disability and building codes: A quantitative study*. Tucson: Southwest Arthritis Center, University of Arizona.

III

NEW DIRECTIONS IN RESEARCH METHODS

Research in enabling environments initially focused on the accessibility of spaces and buildings. The first generation of studies was almost exclusively concerned with identifying problems of access and usability. In addition, this work was primarily conducted through experiments using full-scale simulations of real world settings, or "fitting trials." In most studies of this type, research subjects are brought to a research setting or the research apparatus is constructed where potential subjects can be frequently found. Through standardized procedures, the simulated environment is systematically adjusted to create different conditions, and the differences in performance are compared.

Simulation experiments have their strengths and limitations. A major advantage is the control provided over the setting. The high level of control eliminates unplanned and extraneous events from influencing performance of the subjects (e.g., interruptions by coworkers or the telephone) and variability in the research environment (e.g., different sized plumbing fixtures). Moreover, a specially built research apparatus allows the environment to be systematically adjusted in ways not possible in a real life setting (e.g., variable height of toilets). On the other hand, simulations usually are not experienced in the same manner as real world places. For example, running water was not present in any of the existing studies of bathroom use. There are also other limitations to this method of study. First, unless field studies are completed as a validity check, the methods only have face validity with real world experience. Second, the variables studied, as in most experimental studies, are determined by the investigator. They may not address the priorities of the people with disabilities themselves. Third, there is no guarantee that the results have predictive validity without follow-up using field methods. Finally, generalizing findings from such research to innovative environments that have not been subject to research may be impossible. This last concern has major implications with respect to accessibility codes. Innovative

products such as pivoting grab bars and bathtubs with side-opening doors are being rejected for use in applications where code compliance is required because they have not yet been tested.

A second generation of research has been exploring the use of methodologies designed to overcome the limitations of full-scale simulation experiments. One major objective of some new studies is to understand the impact of accessible environments, in other words, to link accessibility to outcomes like satisfaction, quality of life, or social perceptions of people with disabilities. To reach this goal, researchers must develop methods that allow the collection of data in naturalistic settings in which people live on a day-to-day basis. Another direction is the development of tools for describing environments. Research on outcomes, for example, needs to incorporate methods that can describe the physical environment being studied with a fair degree of complexity in order to compare actual settings and understand how they differ from one another. A third new research direction is the development of predictive tools, that is, methods that will help predict the degree of accessibility or usability of a design prior to its construction. Computer simulation is clearly a promising approach for such a purpose. Finally, there is a movement to involve the research subject in the process of discovering new knowledge. In fact, the idea is to redefine the "subject" into a "consultant." The argument here is that if the researcher involves the inhabitants of environments in the process of defining the research issues, it will more likely ensure that their priorities are addressed.

The four contributions in this part are not the only examples of new directions in research methods in this book. For example, van der Voordt (Chapter 3) and Blasch et al. (Chapter 13) describe new uses of computer technology, Falta (Chapter 16) describes a survey research approach, and Finkel (Chapter 15) and Iwarsson and Issacson (Chapter 4) describe studies completed in naturalistic settings. However, the four chapters in this part, taken together, provide a good overview of the range of new directions in methods and what they portend for the future.

Sekulski, Jones, Pastalan, and their associates (Chapter 9) observed that typical clinical assessment methods for activities of daily living or instrumental activities of daily living do not sufficiently predict the ability to successfully complete the same tasks in the home environment. They believe that, because these assessment methods focus on quantitative measurement, they miss important details about the relationship between people and their living environment. Their research team developed a game/simulation that elicits the real life experiences of daily life activities in the context of the everyday environment. During game play, the person with a disability explores questions that focus his or her attention on the problems they experience using the physical environment and the coping strategies they employ to address them. This subjective and qualitative approach to assessment fully engages the individual in the process of identifying problems and identifying his or her own approach to solving them.

Rather than assess the person's abilities, it identifies relationships and reveals competencies as well as limitations.

Steinfeld and Richmond (Chapter 10) report on a study that extended full-scale simulation experiments into naturalistic settings. Their research focused on the use of detectable tactile surfaces as mobility and orientation aids for people with visual impairments who use a cane or guide dog as a mobility aid. A prior phase of research had identified a set of materials that were reliable in detection tasks under "benign" laboratory conditions. In this study they sought to determine whether the same materials would actually improve direction-finding in real buildings and sites. They also examined the impact of field conditions on the durability and usability of the materials in all kinds of weather. To accomplish the project goals, a research method was devised in which subjects completed a standardized set of routes indoors and outside while an observer recorded the errors in direction-finding and detection tasks. Although they found that several materials were detected with a high degree of reliability, their usefulness to visually impaired people is limited to applications for certain purposes and certain locations. Their findings demonstrated that detection tasks in a laboratory setting are not the same as in the field. The results also emphasize the importance of extending research on tactile surfaces beyond detection tasks to discrimination, distinguishing signal surfaces from other surface changes that occur with frequency in most buildings and sites. The results clearly demonstrate the importance of establishing the construct validity of laboratory methods.

In Chapter 2, Connell and Sanford pointed out that the claims of universal design have not yet been justified by research. One such claim is that universal design will lead to better social integration of people with disabilities; another is that the appearance of the environment is a critical factor in achieving that integration. In this part, Robinson and Thompson, in Chapter 11, take up the challenge of these two claims. They argue that less attractive environments and those identified by others to be "for the handicapped" will reinforce the separation between people with disabilities and mainstream society and stigmatize their inhabitants. They describe a method for measuring the symbolic impact of architectural settings and demonstrate how that method can be used in a study of group homes for people with developmental disabilities. Their findings confirm that homes that look institutional are associated with a stigmatized identity for the inhabitants and those that look homelike are associated with a normal identity. The methods they have developed allow the identification of specific features that contribute to stigma and those that can be used to avoid it. This research demonstrates that the claims of universal design can be confirmed by research and provides some tools to do so.

Computer simulation promises significant increases in the power of research methodologies for studying enabling environments. Although the development and validation of computer models is an expensive and time-consuming task, once a model has been completed and is demonstrated to mimic events in

the real world reasonably well, it can be useful not only as a research tool, but also as real time design tool. Simulations can have enormous practical utility. For example, Robo-Cane®, described by Blasch et al. in Chapter 13, can provide invaluable assistance in research and design related to hazard avoidance for visually impaired individuals. In research, simulation eliminates the need to put research subjects at risk to study hazards in the path of travel. Some environment-behavior relationships, like those modeled in Robo-Cane, are relatively discrete and easy to observe and describe; other relationships, however, have a greater cognitive component and take place in very complex settings. The ISOKIN methodology described by Lantrip in Chapter 6 is one of those complex modeling endeavors. In his chapter in this part (Chapter 12), Lantrip describes the statistical approach to testing the predictive power of the model. This methodology, although still requiring more development, provides a glimpse of what the future of computer modeling might bring. His technique seeks to model not only physical phenomena but also the impact of physical experience on behavioral outcomes. Moreover, it places anthropometrics into a multivariate context in which interaction with other phenomenon can be understood in a more realistic manner. It would be very exciting if any design could be drawn in a computer-aided design program and subjected to the type of analysis the ISOKIN technique provides. Not only would it be possible to identify all the detailed problems of general anthropometric fit, but it would be possible to predict how the design would influence broader outcomes like job satisfaction. Another interesting use would be to compare results for individuals with and without impairments. With such a model, it would be possible to do such analysis during the process of design so it can have a direct bearing on decision making as design choices are confronted.

9

A Day's Journey Through Life©

An Assessment Game

Ron Sekulski, Louise Jones, and Leon A. Pastalan

INTRODUCTION

Forty-nine million Americans are permanently disabled (U.S. Bureau of the Census, 1992), but the scope of the problem is much greater in that anyone who lives long enough will, at some point, experience a disability, for example, a problem with walking, seeing, or hearing. "We are not only different from each other, we are also different individually from who we were yesterday and who we will be tomorrow" (Mueller, 1993). Increasing numbers of people with disabilities are striving to live independently, but the available information is incomplete as to the characteristics of the micro and macro environment that support successful completion of the activities of daily living (ADLs) in the context of the home setting. To further complicate the problem, there may be a disparity between the typical clinical assessment modalities for performing ADLs and the individual's ability to successfully initiate the same tasks in the home setting. All too often the physical environment inhibits the performance of daily life activ-

Ron Sekulski • Industrial Design, Suomi College, Hancock, Michigan 49930-1882. **Louise Jones** • Department of Interior Design, Eastern Michigan University, Ypsilanti, Michigan 48197. **Leon A. Pastalan** • College of Architecture, The University of Michigan, Ann Arbor, Michigan 48109.

Enabling Environments: Measuring the Impact of Environment on Disability and Rehabilitation, edited by Edward Steinfeld and G. Scott Danford. Kluwer Academic/Plenum Publishers. 1999.

ities by the person who has a disability. These physical barriers, whether product or architectural, are contrary to the prevailing desire to attain or sustain independence. Lawton and Nahemow (1973) point to the negative effects that result from an imbalance between the demands of the environment and the functional capacity of the individual. The importance of an appropriate "fit" between the individual and the designed environment may be the key factor in preventing accidents, withdrawal from activities, and even death (Lawton, 1980).

There is little documentation of how individuals with disabilities, their families, and their friends have attempted to modify products or the physical environment to meet their individual requirements. Knowledge of their needs and adaptations would be invaluable to all those interested in developing non-handicapping environments for independent living. However, traditional data collection techniques are sometimes problematic because of the demands of time related to interviews, the contamination of data related to participant observation, the objective structure of standardized test forms, and the low response rate often associated with survey questionnaire requests. An interactive experience with the target population is needed to identify the problems encountered on a day-to-day basis and the strategies that may be adopted to cope with handicapping environments.

At the University of Michigan, a multidisciplinary group, the Environmental Design for Aging Research Group (EDARG), with experience in professional practice and advanced graduate work in the behavioral sciences, specializes in the environmental problems of frail elders and/or people with disabilities. To expand the breadth of empirical experience, EDARG associates[1] developed a game/simulation as an innovative data collection instrument. A Day's Journey Through Life© offers a contextual evaluation technique that provides insight into the nature of the relationship between the physical environment and individuals with disabilities.

WHY A GAME?

The complexity of day-to-day life is something that has to be understood more or less all at once. An approach that stresses piece-by-piece procurement of information without prior acquisition of a holistic impression carries severe threats of conveying miscomprehensions of the sort that "beset the king's blind emissaries who stationed themselves at different parts of an elephant and offered descriptions of the creature they felt" (Greenblat, 1981a, p. 16). What is required is a mode of simultaneous rather than sequential presentation of parts of the

[1]The base game from which A Day's Journey Through Life©: An Assessment Game is derived was developed by EDARG associates Leon A. Pastalan, Louise Jones, Benjamin Schwarz, Ron Sekulski, and Laura Struble.

overall message. Prose is a poor tool for creating pattern comprehension. It is "sequential, working point-to-point along a chain of assertions or questions. It treats one molecule of meaning at a time" (Rhyne, 1975, p. 19). Games serve as communication devices, providing a systems approach that addresses the need for a holistic language, one able to convey the gestalt.

A Day's Journey Through Life© is part of a long-standing gaming/simulation paradigm that structures communication in a context of multilogue, as compared to dialogue, because words in sequence are less powerful than the combined interactive effects of words and images in a situational context. Multilogue can more readily convey totality and therefore increase understanding and the generation of more insightful information concerning complex environmental design problems.

The following is an example of how the multilogue of one game play provided insight into the person with a disability's response to an emergency situation. The player, who used an electric cart for mobility due to the progression of multiple sclerosis, was asked during one play of the game, "What would you do if there was a fire in the kitchen?" She immediately took the research team into her kitchen to show them the fire extinguisher that was mounted on the wall in a prominent location between the cooktop and wall oven. However, in attempting to retrieve the extinguisher, she discovered it was too high for her to reach, having been positioned when she was using a walker (see Figure 9.1). To her further chagrin, when handed the extinguisher, she was unable to disengage the locking mechanism due to limited finger dexterity and degradation of strength. If she had been scored by an occupational therapist on a standardized functional assessment form for "meal preparation and clean-up" or if the researchers had used an interview format such as, "Is there a fire extinguisher conveniently located in the kitchen?," the ensuing answer may not have identified the multiple problems that would have surfaced in an emergency situation. Only through the multilogue, that is, the combination of words and images in the situational context, were the researchers able to understand the complexity of the situation.

HISTORY OF GAMING

Games are frequently described in the research literature as a safe environment for learning; a major function of games is to increase interest and motivation and perhaps thereby facilitate subsequent learning (Boocock & Schild, 1968). In the 1960s, at John Hopkins University, sociologist James Coleman initiated the development of games for educational purposes. He found that "a game is a kind of play upon life in general, it induces, in a restricted and well-defined context the same kinds of motivations and behavior that occur in the broader contexts of life" (Coleman, 1968, p. 29). Of particular interest were

Figure 9.1. Fire extinguisher is not accessible by a person using a wheelchair.

certain peculiar properties of games that facilitate learning, such as their ability to focus attention, their requirement for action rather than merely passive observation, and their abstraction of simple elements from the complex confusion of reality. Gary Shirts, Hall Sprague, John Raser, and Waymon J. Crow, at the Western Behavioral Institute, extended the investigation to include the use of simulation. The elements in a gaming simulation are patterned from real life. The roles, goals, activities, and constraints, and the consequences and the linkages among them, simulate those elements of the real world system (Greenblat, 1981b). At the University of Michigan, Richard D. Duke, Allan Feldt, Layman Allen, Fred Goodman, and others continued the development and investigated multiple uses for games. Their findings indicate that games serve as metaphors of reality that permit the participant to develop a common language to use in discussing the problems at hand. Gaming improves communication about a complex environment to enable new alternatives to be envisioned and tested. This, combined with their ability to hold the participants' attention and to quickly convey the central characteristics of a complex environment, makes them excellent as innovative teaching aides. Increasingly, games are employed to clarify a vision of a desired future state. They are designed to free participants from everyday constraints, to encourage innovation, and to assist in the communication of complex and emergent ideas about possible alternate paths (Duke, 1991).

A DAY'S JOURNEY THROUGH LIFE©

Games are an invaluable, but as yet little explored, assessment technique that allows the participants to interact in a structured, but open-ended, exercise to achieve an enhanced understanding of the physical and/or psychosocial barriers experienced daily in familiar environmental contexts by individuals with disabilities. Therefore, a game was selected as the mechanism for data collection regarding the performance of ADLs in the home setting, rather than a more traditional method, for example, interviews, observations, or standardized evaluation forms. The game can provide access to formerly inaccessible information and stimulate interaction and discussion, which may yield new insights and new attitudes regarding constraints of the physical environment.

Because the primary goals are to understand how people with disabilities negotiate their environment, to determine the contribution of the micro and macro environment in enabling or handicapping successful ADL task completion, and to define product needs, it is essential that the story of each player be captured. Inevitably, this requires both quantitative and qualitative data collection methods. The game board and icons are used in conjunction with other methods of observation and recording (e.g., participant observation, video and/ or audio recordings) to capture the rich details of the player's daily experiences (see Figure 9.2). The game provides an opportunity to observe the extremely diverse and complex population of people with disabilities in the home setting in order to achieve a clarity of vision in developing nonhandicapping environments.

The game board and sequence of play was developed to move participants through the ADLs in a familiar setting. During a 2- to 3-hour time period (including orientation, game play, and debriefing), a research team engages an individual with a disability—the VIP (i.e., very important person)—and his or her caregiver (if applicable) in an ongoing multilogue to identify the aspects of the micro and macro environment that inhibit autonomy and independence, that is, to identify handicapping environments.

The game play takes place in the VIP's residence to encourage identification of specific handicapping features in the home environment. The familiarity of the home setting encourages a more relaxed ambiance where the VIP is willing to share insights and intimate experiences, disclosure of which may be inhibited by clinical or unfamiliar surroundings. During the game play, the VIP, a caregiver (if applicable), the facilitator, and a recorder (i.e., the research team) are seated around a table large enough to accommodate the game board and playing pieces. Permission is sought to video and/or audio tape the game play to facilitate data capture and to accommodate reliability checks. Although a few VIPs may be initially reluctant to have the game play videorecorded, the benefits of body language analysis, in addition to accurate capture of dialogue and enunciation, more than outweigh the disadvantages of a period of initial awkwardness, and the intrusiveness of the video quickly recedes as the game progresses.

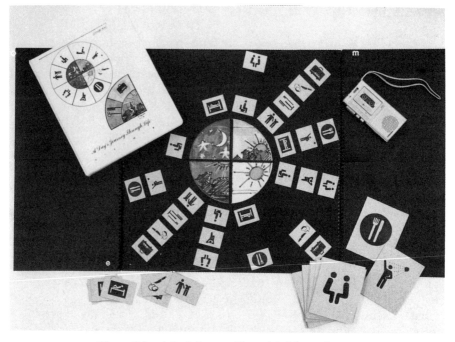

Figure 9.2. A Day's Journey Through Life© gameboard.

To initiate the game play the facilitator, using a series of 20 icon cards, requests the VIP to determine if a given ADL is difficult or easy to execute (see Figure 9.3). This process exposes the VIP to icons that are visually and symbolically connected with the ADLs that will be explored in future steps of play. This round of play introduces the range of ADLs that will be discussed and initiates consideration of the limitations and challenges associated with the VIP's specific disabilities and living environment. For example, the VIP is shown the icon for getting up in the morning and asked if it is difficult or easy to turn off the alarm clock (see Figure 9.4). If the VIP had a problem with hearing and indicated that this task was easy to accomplish, the facilitator would make a mental note to probe more deeply into this task during Round 3, in that hearing the alarm would often be considered difficult given the constraints of this disability. What process or assistive device is in place that is enabling the VIP to complete this task without difficulty? During Round 1, the facilitator and VIP move quickly through the cards, following semantic differential protocol (i.e., asking the VIP to choose between two opposite positions), without pausing to discuss problems or issues.

In the second round of play, the VIP identifies the time of day when a particular ADL is most likely to be performed or, if performed several times a day,

Figure 9.3. Round 1: tasks are designated as Easy or Difficult.

when it is most troublesome (see Figure 9.5). For example, bathing might be part of either a morning or evening routine; toileting may be more difficult during the night than during the day when caregivers are available to lend assistance; housekeeping chores may not be part of the VIP's responsibility, eliminating this topic from Round 3 of game play. The activity cards are placed on the game playing field, which is segmented into four time quadrants—morning, afternoon, evening, and night—as determined by the VIP's responses (see Figure 9.6).

The third round of play focuses on a more intensive depth of inquiry to

Figure 9.4. Game cards for Round 1.

Figure 9.5. Round 2: VIP identifies the time of day a task is typically performed.

prompt the VIP to relive A Day's Journey Through Life© (see Figure 9.7). Starting with the morning quadrant and progressing through the time periods, the VIP chooses an ADL activity card and responds to the question (i.e., "What do you do when you first wake up?"), thereby identifying the problems encountered on a day-to-day basis and the coping strategies routinely implemented to address them (see Figure 9.8). For example, the facilitator would follow up on a response in Round 1 that indicated that adjusting the water temperature was not difficult for someone with a visual impairment. As the VIP discusses bathing as part of the morning routine, the facilitator might say, "You mentioned earlier that adjusting the water temperature was not problematic for you; how do you regulate the temperature?" This discussion might result in a visit to the bathroom to enable the VIP to demonstrate the ease with which the water temperature can be adjusted using a faucet that maintains a uniform water temperature by disassociating temperature and volume control, that is, when the water is turned on the water temperature automatically adjusts to a preset temperature regardless of the volume of water moving through the tap (see Figure 9.9).

The final round of play identifies any issues that have not been addressed by inviting the VIP to describe the most troublesome activity experienced on a daily basis and the product he or she finds most difficult to use. For example, one VIP described her process for adjusting the thermostat, which was part of both her morning and bedtime routine (see Figure 9.10). However, the thermostat was

Figure 9.6. Game board for Round 2.

mounted too high for her to easily see the small numbers, so she kept a three-legged stool in a nearby closet. Because she was unsteady when standing on the stool, she used a floorlamp to stabilize herself while adjusting the dial. The researchers did not believe this to be a safe procedure for someone who was experiencing mobility problems that necessitated the use of a cane. They suggested she ask the building supervisor to install a thermostat that utilized large numbers to improve readability at a more convenient height.

Preliminary testing indicates that individuals with disabilities share a level of specificity and richness of experience that exceeds levels obtained through interviews, structured questionnaires, or standardized functional assessment instruments. During one game play a woman who was a candidate for hip replacement surgery took the researchers into her kitchen to show them how it had been planned using *Good Housekeeping* guidelines that mandate storage be in close proximity to demand. Therefore, dishes were stored near the pass-through from the kitchen to the dining room. However, access required use of a stepstool to reach the wall cabinet, and this was problematic in that she was unable to step up onto the stool and reach into the cabinet safely (see Figure 9.11). The environmental struggles experienced by those whose world is ergonomically, anthropometrically, and/or physiologically limited are captured and conveyed through the personal stories of the VIPs.

QUALITATIVE VERSUS QUANTITATIVE METHODS

Most assessment techniques currently used to evaluate an individual's functional capacity to complete the ADLs utilize systematic, quantitative instruments

Figure 9.7. Round 3: VIP responds to the questions on each game card.

that reduce evaluations to set response categories. In a typical assessment, the occupational therapist leads the client through a predetermined series of standardized questions to rate the client's ability to complete the activities of daily living [see the Klein-Bell ADL Scale (Klein & Bell, 1979)] or the Functional Assessment Compilation Tool (Trades Research and Development Center, 1991). The ADLs are broken down into essential behavioral components (i.e., subtasks), and each component is scored separately, using preset response categories (see Figure 9.12 for an example of standardized functional assessment form). The compiled numerical score reflects the individual's functional independence, that is, independent, requires supervision, minimal assistance, moderate assistance, maximum assistance, or total assistance. The deficient functional areas are

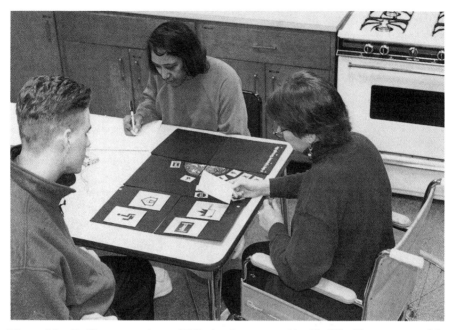

Figure 9.8. Facilitator, recorder, and VIP play the game to identify difficulties encountered in completing the activities of daily living.

thereby revealed and lead the therapist toward problem identification and treatment planning (Asher, 1989).

For example, an occupational therapist working in a skilled care unit of a nursing home developed a treatment plan that included a series of exercises to improve dexterity, muscle strength, and eye–hand coordination of a client who had a stroke. Eating and dressing were identified as being particularly problematic because the stroke affected grasp, strength, flexion, and extension of the left hand. In the clinical setting, the ADLs were practiced until the client gained competency for self-management. After his discharge to an independent residential unit, A Day's Journey Through Life© game play revealed the VIP was experiencing difficulty cleaning his eyeglasses due to his inability to grasp the glasses in the left hand while washing and drying the lenses with his right hand. His vision was therefore diminished (1) by age-related changes in acuity, (2) by the initial impairment that necessitated the prescription lenses, and (3) by the additional visual handicap caused by dirty glasses! Although the functional assessment score obtained using the standardized test instrument indicated "functional independence," the multilogue of the game play revealed a problem that was not predicted by the conventional occupational therapist's evaluation.

Figure 9.9. Faucet design maintains consistent water temperature.

After a stroke that diminished strength on the left side, one woman worked with an occupational therapist to develop behavior modifications that would allow her to live independently. The therapist suggested a tub stool and handheld shower to facilitate bathing. Under the therapist's supervision, the woman demonstrated her ability to get into the tub, sit on the stool to facilitate reaching the tap controls, regulate water temperature, and bathe using the hand-held shower. However, during game play with the researchers, the woman discussed her typical bathing routine. She preferred soaking in the tub to showering, so she leaned over the toilet, supporting herself on the extension bar for the hand-held showerhead, turned on the water and adjusted the temperature. She undressed as the tub filled, then used the stool, which was positioned at the faucet end of the tub, for support as she lowered herself into the water (see Figure 9.13). Although the occupational therapist had determined that the VIP had modified her behavior in order to bathe in a safe way, in reality she was using the assistive devices to facilitate bathing in the preferred mode—placing herself in jeopardy.

Standard assessment instruments diminish the opportunity to uncover unpredictable handicapping conditions. The game offers an alternative that uses a qualitative data collection technique to gain a fuller understanding of the complex relationship that exists between the individual and the micro and macro environment. Although the game, A Day's Journey Through Life© is still under

Figure 9.10. Thermostat with large numbers increases ease of use.

development, the pilot studies suggest it is a powerful tool that can enable the researcher or practitioner to accommodate the heterogeneity represented by varying physical, social, and emotional needs. The game appears to identify the same nuances of daily routines, regardless of the facilitator, and to identify the same categories of problem areas as standardized tests, although providing more depth of information; however, formal testing for both reliability and validity is ongoing.

During the game play, the VIP is asked to categorize ADL activities as either difficult or easy, which is a quantitative assessment using semantic differential protocol. With numerous plays of the game is may be possible to foresee potential problem areas, given a particular subpopulation in a specific environment. In the short run, this round of play can provide insights as to specific problem areas that should be explored in more detail during Round 3. Discussion

Figure 9.11. In this scenario, access to cabinets required use of a stepstool.

between the VIP and the caregiver allows the participants to interact in a structured, but open-ended, multilogue to identify barriers that inhibit completion of ADLs in the context of the home environment, which is a qualitative assessment. Empowering the VIP to narrate his or her own story provides a specificity of detail seldom revealed using exclusively objective data collection instruments. The contextual, open-ended structure of the game allows the VIP to identify the most salient aspect(s), whether product or architectural, of the handicapping environment.

Handicapping Environments

Life satisfaction is often difficult to define and measure, but it is the ultimate outcome of the desire for independence and autonomy often expressed by

DRESSING:

A. Obtain clothing from bureau

 1. Grasp drawer (1)

 2. Pull drawer open (2)

 3. Reach into drawer (2)

 4. Grasp clothes (1)

 5. Shut drawer (1)

B. Obtain clothing from closet

 6. Grasp clothing hung in (1)
 closet

 7. Place clothes within (1)
 reach for dressing

C. Socks

 8. Grasp sock (1)

 9. Reach sock to R foot (2)

 10. Reach sock to L foot (2)

 11. Pull sock over R toes (2)

 12. Pull sock over L toes (2)

 13. Pull sock over R foot (2)
 with heel to heel

 14. Pull sock over L foot (2)
 with heel to heel

 15. Pull sock up to full (2)
 extension on R leg

 16. Pull sock up to full (2)
 extension on L leg

D. Shoes

 17. Place R toes into R (2)
 shoe

Figure 9.12. Klein-Bell ADL Scale: standardized functional assessment form.

11. FUNCTIONAL ACTIVITIES OF PERFORMANCE

A. Personal Care Activities

1. Cleanliness, hygiene, and appearance
Subtotal raw score ____/Subtotal possible (54) ____ × ____ × 100 = ____? (from p. 6 to graph 2)

2. Medical and health management activities
Subtotal raw score ____/Subtotal possible (24) ____ × ____ × 100 = ____? (from p. 9 to graph 2)

3. Nutrition activities
Subtotal raw score ____/Subtotal possible (24) ____ × ____ × 100 = ____? (from p. 11 to graph 2)

4. Sleep and rest activities
Subtotal raw score ____/Subtotal possible (8) ____ × ____ × 100 = ____? (from p. 12 to graph 2)

5. Mobility activities
Subtotal raw score ____/Subtotal possible (24) ____ × ____ × 100 = ____? (from p. 15 to graph 2)

6. Communication activities
Subtotal raw score ____/Subtotal possible (28) ____ × ____ × 100 = ____? (from p. 20 to graph 2)

B. Occupational Role-Related Activities

1. Home management activities
 Subtotal raw score ____ /Subtotal possible (38) ____ × ____ × 100 = ____? (from p. 27 to graph 2)

2. Consumer activities
 Subtotal raw score ____ /Subtotal possible (12) ____ × ____ × 100 = ____? (from p. 29 to graph 2)

3. Studentship activities
 Subtotal raw score ____ /Subtotal possible (14) ____ × ____ × 100 = ____? (from p. 31 to graph 2)

4. Employment and volunteer preparation activities
 Subtotal raw score ____ /Subtotal possible (8) ____ × ____ × 100 = ____? (from p. 32 to graph 2)

5. Caregiving activities
 Subtotal raw score ____ /Subtotal possible (4) ____ × ____ × 100 = ____? (from p. 33 to graph 2)

6. Employer activities
 Subtotal raw score ____ /Subtotal possible (14) ____ × ____ × 100 = ____? (from p. 33 to graph 2)

7. Community activities
 Subtotal raw score ____ /Subtotal possible (10) ____ × ____ × 100 = ____? (from p. 37 to graph 2)

8. Avocational activities
 Subtotal raw score ____ /Subtotal possible (12) ____ × ____ × 100 = ____? (from p. 39 to graph 2)

Total raw score ____ Total possible (268) ____ × ____ × 100 = ____? (from p. 39 to graph 1 and graph 2)

Figure 9.12. (*Continued*)

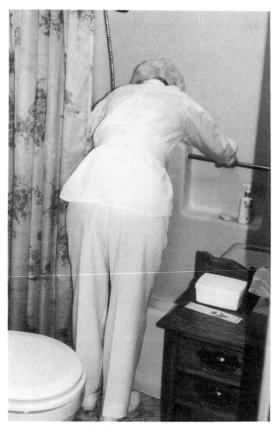

Figure 9.13. Game participant used tub stool in an unusual manner to enable bathing in the preferred manner.

people with disabilities. Their quality of life is directly impacted by the parameters of the behavioral, psychosocial, and environmental context in which the ADLs occur. Handicapping environments negatively skew the complex relationship needed to achieve congruence between environment and behavior.

A VIP with Parkinson's disease who lived at home was fed by his wife because of the severity of his tremors. The game question, "What is your mealtime routine?" stimulated a lively conversation between the two, revealing VIP's desire to feed himself, despite the time and effort this would involve. His wife believed that, by feeding her husband, she was providing quality care, but confessed that caring for her husband consumed most of her time. He felt his dignity was diminished because of the dependency he felt when being fed. She was at risk of burn-out, having given up most of her personal interests to her role of caregiving. In the ensuing discussion they decided he would feed himself at least one meal a

day, using a warming dish to accommodate the extended time this would involve, thereby relieving his wife of one caregiving task. She agreed to use this time for herself, as a brief respite from her caregiver role. In this case, the multilogue enabled both the VIP and the caregiver to express their needs and assume control over one aspect of their lives, uncovering insights into the complex nature of the psychosocial milieu. The game play contributed to both the VIP's and the caregiver's life satisfaction in a way that may not have occurred using a standardized form to evaluate the individual's ability to feed himself.

Comprehensive standardized ADL evaluation instruments break each activity into essential behavioral components and score those components (see Figure 9.1); treatment plans developed based on these competency assessments facilitate the patient's successful completion of the ADLs in the clinical setting. Subsequent clinical exercises develop competency in the individual's ability to accomplish the sequential subtasks associated with ADLs. The control of variables in the clinical setting provides a reliable measurement, but it may not be valid outside of the clinical setting due to complexity of stimuli in the home environment. In comparison, A Day's Journey Through Life identifies interrelationships among the VIP, the ADLs, and the home environment. The game accesses the larger macro context of the ADL in addition to the micro task competencies, focusing on a more holistic viewpoint than the narrower domain of the standardized, objective test instrument.

The inability of the standardized evaluation form to identify characteristics of the environmental context in which the activity is performed was demonstrated in one game play with a VIP who used a wheelchair. In the rehabilitation facility, the VIP learned how to transfer from his wheelchair to a stair lift, anticipating the need to access a second-level bedroom when he returned to his home environment. However, the configuration of the stairs in the clinical setting (a straight run) and the configuration of the stairs in the home setting (a 90° turn with a landing two steps from the bottom) differed in a way that made the task more difficult to execute in the home setting. The change from a straight run stair to a stairway with a landing necessitated transfer form the wheelchair to the floor of the landing and then a transfer to the chair lift, depleting his minimal energy reserves. The problem was identified when the VIP responded to the question during game play, "What is your bedtime routine?" The researchers were able to suggest modifying the stair lift to turn the corner or, in lieu of this expense, utilization of a permanently attached, folding transfer board to span the distance between the wheelchair and the stair lift seat.

CONCLUSION

Developing and renewing the physical competencies lost through disease, trauma, or aging often yields substantial benefits. Under the auspices of occupational and physical therapists, alternative skills are sought for individuals with

disabilities in order to compensate for their diminished capacities. Yet at times Herculean rehabilitation efforts fall short of complete rehabilitation or adaptation. It then becomes a demand placed upon the physical environment to accommodate the imbalance between the individual's functional ability and the task requirements. Deciphering the need and identifying a range of solutions that include therapy interventions, product, and environmental solutions can enhance the potential to sustain greater levels of independence and extend the possibility to continue to maintain an independent lifestyle.

Using data collected through use of A Day's Journey Through Life, researchers and practitioners can gain insightful knowledge of product/environmental performance and achieve a fuller understanding of the interaction between the individual with a disability and the physical setting in which the ADLs occur. Benefits derived from using the game include:

1. Development of a comprehensive understanding of the efficacy of the micro and macro physical environmental elements that affect behavior throughout the lifespan
2. Compilation of ideas, perspectives, and knowledge that challenge existing preconceptions and myths associated with people with disabilities
3. Recognition of the product and environmental needs of people in a physically diverse society
4. Exposure to a range of product and environmental interventions that can accommodate the heterogeneity represented by the varying physical, social, and emotional needs
5. Establishment of a knowledge base that can be translated into performance criteria for the designated population's macro and micro interior, architectural, and product needs
6. Identification of any disparity between task implementation in the clinical setting and in the home setting
7. Initiation of a changed perception of accessibility and handicapping environmental issues.

As a result, scholars and practitioners will be able to develop unique insights into issues that pertain to and anticipate the performance requirements that will govern sociopsychological, environmental, or product design resolutions.

REFERENCES

Asher, I. E. (1989). *An annotated index of occupational therapy evaluation tools*. Rockville, MD: American Occupation Therapy Association.
Boocock, S. S., & Schild, E. O. (Eds.). (1968). *Simulation games in learning*. Beverly Hills, CA: Sage.
Coleman, J. S. (1968). Social processes and social simulation games. In S. S. Boocock, & E. O. Schild, (Eds.), *Stimulation games in learning*. Beverly Hills, CA: Sage.

Duke, R. (1991). *People at play. UNESCO*. New York: United Nations.

Greenblat, C. S. (1981a). Seeing forests and trees: Gaming-simulation and contemporary problems of learning and communication. In C. S. Greenblat, & R. D. Duke (Eds.), *Principles and practices of gaming-simulation*. Beverly Hills, CA: Sage.

Greenblat, C. S. (1981b). Basic concepts and linkages. In C. S. Greenblat, & R. D. Duke (Eds.), *Principles and practices of gaming-simulation*. Beverly Hills, CA: Sage.

Klein, R. M. & Bell, B. J. (1979). Klein-Bell Activities of Daily Living Scale. Seattle: Health Sciences Learning Resource Center, University of Washington.

Lawton, M. P. (1980). *Environment and aging*. Pacific Grove, CA: Brooks/Cole.

Lawton, M. P., & Nahemow, L. (1973). Ecology and the aging process. In C. Eisdorfer & M. P. Lawton (Eds.), *Psychology of adult development and aging*. Washington, DC: American Psychological Association.

Mueller, J. (1993). *Toward universal design* (videotape). Chantilly, VA: Universal Design Initiative.

Regnier, V., & Pynoons, J. (1978). *Housing the aged*. New York: Elsevier Science.

Research Foundation. (1987). FIM: Functional Independence Measure. Buffalo: Research Foundation, State University of New York.

Rhyne, R. F. (1975). Communication holistic insights. In C. S. Greenblat, & R. D. Duke (Eds.), *Gaming simulation*. New York: Halsted.

Sekulski, R., Jones, L., & Pastalan, L. (1994). *A Day's Journey Through Life©: An assessment game*. Paper presented at the Measuring Handicapping Environments Conference, The Adaptive Environments Laboratory, State University of New York, Buffalo.

Trades Research and Development Center. (1991). *FACT: Functional Assessment Compilation Tool*. Rockville, MD: American Occupational Therapy Association.

U.S. Bureau of the Census. (1992). *1990 Census of population and housing summary: Social, economic and housing characteristics of the United States*. Washington, DC: U.S. Government Printing Office.

10

Detection and Discrimination of Tactile Warning Signals in Field Conditions

Edward Steinfeld and Gary Richmond

INTRODUCTION

The chapter describes field research conducted in Buffalo, New York, as part of the Detectable Tactile Surface Treatments Project during 1984 and 1985. The overall project identified and tested the use of walking surface materials as mobility and orientation aids for people with visual impairments. Earlier phases of this effort included laboratory studies that tested a number of materials under controlled environmental conditions. The work reported here is a field study that tested materials under conditions simulating actual use of buildings and sites.

Edward Steinfeld • Center for Inclusive Design and Environmental Access, State University of New York at Buffalo, Buffalo, New York 14214. **Gary Richmond** • Cannon Design, Grand Island, New York 14072.

Enabling Environments: Measuring the Impact of Environment on Disability and Rehabilitation, edited by Edward Steinfeld and G. Scott Danford. Kluwer Academic/Plenum Publishers. 1999.

Conveying Environmental Information

People use two kinds of environmental information for wayfinding and orientation: "affordances" and "signs" (Norman, 1988). Affordances include physical features of the environment such as paths, boundaries or edges, intersections of paths (nodes), and other, more psychological, constructs such as landmarks and districts that attain consensual meaning because of their personal or social significance (Lynch, 1960). They are not necessarily intended to serve as specific wayfinding and orientation aids but, in fact have such uses. Their significance is learned by the traveler solely through experience, as events are associated with nearby environmental features. A good example is the sidewalk curb that is intended to separate pedestrian and vehicular traffic and/or keep storm water off the walking surface. Although not intended for this purpose, curbs are also used by both sighted and visually impaired individuals as an orientation aid.

Signs or signals, on the other hand, are specifically intended to aid wayfinding and orientation. Examples are instruction signs, milestones, directional traffic signals, addresses, pedestrian markings, and speed bumps. Tactile materials on walking surfaces can obviously fall into both categories. In fact, changes in walking surface materials are generally used by people with visual impairments as nonvisual landmarks. Purposefully designed as such, they become "signs."

There are three purposes for which tactile surface treatments can be used and four types of signals (in quotation marks) that can be created with them:

1. *Warning*: to warn of hazards upcoming in the path of travel, for example, a "hazard" signal placed across a path in front of the hazard
2. *Location identification*: to help people find places, for example, a "landmark" signal placed at a decision point
3. *Guidance*: to guide people in a specific direction in an open, undefined area by creating a "track" or a "shoreline"

This research examined the value of tactile surface treatments for all three purposes. All four types of signals were investigated.

Theoretical Background

Two areas of theory development had a bearing on the research design:

1. To ascertain how easily materials on walking surfaces can be detected as tactile cues within a real world environment by people with visual impairments
2. To determine how effective these treatments are as an aid to orientation and mobility, particularly as warnings of hazards

The first research goal was addressed using signal detection theory, the second by cognitive mapping theory.

Signal detection theory applies to a broad array of tasks in which awareness and perception of a source of information or signal within an environment is critical for successful performance. There has been a great deal of research attention given to such tasks, ranging from perception of highway signs at high speeds, instrument readings on control panels, and quality-control functions in manufacturing processes (see, e.g., Sanders & McCormick, 1993). One concept in signal detection theory is that two types of errors can occur in detection tasks. One type of error occurs when an individual fails to detect (misses) a signal. Another type occurs when an individual erroneously detects a signal that is not present (false alarms). The existence of these two types of error implies that measuring performance must examine both the ability of a signal to be detected and the ability of the signal to be discriminated from other potential stimuli. Research into tasks of signal detection has demonstrated that human performance in "benign" environmental conditions where attention can be concentrated on one source of information is much better than in "stressful" conditions where attention must be divided to simultaneous sources of information. Thus, signals that can be detected easily in benign environmental conditions may be difficult to detect under difficult conditions. These assumptions underlay our research design.

Research in the field of environmental cognition has demonstrated that people create mental images, or "cognitive maps," that help them remember the location of things and places and to orient themselves in space (see, e.g., Downs & Stea, 1977; Passini, 1984). The level of detail in these maps and their accuracy are directly related to both the familiarity that an individual has with a place and the "imageability" of the place itself. While the effectiveness of a tactile surface treatment can be measured by signal detection theory, the usefulness of the signal is determined by how it affects the user's cognitive map. Tactile signals are, in effect, landmarks that should strengthen the legibility of a place and help people in orientation and mobility tasks.

Both theories recognize that successful task performance is a function of both the environment and the abilities of a person. Thus, the degree to which a surface treatment can be perceived is directly related to the stimulus provided by the materials, the surrounding environmental context and the abilities of a person to perceive the material. The ability of a person to maintain an accurate image of the world is likewise a function of both one's ability to construct useful cognitive maps and the properties of a place that contribute to the development of such maps. Furthermore, both theories recognize the importance of experience in human performance. With increased familiarity and/or training, a specific material will be perceived more easily and a cognitive map will be richer and more accurate.

OBJECTIVES

The specific objectives of the research were as follows:

1. Evaluate the detectability of experimental tactile surface treatments on walking surfaces under conditions of actual use
2. Evaluate the impact of the surface treatments on orientation and mobility performance
3. Assess the impact of environmental factors on orientation and mobility performance
4. Determine whether surface treatments will have any detrimental impacts on pedestrian behavior of people with and without disabilities
5. Identify problems related to installation and maintenance and long-term durability of the materials

RESEARCH DESIGN

General

The research method used simulated walks through preselected routes, three in buildings and three outdoors. All trials were in Buffalo, New York. Subjects, all of whom had visual impairments, were read standard instructions that included reference to a few design features of the route as well as what turns to take. After each walk on a route, a debriefing interview was given to ascertain a subject's recall of the route (cognitive map). During the walk, researchers recorded the location and type of mobility and orientation problems encountered by the subject on a standardized checklist. Elapsed time for route traverse was also recorded.

Three sets of trials were completed:

- Phase 1 (baseline)—no signals in place, no training
- Phase 2—signals in place, no training
- Phase 3—signals in place, with training

To measure detection of experimental materials in Phases 2 and 3, subjects were asked to stop as soon as they encountered a walking surface change and to notify researchers. One of the materials on each route was used as a simulated hazard warning signal. This signal was used to study discrimination of one material from another. In each case, the selected material was presented to the subjects for identification before the route trial began. They were asked to indicate if and when they found that particular material during the route. In Phase 3, only two routes were used, one indoors and one outdoors. Training was provided by walking each subject through the route and thoroughly familiarizing

them with all the features of the route and signals used on it. To evaluate the impact of the experimental surfaces on orientation and mobility, subject performance was measured by the change in performance (e.g., the number of errors made, total elapsed time, amount of information recalled) on each segment from one phase to the next.

A set of cold weather field testing trials was organized for a subsample of cane users and for three of the experimental outdoor materials. These were pure detection trials. Between periods of subject testing, we left the tactile signals in place and, through time, sampled naturalistic observations and noted the usefulness of the signals and any problems they caused for the general population.

The analysis of the data focused on:

1. Signal detection and discrimination
2. Comparison of actual mobility and orientation performance with and without signals in place and with and without training
3. The impact of environmental conditions—weather, background noise, and locational factors—on performance
4. Comparison of recalled knowledge about the routes with and without signals in place

Experimental Settings

With the aid of an orientation and mobility instructor, three indoor routes and three outdoor routes were identified that would present problems for orientation and mobility even to good "travelers" but would not be impossible for poor travelers. The routes took an average of about 5 min to traverse. All routes included sections that were difficult to understand easily without vision under the assumption that successful use in these conditions would imply successful use of surface treatments in less difficult surroundings. The signals were located at several places on each route.

The six routes provided a range of environmental features, including:

1. Variation of background noise levels
2. Winding circulation through interior aisles or on complex exterior pathways and very long, straight paths
3. Intersections of different types (e.g., cross, T-shaped)
4. Undifferentiated open space
5. Clearly differentiated and undifferentiated path edges
6. Stairs, both up and down
7. Vehicular circulation areas (e.g., driveways and parking lots)
8. Variation in microclimate, including air movement, sun, and shadow
9. Presence of other people and movable obstacles (e.g., chairs and tables)

Independent Variables

In the context of this research, independent variables are factors that could cause variability in orientation and mobility task performance. The independent variables included:

1. Experimental materials
2. Imageability of the place at which the signals are installed—bland or confusing
3. Type of the signal—hazard, landmark, track, or shoreline
4. Familiarity of subject with the route and signals through past experience and through experimental use
5. Environmental conditions—precipitation, temperature, wind speed, light level, background noise, and environmental design characteristics
6. Functional ability of the individual in orientation and mobility tasks

Experimental Materials

Seven materials were selected from among a larger set tested in previous laboratory research. Three materials had proven only moderately reliable (Pavlos,

Figure 10.1a. Steel checker plate with gritty thermoplastic surface.

Figure 10.1b. Gritty thermoplastic surface.

Figure 10.1c. Stainless steel grate.

Figure 10.1d. Resilient thermoplastic surface.

Steinfeld, Shiro, & Sanford, 1985), whereas four of the selected materials had proven very reliable (Figure 10.1). The experimental materials used were:

1. Steel checker plate with gritty thermoplastic surface above hollow space ("checker plate")
2. Gritty thermoplastic surface applied directly to walking surfaces ("gritty")
3. Resilient thermoplastic surface applied directly to walking surface ("resilient")
4. Stainless steel grate above hollow space ("grate")
5. Artificial grass
6. Gritty antislip mat ("antislip")
7. Narrow-ribbed rubber mat ("ribbed mat")

Imageability

Previous research on cognitive mapping by visually impaired people demonstrated that places with poor imageability due to blandness or a high degree of complexity are the most difficult to negotiate and remember (Aiello, 1981). It is precisely in such places that tactile signals should be most helpful. Both the indoor and outdoor routes had similar overall imageability levels along these two dimensions. Within each route section, two to four locations were chosen for the installation of experimental signals.

Signal Type

A total of 18 locations were included, nine indoors and nine outdoors. Because two signals were encountered twice by each subject as they traversed the routes, there were a total of 20 signal encounters. Two signals also served multiple functions. Categorized by signal type, six warnings, eight landmarks, one track, and seven shorelines were encountered.

Familiarity

After each phase, subjects were asked if they were familiar with the route segment that they had just traversed. In Phase 2, the research subjects were familiarized with each of the warning signals before encountering them. None of the other signals were introduced to the subjects. In Phase 3, subjects were thoroughly familiarized with the route itself, the experimental signals, and their location. Phase 3 took place during the same testing session as Phase 2.

Environmental Conditions

For each set of outdoor trials, a record of environmental conditions was recorded. Measurements were made during each route traverse. After data collection was completed, outdoor trials were separated into those during which extreme conditions were present and those during which more benign conditions prevailed.

Functional Abilities

For each person in the subject pool, a profile of functional visual ability was developed based on their response to a screening interview. Subjects were classified as cane travelers who were totally blind, cane travelers who also had some useful vision, partially sighted travelers who did not use either a cane or dog, guide dog travelers, and sighted guide travelers. The subjects were rated as "multiply disabled" if they reported other disabilities that were related to mobility and orientation skills.

Dependent Variables

In the context of this research, dependent variables are measurable indicators of orientation and mobility performance. The dependent variables included:

- Performance in signal detection and discrimination tasks
- Performance in mobility and orientation tasks

Detection and Discrimination

Signal detection, for the purposes of this research, is the ability of subjects to recognize changes in surface materials. Detection alone is sufficient for using a material as an affordance. However, to use a material as a "sign," an individual must be capable of distinguishing one material from another and recognizing a particular material that has a specific meaning. In this study, signal detection performance was measured by the frequency with which subjects detected signals as surface changes on the route. Discrimination was measured both by the number of "hits" or correct detection of hazard signals and also the number of errors, which includes both "misses" and mistaken detection or thinking a hazard signal is present when none was. Detection and discrimination performance were measured only for Phases 2 and 3.

Mobility and Orientation

Good mobility for visually impaired people can be defined as the ability to move through an area without impediment or difficulty. For the purposes of this research, mobility was measured in four ways: elapsed time for negotiating a route, not including the time spent recovering from errors; frequency of obstacles encountered on the route; frequency of altered course—difficulty walking or staying on course; use of "cautionary" mobility technique—trailing walls with hands or "shorelining" with a cane.

Orientation refers to the understanding of a location, such as knowledge of its physical characteristics and cardinal directions, or understanding a route in its relationship to the street or its layout. Several measures were used to evaluate orientation performance: frequency of decision point errors (e.g., missing a turn at an intersection), frequency of reversal of direction and frequency of pausing for gathering data about surroundings. We also assessed orientation as a cognitive process through debriefing after the traverse of a route. The variables studied in the debriefing included:

- Subject's estimate of the route length and travel time
- Amount and type of information recalled about the route
- Accuracy in recall of the route

Subjects

To select a representative sample for generalization of results requires a well-defined target population. Previous studies have identified a range of categorical traits associated with visually impaired pedestrians. In the larger sense, the target population includes all visually impaired travelers. But for the purposes of this research, we did not include people who were visually impaired but who did not travel independently and those who were nonambulatory.

Relevant subject characteristics include degree of visual impairment, travel proficiency, proficiency in orientation, and physical mobility skills. The visual dimension is especially important since it is central to the definition of the population.

Research subjects were recruited through extensive media coverage and solicitation at meetings of visually impaired people. From a pool of 160 volunteers in Buffalo, the 70 most impaired individuals were selected using an index of visual abilities derived from items on the screening interview. Fifteen volunteers declined to participate in Phase 1, bringing the initial sample down to 55. Further attrition for a variety of reasons reduced the sample to 45 in Phases 2 and 3 indoors and 40 in Phases 2 and 3 outdoors. The cold weather testing used a subsample of 12 cane and guide dog users—all those who were willing to participate in inclement weather.

The causes of visual impairment among members of the initial sample of 55 included 20 different illnesses and chronic conditions as well as trauma. The most prevalent single cause was diabetes (18.8%). Nine percent ($n = 5$) and 7.3% ($n = 4$) of the sample had glaucoma and retinitis pigmentosa, respectively. Aside from these categories, no other single cause was reported by more than two people in the sample. Twenty-seven percent of the sample reported multiple causes.

FINDINGS

Signal Detection and Discrimination

Materials that had been easy to detect in the laboratory were generally easy to detect in the field. Materials that had been difficult to detect in the laboratory were difficult to detect in the field. However, based on detection and discrimination rates, some serious limitations on the use of even "good" materials were identified. From the perspective of simple detection without training, the artificial grass, the ribbed mat used as a track, and the ⅛ in. checker plate were very reliable (detection rate over 80%). Ribbed mats used as landmarks or warnings, however, were not reliable, nor was the metal grate, even though they had been reliable in detection in the laboratory research. A slight increase in thickness

from ⅛ in. to ¼ in. in one of the checker plates resulted in a significant decrease in detectability because of a reduction in deflection and a change in the sound frequency of cane taps.

There was some evidence to indicate that tracks are easier to detect than hazard or landmark signals. However, there were not enough tracks tested to generalize with certainty. Shorelines, either flush with or applied to the walking surface, appear to be the most difficult type of signal to detect.

From the perspective of discrimination, only one material tested could be considered truly reliable: the artificial grass. In general, the discrimination of the hazard signals (which were the easiest to detect) was poor. The total discrimination rate was 53%, and the total error rate (both "misses" and "false detections") was 52% for all six hazard signals. Training provided during Phase 3 improved discrimination rates but not to the point of making either of the two signals tested during this phase reliable as hazard signs.

In the training trial (Phase 3), detection of the materials improved dramatically. Several materials improved enough to make them reliable—antislip mat on VAT, ribbed mat on VAT, and the metal grate.

The cold weather testing actually demonstrated better detection rates for two of the three signals tested than the regular controlled field testing. The difference in the results can be explained partially by the decreased complexity of the task required.

Mobility and Orientation Performance

Baseline (Phase 1) performance on each route showed a high degree of variation by route and within each subsample. This variation demonstrates that the six routes provided a wide variety of mobility and orientation experiences for the subjects and also that there was a great deal of variation in the subjects' mobility and orientation abilities. Mobility and orientation performance in both Phase 2 and Phase 3 was compared to baseline performance. In general, there were no broad improvements in performance that could be associated with the experimental surface treatments. Although there were dramatic and consistent reductions in almost all types of problems from Phase 1 to Phase 2, analysis of problem frequency on matched pairs of route segments (signal locations and comparable nonsignal locations) showed that the impact of the surface treatments themselves was only significant from the perspective of serious problems— difficulties that were so severe that subjects had to be reset on the course. In Phase 2 we found an increase in directional problems. One explanation of this finding is that subjects may have been overconfident about their knowledge of the routes in Phase 2. A second possibility is that the discrepancy between what they encountered and what they remembered led to confusion. Another cause of directional problems may be distraction and confusion in Phase 2 due to the detection and discrimination tasks that were not included in Phase 1.

There was an association between elapsed route time and incidence of problems; however, recall knowledge failed to correlate with actual performance. Recall data demonstrated that walking surfaces were the third most important category of information remembered about the routes (behind places and fixed objects). In addition, walking surfaces were the most important category of sensory information remembered. Surfaces were also the most consistently remembered across all routes. Previous familiarity with the routes had a strong positive impact on observed performance but, interestingly, not on recall of the route.

Impact of Environmental Conditions

No association between environmental conditions and orientation and mobility performance was evident. Environmental conditions could not be controlled on any of the routes. "Extreme conditions" were distinguished by any of the following: temperature extremes, high wind, precipitation, noise, wet ground surface, or unusual debris. Mean number of problems per route and mean elapsed time per route were compared for extreme conditions and all conditions. Since extreme conditions occurred for different people on different routes, comparisons of means from one phase or sample to another are, therefore, only useful for identifying major patterns. The analysis revealed small and inconsistent differences in performance.

Design Features

Mobility and orientation performance was coded onto route maps to examine the impact of environmental design features on performance (see Figure 10.2). This analysis identified two main problem areas: (1) open, unbounded spaces with obstacles and (2) places where subjects had to make a decision on turning. Decision points caused more problems when there was no boundary across the path of travel to prevent subjects from passing the turn (i.e., cross-intersections rather than "T" intersections). It is clear from this that strong boundaries at intersections aid orientation and mobility performance. Warning signals located in unexpected places along the routes (e.g., long uneventful straight segments) were associated with increases in directional problems during Phase 2. Apparently, the required task of identifying the signal caused distraction. In general, each successive phase of research resulted in a "smoothing out" of problem frequency along each route. With more exposure, the initially more difficult areas became close to average in difficulty. Since there were only three trials at most on each route, this suggests that there may be little need for surface treatments in places that are familiar to visually impaired people.

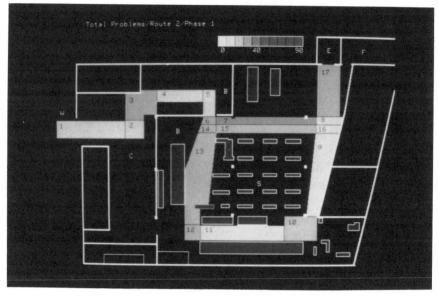

Figure 10.2. Example of coded route map.

General Pedestrian Behavior

Four signal locations were observed during the naturalistic time-sampled observations. The experimental surface treatments at these locations were generally not used by either the visually impaired inhabitants of the building or other users of the sites as orientation or mobility aids.

Installation, Maintenance, and Durability Issues

Several installation, maintenance, and durability problems were identified. The only materials that performed satisfactorily in all these areas were the ribbed mat and artificial grass (with the exception of initial staining). From our general experience and observations, we discovered that several construction issues must be addressed in selecting tactile surface treatments: cost of installation, weather conditions at installation, presence of vehicular traffic, structural support, fastening methods, and routine maintenance and long-term deterioration.

Validity Issues

Are these findings generalizable to the broader population and to other places? Without replication of the research, no conclusive evidence is available. However, there is enough evidence to suggest that they are.

One could assume that multiple disability and old age both would tend to reduce performance on the tasks studied. The sample had very few subjects with multiple disabilities, but it did have a high percentage of older people. Thus, in terms of aggregate performance, the lack of people with multiple disabilities was likely offset by the prevalence of older people.

Many people in the sample were familiar with the various settings in which testing took place, but only 20% of the routes were "familiar." Some degree of familiarity would be present among the users of any building or outdoor areas. Thus the degree of familiarity with the routes is unlikely to have made a significant impact on the generalizability of results.

Although a relatively small number of people were studied, there was considerable variability in subjects' performance. Also, the large number of observations for each subject and the generally consistent patterns of performance provide evidence that findings are not the result of random events. Moreover, there was enough variation in performance to ensure that the results do not reflect the abilities of people with only a narrow range of competencies.

As part of the screening interview, we utilized two separate self-reported ratings of functional ability: our own Visual Abilities Scale and a set of general items on limitations in activities from New York University Rehabilitation Institute's (RI) Indicator Project. Correlations of each of these scales with actual performance on the routes demonstrated an association between the Visual Abilities score and actual performance but virtually none for the Rehabilitation Indicator set (correlation coefficients, -0.60 and -0.03, respectively). There was also virtually no association between the two self-report scales. Our scale was specifically designed to focus on abilities of direct relevance to using the built environment while the RI scale items were based on general tasks of independent living. The lack of association demonstrates that the two scales were measuring different things. They also suggest that orientation and mobility skills are not necessarily related to independence in general tasks of daily living. Future research in this area could be facilitated by using some version of the Visual Abilities Scale to classify subjects. Using this scale, small numbers of subjects could be studied and results could still be generalized to the larger population.

A wide range of places were studied. They included great variation in types of spaces, background noise, illumination levels, activities, and so on. Although the routes lacked diversity in walking surfaces, this helped to provide an element of clarity in comparing the performance of the various materials, particularly in comparison to the laboratory research. However, assumptions must be made to extend findings to other surfaces. Previous work by Templer, Wineman, and Zimring (1982) and the laboratory research completed for this project demonstrated that background surfaces of unit paving materials such as stone, brick, and asphalt pavers make little difference in detection and discrimination of signal materials. Differences in concrete finish or carpet pile are unlikely to have an impact on orientation tasks since the key variables in detection and discrimination appear to be sound and resilience.

With respect to the reliability of the research methods, there were several potential threats:

1. The order in which routes were tested could have affected the findings because of fatigue caused by long testing sessions and learning effects
2. Associations discovered in the correlation analyses could have been caused by random factors rather than true cause-and-effect relationships
3. Recall data could have been highly inaccurate
4. The loss of subjects in the sample over time might have limited the comparability of data between phases

The data was examined with respect to each of these threats. The first threat to validity was investigated by completing a correlation analysis for route order and performance. No significant statistical association was found. The second threat was investigated by examining actual frequency plots of correlation data. These plots demonstrated associations that have little chance of being caused by random events. To ensure that the coding method used for the recall data was reliable, an interrater reliability analysis was performed for three coders using four debriefing interviews. After training, the index of agreement was 81.9%, and the indices of relative disagreement for the three ranged from .66 to .67. These scores indicate a very good level of agreement and consistency in the level of disagreement. Although the process of coding recall data was controlled and evaluated, the reliability of the data provided by subjects can still be questioned. In coding the recall data, it was evident that some subjects mixed up information about one route with that of another. Some items were clearly not on the routes at all, and others were misinterpreted. In many cases, it was felt that decision points recalled were based on reiteration of memorized directions rather than real knowledge. Given the lack of association between recall data and performance, the reliability of recall data remains in question.

The last threat to reliability was examined by comparing background data from those that completed the research and those that did not. There was no significant difference between background characteristics in these two groups. To further ensure that our analysis was not affected by making comparisons between different groups of people, independent analyses were completed that controlled for dropouts.

In summary, the results of this research appear generalizable to the larger population. Although some limitations exist in the characteristics of the sample, it was diverse enough that it does not reflect the performance of a narrow or restricted group, a group of people with neither predominantly high- nor low-level abilities. The major limitation to generalizability lies not with this research but with our knowledge of the functional abilities of the visually impaired population at large. Although we discovered a strong association between self-reported functional visual abilities and orientation and mobility performance, there are no general data on functional abilities for the larger population. If such data were available, we could make some very concrete conclusions on this issue.

The findings of the research can be generalized to a wide variety of places with some reasonable assumptions. They can also be generalized to a wider variety of walking surfaces than those actually studied.

The reliability of the research methods could have been affected by several validity threats inherent to the methods and the research process. Each of these threats has been investigated and, for the most part, adequate evidence to support reliability is available. In one area, accuracy of recall information, reliability is still in question. In fact, our informal experience calls into question the reliability of other research using recall tasks. Improved methods for ensuring reliability of recall data are needed, particularly when trials of several routes are run within a single testing session.

CONCLUSIONS

The research findings can be generalized to a wide range of people and places. Both the subjects and routes used were reasonably diverse and representative of the larger population of people and places.

The recall data indicates that walking surface materials can be a reliable way to convey information to visually impaired people. People with visual impairments do pay attention to these materials. The materials also proved to be effective in reducing the number of severe mobility and orientation problems encountered. This finding, however, is qualified by the fact that they had no significant impact on the broader range of problems. Moreover, mobility and orientation problems on any specific route were reduced with continued exposure and familiarity. The presence of detectable tactile surfaces alone did not have as significant an impact in reducing problems as did familiarity.

The findings demonstrated that laboratory research can be useful in predicting the performance of surface materials. In general, those that performed well in the laboratory also did well in the field and those that did poorly in the laboratory did poorly in the field. The field studies corroborated the most important laboratory research finding: the most detectable materials are those that have differences in sound resilience and texture compared to their background surface. However, the field research also demonstrated that field conditions can seriously reduce the detectability of materials. Signals in locations that are out of the main pathway or that people can veer around will not be encountered or detected easily. Discrimination is definitely more difficult in the field. There are more surfaces and more distractions. Poor weather than masks the signal can limit the usefulness of detectable tactile surfaces located outdoors. In fact, we were not able to test the outdoor materials for 3 months at all because they were covered with ice and snow. Such conditions could reduce the amount of time that people could use these materials in cold climates by 25-30%.

The importance of training in the use of detectable tactile surfaces is very clear. In places where the surfaces can be explained and their utilization prac-

ticed, it would be expected that their effectiveness would be significantly improved. Such training is unlikely except in educational, residential, and employment settings or transportation facilities used frequently by individuals (e.g., commuting to work and back). However, it is in precisely those settings that continued exposure to familiar routes would decrease the need for detectable tactile surfaces. The best applications for these surfaces are, therefore, in public facilities where people are less familiar with the environment and to solve specific problems in other buildings only when they arise and cannot be solved through training alone. Efforts should be made to improve rehabilitation training in the use of detectable tactile surfaces so that applications in public facilities will be most effective.

REFERENCES

Aiello, J. F. (1981). *Dynamics of imageability of the built environment for the non-visual traveler.* Unpublished Ph.D. dissertation, Syracuse University.
Downs, R. M., & Stea, D. (1977). *Maps in minds: Reflections on cognitive mapping.* New York: Harper & Row.
Lynch, K. (1960). *The image of the city.* Cambridge, MA: MIT Press.
Norman, D. (1988). *The design of everyday things* (p. 9). New York: Doubleday.
Passini, R. (1984). *Wayfinding in architecture.* New York: Van Nostrand Reinhold.
Pavlos, E., Steinfeld, E., Shiro, A., & Sanford, J. (1985). *Detectable tactile surface treatments.* Atlanta: School of Architecture and Planning, Georgia Institute of Technology.
Sanders, M. S., & McCormick, E. J. (1993). *Human factors in engineering and design.* New York: McGraw-Hill.
Templer, J. A., Wineman, J. D., & Zimring, C. M. (1982). *Design guidelines for making crossing structures accessible to the physically handicapped: Final Report to the Federal Highway Administration.* Washington, DC: Federal Highway Administration.

11

Stigma and Architecture

Julia W. Robinson and Travis Thompson

INTRODUCTION

Insofar as people with disabilities work and live in settings that are less attractive and that are identifiable as "for the handicapped," they are likely to remain outside mainstream society. As stated by Wolfensberger and Thomas (1983):

> if handicapped [sic] people were served in valued locations that had positive names and appearances, and if they were involved together with valued people in valued activities, then [they] … might come to be [more] valued as members of society, believed to belong to the community, and expected to be competent, contributive and productive. (p. 35)

A number of people in the normalization movement for developmentally disabled adults have worked on ways to assess the symbolic and instrumental effects of setting on status, most notably, Nirje (1969) and Wolfensberger (1977). However, the proponents of universal design focusing on physical access have not yet recognized access to status as central to their work. This chapter argues that the stigmatizing effects of architectural setting are a central concern in universal design and proposes a method for identifying and measuring stigmatizing environments.

Stigma is a complex phenomenon that affects not only the stigmatized person but also those who associate with him or her. While Erving Goffman does

Julia W. Robinson • Department of Architecture, University of Minnesota, Minneapolis, Minnesota 55405. **Travis Thompson** • John F. Kennedy Center for Research in Human Development, Vanderbilt University, Nashville, Tennessee 37203.

Enabling Environments: Measuring the Impact of Environment on Disability and Rehabilitation, edited by Edward Steinfeld and G. Scott Danford. Kluwer Academic/Plenum Publishers. 1999.

not address the issue of eliminating stigma through architecture directly in his important book *Stigma: Notes on the Management of Spoiled Identity* (1963), he defines what a stigma is and how it operates in terms of a given individual:

> Society establishes the means of categorizing persons and the complement of attributes felt to be ordinary and natural for members of each of these categories. Social settings establish the categories of persons likely to be encountered there. The routines of social intercourse in established settings allow us to deal with anticipated others without special attention or thought. When a person comes into our presence, then first appearances are likely to enable us to anticipate his category and attributes, his "social identity...."
>
> We lean on these anticipations that we have, transforming them into normative expectations, into righteously presented demands....
>
> When the stranger is present before us, evidence can arise of his possessing an attribute that makes him different from others in the category of persons available for him to be, and of a less desirable kind—in the extreme, a person who is quite thoroughly bad, or dangerous, or weak. He is thus reduced in our minds from a whole and usual person to a tainted, discounted one. Such an attribute is a stigma, especially when its discrediting effect is very extensive, sometimes it is also called a failing, a shortcoming, a handicap.... (pp. 2-3).
>
> By definition, of course, we believe the person with a stigma is not quite human. On this assumption we exercise varieties of discrimination, through which we effectively, if often unthinkingly, reduce his life chances. (p. 5)

It is clear from this quote that stigma is a powerful social force and one that may be difficult to eliminate. However, the civil rights movement has called into question normative, stigmatizing stereotypes. Societal categories are amenable to change if the long view is taken. One force in such change is the physical alteration of the architecture of social settings in order to reinforce new ways of acting and perceiving.

While stigma can affect different kinds of people in different places, most research on the effects of stigmatization in architecture have focused on housing people who have developmental disabilities. There is an increasing body of evidence demonstrating that this group of people is significantly affected by the housing setting in which they are placed. Our recent research (Thompsom, Robinson, Dietrich, Farris, & Sinclair, 1996a,b) has documented that the degree to which a building is perceived as homelike or institutional affects the behavior of both staff and resident. Residents of buildings perceived as more institutional were found to have significantly more stereotypic repetitive behaviors (repetitious movements) and significantly fewer independently generated behaviors. The reverse was found in the settings perceived (by parents, staff, and residents) to be more homelike. The findings suggest that the symbolic environment works in tandem with the instrumental environment to affect people's actions both directly by engendering expectations and actions and indirectly by affecting expectations of and actions toward others. The residents are not just affected by the environment itself, but also by staff attitudes and actions engendered by the

housing, and vice versa. Stigma is not only a societal problem, but also a personal one for the stigmatized person who is inevitably affected by others' evaluations. The quality of architecture then can serve not only to communicate the person's status to others but also, both directly and indirectly, to the self.

How can the stigmatizing effects of environment be measured? In previous research, when selected environmental features were hypothesized to be important and behavior was studied in terms of only a few variables, it was difficult to demonstrate the importance of architectural setting. This is because architectural settings are extremely rich and complex, and architectural cues may be ambiguous and weak. When architectural settings were characterized as a whole it was impossible to identify the significant architectured features of the settings. Moreover, settings have what has often been called redundant cues (more than one feature being related to perceptions and use; see Norberg-Schulz [1965, p. 151] and Rapoport [1982, pp. 51, 149-152]). Thus there is no certainty that the selected variables are the most salient or that other important factors are not overlooked. This chapter outlines an approach to the assessment of environment based on descriptions of settings and correlational analysis such as multiple regression and cluster analysis. This methodology uncovers the factors that are associated with documented effects and their degree of impact. In this way, particular environmental attributes that are important to given outcomes are identified for further examination.

STIGMA AND THE NORMALIZATION MOVEMENT

It is important to understand that stigma is a socially constructed concept. Stigma involves:

1. An agreement on what is considered normal
2. A category defining what is not normal
3. A devaluation of what is not normal

As stated by Wolfensberger and Thomas (1983), "A person can be considered 'deviant' or devalued when a significant characteristic (a 'difference') of his/hers is negatively valued by the segment of society that constitutes the majority or that defines social norms.... Thus, deviancy can be said to be in the eyes of the beholder, and thus is also culturally relative" (p. 23).

While the existence of different categories of people is a necessary precursor to the creation of stigma, without devaluation of a given category, there will be no stigma for belonging to it. Stigma, therefore, is not a fixed or rigid attribute, but rather a changeable characteristic. While amenable to change, social categories and attitudes held toward them are not, however, easy to alter; modification involves an evolution of attitudes that normally takes considerable time.

Changing attitudes about stigmatized people requires either redefining as normal what was formerly seen as not normal, or valuing what was formerly devalued. These are the goals of the normalization movement for people who are mentally ill and developmentally disabled. The movement's central tenet is the importance of "enabling devalued persons to attain (more) valued membership in society" (Wolfensberger & Thomas, 1983, p. 24).

Another critical aspect of stigma is that there is a "tendency for a stigma to spread from the stigmatized individual to his close connections" (Goffman, 1963, p. 30). Thus people who work with stigmatized people, families, or even neighbors may become stigmatized themselves through association. Because the effects of this spread are due to the process of devaluation, any improvement in the status of the stigmatized person will also improve the status of their associates. In the past, many stigmatized people were isolated from society, grouped by their stigma. Those who were mentally ill, elderly and infirm, developmentally disabled, or criminal were housed outside the urban area on segregated and self-contained campuses often serving several thousand residents. While in certain places we continue to maintain large institutional settings for such groups, they are no longer considered appropriate for people who are not criminals. As a society we are replacing these old large edifices with smaller, community-based residences that are intended to more closely resemble ordinary housing. Additionally, there is also an attempt to provide appropriate work and leisure environments for these individuals. It is anticipated that by integrating such people into the broader community, they are more likely to be accepted as normal members of society; by providing them normative places of dwelling, work, and recreation, they will be valued. In fact, people with physical disabilities have already experienced a reduction in stigma largely through the provision of access to normative places. For people with developmental disabilities there is evidence that in comparison to living in a large institution, residing in smaller, community-based housing results in more normative behavior (Larson & Lakin, 1989), which should result in a reduction of stigma as well. This suggests that access to nonstigmatized settings may benefit many different kinds of people who are presently stigmatized.

Since the 1950s and 1960s there has been considerable interest in reducing stigma in the United States. The civil rights movement, which focused on racial discrimination, opened our eyes to other forms of discrimination—toward women, children of unwed mothers, religious and ethnic minorities, those of different gender orientation, those with different diseases such as alcoholism or AIDS, and, most relevant here, those with disabilities. We have come to believe that each individual who obeys the law has a right to life, liberty, and the pursuit of happiness. But ideals are often not matched by actions. Like all societies, ours has considerable amount of divergence between the ideal and the actual. Discrimination against many groups of people remains. Notwithstanding, since architecture, as described by Goffman, sets the stage for and reinforces categoriz-

ation, it is a potentially powerful tool for recongifuring both the categories and the value of those individuals within a given category.

THE RELATIONSHIP BETWEEN ARCHITECTURE AND STIGMA

While many places are stigmatized, and thereby stigmatizing, there are no developed theories on how physical places carry stigma. There has, however, been work that addresses the role of architecture as it relates to the communication and establishment of social status (see Rapoport, 1977, pp. 51–54). In every American city, identical houses will be priced very differently depending upon their location. Those neighborhoods that have lower property value can be considered stigmatized, since fewer people find them desirable. Easily recognizable public housing projects communicate stigma (e.g., Cooper, 1975). Architecture not only plays an important role in establishing and communicating marginalization, but it can either support or impede behavior considered normal and/or behavior that is divergent and thus stigmatizing. Wolfensberger and Thomas (1983) discuss three of the important effects of social devaluation:

> 1.... Devalued people are apt to be rejected, even persecuted and treated in ways which tend to diminish their dignity, adjustment, growth, competence, health, wealth, lifespan, etc.... 2. The (bad) treatment accorded to devalued persons will take on forms that largely express the societal role perception of the devalued person or group. For instance, if a group of handicapped children are [sic] (unconsciously) viewed as animals, then they may be segregated into settings that look like cages and animal pens, ... a class for retarded children may be called "the Turtles." 3. How a person is perceived and treated by others will in turn strongly determine how that person subsequently behaves. Therefore, the more consistently a person is perceived and treated as deviant, the more likely it is that s/he will conform to that expectation and will behave in ways that are socially expected of him/her—or at least that are not valued by society. On the other hand, the more social value is accorded to a person, the more s/he will usually be encouraged to assume roles and behaviors which are appropriate and desirable, the more will be expected of him/her, and the more s/he is apt to achieve. (pp. 23–24)

They go on to describe two strategies that may affect value: reduction of the overt signs of stigma and alteration of the perceptions and values of society toward a devalued person or group. Clearly these are not independent, since the change of society's values may involve the reduction of those socially reinforcing "signs" that we take for granted. Architecture is a medium that carries many of these signs.

The elimination or reduction of stigma then must take into account both the instrumental and symbolic effects of environment not only on the stigmatized person, but also on those who associate with that person either regularly (e.g., caregivers, family) or on an occasional basis (the broader public). While the direct, instrumental effects of the environment can serve to reduce stigmatized

behaviors and support more normative patterns, the symbolic effects of the environment can affect not only the person's self-esteem but also the value others place on him or her, as well as others' expectations for that person, as discussed by Wolfensberger and Thomas. Some key principles by which architecture can reinforce or reduce stigma for people who use and occupy it are embodied in the normalization principle: the creation of situations for all members of society that are as close as possible to societal norms (thus supporting normative expectations and normative behavior) and, in Wolfensberger's (1977) "conservatism corollary," that settings, in order to balance negative value, must be created to convey not just neutral value, but decidedly positive value as well. Only by creating settings of high value can vulnerabilities to the stigma be reduced or prevented. If a ramp is needed for access to a building by people who use wheelchairs, the ramp should not be made of inexpensive materials and placed by a back door. It should be made of materials as good as or better than the building it is accessing and should be placed by the entrance with the most significance.

THE ROLE OF MEASUREMENT IN CREATING VALUED ENVIRONMENTS

If one seeks to reduce stigma and believes that environments play an important role in reinforcing it, then it is useful to measure the degree to which particular environments create stigma, and, moreover, to discover which attributes of an environment contribute to its development. Measurement requires description, valuation, and comparison. To measure something, it must be described relative to a quality and in comparison to something else with the same quality. To discover which of the compared entities has more of the quality in question, both entities must be described relative to some definition of that quality. If that definition is quantified, it is a measure.

In the research presented here, the goal was to discover the degree to which a housing setting is appropriate for people with developmental disabilities. Rather than take the standard prosthetic approach (defining the physical and mental problems of such individuals and designing a building that will address these specific problems), we followed the normalization principle discussed earlier in this chapter, assuming that the best solution would be to provide a setting that would promote "normal" behavior and high status for the residents. Our premises were that normal, ordinary environments are not stigmatizing, that they will tend to reproduce normative behavior, and that the single-family house as the normative "ideal" environment denotes high value. Thus, the single-family dwelling was initially selected to be the form of housing against which others were to be compared. We used a variety of descriptive techniques but discovered that, although we could describe characteristic differences, it was a challenge to develop a valid scale for evaluation. To develop measurement scales, we first had

to describe normative housing settings, both those that are generally found and those we sought to emulate. Interestingly, there is little research on what constitutes normative environments. We tend to take normative environments for granted. However, if we seek to understand what makes environments normative or valued, it becomes significant to describe and understand the meaning and use of ordinary environments. It is recognized that many, if not most, "normal" people in the United States do not live in single-family dwellings and that while the "ideal" environment may be the house, "normal" environments clearly include other types of inhabitation. Like other researchers, during the course of both the early and later work, we found consistent evidence that the single-family dwelling is the preferred form of residence.

The normalization principle implies a polarity between normal and institutional settings that forms the basis for the measure of stigma presented here. An exploratory study of 10 examples of housing (four group homes for adults with developmental disabilities and six normative settings: two houses, two apartments, a dormitory, and a hospital), revealed an apparent continuum of institutionality in both the group homes and the normative settings as indicated by the perceptions of student respondents (Robinson, Thompson, Emmons, & Graff, 1984). The investigation also documented characteristics of the settings that seemed to account for differences between the institutional and homelike settings.

The initial research project on housing for people with developmental disabilities was intended to inform designers of the issues involved in the creation of housing that would be more homelike and less institutional. It resulted in a set of design principles. The presentation of the principles was organized around spatial subsettings of housing (site, exteriors, entries, corridors, rooms, etc.) based on their typical arrangement in institution and home settings. From documentation of the 10 settings and observation of use in the four contrasting group homes, the following descriptions were used to characterize the differences between homelike and institutional qualities:

1. Paired drawings contrasting the appearance of the two types of settings
2. Annotations hypothesizing the significance of the differences
3. A bipolar checklist of architectural features found to discriminate between the two types of settings

The images in the descriptions were evaluated by students and were found to be valid representatives of the perceptions of "institutional" and "homelike" settings (Robinson et al., 1984; Robinson, 1988a). Figure 11.1 shows examples of "institutional" and "homelike" buildings. While this document is a valid and useful description, it is limited by being based exclusively on human observation. While 88% of the 236 items on the checklist were associated with the two qualities they evaluate (Robinson, 1988b; Robinson, Klensin, Bermudez, & Johannes, 1992), the reliance on observation meant that potentially important unobserved variables are excluded.

Figure 11.1. Institutional and homelike residences.

THE ARCHITECTURAL INVENTORY MEASURE

A different approach to architectural description is based not on observation of existing settings but on the design of prospective settings. The Architectural Inventory Measure (AIM) is modeled on the architectural specification, a legal document that supplements the building plan by describing the required materials, equipment, hardware, and other factors not part of construction drawings. In combination with the drawings, the specification attempts to fully describe the prospective structure. In applying the principle of complete description to already existing buildings, the assumption was that, through comparative analysis, it would be possible to discover which architectural attribute(s) contribute to a particular effect and the degree of the contribution. While a complete description is only theoretically possible, the specification approach offers an

alternative to observation that provides descriptive consistency and relative thoroughness.

The specification approach has limitations, primarily due to its breadth and complexity. Although the pattern of structural relations among the described physical features that generates the environmental meaning could ideally be developed from the research findings, because of the necessity of managing a large number of variables we had to impose a structure prior to analysis rather than letting the structure emerge from it. The conceptual structure (see Figure 11.2) for an individual building consists of the site (including a few neighborhood variables), the building exterior, the building structure, and the building interior. The building structure was only considered as part of the exterior or interior where it is visible to the building user. The building interior, because of its importance in assisting the behavior of residents, is the part of the inventory that has been most thoroughly developed and tested. It is divided into spatial subsettings: entry, corridor, living room, etc. Identical descriptive measures are available to describe each subsetting where applicable, for example, building configuration, building materials, furniture, or environmental systems such as plumbing, heating, air conditioning, and fire safety. Several thousand variables per setting are generated. Although the use of the inventory instrument has presently been limited to the assessment of the institutional and homelike character of housing, its conceptual design would enable its use for many different research questions.

Because it is more completely developed, we will focus on the interior measure here. Rather than developing a special measure for each kind of room, the interior AIM is a generalized instrument that can be used to measure any interior space. Its structure is developed as a nested system in which large categories or sections are divided into successively more detailed subsections. The overarching architectural sections are:

1. Context
2. Configuration
3. Materials
4. Systems
5. Furniture
6. Other objects and decorations

At the next level, within the Configuration section, for example, are an additional set of subsections:

- Floor area
- Wall
- Columns
- Ceiling
- Doorway
- Windows

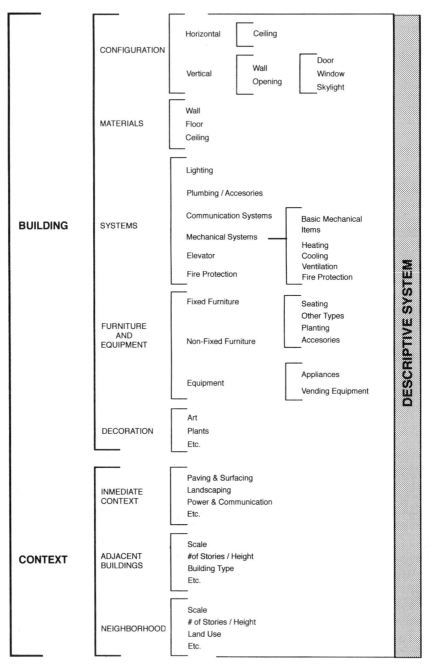

Figure 11.2. The structure of the Architectural Inventory Measure (AIM).

- Partitions
- Closets

The Systems section is divided into:

- Artificial lighting
- Other electrical services
- Heating and cooling
- Plumbing
- Fire equipment
- Appliances

Although some sections can be expanded to basic level, others cannot, and still others have a nested structure even at the basic level (where nominal categories are recognized as objects rather than parts of objects or groups of objects). For example, *doorway* (see Figure 11.3) consists of the door opening, which is at the basic level, but also includes the door and its characteristics. The door, itself a basic level category, is also a subset of doorway, and is not necessarily structurally parallel to basic level categories in other subsections or even within its own subsections (see the door and door hardware discussion later). The technique used to describe the basic objects and features is the identification of (1) the total number of that particular feature, (2) the total number of types of that feature, (3) the numbers of this type of feature, followed by (4) a description of the type in terms of characteristics. So, in a particular room, there might be three doorways and (based upon both the nature of the doorway and of the door) only one type of doorway. For the feature *doorway*, the descriptive characteristics are (1) *dimensions*, (2) *frame*, (3) *material*, and (4) *door*. Dimensions are described by size in inches (opening width, opening height, depth of wall at opening); frame material can be described as wood, metal, same as wall, other, or none; the door itself can be described in terms of number of panels in doorway, door material (by percentage), door material (by flexibility), door operation, and door hardware.

The use of inventory measure to describe institutional and homelike settings has, to date, been applied as a supplement to subjective descriptions of settings based on respondents' evaluations of photographic representations. Once the perceived character of the setting is assessed, the inventory allows the relevant features for stigma to be identified through multivariate analysis.

The AIM is being developed in a series of studies beginning with the 10-building study mentioned earlier, followed by a 29-building investigation of different types of housing, and, finally, the study of 20 group homes. As a part of the study of 29 housing environments, inventory features described by AIM were compared to student evaluations of slide and photographic images as "homelike" or "institutionlike." A detailed analysis of the living room, selected due to its important role in household functioning, permitted identification of attributes

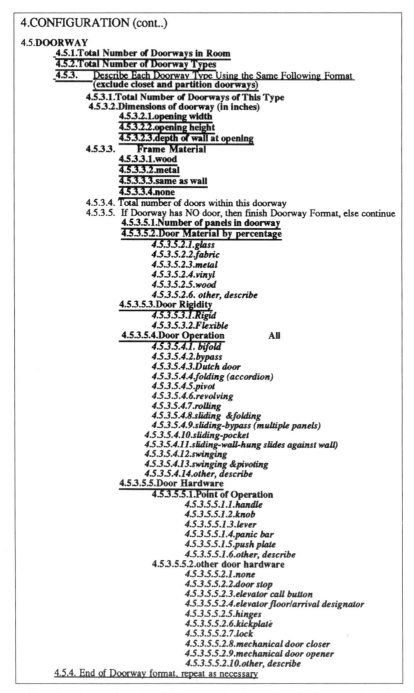

Figure 11.3. Sample page from the AIM: Doorway description from the Configuration subsection.

that contributed to either more homelike or more institutional character. An assessment device (Institution–Home Assessment Measure) was developed using weighted features (see Figure 11.4) for a comparison of items from the original Robinson/Emmons/Graff Architectural Checklist, the AIM, and the Institution–Home Assessment Measure. Not yet fully developed for testing, the Institution–Home Assessment Measure demonstrates that such an approach can lead to detailed quantitative measures that are easy to administer and analyze (see Figure 11.5).

In a current study of 20 group home settings in a southern state, behavioral data gathered on actual use of settings were compared both to perceptual evaluations of subsettings by various members of the community and to inventory measurements of the subsetting. This identified features that are linked to

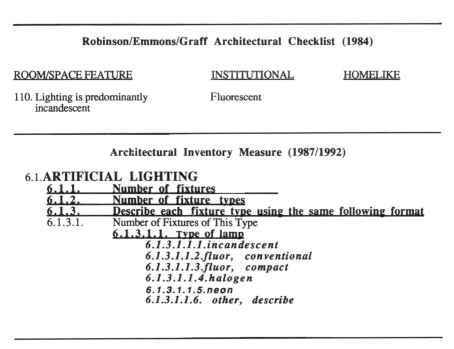

Robinson/Emmons/Graff Architectural Checklist (1984)

ROOM/SPACE FEATURE INSTITUTIONAL HOMELIKE

110. Lighting is predominantly Fluorescent
 incandescent

Architectural Inventory Measure (1987/1992)

6.1. **ARTIFICIAL LIGHTING**
 6.1.1. Number of fixtures
 6.1.2. Number of fixture types
 6.1.3. Describe each fixture type using the same following format
 6.1.3.1. Number of Fixtures of This Type
 6.1.3.1.1. Type of lamp
 6.1.3.1.1.1.incandescent
 6.1.3.1.1.2.fluor, conventional
 6.1.3.1.1.3.fluor, compact
 6.1.3.1.1.4.halogen
 6.1.3.1.1.5.neon
 6.1.3.1.1.6. other, describe

Institution–Home Assessment Measure(1992)

	Institution				Home
	1	2	3	4	5
Type of Light	All fluorescent		Mixed fluorescent and other		All nonfluorescent

Figure 11.4. Three related measures: the original Robinson/Emmons/Graff Architectural Checklist, the AIM, and the Institution–Home Assessment Measure.

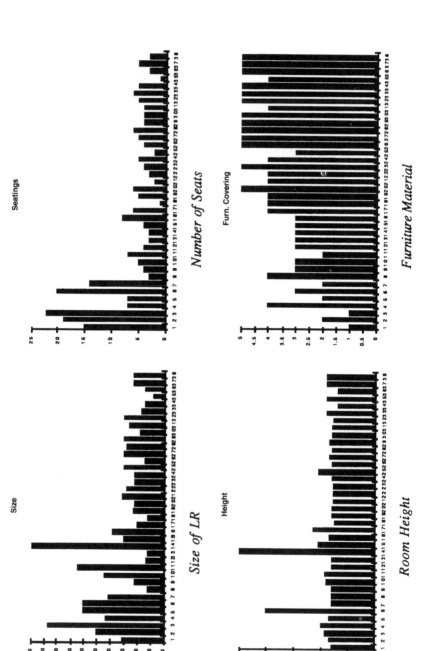

Figure 11.5. Graphic analysis of selected variables for 29 living rooms and lobbies from a study of housing in the midwestern United States (rooms are ordered from least to most homelike). Analysis by Julio Bermudez.

perceptions of institution and home as well as features that are linked to actual behavioral findings (see Thompson et al., 1996a,b).

The AIM currently is a hypothesis-generating exploratory tool and is not intended to be used for testing of statistical hypotheses. It includes a large number of variables (i.e., items) compared with the number of settings studied, which poses statistical problems. To reduce the number of scaled variables, individual items are collapsed into aggregate scales composed of many items each. In collapsing items, individual variables that may be important predictors of homelikeness or institutionality (e.g., an exit sign in a residential living room) may be submerged among a large number of weaker variables of less interest (e.g., recessed ceiling lighting, vinyl moldings, rough wall surfaces, loose pieces of carpeting) yielding statistically nonsignificant relationships, yet the single variable itself may have a highly significant association with institutionality. An alternative analytical strategy to uncover these associations is a visual inspection of individual variables that differentiate settings. Patterns can be identified in this manner, even though the absolute number of items may be too small to be detected using conventional inferential statistical methods. For example, a feature that is rarely found in most homelike settings (e.g., steel paper towel dispensers in private residential bathrooms) but is found in each of the most institutional-appearing group homes becomes apparent. Computer algorithms could be written to conduct such item by item comparisons as well; this would identify, for instance, variables that nearly always occur in the most institutional buildings and almost never occur in the most homelike buildings and that occur in the overall data set less frequently than required for inferential statistical analysis.

EMPIRICAL STUDY

In earlier studies we found that respondents from widely varying backgrounds distinguish the homelikeness of residential buildings with very high interrater agreement (Thompson, Robinson, Graff, & Ingenmey, 1990; Thompson, Robinson, Dietrich, Farris, & Sinclair, 1997a,b), but it is another matter to demonstrate that such qualities are important to the way that people who live in those residences behave. We conducted systematic observations of resident behavior in 20 residential buildings from which architectural inventory data had been independently obtained. We also asked supervisory staff to provide information regarding resident behavior using the Aberrant Behavior Checklist (Aman & Singh, 1986), an instrument for documenting undesirable behavior in developmentally disabled people. We analyzed these behavioral data in relation to the perceived homelikeness of the 20 buildings, statistically controlling for client admission characteristics, program philosophy, and staff/client ratios. In addition, we determined the degree to which there was a relationship between

specific architectural features (as distinguished from the perception of these features) and the behavior of residents with mental retardation.

Eighty adults with mental retardation were included in the study. Four residents were randomly selected from each home. If less than five lived in a given residence, all participated in the observational study. Fifty-nine percent were men. Their mean chronological age was 36.9 years, and the average intellectual functioning level was in the severe to moderate range of retardation. The average length of residence was 7.33 years; 34.5% of the residents were receiving psychotropic medication for behavior problems.

We conducted four periods of direct observations of the four adults in each residence: (1) once during a meal or meal-related activity, (2) once during a formally structured training or educational activity, and (3) twice during free time. Observational periods were selected based on the daily schedule within each residence (i.e., when the clients were there and a given activity normally occurred). Residence staff members were requested to follow their usual routines and were asked not to schedule any special activities because of the observers' presence. Observations were recorded using a hand-held optical bar code reader recorder (the Videx Time Wand), in which each room, various types of activities (e.g., meals, instruction), and behavioral categories (e.g., client-to-client positive interactions) were all represented by bar codes. By drawing the lens of the bar code reader across the appropriate bar codes printed on a sheet of paper, the time (to the nearest second) at which the code was scanned was saved to memory in the bar code reader. At the end of the day's observation period the Time Wand bar code readers were inserted into a downloader, which was connected via a cable to a portable computer. The recorded data was saved to disk for later analysis.

Observation periods began by entering the observer's identification (ID) number, the observation number, and the client ID number. Then the type of on-going activity (e.g., meal), room and the number of staff present were scanned. In the next 10 sec, any of 15 behavioral codes were recorded. The sequence was as follows: observe for 10 sec, then record for 10 sec. This sequence was repeated for each 10-min observation period. The two observers practiced behavioral observations using videotaped behavior of people with mental retardation from group homes that were not involved in the study until an interrater reliability coefficient of .90 was achieved. Several additional practice observation sessions were used to achieve reliability in settings similar to those that would be encountered once observations began. Throughout the actual observations, one in four observation periods was used for reliability assessments in which two observers were present simultaneously. The overall interrater reliabilities ranged from .725 to .992 (mean = .90) for codes that were observed at least 10 times over the course of the study.

Hierarchical multiple regression analyses were used to study the association between observed resident behavior and homelikeness ratings of houses. The

associations between resident admission characteristics, staff ratios, program philosophy, and noise and humidity were statistically controlled prior to analyzing the resident behavior correlations with homelikeness. These person and programmatic factors were all significantly correlated with ratings of homelikeness: stereotypic repetitive movements (−), aggression (−), and positive interactions between staff and residents (+). Follow-up comparisons of residences falling above and below the median homelikeness rating were also conducted. Generally, inhabitants of more homelike residences were more likely to be involved in independent household chores (*t* test, $p < .006$). This included participating in meal-related activities in the kitchen (p, .024) or doing individual activities alone (*t* test, $p < .009$), while residents of more institutional-appearing housing were more likely to be uninvolved (i.e., inactive) (*t* test, $p < .005$) or engaged in repetitive, stereotyped movements (*t* test, $p < .002$).

A post hoc analysis of the relationships between architectural features and resident behavior reveals several consistent findings. Behavior of residents in four homes (ranked according to their mean homelikeness ratings as numbers 13, 17, 19, and 20) differed from residents in the other 16 homes on a variety of observational dimensions. Cluster analyses based on physical features were conducted separately for each room (bathroom, bedroom, dining room, and living room). For all four room types, residences ranked 17 and 19 clustered together and/or with residences ranked 13 or 20 according to their interior physical features.

Two of the four buildings falling in these clusters were institutional-appearing residences for 12 or 14 people constructed of concrete block and brick with vinyl floors and moldings throughout. Their features were among the more institutional of any building studied. One of the buildings in the same physical feature cluster was an eight-person HUD home that included the most institutional interior features of any building studied. The fourth home that clustered with the foregoing buildings was originally designed as a single-family home but had been renovated on the interior using highly institutional lighting, moldings, and floor and wall surface materials. There were significant differences in resident behavior across clusters of homes based on physical features of a given room type. The best predictor of maladaptive behavior of group home residents was the physical features of dining rooms. They were associated with significant differences on four or five Aberrant Behavior Checklist scales and eight negative behavior observational codes as well as the degree to which residents were uninvolved in any meaningful activity.

We are not suggesting that these specific features directly caused the behavior problems that were observed. Our study indicates that homelike appearance and program philosophy variables are intertwined, and even that program philosophy may be a major determinant of the physical features of a setting. It is likely that the features found in the homes may have contributed to differences

in staff behavior toward residents (some perhaps as a result of expectations about the residents), although it is possible that crowding 12 or 14 young men with significant disabilities along the length of a dining room table will inevitably increase the likelihood of problem behavior. This was the dining pattern in one or two of the residences studied. For dining rooms, some of these features are: the presence of chandeliers versus other kinds of lighting, the number of pieces of furniture other than tables and chairs (such as sideboards), and, as suggested, the number of places for people to sit.

CONCLUSIONS

If the universal design movement is to address the issues of access to status, it becomes critical to understand the relation between the physical form of buildings and the perceptions and actions of the people who use them. Architecture plays a complex role as a medium for cultural patterns and attitudes. Although we are often unconscious of their effects, buildings communicate status and appropriate roles in the context of the normative ideas of the society. And yet, when cultural change is sought, all too often, existing architecture reinforces old habits. But buildings are also capable of supporting changes in attitudes, as they represent — in a powerful form — what ought to be. As formerly innovative ideas are accepted, they become part of a new background of accepted norms. Ramps for people with disabilities used to be stigmatizing, but are now an accepted part of the landscape, and when added to houses, may even be seen as an economic advantage, enhancing property values.

If change in a certain direction is desired, then it makes sense to develop tools to discover what changes need to take place as well as the degree to which they have occurred. Of course, measuring the stigmatizing effects of architecture requires a process that is ongoing, since environments, their use, and the attitudes they embody/engender change over time. The AIM provides the groundwork for developing assessment instruments that are appropriate to a given time, place, and issue. In the analysis of the 20 group homes discussed here, the use of the architectural inventory permitted researchers to distinguish between the effects of the perceived character of the setting and the effects of the physical characteristics of the settings. It permitted identification of particular architectural features that affected not only the perception of the setting, but also, even more importantly, the actual behaviors of occupants. The development of designs that support the lives of all people requires understanding how stigma and value are transmitted through architecture. The inventory pinpoints architectural features that are related to the stigmatizing use and perceptions of the settings. This makes possible the creation of environments that impart value to their inhabitants.

REFERENCES

Aman, M. G., & Singh, N. N. (1986). *Aberrant behavior checklist*. East Aurora, NY: Slosson Educational Publications.

Cooper, C. (1975). *Easter Hill Village: Some social implications of design*. New York: Free Press.

Goffman, E. (1963). *Stigma: Notes on the management of spoiled identity*. New York: Simon & Schuster.

Larson, S., & Lakin, K. C. (1989). Deinstitutionalization of persons with mental retardation: Behavioral outcomes. *Journal of the Association for Persons with Severe Handicaps, 14*(4), 324-443.

Nirje, B. (1969). The normalization principle and its human management implications. In R. Kugel & W. Wolfensberger (Eds.), *Changing patterns in residential services for the mentally retarded*. Washington, DC: President's Committee on Mental Retardation.

Norberg-Shulz, C. (1965). *Intentions in architecture*. Cambridge, MA: MIT Press.

Rapoport, A. (1977). *Human aspects of urban form*. Oxford: Pergamon Press.

Rapoport, A. (1982). *The meaning of the built environment: A nonverbal communication approach*. Beverly Hills, CA: Sage.

Robinson, J. W. (1988a). Architecture as a medium for culture: Public and private home. In S. Low & E. Chambers (Eds.), *Culture, housing and design: A comparative perspective* (pp. 253-280). Philadelphia: University of Pennsylvania Press.

Robinson, J. W. (1988b). Institution and home: Linking physical characteristics to perceived qualities of housing. In H. van Hoogdalem, N. L. Prak, T. J. M. van der Voordt, & H. B. R. van Wegen (Eds.), *IAPS 10/1988: Looking back to the future:/Se retourner vers l'avenir. Volume 2. Symposia and papers* (pp. 431-440). Delft, The Netherlands: Department of Architecture, Technical University.

Robinson, J. W., Klensin, J., Bermudez, J., & Johannes, M. (1992). Probing terminology for cultural categories: Institution and home. In A. Mazis, C. Karaletsou, & K. Tsoukala (Eds.), *Socio-environmental metamorphoses: Proceedings of the IAPS 12 Conference* (pp. 180-189). Thessaloniki, Greece: Aristotle University.

Robinson, J. W., Thompson, T., Emmons, P., & Graff, M. (1984). *Towards an architectural definition of normalization: Design principles for housing severely retarded adults*. Minneapolis: School of Architecture, Graduate School, University of Minnesota.

Thompson, T., Robinson, J., Dietrich, M., Farris, M., & Sinclair, V. (1996a). Architectural features and perceptions of community residences for people with mental retardation. *American Journal on Mental Retardation, 101*, 292-313.

Thompson, T., Robinson, J., Dietrich, M., Farris, M., & Sinclair, V. (1996b). Interdependence of architectural features and program variables in community residences for people with mental retardation. *American Journal on Mental Retardation, 101*, 315-327.

Thompson, T., Robinson, J., Graff, M., & Ingenmey, R. (1990). Home-like architectural features of residential environments. *American Journal on Mental Retardation, 95*, 328-341.

Wolfensberger, W. (1977). The normalization principle and some major implications for architeuctural-environmental design. In M. J. Bednar (Ed.), *Barrier-free environments* (pp. 135-169). Stroudsburg, PA: Hutchinson and Ross.

Wolfensberger, W., & Thomas, S. (1983). *PASSING: Program analysis of service systems' implementation of normalization criteria and ratings* (2d ed.). Toronto: Canadian National Institute on Mental Retardation.

12

Evaluating Models and Measures of Environmental Performance

David B. Lantrip

INTRODUCTION

State and federal legislation, such as the Americans with Disabilities Act of 1990 (ADA), mandates that built environments accommodate the activities of inhabitants with disabilities. Kilborn (1992) estimates that potentially 14 million people will benefit from the ADA. Unfortunately, there are no quantitative methods for assessing how well proposed designs will achieve ADA goals or even whether ADA-inspired design guidelines will improve inhabitant satisfaction and productivity.

The ADA gives us an opportunity to create truly enabling environments for a diverse population. But success will require improvements in three areas: our understanding of inhabitants' needs, the performance measures we develop to assess how well environments support these needs, and the validity of our models describing the relationships among performance measures and desired outcomes.

This chapter focuses on developing and testing good measures and models of environmental performance. The chapter begins with an introduction to the

David B. Lantrip • Cartia, Inc., 2040 Langley Street, Oxnard, California 93033.

Enabling Environments: Measuring the Impact of Environment on Disability and Rehabilitation, edited by Edward Steinfeld and G. Scott Danford. Kluwer Academic/Plenum Publishers. 1999.

subject of empirical modeling and then uses a case study to illustrate the six steps required to develop and test a model of environmental performance. The case study is an initial attempt to operationalize these steps and is offered as a foundation upon which we can systematically build more valid and comprehensive models of environmental performance.

The steps to develop and test a model of environmental performance are:

1. Begin with a firm theoretical foundation for a model.
2. Represent the model so that all hypotheses are explicit.
3. Identify suitable measures for the model constructs.
4. Collect accurate data to test the measures and model.
5. Evaluate the measures and model.
6. Revise theory, then repeat process with new measures and model.

COVARIANCE STRUCTURAL MODELING

A model is a simplified representation of some aspect of reality. Just as miniature architectural models convey certain relationships among form, structure, and space of a building, conceptual models represent how we think certain constructs and their measures are related. Graphical techniques, generally referred to as "path" models, illustrate these theoretical relationships. Figure 12.1 is an example of a path model that shows the relationships among three constructs or "latent variables." The graph is a concise statement of our hypotheses about these relationships:

1. Inhabitant characteristics directly affect perceived environmental quality.
2. Environmental characteristics directly affect perceived environmental quality.
3. Inhabitant and environmental characteristics affect one another.

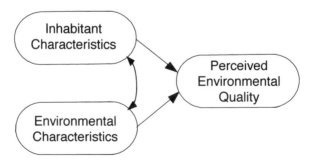

Figure 12.1. A structural model showing the structure of hypothesized relationships among three constructs.

The direction of the arrow on each link indicates which construct we hypothesize has a direct affect on the other. In this case, we hypothesize that inhabitant characteristics and environmental characteristics directly affect how inhabitants perceive environmental quality. In other words, when viewed from an individual's perspective, personal needs, values, beliefs, and so on, all influence how an environment is perceived, as do the physical attributes of the environment. Conversely, the model shows we hypothesize that perceived environmental quality has no direct effect on either inhabitant or environmental characteristics, although there may be indirect pathways through variables not shown in the model. The double-headed arrow indicates a reciprocal, or covariant, influence suggesting that changes in the environment can cause changes in inhabitant characteristics, such as attitude, attention span, etc., and that inhabitants can change aspects of the environment. Because the model shows the structure of the relationships among constructs, it is called a "structural model."

A structural model, as shown in Figure 12.1, is sufficient to communicate hypotheses about the relationships among a set of constructs, but it is insufficient to show how one intends to test them. Just as the term "spacious" is too imprecise to specify construction plans, the constructs "inhabit characteristics" "environmental characteristics," and "perceived environmental quality" lack clear, quantitative definitions. For this reason, we must add information to the model to test these hypotheses using research data. The additional information must describe how each of the constructs, which belong to the world of ideas, are to be observed and measured in the physical world. Figure 12.2 shows several possible measures for each of the constructs of Figure 12.1. We refer to this part of the model as the "measurement model."

The measurement model defines the constructs (latent variables) in terms of measures (observed variables). The directions of the arrows in the measurement model indicate that we believe the constructs directly cause changes in the

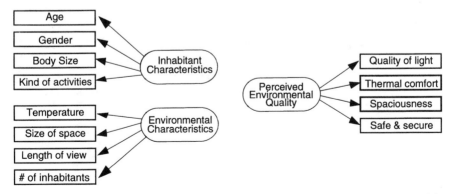

Figure 12.2. A measurement model showing observable quantities proposed as measures of the three constructs.

measures (observed variables). For example, in Figure 12.2, a change in the state of perceived environmental quality (potentially caused by other latent variables) is hypothesized to cause a change in the observed values of each of the associated measures, such as thermal comfort. The magnitude of the change in each measure value will depend on the strength of the relationship between the measure and its construct. The coefficient that quantifies this strength of relationship is similar to a factor "loading" in factor analysis. The coefficient is related to both the validity of the measure for defining the construct and the reliability of the measure in terms of how strongly it is correlated with other measures of the construct. In other words, if we assume that changes in multiple measures are due only to the construct they measure, then a strong positive correlation indicates that they are reliably measuring the same thing (i.e., construct validity). Other means (often good judgment) must be used to decide if they are measuring the "right" construct. For example, we assume that age, gender, and body size are reasonable measures of inhabitant characteristics.

We collect data for each of the measures and for each of the inhabitants in the environment being studied. For example, in Figure 12.2, environmental characteristics, such as temperature, are recorded from the point of view (i.e., in the vicinity) of each inhabitant. This means that there are potentially as many descriptions of the environment as there are inhabitants participating in the study.

When we combine the structural and measurement models, as shown in Figure 12.3, the results is a concise yet explicit graphical representation of all the hypothesized relationships among constructs and their respective observable measures. Comprehensive models of this kind are referred to as "covariance structural models" and can serve as the foundational statement of an entire

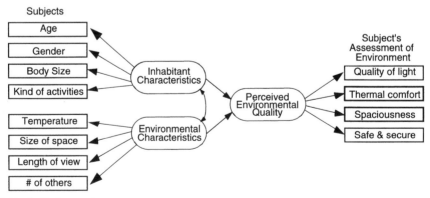

Figure 12.3. A covariance structural model, a combined structural model of construct relationships and a construct measurement model indicating observed variables.

research project. For example, the graph in Figure 12.3 represents three hypotheses about how inhabitant and environmental characteristics affect perceived environmental quality and also specifies what data are required to test these hypotheses. Furthermore, the graphic is a programming guide for computer software designed to evaluate how well the model explains variance in the data. In other words, the graphic represents our beliefs as to how the real world operates, and with a little additional work this model can be understood by a computer and its validity checked against what is actually observed to happen (i.e., the measures data). The following section more fully describes how we can use covariance structural modeling to test our measures and our understanding of their relationships. I reference a study recently conducted at the University of Michigan to illustrate the approach.

AN ILLUSTRATIVE CASE

The empirical study I describe in this section addressees how an environment can constrain and interfere with the planned activities of its inhabitants. Although focused on evaluating measures of constraint and an associated model of environment-behavior relationships, the study illustrates a generalizable approach for developing and evaluating models. Furthermore, the results of this study suggest that the model presented here may offer a framework for testing other environment-behavior phenomena and new measures of the three constructs—inhabitant and environmental characteristics and perceived environmental quality.

Study Background

People often feel cramped or crowded when the environment gets in their way or constrains their behavior (Baum & Koman, 1976; Desor, 1972; Hall, 1966; Heimsath, 1977; Imamoglu, 1986; Schiffenbauer, 1979; Schiffenbauer, Brown, Perry, Shulack, & Zanzola, 1977; Stokols, 1972; Worchel & Teddlie, 1976). This suggests that appropriate indicators of environmental constraint may be predictive of perceived environmental quality and environmental satisfaction. This study was the culmination of efforts to develop such indicators and quantitative methods—referred to collectively as the ISOKIN model (Lantrip, 1986, 1988, 1990, 1993, 1994; Wise, 1988). Specifically, the study attempts to quantify the different ways that the physical environment imposes constraints on the activities of inhabitants, either directly or where inhabitants' movements are channeled into situations of likely interference with one another. The purpose is to investigate how these new measures of physical constraint are related to inhabitant's attitudes about their environment. An office environment is used as a test case.

The general hypothesis being tested is that the less constraining a work environment is to the activities of its inhabitants, the greater the likelihood that the environment will be favorably perceived. Although prosaic sounding, the difficulty in testing even this simple hypothesis lies in specifying a model that accounts for the complexity of human–environment interactions and includes useful quantitative measures of the constructs.

Theory and Structural Model

The theoretical foundation for this study begins with Marans (1989), who proposed that environmental and worker characteristics act jointly to first affect inhabitants' perception of environmental quality and ultimately to influence inhabitants' satisfaction with the environment and productivity. Figure 12.4 illustrates this general model using the conventions of path analysis discussed previously. Most importantly, this model hypothesizes that it is primarily the mediating action of human perception that causes environmental satisfaction and productivity rather than any direct action by worker or environmental characteristics.

The Marans model has important implications to researchers because it suggests a type of environmental measure that will be most strongly linked to outcomes such as perceived environmental quality, environmental satisfaction, and productivity. For example, research shows that actual workplace floor area is a less reliable predictor of environmental satisfaction than the inhabitants' subjective impression of the amount of available space (Brill, Margulis, & Konar, 1984; Marans & Yan, 1989; Spreckelmeyer, 1993). These findings suggest that actual floor area is not a highly perceivable quantity and that other clues in the environment inform inhabitants that their space is or is not adequate. The point is that if we can understand what inhabitants need and expect, then we may be able to define measures that also relate to what they perceive as good or bad about the

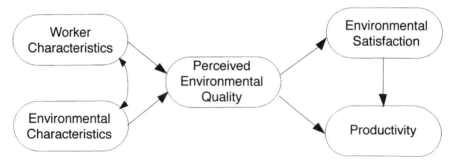

Figure 12.4. A fundamental structural model.

environment. According to the model, these perceptions then cause states of satisfaction and productivity. This is an important distinction because environmental designers and facility managers have traditionally depended on simple measures of area and volume as indicators of spatial accommodation. This empirical study seeks to show that the ISOKIN measures of environmental constraint are measuring quantities that are perceivable and important to inhabitants.

Measurement Model

An important feature of the structural model illustrated in Figure 12.4 is that physical environmental characteristics are linked to subjective perceptions of them. This means that before this model can be tested, both physical and psychological measures must be developed and appropriate data collected. Figure 12.5 shows the combined structural and measurement model and substitutes more specific and measurable constructs for the general constructs of worker and environmental characteristics introduced in Figure 12.4. The variables used to measure the constructs are shown in rectangular boxes and are briefly described here.

Measures of Environmental Characteristics

There are two kinds of environmental measures—those that describe an environment in terms of some arbitrary physical characteristic, such as its size or lighting level, and measures that describe the environment in terms related to the needs of inhabitants. The second kind anticipates what is important to the inhabitant and attempts to quantify the difference between inhabitants' environmental needs and what is actually present. For example, typical measures of offices (from the first category) include the number of windows, air temperature, foot-candles of illumination on the worksurface, or floor area of a workstation. Because these measures do not include key information about how the environment either supports or hinders workers, one should not expect to see a direct empirical relationship between any of these measures and worker attitude (e.g., satisfaction). In contrast, the number of windows visible to a worker from the workstation measures something of potential value to the worker. If the worker is a computer analyst, operable window coverings and window placement may also be important considerations to include in the measure. Similarly, measures of "thermal comfort" take into account not only temperature, but also how much clothing the worker usually wears, his or her typical amount of activity, humidity, and air flow in the workspace. Brightness contrast ratios on the worksurface or monitor measure potential glare and extend ambient illuminance measures to include qualities relevant to the worker's tasks. By considering the various ways that an environment can support or interfere with the needs and activities of a

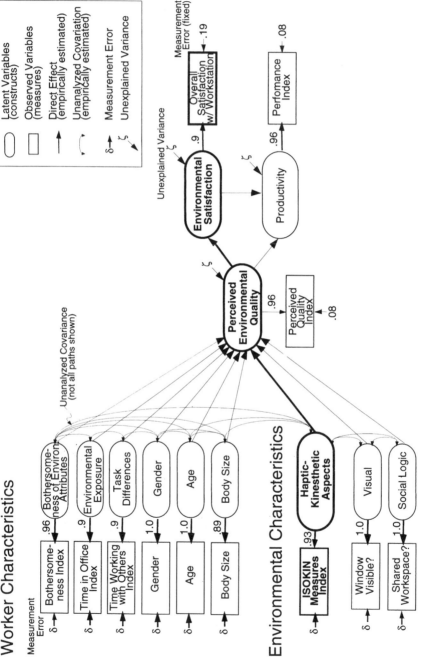

Figure 12.5. A combined structural and measurement model showing detailed breakdowns of worker and environmental characteristics and measures. Link coefficients shown are computed as the square root of Cronbach reliability alpha for composite measures (indexes) and 1.0 for assumed "perfect" measures of constructs.

diversity of inhabitants we can begin to develop meaningful measures of environmental performance.

The "interference-free area" is one of several proposed measures developed for this study. It is the workstation floor area normally reported minus the area required for all furnishings, planned activities, and corners of spaces that are not usable for the activities. The interference-free area indicates the actual area available for work—that is, the area most likely perceived by the worker when involved in daily activities.

Another proposed measure, called the probability of interference, estimates the likelihood that two or more co-workers will interfere with one another's activities. This measure may be a good indicator of the inhibiting influence that the environment has on co-workers' behavior. Neither observation of inhabitant behavior outside its setting nor measurements of the environment without reference to inhabitant behavior can provide this insight into the interactions that occur between them. By using measures of the environment–behavior relationship, such as interference-free area and probability of interference, we can begin to investigate the characteristics of environments that enable inhabitant activities and lead to positive outcomes.

The ISOKIN Measures index shown in Figure 12.5 is a composite of six measures such as those just described—gross free area (GFA), interference-free area (IFA), radial interference margin (RIM), conformity index (CI), and two types of probability of interference (POI). I summarize each of these measures in Table 12.1 and describe them in detail in Lantrip (1993). The index is the unweighted and standardized sum of the six measures. Standardizing the measures ensures that each contributes an equal amount of variance to the index. The standardized Cronbach alpha reliability[1] α for the ISOKIN measures index is 0.87, which results in a link coefficient (construct validity) of 0.93, as shown in Figure 12.5.

Whether one should include a particular measure in a model must be decided based on theoretical and methodological considerations. Because investigation of the visual and social aspects of spaciousness is not the focus of this study, only two of many plausible measures are used for these constructs. Both the "window visible" and "shared or private workspace" measures are derived from physical survey data and are assumed to be perfect measures of their respective constructs (i.e., reliability $\alpha = 1$), as indicated by the link coefficients of 1.0 in Figure 12.5.

[1]See Nunnally (1978) for a more in-depth discussion of the Cronbach alpha statistic of reliability and construct validity. Cronbach alpha indicates how well the items making up a composite variable (i.e., multiple measure index) seem to describe the same construct; that is, how well they "hang together" as a measurement unit. Nunnally (1978) suggests that for basic research, reliabilities above 0.80 are sufficient and that correlations will be effected very little by measurement error in this range. Variables that significantly reduced the reliability of the index and didn't appear to be required from a theoretical perspective were removed from the final index. If it is assumed that all of the measures of an index are equally valid, then the construct validity is α^2.

Table 12.1. ISOKIN Measures of Environmental Constraint

Area measures: Comparing how much space is needed with how much is provided

1. Total Enclosed Area (TEA): What is often called "floor area" in architectural literature; the total floor area enclosed by the walls or other space-defining elements (e.g., doorways, columns, corners)
2. Gross-Free Area (GFA):[a] The total enclosed area *minus* the area required for a specific activity (i.e., a body-motion envelope, or BME) and furnishings or other space occupying elements in the TEA
3. Interference-Free Area (IFA):[a] The *usable* area within an enclosure *for a specific activity* defined by an envelope of unrestricted movement. Area that is not accessible to the BME without deformation (i.e., without behavioral adaptation by user) is not included; IFA = GFA − unusable area

Conformity measures: Comparing the shape of space needed with the shape of space provided

4. Form Factor (FF): A ratio of the greatest linear distance between any two points within a BME or enclosure GFA to the diameter of a circle with the same area as the BME or enclosure. *Magnitude of shape elongation* is indicated relative to a circular standard; increasing L/d = greater elongation; $FF_{BME} = L_{BME}/d_{BME}$ and $FF_{encl} = L_{encl}/d_{encl}$; $FF \geq 1.0$
5. Conformity Index (CI):[a] The difference between enclosure and BME form factors; indicates similarity of BME and enclosure *shape* in terms of their elongation; $CI = FF_{encl} - FF_{BME}$

Interference measures: Assessing the potential impact of spatial constraint on activities

6. Radial Interference Margin (RIM):[a] A measure of positional constraint or "margin of accommodation." The magnitude of separation (+) or overlap (−) of the maximum *radial* of a preferentially located BME with the minimum radial of an envelope; $RIM = R_{min}(enc) - R_{max}(BME)$
7. Total Angular Interference (TAI):[a] A measure of positional constraint; the total angle through which contact is observed between a rotating preferentially located BME and an enclosure.
8. Adaptation Index (AI): The magnitude of radial and angular interference. Computed as the mean area of a preferentially located BME that overlaps the enclosure boundary as it changes orientation; $AI = (A_{out}/A)_{BME}$
9. Probability of Interference (POI):[a] Statistics and graphics indicating the probability that two or more activities will interfere due to space and scheduling constraints.

[a]Included in the ISOKIN Measures Index of overall spatial constraint (see Figure 12.5).

Measures of Worker Characteristics

Worker characteristics are included as controls for the primary relationships being studied—that is, the relationships between constraining environmental characteristics and the outcomes, perceived environmental quality, and environmental satisfaction. The model accounts for the influence of various worker characteristics on the outcome variables. Six worker characteristics variables were defined by one or more responses to a questionnaire that was developed for the study and distributed to office workers. For example, the "Bothersomeness Index" is a composite of responses to 20 questions concerning how bothersome various environmental characteristics are. The Bothersomeness Index accounts for individual differences in the value assigned to environmental charac-

teristics. How much a characteristic bothers a worker is assumed to be related to both its importance and adequacy for that worker. The Cronbach alpha statistic, which indicates the reliability of the Bothersomeness Index, is 0.92. Other worker characteristics included are environmental exposure (i.e., how long has worker been in same workspace and what percentage of time is spent there, .81), task differences (i.e., amount of time spent working alone or with others, .81), gender (1), age (1), and body size (i.e., height, weight, and frame size, .79).

Measures of Outcomes

Outcomes are constructs whose changes in state we are interested in predicting based on changes in other controlled variables. For this study, we are interested in predicting the changes in the outcomes of perceived environmental quality, environmental satisfaction, and productivity based on changes in worker and environmental characteristics.

Perceived Environmental Quality Indices

To improve the model's discrimination, the construct in Figure 12.5 labeled "Perceived Environmental Quality" (PEQ) was divided into two parts (see Figure 12.9). The first part, labeled Physical Space PEQ concerns the perceived quantity and quality of the physical space available for various inhabitant activities. The second part, Visual, Social, & Other PEQ, concerns the perceived visual, acoustic, olfactory, and social aspects of the environment. The measures for the two PEQ constructs were developed from responses to 81 questionnaire items. The questions were of two types. One type required the respondents to rate the quality of various characteristics of their primary workstation from (1) "very poor" to (5) "very good." The characteristics listed were broad-ranging and included style and materials of furnishings, lighting, amount of space, workstation layout, security and safety, windows, privacy, acoustics, heating and ventilation, facility services, and so on. The second type of question required the respondent to indicate how frequently he or she has had, on average, various kinds of work experiences. Responses ranged from (1) "never" to (5) "always" and addressed experiences such as ease of finding others, bumping into furnishings, apologizing to visitors for cramped conditions, lighting hinders work, and so on. The PEQ indices were computed from the means to both types of questions. The standardized Cronbach statistic of reliability is the same for both indices—0.89.

Environmental Satisfaction Measure

A single item in the questionnaire measured how satisfied workers were with their immediate workspace. The question was similar to those used in previous studies (Brill et al., 1984; Harris, 1978; Marans & Spreckelmeyer, 1981;

Figure 12.6. A covariance structure model with parameter estimates.

Marans & Yan, 1989; Sundstrom, Herbert, & Brown, 1982): "All things considered, how satisfied are you with your primary workspace?" The responses ranged from (1) "very unsatisfied" to (5) "very satisfied." This single measure is assumed to be a less than perfect measure of the environmental satisfaction construct and was assigned a reliability of 0.81.

Performance Index

This index measured differences in how well respondents felt they performed their work. The index included responses to 16 questionnaire items that addressed various dimensions of individual performance. The question was worded as follows: "Check the space that best reflects how you rate your own performance on each of the following dimensions. Please rate your performance on each dimension against absolute standards (from absolutely unacceptable to absolutely ideal) rather than how your performance compares with that of other employees." The performance dimensions addressed the amount and quality of work, meeting deadlines, taking responsibility, collaboration, flexibility, dependability, efficiency, creativity and innovation, skill development, and contributions to organization. These dimensions were drawn from a variety of sources (Brill et al., 1984; Ellis, 1985a,b; Jockusch, 1985; Korman, 1982; Quinn, 1977) in an attempt to bridge the many recommended approaches to measuring productivity. The standardized Cronbach alpha statistic for this index is 0.92.

DATA

One hundred and ninety-four (194) workers participated in this study at the Institute for Social Research (ISR) in Ann Arbor, Michigan. Three kinds of data were collected to evaluate the model.

1. Environmental characteristics. Detailed floorplans of all workspaces were drawn that included the locations of all furnishings and identification of primary worksurfaces. Other information was also recorded such as worker access to window views and whether workspaces were private or shared. Figure 12.7 shows one floor of workspaces that was surveyed and entered into a computer database.
2. Worker perceptions and attitudes. Workers were asked to rate the quality and the bothersomeness of various environmental characteristics, generally how satisfied they were with their work environment, how well they performed at work, other job-related information, and demographics. The response rate for the questionnaire was nearly 95% (*N* = 194).
3. Video records of activities. The daily activities of 10 workers were

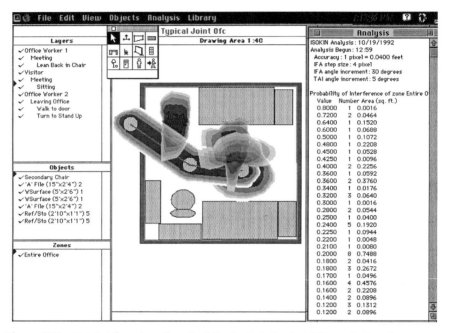

Figure 12.7. Detailed floorplans, floor 3 of the Institute for Social Research. Four floors were surveyed for environmental characteristics.

videotaped for 2 days. These workers were selected from the sample population based on their body sizes, willingness to be videotaped, and the type of ceiling (i.e., for mounting the video camera). Figure 12.8 shows how sequences of video frames were used to identify the space needed for a single event. A final sample of events for each type of activity was randomly selected from body size strata so that each size was equally represented in the final sample. The final space requirement for each activity, called the "body-motion envelope," was derived from the mean and standard deviation of randomly sampled event envelopes after adjusting for lens curvature and parallax. This standardized set of body-motion envelopes represents a statistical distribution of space required by the sample population for various daily activities.

The unit of analysis for this study was the individual worker. This means that each of the 194 participants had data entries for each of the three kinds of data. For example, environmental characteristics, such as window views, were recorded from the point of view of each worker, questionnaire responses where tabulated by individual case, and ISOKIN index values were computed for each

Figure 12.8. Estimating a body-motion envelope using video images.

worker based on his/her normal working location and position and the standard set of body-motion envelopes developed for the population.[2]

PROCEDURES

Computer Analysis of Workspaces

ISOKIN analysis is based on the proposition that workspaces that best accommodate the activities of a diversity of workers are preferable to those that are more constraining. During analysis, the body-motion envelope represents the space required for each planned office activity. How much a space constrains the activities of workers is estimated by positioning a representative set of body-motion envelopes into the floorplan of each workstation and then computing a set of ISOKIN measures, as described earlier. This analysis is accomplished using a computer program developed for this purpose, MacISOKIN. Figure 12.8 shows what the computer analysis of a typical workspace looks like while in progress. Each ISOKIN measure is sensitive to a particular type of constraint and may be considered independently, or, as in this study, a combination of measures may be used as an index of overall spatial constraint. Values for the spatial constraint

[2]The use of standardized body-motion envelopes for individuals provides for a general assessment of the environment in terms of its accommodation of a diverse population of inhabitants. A user-specific analysis would require body-motion envelopes based on the space requirements of individuals.

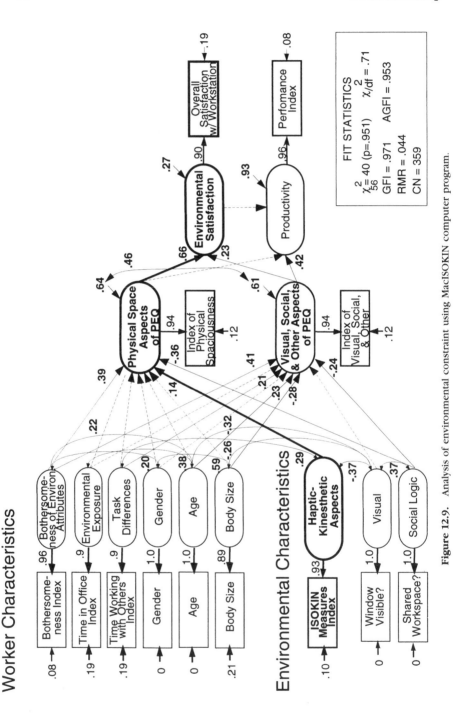

Figure 12.9. Analysis of environmental constraint using MacISOKIN computer program.

index are computed for each worker's space and are related to the worker's perceptions of environmental quality and environmental satisfaction using the computer evaluation techniques discussed in the following section.

Evaluation of the Model

Up to this point, the model has offered a graphical representation of the study hypotheses and a detailed accounting of all the variables involved. Once case data has been collected and tabulated for each variable, then it is possible to use a computer program to evaluate the graph and compute the strengths of hypothesized paths and other indicators of model validity. There are several computer programs available for evaluating covariance structural models (see Long, 1983, p. 84 for a brief review). The model shown in Figure 12.9 was evaluated using LISREL (linear structural relationships). LISREL is a "general purpose" computer program for estimating the unknown coefficients in a set of linear structural equations (Joreskog & Sorbom, 1978). Multiple linear regression, analysis of variance (ANOVA), exploratory and confirmatory factor analysis, path analysis, structural modeling (econometrics), and correlation models are all considered special cases of the general covariance structural approach used by LISREL. The variables in the equations can be either "observed variables," such as ISOKIN measures, or "unobserved" latent variables, such as perceived environmental quality. As previously described, we hypothesize that the latent variables cause the variances and covariances in the observed variables (i.e., variance in individual case data over the analyzed population). The relationships among the observed variables in the measurement model, as defined by the sample data, are represented by a matrix of covariance coefficients (in this case, standardized Pearson correlation coefficients).

The structural part of the model specifies the hypothesized causal relationships among latent variables and is used to describe the causal effects and the amount of variance that remains unexplained by the model. We can say that the model "fits" the data to the extent that the relationships and assumptions contained within both the measurement and structural models can reproduce the relationships among the observed variables (i.e., the input correlation matrix).

Major advantages of using this computer-based evaluation technique are that the covariance structure model allows both errors in variables, as in the factor analytic model, and errors in equations, as in the structural equation model (Long, 1983). The technique also provides a number of statistics that are useful to gauge the "goodness" of the model in terms of how well it reproduces the relationships in observed data.

INTERPRETING RESULTS

The parameter values in Figure 12.9 are the standardized LISREL estimates for the covariance structural model. Significant estimates ($p < .05$) are shown

adjacent to solid link lines (insignificant links are dotted). Interpretation of the parameter estimates requires several steps. First, an inspection of the link coefficients and their statistical significance (*not* shown in Figure 12.9) suggest how many of the study hypotheses are supported by the data. In this case, the hypothesis that environmental constraint (as measured by ISOKIN analysis) directly affects the physical aspects of perceived environmental quality is supported by a link coefficient of 0.14 ($p < .05$). There are also significant links between the two predictors—bothersomeness and social logic—and the physical space aspects of perceived environmental quality (P-PEQ). P-PEQ is shown to strongly affect environmental satisfaction with a link coefficient of 0.66. However, neither P-PEQ nor environmental satisfaction significantly affect productivity.

The next step is to inspect the "fit statistics" provided by LISREL to learn if the model reproduces the variance observed in the data better than what one would expect by sampling fluctuations (i.e., change). In this case, the various fit statistics shown in Figure 12.9 indicate that discrepancies between covariances in the sample data and the model solution are modest and that the model fits the data reasonably well.[3] For example, Wheaton, Muhten, et al. (1977) suggest that a chi-square statistic in the range 2–3 is an "adequate" fit with smaller values being better. This model has a very strong value, with 0.71.

An additional step is to see how much of the variance in the data is explained by the model. This quantity is shown in Figure 12.9 as the complimentary "residual" value (1-explained variance)—an arrow directed at the top right-hand corner of each construct. A perfect model would account for 100% of the observed variance in each measured construct and the residual value would be 0. In this case, the model accounts for 36% of the variance in the physical aspects of perceived environmental quality; 39% of the variance in the visual, social, and

[3]A chi-square (χ^2) test can be computed to test the hypothesis that the observed covariance matrix is the same as that generated by the hypothesized model. Chi-square values tend to vary with sample size, so the ratio is a good indicator of fit with large samples. In the 2–3 range is an "adequate" fit (Wheaton, Muhten, Alwin, & Summers, 1977), with smaller values being better. The probability level indicates the significance of the difference between observed and model-implied covariance matrices. A probability value less than .05 is sufficient to accept (fail to reject) that the differences are small enough to be sampling fluctuations. Since accepting the null hypothesis amounts to accepting one's theory (a reversal of the usual role of the null hypothesis), Hayduk (1987) suggests that a .1 or .2 level of significance is preferable. Goodness of fit (GFI) and adjusted goodness of fit (AGFI) indices measure the relative amount of variances and covariances jointly accounted for by the model (Joreskog & Sorbom, 1978) and should be as close to 1.0 as possible. Bagozzi and Yi (1988) suggest that AGFI $\geq .9$ is "promising." Root mean square residual (RMR) is a measure of the average of residual variances and covariances. Low values indicate a good fit of the model to the data and high explanatory power. The Hoelter critical number (CN) statistic is an estimate of the sample size necessary to accept the fit of a given model on a statistical basis (Hoelter, 1983). Hoelter suggests that CN values greater than 200 indicate that a model "adequately" reproduces an observed covariance structure and that "trivial" differences exist. Hoelter suggests that CN is most useful for sample sizes greater than 200.

other aspects of perceived environmental quality; 73% of the variance in environmental satisfaction; and 7% of the variance in productivity. Considering the complexity of the environment–behavior system we are modeling, it is encouraging that we can account for so much of the variance in the data by this simple description. It is particularly impressive that we can account for 73% of worker's satisfaction with their environment using only the five worker and three environmental characteristics predictors. Self-rated productivity is not well explained by the model; potential reasons for this are discussed in the next section.

DISCUSSION OF CASE STUDY

The results of this study suggest that the proposed measures of constraint may be useful environmental performance indicators, particularly when it is desired to reduce the negative effects of constraining environments on both able-bodied inhabitants and those with disabilities. How great a contribution these measures may make to future studies and environmental performance assessments is difficult to assess with the results of this limited study.[4] The ISOKIN measures alone account for about only 1% of the variance in perceived quality of workspace size and layout (although floor area, a traditional measure of constraint, accounted for none of the variance). The modest amount of variance accounted for by the ISOKIN measures may have been more the result of the larger than average offices provided workers at the Institute for Social Research than to the low explanatory power of the measure (see Table 12.2). The study results suggest that most ISR workers' activities were well accommodated by their workspaces and that their perceptions of environmental quality were not as varied as one might find in more constraining settings (see Figure 12.10). To understand more fully the explanatory power of these measures, additional studies are required where there are greater ranges of constraint to worker activities and perceptions of quality.

The results concerning self-rated productivity raise some interesting issues. The model accounts for only 7% of the variance in productivity and fails to show a direct causal relationship between environmental satisfaction and productivity. This contradicts other studies where findings suggest that workers who are dissatisfied with their working environment do not perform as well as others (BOSTI, 1981; Brill, Margulis, & Konan, 1984; Harris, 1978). However, the measures and methods used to measure worker performance vary considerably in these studies. These differences may explain the contradictory results.

A self-administered questionnaire was used for this study, although it has been suggested that self-assessment may be an unreliable method of measuring

[4]Lantrip (1993) provides a thorough discussion of the various limitations of this study and recommendations for future studies.

**Table 12.2. Comparison of the ISR
and National BOSTI[a] Studies
of Floor Area Statistics**

	ISR building	Brill/BOSTI
Floor area (mean, sq. feet)		
Managers/supervisors	120	115
Technical/professional	99	82
Clerical	78	43
Private workspaces	30%	15%

[a]A study covering a broad range of office types and populations
reported in BOSTI (1981).

performance. Other methods of assessment, such as supervisory records, were
not available and most likely would have introduced different measurement
errors. As described earlier, respondents were asked to rate their performance
according to a broad range of characteristics that various authors have associated
with performance. The performance dimensions included in the questionnaire
addressed the amount and quality of work, meeting deadlines, taking responsibil-
ity, collaboration, flexibility, dependability, efficiency, creativity and innovation,
skill development, and contributions to organization. The Cronbach reliability
statistic indicated that these various dimensions all seem to be related well to a
common construct ($\alpha = 0.92$), although further research would need to verify
that "worker productivity" is an accurate label for the construct. The strong link
to Visual, Social, and other Aspects of PEQ raise the possibility that the Perfor-
mance Index may be measuring more social than productivity aspects of work. A
"social desirability bias" to questionnaire responses may also explain the result.
Clearly, standardized procedures for measuring worker performance need to be
defined before results to studies such as this can be compared and consistently
interpreted.

ISOKIN analysis requires no assumptions concerning the physical charac-
teristics of inhabitants. Accordingly, the approach is suitable for general or very
special populations, depending entirely on the body-motion envelopes selected
for the analysis. An important point is that these methods show how it is fea-
sible to quantitatively compare the levels of constraint for various environments
and populations where this wasn't possible before. The potential payoff of this
approach is a consistently higher level of environmental satisfaction by inhabi-
tants and a greater conformance with the intent and goals of the ADA guidelines.
In fact, this methodology can be used to evaluate the effectiveness of design
guidelines in meeting the intent of the ADA.

There is evidence that the approach used to define environmental measures
in this study may improve measures of other performance criteria, such as those

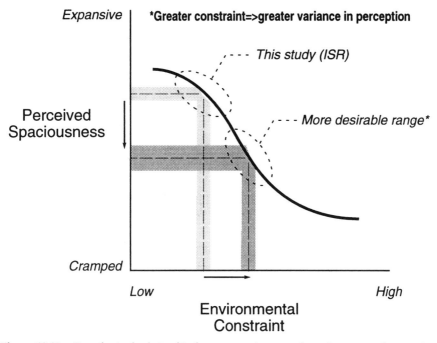

Figure 12.10. Hypothesized relationship between environmental spaciousness and constraint. Most ISR workers' activities were well accommodated by their workspaces, and their perceptions of spaciousness were not as varied as one might find in more constraining settings.

concerning visual and social aspects, communication and privacy, flexibility, safety, and so on. Central to this approach is the concept that appropriate measures of environmental characteristics must include information that relates physical characteristics to inhabitant needs; that is, the measures must quantify how the environment will either support or hinder inhabitants.

It is important to emphasize that this is a pilot study, done with the intent of demonstrating an approach for modeling environment–behavior phenomena. The results provide support for the approach in that the model accounted for 73% of the variance in worker satisfaction with their work environment, even though there was relatively little development of the visual, acoustic, or social measures of environmental characteristics. It is similarly encouraging that a statistically significant causal relationship was indicated between the ISOKIN measure's index of constraint and worker's perception of environmental quality. Furthermore, the model and procedures are sufficiently documented to facilitate both the replication of this study and their application to future studies that explore new measures of environment performance and their relationships to inhabitant perceptions of quality and satisfaction.

CONCLUSION

This chapter has provided evidence that environmental performance can be measured in terms of a human-environment transaction. The qualities of environments that make them habitable are tangibly related to the needs of inhabitants, particularly the need for the support of inhabitant activities with their many human variations. The environment is not a neutral medium; it either provides the context for satisfying needs or it handicaps these pursuits. This means that environments we plan and build to support inhabitant needs, with all the diversity that being human implies, will likely be perceived by their inhabitants as more enabling, more satisfying, more habitable. To advance this goal, we must develop models that embrace the rich, transactional nature of environment-behavior phenomena and measures that quantify what is perceivable and important to inhabitants.

The model and measures presented here serve two purposes. First, they provide a context for discussing important considerations related to formulating models from theory, developing measures, and, finally, testing the models against data collected within an environment-behavior setting. Second, and perhaps most importantly, the model provides a framework for future development of environmental performance measures. The five constructs—environmental characteristics, worker characteristics, perceived environmental quality, environmental satisfaction, and productivity—are generally relevant to a wide range of environmental performance research initiatives and can serve as the common factors for many new and promising quantitative measures. The measures of constraint emphasized here are only early versions of more comprehensive and sensitive measures that will account for a much broader range of inhabitant needs. This progress will undoubtedly be reflected in ever-improving empirical results and a more general usefulness of the methods.

The approach for evaluating environmental performance models and measures described here has several benefits. It encourages the early development of a theoretically based structural model that explicitly defines the relationships between key constructs. The model then guides the systematic definition of measures for each construct, the identification of data collection requirements, and the specifications for the computer software used to evaluate the model and measures. Products of this process include statistics that indicate how well the model explains patterns in the data, how reliable the measures are, how strong hypothesized links are among constructs, and where possible improvements may be made to the model for future evaluation.

In summary, this approach allows researchers to move systematically from a theoretical perspective to the quantitative measurement of environmental performance. Once a model and measures have been validated—based on fit statistics and other statistical indicators—and are shown to explain a reasonable amount of the variance in inhabitant environmental satisfaction, then the most reliable

measures of environmental characteristics may be used directly as indicators of environmental performance. For example, it would be advantageous to have a validated index of environmental constraint as a criterion for selecting floorplans that best accommodate the diversity of activities for which they are designed. Furthermore, specific body-motion envelopes could be developed to assess whether a building conforms to both the guidelines and the intent of the ADA. This is the goal of this research: to make it possible to assess quickly and accurately the performance of planned or existing environments in terms that are meaningful to inhabitants of all physical abilities. In essence, by measuring and systematically eliminating many of the physical handicapping features of our buildings, we may begin to discover what it means to build truly enabling environments.

REFERENCES

Bagozzi, R. P., & Yi, Y. (1988). On the evaluation of structural equation models. *Journal of the Academy of Marketing Science, 16*, 74–79.

Baum, A., & Koman, S. (1976). Differential response to anticipated crowding. *Journal of Personality and Social Psychology, 34*, 526–536.

BOSTI (1981). The impact of office environment on productivity and quality of working life: Comprehensive findings. Buffalo, NY: Buffalo Organization for Social and Technological Innovation (BOSTI).

Brill, M., Margulis, S., & Konar, E. (1984). *Using office design to increase productivity*. Buffalo, NY: Workplace Design and Productivity.

Desor, J. A. (1972). Towards a psychological theory of crowding. *Journal of Personality and Social Psychology, 21*, 79–83.

Ellis, P. (1985a). A functional, disaggregated approach to office productivity and environment. In M. E. Dolden & R. Ward (Eds.), *The impact of the work environment on productivity* (pp. 129–140). Washington, DC: The Architectural Research Centers Consortium.

Ellis, P. (1985b). Office productivity. *Facilities, 3*(1), 000–000.

Hall, E. T. (1966). *The hidden dimension*. New York: Doubleday & Co.

Harris, L. A. (1978). *The Steelcase national study of office environments: Do they work?* Grand Rapids, MI: Steelcase.

Hayduk, L. A. (1987). *Structural modeling with LISREL*. Baltimore: Johns Hopkins University Press.

Heimsath, C. (1977). *Behavioral architecture*. New York: McGraw-Hill.

Hoelter, J. W. (1983). The analysis of covariance structures: Goodness-of-fit indices. *Sociological Methods and Research, 11*, 325–344.

Imamoglu, V. (1986). Assessing the spaciousness of interiors. *O.D.T.U. Mimarlik Fakultesi Dergisi, 7*(2), 127–137.

Jockusch, P. (1985). The changing office—some recent German developments and issues. In M. E. Dolden & R. Ward (Eds.), *The impact of the work environment on productivity* (pp. 59–68). Washington, DC: The Architectural Research Centers Consortium.

Joreskog, K. G., & Sorbom, D. (1978). *LISREL: Analysis of linear structural relationships by the method of maximum likelihood (Version IV)*. Chicago: National Educational Resources.

Kilborn, P. T. (1992, June 19). Big change likely as law bans bias toward disabled. *New York Times*, Sec. 1, p. 1.

Korman, R. (1982, November/December). Corporations ignore productivity possibilities. *Facilities Design and Management*.

Lantrip, D. B. (1986, September 29–October 3). *ISOKIN: A quantitative model of the kinesthetic aspects of spatial habitability.* Paper presented at the Proceedings of Human Factors Society 30th Annual Meeting, Dayton, Ohio.

Lantrip, D. B. (1988). *The design and analysis of space for haptic and kinesthetic habitability.* Unpublished master's thesis, University of Washington.

Lantrip, D. B. (1990). *The built environment as a constraint to human freedom: An activity-based stochastic model.* Paper presented at the Proceedings of 21st Annual Conference of the Environmental Design Research Association (EDRA), Denver, Colorado.

Lantrip, D. B. (1993). *Environmental constraint of human movement: A case study of the effects on office worker environmental satisfaction and self-rated productivity.* Unpublished Ph.D. dissertation, University of Michigan.

Lantrip, D. B. (1994). *Beyond CAD to computer-aided analysis of environmental performance: A case study of the office environment.* Paper presented at the Proceedings of the 12th Annual ACSA Technology Conference, University of Michigan.

Long, J. S. (1983). *Covariance structure models; An introduction to LISREL* (Vol. 07-034). Beverly Hills, CA: Sage.

Marans, R. W. (1989). Generative evaluations using quantitative methods: A case study. In W. F. E. Preiser (Ed.), *Building Evaluation* (pp. 249–265). New York: Plenum.

Marans, R. W., & Spreckelmeyer, K. (1981). *Evaluating built environments: A behavioral approach.* Ann Arbor, MI: Survey Research Center (SRC) and Architectural Planning Research Laboratory.

Marans, R. W., & Yan, X. (1989). Lighting quality and environmental satisfaction in open and enclosed offices. *Journal of Architectural and Planning Research*, 6(2), 118–131.

Nunnally, J. C. (1978). *Psychometric theory* (2nd ed.). New York: McGraw-Hill.

Quinn, R. P. (1977). *Effectiveness in work roles: Employee responses to work environments.* Ann Arbor: Institute for Social Research, The University of Michigan.

Schiffenbauer, A. I. (1979). Designing for high density living. In J. R. Aiello & A. Baum (Eds.), *Residential crowding and design* (pp. 229–240). New York: Plenum.

Schiffenbauer, A. I., Brown, J. E., Perry, P. L., Shulack, L. K., & Zanzola, A. M. (1977). The relationship between density and crowding: Some architectural modifiers. *Environment and Behavior*, 9(1), 3–14.

Spreckelmeyer, K. F. (1993). Office relocation and environmental change: A case study. *Environment and Behavior*, 25(2), 181–204.

Stokols, D. (1972). On the distinction between density and crowding. *Psychological Review*, 79, 275–277.

Sundstrom, E., Herbert, R. K., & Brown, D. W. (1982). Privacy and communication in an open-plan office: A case study. *Environment and Behavior*, 14, 379–392.

Wheaton, B., Muhten, B., Alwin, D. F., & Summers, G. F. (1977). Assessing reliability in panel models. In D. R. Heise (Ed.), *Sociological methodology* (pp. 85–136). San Francisco: Jossey-Bass.

Wise, J. A. (1988). *The quantitative modelling of human spatial habitability* (NASA Contractor Report NASA CR177501). Seattle: College of Architecture & Urban Planning, University of Washington, Seattle.

Worchel, S., & Teddlie, C. (1976). The experience of crowding: A two-factor theory. *Journal of Personality and Social Psychology*, 34, 30–40.

IV

MEASUREMENT IN PRACTICE

Formal recognition of the physical environment's influences on the lives of people with impairments is occurring in a number of forums. Two deserve particular mention because of their widespread impact on policy, practice, and research. Civil rights legislation such as the Americans with Disabilities Act of 1990 has been enacted to protect people with impairments against acts of discrimination perpetrated by unaccommodating environmental designs. And proposed revisions to the World Health Organization's *International Classification of Impairments, Disabilities and Handicaps* explicitly acknowledge the physical environment's role in the disablement process.

With such acknowledgements, however, comes the need for practical ways to measure the need for and the benefits of enabling environmental design interventions for people with impairments. The challenge of such practical measurement is the diverse range of settings in which people with all types of impairments participate: residential, institutional, work, public accommodation, transportation, and so on. The chapters in this part address that challenge by presenting a number of measurement techniques designed for use in practical applications.

In Chapter 13, Blasch, De l'Aune, and Coombs describe a measurement technique designed to evaluate physical environments in terms of their likely consequences for people with vision impairments using different long-cane techniques. The RoboCane computer software simulates use of a person's individual cane technique in a given environment to predict outcomes. Unlike direct observation measures, the RoboCane® program permits individualized assessments without exposing the person with a vision impairment to actual risks.

Chapter 14 by Haley and Bermudez also discusses a computer-based measurement process. The authors argue for development of an expert system to check building code compliance from computer-aided design (CAD) representations of architectural artifacts. Modeled after the spell- and grammar-check functions found in word-processing programs, this knowledge-based system

would employ a "virtual" user to check compliance, highlight mistakes, and suggest changes—all within the same CAD document.

In Chapter 15, Finkel reports on a research study that reinforces the importance of going beyond code issues when determining the usability of environments. This study was designed to determine the specific environmental information that enables/disables the individual with an impairment. Employing a multimethod approach, the author's measurement process emphasizes the need to understand informational aspects of environments—particularly relating to role perception and cognition—as key to creating universally accessible environments.

Chapter 16 by Falta also embraces the concept of universal design and specifically advocates the postconstruction diagnostic evaluation of designs in use to determine their actual effectiveness. Reporting on a postoccupancy evaluation of "universally accessible" apartments units, the author demonstrates the method's ability to determine whether environments that supposedly demonstrate universal design do indeed accommodate a range of users (e.g., families, couples, singles, elderly, etc.) both with and without physical or sensory impairments.

Chapter 17 by Cooper et al. reviews 41 measures used in occupational therapy to evaluate a wide range of environmental settings (e.g., residential, institutional, and work) to determine the suitability of the person-environment interactions they promote. The authors organize the 41 measures into a matrix to facilitate identification of the most appropriate instrument given various personal and environmental factors.

13

Computer Simulation of Cane Techniques Used by People with Visual Impairments for Accessibility Analysis

Bruce B. Blasch, William R. De l'Aune and Franklyn K. Coombs

INTRODUCTION

The wheelchair symbol is the modern designation representing access for people with disabilities. However, wheelchairs are relatively new devices of mobility for people with disabilities. The use of a staff or cane as a mobility aid for people with visual impairments has been recorded for centuries. In the Bible, Leviticus 19:14, we find: "Thou shalt not curse the deaf, nor put a stumbling block before the blind, but shalt fear thy God," and in Deuteronomy 27:18: "Cursed be he that maketh the blind to wander out of the way. And all the people shall say Amen."

Bruce B. Blasch and William R. De l'Aune • Rehabilitation Research and Demonstration Center, Department of Veterans Affairs Medical Center, Decatur, Georgia 30033. **Franklyn K. Coombs** • BEAR Consultants, Lilburn, Georgia 30076.

Enabling Environments: Measuring the Impact of Environment on Disability and Rehabilitation, edited by Edward Steinfeld and G. Scott Danford. Kluwer Academic/Plenum Publishers. 1999.

Greek mythology also had a focus on the blind person walking with a staff. Levy (1949) observed that "the ancients were so much struck with the circumstance of the blind walking alone, aided only by a stick, that, in their usual way, they made it a miraculous gift of the gods ... when the ancient prophet Teresias was deprived of sight for an offense against the gods, he was compassionated by the goddess Chariclo, who in pity for his misfortune, gave him a staff, by which he could conduct his steps with as much safety as if he had the use of his eyesight" (p. 106). (Note the emphasis on pity as a response to disability.)

The passage of the Americans with Disabilities Act (P.L. 101-336), commonly known as the ADA, requires building owners and public bodies to make reasonable accommodations for people with disabilities and to make new environments fully accessible. This places these caring professionals on the horns of a dilemma: What is reasonable? And what really aids people with disabilities? What helps a person using a wheelchair may be confusing for a person with visual impairments. An example is a curb-cut provided to aid wheelchair users. A person using a long cane or a dog guide as a mobility aid may not detect a subtle grade change in the curb-cut and walk into the street unaware of the danger. It is easy to understand why some people with different disabilities find the International Symbol of Accessibility a confusing indication of accessibility because it often applies only to wheelchair accessibility and does little for people with other disabling conditions. An additional confounding factor is that all people, whether using a long cane or wheelchair, do not function at the same level of independence or proficiency. Thus, what may work for one level may not be helpful for individuals at other levels of the same disability. This variability may cause problems for designers and planners who build mock-ups of planned environments to evaluate the accessibility of the prototype environments with feedback only from a few individuals with disabilities. These small samples may result in misleading results, even with the best intentions. This is a problem area where computer technology similar to that used by architects and designers in their daily work can generate simulations of mobility patterns of people with disabilities.

Detecting and avoiding common environmental objects that are potential hazards to people with visual impairments are important mobility skills needed for safe travel. Typical hazards are parking meters and street signs in the sidewalk, uneven or broken sidewalks, sidewalk curbs, and other elevation changes (transit platform edges, stairway entrances, or construction holes in pedestrian areas). Orientation and mobility specialists, professional instructors, teach the strategies and techniques of independent travel with a long cane or other mobility aids to people with visual impairments. Until recently (Blasch & De l'Aune, 1992), there were no rigorous methods to evaluate objectively both the mobility coverage (or detection of a safe path) with any cane technique and the resultant level of safety for the traveler with a visual impairment. Until the development of this software modeling program to evaluate cane techniques without putting people at risk, the relatively safety of various cane techniques has been supported only through

speculation regarding best protection. Also, the creation of new techniques to meet the needs of the changing population have been achieved by trial and error at the expense of persons with visual impairments.

There are two approaches to accessibility for people with visual impairments. The first approach is teaching people with disabilities to solve environmental problems creatively, that is, modify what the learner does in response to a difficult (for the learner) environment. The second approach uses design to reduce the barriers to accessibility for people with disabilities. Both approaches have strengths and limitations. Too often, however, one of these approaches has been championed to the exclusion of the other, for example, installing raised line building floor plans without providing a method of informing the visually impaired individual of the location of these maps or teaching the individual how to use them. Through computer simulation, the appropriate use of both approaches can be examined and new strategies can be developed that yield more effective results than either alone. This chapter describes computer simulations of people with visual impairments using planned environments and results from research in this area. Some historical background is useful as a context for the research to be described.

Historical Background

Mobility Training for People with Visual Impairments

The foundation of independent travel used by most people with a visual impairment is known as the touch technique for using the long cane. The basics in the use of the long cane were developed in 1872 by W. Hands Levy, a British authority on blindness. In a discussion of Levy, Blasch and Stuckey (1995) stated, "Maybe because of his own person frustration, he [Levy] made the following extremely strong statement about mobility and independence: 'The importance to every blind man of acquiring the power of walking in the streets without a guide can scarcely be exaggerated. Loss of sight is in itself a great privation, and when to it is added the want of power of locomotion, the sufferer more nearly approaches the condition of a vegetable than that of a member of the human family'" (p. 419). Levy asserted that the hand holding the cane should be centered in front of the body, and the cane tip should swing from side to side in rhythm with the traveler's foot falls in a horizontal arc approximately shoulder width. The cane tip touches the ground at each extreme of the shallow vertical arc described by the cane. For whatever reason, these techniques and the use of the cane were not accepted or popularized at that time either in England or the United States. Again, note the negative attitude toward blindness in Levy's statement.

In the United States, systematic orientation and mobility training of individuals with a visual impairment began on an organized basis with the dog guide

school, The Seeing Eye, in 1929. The Seeing Eye program and the success of the graduates increased awareness that mobility is central to an individual's ability to work, go to school, and live independently.

In 1930, another major milestone for accessibility and independent mobility for the visually impaired was established. In Peoria, Illinois, the local Lions Club succeeded in obtaining passage of the first White Cane ordinance, giving pedestrians with a visual impairment the right-of-way in crossing streets. The background of this law and why the cane is white with a red tip, according to Martin (1991), was as follows:

> During George A. Bonham's term as president of the Peoria, Illinois, Lions Club in 1930 he saw a problem. Soon after, he devised the solution. Bonham watched a blind man trying to cross a street, left helpless as traffic whirled about him. Futility tapping his black cane on the pavement, the man was isolated in the center of drivers who did not understand his handicap.
>
> Bonham pored over the problem. Suddenly he had the answer. Paint the cane white and put a wide band of red around it. When the blind person crosses a street let him extend it so that everyone can see and be aware of his blindness. George Bonham presented the idea to the Peoria Lions Club and the members voted unanimously in favor of it. Canes were painted and given to the blind in the city. The Peoria City Council passed an ordinance giving the right-of-way to a blind person using a white cane (p. 62).

In 1931, the International Lions Clubs adopted the promotion of white canes for people with visual impairments as a national program. "By 1956, every state in the US had passed a law giving a person using a white cane the right-of-way as well as protection for individuals using a dog guide. The white cane with a red tip symbol used in Peoria, Illinois in 1930 may have been the first 'accessibility icon' recognized by the general public, similar to the wheelchair as the accessibility symbol of today" (Blasch & Stuckey, 1995, p. 419).

The first major indication of interest in the systematic teaching of the use of the cane was an article written by Richard Hoover, "Foot Travel without Sight," published in 1946. While evolving something very similar to the modern touch technique, Bledsoe (1980) states that Levy "missed what was to be *the most important item of all*, that the cane should always touch (the ground) in front of the trailing foot, rather than the forward foot" (p. 419). This insightful modification by Hoover (1946) allows the cane to touch where the foot would be placed, facilitating the detection of holes, drop-offs, and other level changes. The apparent completeness of the Hoover technique, in terms of providing safety to the traveler with a visual impairment, had a compelling influence on the entire educational and rehabilitation program for this group. These techniques elicited great confidence in independent travel and produced dramatic changes in mobility patterns of people with visual impairments. As a result, most agencies providing orientation and mobility (O&M) training to visually impaired individuals incorporated the Hoover technique into their programs, even for individuals with usable residual vision.

The subjective description of the use of the long cane, simply stated, was

that the movement of the cane serves as a probe and clears a path, much like walking through a jungle and clearing away the bush. Another important concept was the length of the cane. The cane should be modified for each individual, and the length should be the same as the user's height to just above the base of the xiphoid process located at the bottom of the sternum. Based on this preliminary measurement, which may be modified after observations made by the O&M specialist, the cane tip touches where the foot will be placed, one step in advance, as recommended by Hoover (1946).

When O&M started as a profession, teaching the use of the long cane in the late 1940s, most clients were young, World War II veterans in the war, who were relatively healthy and often experienced only the single disability of visual impairment. These men were, on the whole, highly motivated to become rehabilitated successfully and acquire independent travel skills. In the five decades since World War II, education and rehabilitation services and the client population of people with blindness or low vision have undergone radical shifts. The two key changes that have occurred are the dramatic increase in blind individuals over the age of 65 and the growth of the multiply impaired blind population. Because of the greater variation in client characteristics in the present population of people with visual impairments, the evaluation of the client has become much more complex, as has the person's ability to safely perform a specific O&M task.

In 1960–1961, university programs were established to train O&M specialists with a curriculum of systematic instruction in the strategies and techniques of using the long cane, which was originally developed at the Hines VA Hospital. These techniques were focused on the goal of safe, efficient, and effective independent travel by individuals without effective or usable sight. Because these concepts were based on empirical methods, there was no underlying scientific basis for evaluation or analysis. Thus, it was difficult to quantify or objectify any of these techniques, and affordable tools or devices were not available to O&M specialists to conduct ecologically relevant evaluations.

In response to this increased complexity, leaders in the field of orientation and mobility have written textbooks describing the theoretical bases of O&M (Blasch, Wiener, & Welsh, 1997; Welsh & Blasch, 1980) and practical teaching techniques (Hill & Ponder, 1976; Jacobson, 1993; LaGrow & Weessies, 1994). Other authors have addressed issues in measurement of mobility (Dodds, Carter, & Howorth, 1983). The literature in O&M performance assessment is relatively sparse. Recently, however, a greater amount of attention has been given to this important area of mobility research. Research in the measurement of mobility had it roots in the work of Leonard and his colleagues at the Blind Mobility Research Unit at Nottingham, England (Armstrong, 1972). Based on the work at Nottingham, Dodds et al. (1983) conducted a study of the reliability of a set of mobility measures. These measures, which could be observed directly or on videotape, included time on course, cane contacts, body contacts, and curb incidents.

It is important to recognize that the cane in and of itself is only a device or aid. The important aspect of O&M training is teaching the person with the

mobility impairment to use different strategies of problem solving in a given environment. Armed with these strategies, the person can be placed in different travel situations and be able to move about with confidence. The "white cane" can be replaced by any long object in an emergency, and the user can still function or travel independently. This strategy allows the person with a mobility impairment to be independent. As a mobility aid, the dog guide does not provide detection like a cane. A dog guide provides guidance and protection; thus, the techniques and uses of dog guides are not discussed in this chapter.

Blasch and Stuckey (1995) speculate why the techniques proposed by Levy were not taken seriously but were embraced when proposed by Hoover almost 72 years later. One major change may have been the difference in attitude. According to their analysis, during the time when Levy was proposing independent mobility, the prevailing attitude may have been similar to that stated by Koestler (1976). "It was the self-denigrating belief that blindness should be made as inconspicuous as possible, and that the use of a dog guide or a distinctive cane attracted undesirable public attention" (p. 304).

Blasch and Stuckey (1995) state, "[T]he major impact of the pioneering efforts of the Seeing Eye (and subsequent dog guide schools) and the successes of their students demonstrated: 1) it was not a chosen few or the gifted blind individual that could travel independently, 2) techniques could be taught to large numbers of visually impaired individuals and, 3) with the use of a dog guide, visually impaired individuals were no longer segregated but could be integrated into the mainstream of the community" (p. 309). According to Koestler (1976), "Most meaningful of all, the sight of a blind man confidently striding along with his dog guide had come to evoke public admiration rather than pity." Therefore, based on the successful dog guide user, the general public and visually impaired individuals could look forward to the same advantages afforded by instruction and a means to achieve independent mobility.

Blasch and Stuckey (1995) concluded,

> This expectation and belief in the ability of people who are visually impaired to learn to be independently mobile and the success of the programs of the Seeing Eye and the growing number of dog guide schools paved the way for the public's and field's receptiveness to the long cane technique proposed by Hoover and the VA [now the Department of Veterans Affairs]. Thus, it was not a parallel development of the dog guide and long cane techniques, but the pioneering efforts of the Seeing Eye, reinforced by other dog guide schools, that accounted for the change in attitudes, which was the first major barrier that had to be overcome before the long cane technique was even considered. (p. 421)

Accessibility for People with Visual Impairments

The mobility of visually impaired individuals has become safer, and in many cases easier, with the increasing concern for designing an accessible environment. One of the earlier treatments of accessibility was *Barrier-Free Environ-*

ments, edited by Michael J. Bednar (1977). Bednar discusses barriers, both physical (relative to access and use of buildings and mobility in the environment) and social (restrictions to full societal participation imposed by the built environment). The study of accessibility (according to Steinfeld, Duncan, & Cardell, 1977) had focused predominately on barriers to movement and to the use of buildings, equipment, and landscape.

In 1959 the American National Standards Institute (ANSI) developed accessibility design standards. These standards are cited as the beginning of the "accessibility movement." The standards are generally accepted as the first codified criteria for making the environment accessible for individuals with disabilities. However, Blasch and Stuckey (1995) contend that long before this, there were many environmental design features introduced at residential schools and rehabilitation agencies for individuals with visual impairments. They cite some examples of these design features in the early 1900s, such as outdoor bells and wind chimes, railings or ropes between destinations, corrugated edges of sidewalks, tactile markings on sidewalks, and ruts in cement to guide the cane tip in the direction of travel. Based on accessibility standards of today, some of these modifications were of value. However, some were ill-conceived ideas formulated by well-meaning, but uninformed, individuals.

According to Blasch and Stuckey (1995), these early efforts at providing an accessible environment for individuals with a visual impairment were exemplified by an article by Sturgis (1913), entitled "The Perkins Institution and Massachusetts School for the Blind at Watertown, Massachusetts." The article stated:

> Various minor points throughout the plan were the result of the main underlying condition, the blindness of the children. Straight corridors and right-angle approaches are maintained throughout to facilitate the blind in finding their way; stairs lead from the sides of corridors rather than from the end, to avoid the danger of approaching them without knowledge; the top to the gymnasium forms a roller skating rink and indented rulings in the cement surface, a few feet in from the edge, serve as a warning to the skaters. The running track, on the gymnasium balcony, has a continuous brass hand rail bracketed from the gallery railing, which serves to guide the runners safely. The walls of the swimming pool and the level of the water within are raised several feet above the surrounding passages, preventing accidental stumbling into the pool. In the Closes the central paths are abnormally crowned, as also in all the smaller brick paths, assisting the blind in maintaining an accurate sense of direction of the paths. Special raised-pattern tile are used in connection with the concrete work of the museum and low relief carved blocks of various familiar animal forms are placed where dado caps meet door panels. These will serve as points of amusement and interest to the children upon better acquaintance. (p. 157)

Over time, it has become clear that many features in the environment have a significant impact on the ability of people to travel safely and efficiently. In 1980, Wardell differentiated an obstacle (an obstruction in the path of the travel that can be detected and negotiated with standard long-cane techniques) from a

hazard (obstruction in the path of travel than cannot be detected and negotiated with standard long-cane techniques). The latter should be addressed by design. Some of the environmental elements that posed a hazard for the traveler with a visual impairment include protruding public telephones, guy wires, wall-mounted fixtures, the open space on the underside of stairs and escalators, protruding or overhanging planters and shrubbery, certain street signs, display windows, placement of handrails, and the design of certain intersections. In addition to hazards, people with visual impairments experience difficulty in finding their way in many spaces because the environment is primarily designed to be visual in nature. Information is conveyed through signs, directional and traffic signals, landmarks, building features (e.g., columns and pediments), addresses, and so on (Sanford, 1985; Sanford & Steinfeld, 1987). Because people with visual impairments cannot use most overt environmental information, ordinary mobility tasks such as avoiding planters, benches, etc.; finding the entry to a building; and not stepping off a curb into traffic often become hazardous (Pavlos, Sanford, & Steinfeld, 1985; Templer, Zimring, & Blasch, 1989). Consequently, efforts to assist people with visual impairments to travel independently must consider the effects of environmental factors not only on safety but on efficient movement (Blasch & Hiatt, 1983). Environmental factors such as building layout, use of changes in ground surface treatments, or tactile signage have been studied in this context (Passini, 1986; Sanford, 1985; Sanford & Steinfeld, 1987; Steinfeld, Richmond, & Sanford, 1986; Templer, Zimring, & Blasch, 1989). The history of O&M training and accessible design for people with visual impairments demonstrates that both training and environmental design work together. This premise formed the basis for the development of a new computer-based tool for both practice and research.

COMPUTER SIMULATION

The computer simulation of long-cane use presents a relatively new approach toward practice and research in mobility. It is a mathematical model implemented through software for a personal computer. Formerly, this type of modeling was useful only to those with mathematical backgrounds; however, it is accessible now to the nonmathematician through computer graphics. Again, these computer-aided techniques are similar to the computer-aided drafting and design systems used by architects, designers, and city planners.

To be effective and useful clinically, a mobility model must incorporate objective information about the devices, techniques, and strategies used by people with visual impairments to travel independently. It also must contain physical information about the travelers themselves. In the absence of objective information, engineers and scientists will, in general, revert to a focus on ergonomic design of a device (such as a cane's weight or its tensile strength). These

qualities, while important, may have little relevance to safety of a traveler with visual impairments. Measuring a cane's weight provides no relevant data about a traveler's prospect of stepping into an open manhole or negotiating other hazards. The long cane is merely a highly evolved stick. Only when coupled with appropriate techniques and strategies does it become an effective mobility device. Thus a complete mobility model should consider devices coupled with the appropriate techniques and strategies to generate effective and useful clinical measurements.

Modeling of the Long-Cane Technique

Mann (1974) reports the long cane is the single most effective instrument for the blind traveler and thus makes long-cane travel the most widely used mobility technique. This reliance has triggered a number of researchers to investigate the development of mathematical models to simulate cane coverage techniques. Krigman (1967) developed a mathematical model based on treating the traveler as a processor of information. The model includes uncertainties of memory, information decay, and disorientation. The basis for the model was an equation that balanced information gains and losses. Krigman's premise was that such a model could identify significant variables associated with mobility and their interactions. The problem with Krigman's model was the assumption that reactions and dynamics of walking subjects were invariant.

Orthographic projection techniques of the top view of a long cane in use have been applied in the past (Uslan, 1978; Uslan & Manning, 1974), but the underlying model was restricted to the most rudimentary mechanical elements of the Hoover technique (cane length, hand height, arc width, and stride length). The cane was assumed to be centered at the user's midsagittal plane (the center of the front of the body) with the cane tip moving in a smooth, perfectly sinusoidal arc. The orthographic technique was used to calculate percent coverage by the cane, but only within the limitations stated here. In addition, the technique was very labor and mathematically intensive. It is believed that because of these major limitations, orientation and mobility professionals never accepted this technique as a clinically relevant tool or the resulting conclusions.

RoboCane® DEVELOPMENT

The development of the RoboCane® simulation was prompted by a lawsuit filed in Washington, D.C. The case involved a visually impaired person who sued when she fell into an open manhole left exposed and unguarded by the public utility. A typical defense in an accident of this nature implies the individual was not using the proper (Hoover) technique and therefore was at least partially responsible for the accident. Until that point in time, there were no methods to

evaluate the coverage (detection of safe path) of the cane technique and resulting level of safety for specific travel hazards, such as open manholes.

In a concerted effort to develop objective evidence as expert witnesses, two of the authors, Blasch and De l'Aune, developed computer-based modeling software to simulate foot placement and cane coverage patterns of people with visual impairments. This lead to the development of the Mobility Coverage Profile and Safety Index (MCPSI, or RoboCane®) as a basic model of mobility coverage. This model simulates the coverage pattern of a long cane employed by a traveler with visual impairments. The software geometrically models the sequential positions through space and therefore the coverage pattern of a long cane employed by a traveler with visual impairments. The program requests information about biomechanical factors such as the subject's stride length, hand position, and cane length. The program displays a two-dimensional "top view" of the traveler's foot fall, cane movement pattern, and points where the cane tip touches the ground (see Figure 13.1). A measure of percent protection (the coverage required by the traveler minus the coverage provided by the cane) is generated from this output. The software places user-defined objects in random positions in the simulated traveler's path and, using Monte Carlo statistical techniques, generates the probability of an unprotected traveler–object encounter. This probability, in conjunction with the frequency of occurrence of such objects in the user's travel environment, can be used to generate a safety index for the traveler.

The validation of the computer-simulation model was done with a biomechanical motion analysis system. Videography is a method of recording and displaying information about motion that allows quantitative measures to be directly obtained from digitized video images. These measures, along with knowledge of the time or speed of the camera, allow researchers to measure instantaneous velocity, acceleration, and linear and angular displacement. Thus, videography bridges the gap between the mathematics and observation in the comparison, description, and evaluation of motion. Movement analysis is not new to the field of rehabilitation. It is best known for analyzing the gait of amputees to monitor the rate and effectiveness of therapy (Dawson, Reiter,

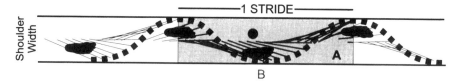

Figure 13.1. Top view of cane user. The shaded area (A) indicates the three-dimensional area requiring coverage by the cane less the three-dimensional area that is covered by the cane (B). The percentage of coverage is calculated as follows: $100\% \times B/(A+B)$.

Sarkodie-Gyan, Provinciali, & Hesse, 1996). This technology is particularly applicable to the movement involved with blind or low vision mobility.

The biomechanical analysis system used for the validation of the RoboCane® software was used in the Sports Performance Laboratory at Georgia State University. It included the following equipment: Panasonic Industrial Grade S-VHS Camcorder, Peak Performance Motion Analysis software, Panasonic AG-7300 Computer Controlled Video Player, Matrox Video Frame Grabber Computer Board, Sony Video RGB High Resolution Monitor, and IBM-compatible 386-33 computer system. The Panasonic video camera operating at 60 Hz (pictures per sec recording rate) was used for capturing body and cane motions for measurement. The Peak Performance Motion Analysis software utilized the video medium for measuring motion (linear and angular displacement, velocity and acceleration) of the human body and cane in three dimensions. This system was designed for analyzing the human form in motion. The foot fall and cane movement patterns of a trained O&M specialist using the techniques as described in Hill and Ponder (1976) were used as the models in the biomechanical analysis system. These data were compared to the early computer simulation models of RoboCane® and the computer program was adjusted to replicate the human models. As a result of these data, additional parameters were added to the software, such as foot displacement and foot splay. These data from the biomechanical analysis were repeated and compared to the final software version to assure the computer simulation represented human motion accurately.

RoboCane® allows both researchers and clinicians to evaluate cane coverage afforded visually impaired travelers by either their existing or modified techniques for specific travel hazards. By demanding an objective set of parameters describing the traveler and cane technique, it promotes documentation of travel characteristics that serve as "snap shots" in the rehabilitation process, or as part of O&M training.

This simulation model develops a baseline for a person with the physical characteristics described and serves as both a teaching tool and a performance measure for training. The software allows the O&M specialist to study the effect of changes in cane length in detecting objects without ever exposing the client or person being trained to any risk. Similarly, it allows the O&M specialist and the client to develop alternative strategies together, evaluate the predicted performance, and then teach the preferred method to the client. As we shall see, this clinical tool can also be very useful in design practice and research on accessible design. In particular, use of the simulation has uncovered much valuable information about how long canes are used in an environment.

Mobility Coverage Provided by the Long Cane

The objective analysis provided by the modeling program prompted a need to be more precise in the terminology. Mobility coverage was first defined as "the

ability of the cane to detect an obstacle or hazard in the student's path" (Blasch, De l'Aune, & Blasch, 1993, pp. 3–4). While the concept of cane coverage for individuals with a visual impairment had been discussed for decades, there was no precise definition until 1993, as it was assumed to be 100%. As greater use was made of the objective evaluation by RoboCane®, it appeared that more information was needed to describe the use of the cane. Blasch and De l'Aune (1994) proposed that the cane is a probe or environmental sensor and, as such, provided a "preview" for the traveler with a visual impairment. The concept of mobility coverage can be divided into three components: object preview, surface preview, and foot placement preview. This revised concept lead to the most recent definition of mobility coverage as "the scope or range of environmental preview of path information provided to the traveler" (Blasch, LaGrow, & De l'Aune, 1996, pp. 3–4).

Mobility coverage should be thought of as detection. The area of coverage provided, however, is dependent upon the unique functions of each of the devices or techniques used. The amount of protection or safety is dependent on variables specific to the traveler (e.g., ability to respond to the detection of information, reaction time, degree of vision). Note this definition is not specific to a disability. Mobility coverage for a motorcycle rider could be restricted by the safety helmet. Glare and bright sunlight on a highly polished lobby or entrance floor may hide level changes or stairs. Similarly, low light levels and a lack of contrasting colors may hide level changes or stairs in a theater or meeting hall. In any of the preceding examples, the viewer may not have any visual impairment other than that caused by the environment, and the definition encompasses this possibility.

According to Blasch et al. (1996), the function of a mobility device such as a cane is to preview the immediate environment for (1) objects in the path of travel (i.e., object preview), (2) changes in the surface of travel (i.e., surface preview), and (3) the integrity fo the surface upon which the foot is to be placed when brought forward (i.e., foot placement preview). Determining mobility coverage provided by the cane is dependent upon the cane length and position, width of the arc, percent of tip contact with surface, physical characteristics of the traveler, and the features of the environment. The purpose of this section is to further specify each of these environmental preview variables to expand on their operational definition as dependent measures for use in future studies.

If the visually impaired traveler walks with a contralateral swing of the cane, the width of the shoulders, with the tip of the cane just above the surface of the ground and not making contact, the cane is providing object preview. "Object preview refers to the detection of objects in one's path of travel" (Blasch, LaGrow, & De l'Aune, 1996, p. 296). Object preview or information about objects in the path is provided for "ground anchored" objects only—not for objects extending down from above to the height of the hand holding the cane. The vast

majority of environmental objects encountered by a pedestrian traveler are objects that have a base on the ground surface.

Object preview is accurately determined by the percent coverage measurement provided by RoboCane®. Prior to RoboCane®, this coverage was thought to approach 100%. However, it is now known that object preview varies with each individual depending on length of cane, stride length, and technique of holding and moving the cane. Based on the information gathered to date, it is not uncommon for the cane user with "good techniques" to have an object preview of under 50% and the person with "bad techniques" to have 80% coverage. This information is important for designers and those developing standards because it introduces the notion that object detection is a probability-based event rather than a certainty.

If the traveler makes contact with the tip of the cane and the surface, information is obtained about the nature of the surface environment in front of the traveler, and the cane is providing surface preview. Therefore, "surface preview refers to the detection of changes in the surface to be traveled, most notably those associated with changes in the plane itself (such as stairs and/or curbs) and the texture (rough or smooth)" (Blasch, LaGrow, & De l'Aune, 1996, p. 298). This information is in addition to that provided by the object preview. The amount of surface preview provided by the cane tip may vary from a constant contact, where the tip is not lifted from the surface, to the touch method, where the cane tip touches only at the most lateral part of the arc swing to either side. Information from surface preview may include early warnings of drop-offs, change in surface texture, the presence of inclines or declines, or pavement edges. Surface preview may be considered crucial particularly for independent travel in unfamiliar environments because it relates to the detection of level changes in one's path of travel and the nature of the surface.

Foot placement preview occurs when the cane tip strikes the surface where the foot will be placed. Information concerning surface irregularities in the location of an eventual foot placement can be provided by the long cane with an appropriate combination of stride length and cane length. This cane–surface interaction serves to check the integrity of the surface area before the foot is brought forward. Therefore, if the placement of the two (i.e., cane tip and some part of the foot) correspond exactly, then foot placement preview has been accomplished. This information is most important in situations with holes and other level changes. The cane tip may be in constant contact with the surface but may be touching the surface 6 in. in front of where the foot steps. In such an example, a traveler may touch the cane just past a hole, one step in advance, and with the next step place their foot in the hole. The relative effectiveness of the cane becomes very dependent on the interrelations between the cane length, the stride length, and where the individual is holding the cane. However, even with perfect technique, coverage is not absolute since the tip of the cane is only able to

validate a small portion of the surface where the foot will be placed (e.g., heel area only, toe area only, from heel to toe, etc.). Therefore, if only the surface area where the ball of the foot is placed is probed and determined safe, the area where the heel comes down may be unknown and the unchecked part of the foot placement can encounter a hole and cause a fall.

Environmental Variables and Cane Techniques

The safety provided by the individual's cane technique in preventing accidents is dependent on the environment and the frequency of hazards. Therefore, the known environmental features would dictate the subtle modifications of the cane technique and the person's speed of walking. This "canemanship" (analogous to penmanship in using a pencil or pen) is taught by the O&M specialist to the visually impaired individual. The following discussion represents the considerations of a variety of environmental features and the implications for the cane techniques.

Object preview, specifically percent coverage as derived from RoboCane®, is at its maximum for objects that are ground anchored and have a height exceeding that of the pivot point (normally the wrist) of the cane (e.g., telephone pole, wall, parking meter). For these objects, the entire length of the cane serves as a probe.

For objects on the ground (e.g., cinder block, small waste receptable) but not extending upward to the pivot point of the cane, only the lower portion of the cane is relevant as a probe. The coverage provided for an object 6 in. tall is graphically demonstrated in Figure 13.2. If the cane tip is lifted during the middle of the arc, it is quite possible for the coverage to be completely lacking in the central area of the cane arc. It can be readily seen that the cane offers minimal preview for these low-lying objects.

Even more problematic are objects that are not ground anchored. The cane gives no information at all about objects occurring above its pivot point. A wall-mounted telephone kiosk, a head-height overhang, or a guy wire are all invisible to the cane.

Surface preview or information about level changes (curbs, holes, etc.) is obtained by the visually impaired traveler from the contact between the cane tip and surface. There are many techniques for establishing such contact, including two-point touch, touch-and-slide, and constant contact. Constant contact technique is a variation of the touch technique in that the cane tip is not lifted from the ground at any point within its arc. According to LaGrow and Weessies (1994);

> Proponents of this technique suggest that it provides the traveler with "superior tactual feedback," resulting in the detection of small surface discontinuities and precise location of walkway margins, with obstacle detection equal to that provided by the standard touch technique and superior detection of vertical breaks in the walking surface, along with rich textural feedback about the nature of this surface. Much of this

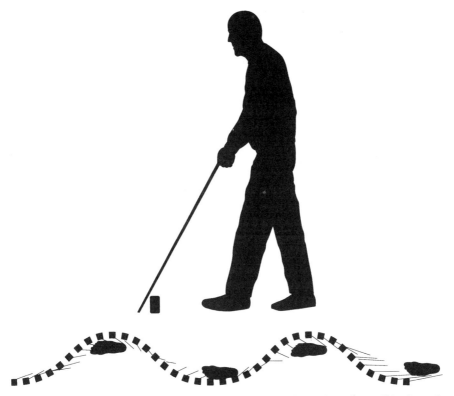

Figure 13.2. (*Top*) Individual traveling using a long cane with an object 6 in. tall in the path. (*Bottom*) Representation from RoboCane® graphically demonstrating a shorter cane and that only the lower portion of the cane is relevant for the preview of an obstacle 6 in. high.

> advantage is obtained because aspects of the standard touch technique and the touch-and-slide technique are combined in one more powerfully comprehensive cane application. Drop-offs, sharp gradients, and blended curbs are detected earlier, thus improving reaction time, because the edge of the discontinuity may be contacted at any point of the cane arc, rather than just at its outer reaches. (p. 126)

Constant contact ensures that curbs and drop-offs will be sensed. The two-point touch technique, especially with longer cane lengths, can place a serious burden on the traveler to detect differences in height from two places sampled (on the right and on the left side of the arc). Both constant contact and two-point touch provide information that is severely compromised when gradual curb cuts are encountered, as noted in the "Introduction."

Since the 1950s (Welsh & Blasch, 1980), work has been conducted on the development of electronic travel aids (ETAs) that would replace the long cane

and dog guide. Because of technological limitations in these attempts, the commercially available ETAs were only to be used as a supplement to the long cane or dog guide. Until the analysis of the cane techniques provided by Robo-Cane®, the prevailing opinion, according to Hoover (1946), was that "by using the technique described ..., it is impossible to step unexpectedly off curbs or into holes, to wander onto the grass, or bump into any obstacle which protrudes from the ground upward" (p. 247). Because of this belief, the use of an ETA has been viewed as a supplement to the long cane. The information from the ETA was considered redundant (based on Hoover's concept of detection) with the exception of detecting overhangs. Using the RoboCane® analysis program, and a plot of an ETA beam, it has been shown that canes used with ETAs can provide 100% mobility coverage. Based on this level of analysis, the beam length of the ETA can be prescribed for each individual to provide maximum coverage and limit extraneous information. Therefore, the ETA is not redundant but complementary.

IMPLICATIONS FOR ENVIRONMENTAL DESIGN

The RoboCane® provides a sophisticated modeling program for use by O&M researchers and practitioners. The model is limited to a description of the preview provided by a long cane for a few steps directly in the path of the traveler and a single user-defined obstacle located in random positions within the simulated traveler's path. But, by dividing the mobility task into environmental components and subtasks, it is possible for the RoboCane® user to analyze the performance of the client in each of the components and derive an estimate of overall safety and efficiency. Work is underway presently to extend the RoboCane® model to large-scale travel tasks. By adding other mobility characteristics of the client (such as veering tendency) and the environment (such as the presence and detectability of path boundaries) to the preview of the immediate vicinity of the traveler already provided by RoboCane®, it should be possible to model a simulated traveler moving through a simulated planned environment. This offers the possibility of evaluating the safety of an area during the preliminary stages of design.

Software with this capability has major significance for environmental designers, O&M specialists, advocates, and other professionals. It can help evaluate and test new designs required for the implementation of ADA and other regulations. The program could be used for both indoor and outdoor environments. It could also provide information about the optimum placement of landmarks to facilitate wayfinding for the visually impaired traveler. For example, the program could simulate tactile surface detection by individual subjects or from a database of consumers. By synthesizing the performance characteristics of actual subjects, the program can expand the limited exposures of live testing for each type of tactile surface and large-scale environment to 1060 simulated or synthetic trials in

one session's use of the computer model. This would result in a statistical error of ±2% and would allow the examination of low-level risks without imposing lengthy and potentially dangerous testing on the actual subjects. It also eliminates the necessity of obtaining human subjects approval for an experimental protocol.

Data synthesis and expansion could be used to examine issues such as: (1) the need or lack of need for detectable surface warnings in specific environments, (2) whether there is a difference in surface detectability for persons using canes compared to persons using dog guides, (3) alternatives to the application of detectable surface warnings, and (4) the effect of different cane lengths used by cane users. Based on the findings of such research, an analysis of discrimination of detectable warnings in large-scale environments could be developed. This simulation technique would provide great dividends in terms of cost-effectiveness and safety. It could also provide a very accurate database for evaluating accessibility standards.

This same method of data synthesis and expansion could be employed to evaluate the effects of environmental features such as curb ramps of different slopes and different types of detectable warnings, based on data of actual cane users. The Department of Veterans Affairs has funded a new follow up study (Blasch & De l'Aune, 1994) of the cane techniques taught and used by consumers with a visual impairment. The objective evaluation of these techniques will use the software package RoboCane® administered at the end of mobility training and every 6 months for 2–3 years. One outcome of the study will be the development of a database of cane techniques used by consumers. This will provide an accurate profile of the mobility techniques actually used by travelers with visual impairments as opposed to "the ideal technique" that travelers with visual impairments are taught. By combining the proposed software of large-scale environments and the data synthesis of cane techniques used by consumers, it will be possible to more precisely and objectively define hazardous areas. In addition, the results of data synthesis, generated with the software being developed, could be used to prepare and justify recommendations for scoping and technical provisions of accessibility considerations for individuals with a visual impairment.

SUMMARY

This chapter reviewed the basics of independent mobility by people with visual impairments, people who are ambulatory travelers in public and private environments. Levy first recommended the systematic use of a cane for people with visual impairments in 1872, but this method of cane use was not widely employed until Hoover began to elaborate and teach these techniques at the VA Hospital in 1946. In 1929, the Seeing Eye dog guide program began offering the first systematic mobility training to individuals with visual impairment. Public

acceptance of dog guides was slow, and commercial transportation in particular had to be coerced into making this accommodation. The public came to understand that a person with a visual impairment could travel independently with a dog guide and later a long cane. In 1930, the Lions Club International promoted the use of the white cane as a symbol of visual impairment, which has become recognized worldwide.

With the advent of the O&M profession, a great deal of the effort was placed on environmental problem solving by people with visual and other mobility disabilities. These instructions included how to use the built environment as it exists by developing new techniques for using the long cane. It was important to emphasize the fact that the cane is just a stick and only when coupled with the appropriate techniques and strategies does it become an effective mobility device to preview the environment. Systematic instruction provided by the O&M specialist has consolidated a host of environmental problem-solving strategies into a formal curriculum. In new or unique situations, the O&M specialist will evaluate the client's abilities and the possible solutions to the problem posed by the environment. The mobility specialist will then suggest or develop a new solution to the problem. This approach to teaching independent mobility has been so successful that it has also been used by the O&M specialist with many other "sighted" individuals, such as wheelchair users; individuals with head trauma, learning disabilities, mental retardation, and gait abnormalities; and individuals with multiple impairments.

The concept of barrier-free environments is not new. The Perkins School for the Blind demonstrated the value of a planned environment as early as 1913. The study of accessibility has focused predominantly on barriers to movement and to the use of buildings, equipment, and landscape. There were ANSI standards on accessibility as early as 1959. The design of public or private areas is, for the most part, for people without visual impairments, and therefore is intended to be pleasing to observe. The movement of people in these areas is aided by signage, traffic signals, and landmarks. Landscaping is often used in this manner. These designs can be obstacles or hazards to people with visual impairments. Obstacles are an obstruction that can be detected and negotiated with standard long-cane techniques, whereas hazards cannot be detected or negotiated with standard techniques.

The efficacy of various mobility techniques, or their modifications, is determined generally by the mobility coverage provided to the visually impaired traveler. Mobility coverage is often treated as a single construct relating to the detection of objects and drop-offs in one's path of travel and as such may be thought of as a single dichotomous variable. Such a conceptualization of mobility coverage, and specifically the cane, does not recognize the various functions of the cane as a tool to preview the area in which one travels, nor does it allow comparisons of the effect of techniques in relation to those functions.

It should be noted here that electronic devices have been developed to aid

people with visual impairments in negotiating objects in the environment. These devices, referred to as ETAs, provide different areas of detection than the long cane and, as such, should be considered as ancillary to the long cane. The combination of a long cane and an ETA can provide 100% mobility coverage using standard cane techniques. Neither device is able to provide this level of coverage alone. ETAs are currently not in widespread use.

A computer-modeling program has been developed that can simulate the ability of people with visual impairment in detecting different obstacles or hazards placed in their path. This system, called RoboCane®, can assist in evaluating an environment without having to put the actual person at risk. This computer simulation uses mathematical methods to ensure, with 95% statistical accuracy, that an environment can reasonably accommodate a person with a visual impairment. The computer simulation has been validated using human performance-measuring techniques of video-based biomechanical analysis. Until the analysis of the cane techniques provided by RoboCane®, the prevailing opinion, according to Hoover (1946), was that "by using the technique described …, it is impossible to step unexpectedly off curbs or into holes, to wander onto the grass, or bump into any obstacle which protrudes from the ground upward." Because of this belief, the use of an ETA has been viewed as a supplement to the long cane. The information for the ETA was considered redundant (based on Hoover's concept of detection) with the exception of detecting overhangs.

In an effort to facilitate more objective analysis and provide a more prescriptive approach to mobility coverage, Blasch et al. (1996) specified three factors of mobility coverage. They identified these functions as object, surface, and foot placement preview. The discussion in this chapter has further specified these functions as either dichotomous or continuous variables and has suggested direct and indirect measures. These measures and specific definitions allow the O&M specialist and other professionals to be more objective in the evaluation, prescription, and research of O&M techniques, training, and environmental design. The ultimate benefactor is the individual in need of precise and individualized orientation and mobility techniques and devices.

The computer-simulation methods of RoboCane® are being expanded to allow evaluation of such issues as the appropriate need and placement for detectable surface warnings in a specific environment, whether or not there is a difference in surface detectability for persons using canes as compared to persons using dog guides, and the effect of different cane lengths in different environments. The same methods of data synthesis and expansion used in RoboCane® could be employed to evaluate the effects of other environmental features, such as curb ramps of varying slopes.

As research in these areas continues to be funded by the Department of Veterans Affairs, the database of actual cane users is being expanded. The software being developed in parallel to this research will provide an even more accurate profile of mobility techniques used by actual travelers. By combining the

proposed software of large-scale environments and the data synthesis of cane techniques, it would be possible to more precisely and objectively define hazardous areas.

The overall goal of this chapter has been to introduce mobility accessibility in terms other than for a wheelchair and to describe some of the basic concepts of orientation and mobility techniques for individuals with visual impairments. Computer-based models are now available to simulate travel and object detection by persons with visual impairments. These computer models allow for the evaluation of plans while still in the early stage of design. If architects, designers, and planners become more aware of the different needs of visually impaired individuals, it may result in more "friendly" environments rather than just meeting ADA or other codes.

REFERENCES

Armstrong, J. (1972). *An independent evaluation of the Kay Binaural Sensor*. Nottingham, England: University of Nottingham.

Banja, J. D. (1994). Risk determination in orientation and mobility services: Ethical and professional issues. *Journal of Visual Impairment and Blindness, 88*(5), 401–409.

Bednar, M. J. (1977). *Barrier-free environments*. Stroudsburg, PA: Dowden, Hutchinson and Ross.

Blasch, B. B., & De l'Aune, W. R. (1992). A computer profile of mobility coverage and a safety index. *Journal of Visual Impairment and Blindness, 86*(6), 249–254.

Blasch, B., & De l'Aune, W. (1994). RoboCane®: A software model of cane coverage and resulting safety. In *Visions in mobility: Proceedings of the International Mobility Conference 7* (pp. 299–305). Melbourne, Australia: Royal Guide Dogs Associations of Australia.

Blasch, B., & Hiatt, L. (1983). *Orientation and wayfinding*. Washington, DC: Architectural and Barriers Compliance Board.

Blasch, B., & Stuckey, K. (1995). Accessibility and mobility of persons who are visually impaired: A historical analysis. *Journal of Visual Impairment and Blindness, 89*(5), 417–422.

Blasch, B., Long, R., & Griffin-Shirley, N. (1989). Results of a national survey of electronic travel aid use. *Journal of Visual Impairment and Blindness, 83*(9), 449–453.

Blasch, K., De l'Aune, W., & Blasch, B. (1994). *RoboCane®, the manual*. Lilbrun, GA: BEAR Consultants.

Blasch, B., LaGrow, S., & De l'Aune, W. (1996). Three aspects of coverage provided by the long cane: Obstacle, surface and foot placement preview. *Journal of Visual Impairment and Blindness, 90*, 295–301.

Blasch, B., Wiener, W., & Welsh, R. (Eds.). (1997). *Foundations of orientation and mobility* (2nd ed.). New York: American Foundation for the Blind Press.

Bledsoe, C. W. (1980). Originators of orientation and mobility training. In B. Blasch, W. Wiener, & R. L. Welsh (Eds.), *Foundations in orientation and mobility* (pp. 580–623). American Foundation for the Blind.

Dawson, M. Reiter, F., Sarkodie-Gyan, Provinciali, T., & Hesse, S. (1996). Gait initiation, development of a measurement system for use in a clinical environment. *Biomedical Technology and Biomedical Engineering, 41*(2–8), 213–217.

Dodds, A. G., Carter, D. D. C., & Howorth, C. L. (1983). Improving objective measures of mobility. *Journal of Visual Impairment and Blindness, 77*, 438–442.

Farmer, L. W. (1980). Mobility devices. In R. L. Welsh & B. B. Blasch (Eds.), *Foundations of orientation and mobility* (pp. 357–412). New York: American Foundation for the Blind.

Hill, E., & Ponder, P. (1976). *Orientation and mobility techniques: A guide for the practitioner*. New York: American Foundation for the Blind.

Hoover, R. E. (1946). Foot travel without sight. *Outlook for the Blind and the Teachers Forum, 40* 244-251.

Jacobson, W. H. (1993). *The art and science of teaching orientation and mobility to persons with visual impairments*. New York: American Foundation for the Blind.

Koestler, F. A. (1976). *The unseen minority*. New York: McKay.

Krigman, A. (1967). *A mathematical model of blind mobility* (DSR Rep. 70249-2 Eng. Proj. Lab.). Cambridge, MA: MIT Department of Mechanical Engineering.

LaGrow, S. J., & Weessies, M. J. (1994). *Orientation & mobility: Techniques for independence*. Palmerston North, New Zealand: Dunmore Press Limited.

Levy, W. H. (1949). On the blind walking alone, and of guides. *Outlook for the Blind and the Teachers Forum, 43*, 106-110. (Originally published 1872)

Mann, R. W. (1974). Technology and human rehabilitation: Prostheses for sensory rehabilitation and/or sensory substitution. In *Advances in biomedical engineering* (Vol. 4). New York: Academic Press.

Martin, P. (1991). *WE SERVE: A history of the Lions Clubs*. Washington, DC: Regnery Gateway.

Passini, R. (1986). Visual impairment and mobility: Some research and design considerations. In J. Wineman, R. Barnes, & C. Zimring (Eds.), *The costs of not knowing: The proceedings of the Seventeenth Annual Conference of the Environmental Design Research Association* (pp. 225-230). Washington, DC: EDRA.

Pavlos, E., Sanford, J., & Steinfeld, E. (1985, October). *Detectable tactile surface treatments*. Unpublished final report to the Architectural and Transportation Barriers Compliance Board.

Sanford, J. (1985). Designing for orientation and safety. In National Institute of Building Sciences (Ed.), *The Proceedings of the International Conference on Building Use and Safety Technology* (pp. 54-59). Washington, DC: NIBS.

Sanford, J., & Steinfeld, E. (1987). Designing for orientation and safety. In *Proceedings of the Annual Research Conference of the AIA/ACSA Council on Architectural Research*. Boston, MA.

Steinfeld, E., Duncan, J., & Cardell, P. (1977). Towards a responsive environment: The psychosocial effects of inaccessibility. In M. J. Bednar (Ed.), *Barrier-free environments* (pp. 7-16). Stroudsburg, PA: Dowden, Hutchinson and Ross.

Steinfeld, E., Richmond, G., & Sanford, J. (1986). Detectable tactile surface treatments. In J. Wineman, R. Barnes, & C. Zimring (Eds.), *The Costs of Not Knowing. Proceedings of the Environmental Design Research Association*. Atlanta, GA.

Sturgis, R. C. (1913). The Perkins Institution and Massachusetts School for the Blind at Watertown, Massachusetts. *The Brickbuilder, an Architectural Monthly, 22*(7), 154-157.

Suterko, S. (1967, December). Long cane training: Its advantages and problems. In *Proceedings of the Conference for Mobility Trainers and Technologists* (pp. 13-18). Cambridge: Massachusetts Institute of Technology.

Templer, J., Zimring, C., & Blasch, B. (1989). Visually impaired people—Design for safety, information and orientation. In J. A. Wilkes & R. T. Packard (Eds.), *Encyclopedia of Architecture: Design, Engineering, and Construction*, Vol. 4. New York: Wiley.

Uslan, M. M. (1978). Cane technique: Modifying the touch technique for full path coverage. *Journal of Visual Impairment and Blindness, 72*, 10-14.

Uslan, M. M., & Manning, P. (1974). A graphic analysis of touch technique safety. *American Foundation for the Blind Research Bulletin, 28*, 175-190.

Wardell, K. T. (1980). Environmental modifications. In R. L. Welsh & B. B. Blasch (Eds.), *Foundations of orientation and mobility* (pp. 477-525). New York: American Foundation for the Blind.

Welsh, R., & Blasch, B. (Eds.). (1980). *Foundations of orientation and mobility*. New York: American Foundation for the Blind.

14

Evaluating Accessibility through Computer-Aided Design

A Software Model

Margaret Haley and Julio Bermudez

INTRODUCTION

This chapter speculates on the use of rule-based software to analyze Computer-aided design (CAD) representations of buildings for physical accessibility. The possibility of creating such a model depends on the development of integrated databases to operate with CAD software, including three-dimensional representations. This would allow for "interference checking" between building code requirements and actual physical dimensions and would also allow checking between a human model and a building model for movement clearances.

We propose two analogies in the development of this model. One analogy is that of a virtual building inspector. The inspector analyzes the digital building

Margaret Haley • Department of Computing and Communications, University of Washington Educational Outreach, Seattle, Washington 98105. **Julio Bermudez** • Graduate School of Architecture, University of Utah, Salt Lake City, Utah 84112.

Enabling Environments: Measuring the Impact of Environment on Disability and Rehabilitation, edited by Edward Steinfeld and G. Scott Danford. Kluwer Academic/Plenum Publishers. 1999.

by performing a "spell-check" to determine if the building meets code, an analogy similar to the use of "spell-checks" in word-processing software. A theoretical model for checking the accessibility code compliance of a digital building would:

- Transfer and interpret information from a limited number of sources to a larger number of users
- Perform a rote comparison of defined clearances required for accessibility by comparing the databases of pertinent building codes and of the digital building and product specifications to identify apparent discrepancies
- Assist professionals to perform continuous accessibility code analysis during the development of design and construction documents
- Reduce time and errors in the performance of repetitive analysis of specific criteria in multiple locations
- Archive the expertise of a limited number of experts in the field of accessibility code analysis
- Provide a means of training by listing the results of the accessibility analysis and referencing video clips to illustrate concepts for junior members of staff and students in educational applications
- Provide an instrument to test consistency in results and reliability in research applications

The second analogy is one of a virtual user who experiences the digital building through programmed animation of a mobility impairment. In this case the model would work as a "grammar check" by running a performance check of the accessibility of the building to determine if it meets the intent of the building code. The theoretical model for checking the accessible experience of a digital building would:

- Simulate the movements of a person with a disability who navigates through a digital building and identifies areas of physical conflict
- Illustrate the experience of physical barriers to a designer who may not be aware of such movement limitations by generating an animation of movement restrictions
- Allow more freedom and creativity in solving accessibility conflicts by providing feedback from a user with a disability early in the design process
- Archive the experience and expertise of research and persons with disabilities in the movement database of the accessibility analysis
- Provide a means of accessibility training by demonstrating the results for junior members of staff and students in educational applications
- Provide an instrument to test consistency in results and reliability in research applications

RATIONALE

State and federal building codes are used by architects to design public buildings for accessibility for person with disabilities. These codes are difficult to understand because the information contained within them is somewhat cryptic and is organized in a complex manner. The comparison of specific criteria within local, state, and national building codes can sometimes produce contradictory results. In addition, the building codes themselves do not provide a means of interaction and feedback about code requirements. As a result, the process of discovering the real meaning of accessible design usually occurs just prior to construction during the permit review process, with little time or opportunity to change the fundamental layouts of large-scale projects.

As an example, a clearance of 32 in. (ANSI A117-1, 1992) is required between the face of the door and the stop of the door frame. One might incorrectly establish a door width of 32 in. to satisfy this requirement. However, the thickness of the door protrudes into the clear width of the frame when standard hinges are used. The actual minimum door width is then dependent on the sum of the width of the frame stops, the door thickness, and the 32-in. clear width requirement.

Another complexity in the use and application of the building codes is the implicit inference of accessibility requirements. For example, the range of reach for customers and salespeople at cash register locations is not specified within ANSI A117-1. With experience, the designer could imply this information from other criteria established for the use of telephones and automatic bank teller machines (ATM), or the designer may mistakenly overlook this need for access at points of sale since it is not explicitly stated as a requirement within the building codes.

The interpretation and the resolution of accessibility conflicts within the building codes can be a constant challenge, even to the seasoned architectural practitioner. If rule-based software and databases were used to index and analyze building codes, it could help the designer understand and apply this complex body of knowledge by performing the following functions:

- Organize the building code into easily retrievable references
- Infer implied criteria to similar areas of usage
- Detect and isolate contradictory building code requirements
- Retrieve informed interpretations of specific building code requirements by using media such as video clips and other digitized building examples referenced to the building code database
- Illustrate new applications of code criteria in specific designs to facilitate building permit review and approval
- Reduce the time necessary to perform repetitive analysis of specific accessibility criteria during the design process

This software model could also be used to facilitate research in the fields of

universal design and of occupational therapy and rehabilitation. A digital simulation could be "constructed" and tested internationally by multiple researchers via the Internet in lieu of constructing a local physical mockup and testing it with local subjects and research. This testing could be used to find conflicts within building codes of participating countries with the intention of developing international standards. In addition, this software model may be used as an instrument to test the validity of empirical data.

Another benefit of this software model is the ongoing analysis of the project during the design process. Its friendly critique would be educational in the best sense of the word. The feedback from the virtual inspector and the simulation of a building visitor or virtual user would improve the learning curve of understanding and applying accessible design concepts not only for the professional but also for design students. For example, this software could be used by an architecture student to learn the concepts of accessible design as they learn to use a CAD system. In this sense, the use of a simulated experiential method for testing the performance of building accessibility can be employed to break away from existing paradigms in architectural design that propagate physical barriers in new designs.

In short, the building codes for accessibility require a certain level of expertise and experience to infer and apply the correct interpretations. This proposed software model would use rules of inference to identify areas of accessibility conflicts.

PRECEDENTS FOR RULE-BASED SYSTEMS IN CAD

Computers have been traditionally used to store and retrieve expertise in the form of numerical and algorithmic analysis (e.g., statistical analysis and database sorting). The development of rule-based systems adds a new type of analytical availability in computer-based systems, that of inferred analysis (Ford, 1991, pp. 3–13). Inferred analysis can be applied to parallel the decision-making process of experts in a profession or research, who through experience and knowledge use rules of thumb to sort through the complex factors involved in complex problem solving.

In the context of this chapter, the model would use rules of inference derived from the expertise of persons with mobility impairments as well as the practical experience of architectural designers, building permit inspectors, and researchers in occupational therapy and rehabilitation to vastly improve the design process for accessible environments. By the use of knowledge bases (databases of requirements for accessibility), the rule-based system can assimilate and analyze information and disseminate this expertise to multiple users. The application of rule-based systems is meeting with increasing success in diverse fields such as medicine, architecture, and information management systems.

In architecture, several authors and researchers see the application of rule-based systems as a logical evolution of the integration of computer technology and the complex process of designing a building. Concrete examples of the vision of an enhanced design process are already available. For instance, a prototype rule-based system was developed to interrogate the database of a commercial CAD system to check conformance with building codes (Coyne, Rosenman, Radford, & Gero, 1991). Another example of a rule-based system integrated with CAD software is a project called ICODES (Pohl & Myers, 1993). In this system, the designer develops the building and artificial "agents" simultaneously perform analysis in specific areas of expertise (e.g., cost, acoustics, and thermal performance). The agents report conclusions to the designer that have been artificially coordinated and compiled by the rule-based system. The designer can then determine whether or not to implement any of these conclusions or can interact with the rule-based system to have it explain its line of reasoning.

Review of the literature and research available indicates that the application of rule-based systems to CAD is leading computer programmers to develop "intelligent" CAD systems that assist the designer with the complex process of building design. These precedents establish the rationale behind our attempt at developing a theoretical model of a rule-based system to analyze CAD environments for accessibility.

SIMULATION OF A BUILDING VISITOR WITHIN A DIGITAL BUILDING

We believe that a rule-based system designed to check accessibility should not be limited to the inference rules extracted from the building codes and expertise of professionals as described by the "virtual inspector" analogy. The virtual inspector may not find an exact match to the definitions of accessible design contained within the building code. One also needs to have a simulation of a building visitor or user with disabilities who experiences the digital building to test if it meets the intent of the building code.

The perceptions and movements of this virtual individual could be simulated by means of inference rules based on research for a specific type of mobility impairment. The animation of this visitor could assist in resolving and identifying design issues that arise from accessibility movement conflicts. This simulation could be modeled by utilizing both commercial software packages and research on the limitations of movement for a specific disability to animate the visitor in a three-dimensional CAD environment.

Despite the relevance of the concept of a virtual visitor or user, the idea is a new application of a rule-based system to CAD. In support of this observation, Steinfeld (1991) concludes that:

> Going back to the early stages of CAD, there has been a strong emphasis on creating artificial designers, but no one has yet considered the artificial user. Perhaps this neglect is consistent with the general trend in the profession to ignore the perspective of the user.... [T]he role of the artificial user would be to answer the design team's questions, demonstrate [the artificial user's] response to alternative designs, and interrogate the designer about aspects of the design. Various models could be developed to represent many different kinds of people.... [D]esigners are more likely to understand a human response or need if they are exposed to it from the user's perspective. (p. 337)

We think that the incorporation of a simulation of a disability will strengthen the functionality of a rule-based system for testing building accessibility.

NEED FOR A NEW GENERATION OF CAD SYSTEMS

The great majority of currently available CAD software generates architectural representations as two- or three-dimensional geometric models (i.e., lines, polygons, or points) but does not recognize the solidity of three-dimensional objects or acknowledge material properties of the building parts. For example, two parallel lines drawn in the software program AutoCAD represent a wall as a geometric model, but it does not yet represent a solid model constructed of specific materials.

In addition, available CAD software is not integrated with electronic media to access information about historical precedents, technical requirements and specifications, or new developments within the field. As a result, the contemporary CAD user works alone at a personal computer without direct access to the living database of historical and current design information, similar to the draftsman of years prior. Considering the power of electronic media to exchange information, it is clear that we are underutilizing current technology. CAD software needs to do much more than replicate the analogy of the architectural apprentice sitting alone at a drafting table with a blank piece of paper.

The next generation of CAD systems should offer the user design support, critiques from user groups, help menus, and the means to selectively access relevant information and prototypes through access to databases and search engines via the Internet. The designer would then be interacting with an instructional and informative CAD workstation utilizing networks, multimedia interfaces, animations, and feedback from experts and potential visitors, and people with disabilities.

A THEORETICAL SOFTWARE PROTOTYPE TO TEST ACCESSIBLE DESIGN

We feel that the best first step to develop a software model that analyzes the accessibility of CAD environments is to clarify the intent of the rule-based system.

In this sense, from the very beginning, it was clear to us that a simple metaphor was needed to guide the initial design of the model.

While researching rule-based systems design, we concluded that there was a strong and usable analogy in the building blocks of the English language (words, sentences, and paragraphs) and the rules for the use of that language (spelling, grammar, and synonyms). This analogy is comparable to the structural elements of a building (objects, space, and circulation) and the rules for compliance with building codes (literal interpretations, structural organization, and related precedents). The similarities between the written language and the language of architectural design conceptually and practically supported our utilization of word-processing functions (e.g., spell-, grammar-, and thesaurus-check) as an analogy to review the code compliance of CAD environments (Bermudez & Haley, 1994). Figure 14.1 illustrates the structure of the application of a rule-based system to analyze building accessibility in CAD.

The Virtual Inspector Knowledge Base (VIKB) is composed of facts and rules extracted from civil rights law, local and national building codes, architectural precedents, etc., regarding limitations placed on the built environment for accessibility. The VIKB is an objective and building-independent database that

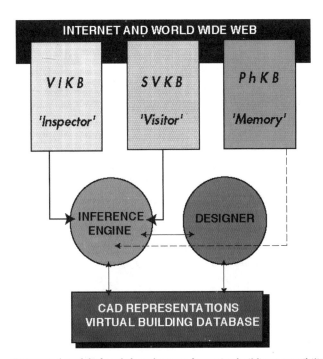

Figure 14.1. Conceptual model of a rule-based system for testing building accessibility. See text for abbreviations.

allows periodical updates to its criteria and is used for its "spell-check" and "thesaurus" functions as its main dictionary of reference. This information allows the rule-based system to act as a "virtual inspector" and compare the digital building against existing legal prototypes to determine matching or lack of a match for accessibility. If a direct match was not found, "synonym" or another building example would be offered as a possible model for resolution.

The Simulated Visitor Knowledge Base (SVKB) is composed of research results and criteria from established standards such as ADAAG (Americans with Disabilities Act Accessibility Guidelines), experience from experts within the field, surveys, ongoing research, and so on. This information would be used to generate simulations of the movement limitations experienced by a person with disabilities and would be used by the rule-based system for its "grammar-check" function. By using this knowledge base, the rule-based system would simulate and embody a "virtual visitor" who could experience the digital building to detect structural conflicts that require resolution (e.g., lack of access to a public shower due to a floor curb). This analysis of objects and their location is similar in concept to the editing of text for grammar errors and would help the designer determine if the digital building meets the intent of the building accessibility code. If a conflict is found, an animation of the movement conflict would be created to illustrate the problem.

The Phenomenal Knowledge Base (PhKB) is composed of inferred knowledge gained through the application of the rule-based system and stored in a custom dictionary. The "virtual inspector" and/or the simulated visitor who analyze the digital building may (1) discover and record new findings about accessibility issues, (2) include detection of discrepancies within the existing building code, and/or (3) add new applications of the building code which have not yet been documented. The memory of this interface is building dependent and could be kept, modified, or erased based on the needs of the designer using the system. The PhKB can be seen as a learned interaction imprinted from the memory of experiencing a particular building for accessibility. This concept is similar to the custom user dictionary in spell-check software. The rule-based system would be able to utilize this custom dictionary (PhKB) along with the other dictionaries (VIKB, SVKB) to analyze and support design activities.

The design of the knowledge bases could follow a decentralized (kept in the local computer network or machine), centralized (kept in a specific location and accessible via internet), or a hybrid model. In all cases these databases would be networked, interactive, and allowed to feed to and from each other. Such a networked software system would provide designers with further communication opportunities and thus overcome the isolation of one person using a CAD software program.

The Inference Engine is the reasoning component of the rule-based system that interfaces with all the knowledge bases, CAD databases, and the designer. The strategies used in programming the inference engine include the use of rules

of inference derived from expertise in the field of building accessibility and dealing with synchronic types of issues (i.e., widths of corridors, heights of objects). In addition, the three-dimensional modeling of the movements of the simulation of a disability would greatly assist the programming of the rules of inference dealing with the diachronic (i.e., phenomenological) analysis of the digital building. For example, an animation of a set of standard paths of travel through CAD representations could be established (e.g., from a building lobby to a public bathroom) to determine the scope of the accessibility test. The objects in the path of travel of the simulated visitor have defined areas of influence as attributes to detect any interference with the moving simulation. The detection of overlapping areas of influence could begin to trigger the recognition of spatial conflicts between building objects (e.g., doorway entrances, drinking fountain clearances) and the simulated visitor moving along a predetermined path of travel.

The Graphic User Interface (GUI) can be achieved through a multimedia computer screen interface (Figure 14.2) that utilizes graphic icons (e.g., the international symbol for accessibility) and pop-up menus to identify commands. The rule-based system would then query the designer to determine the level of

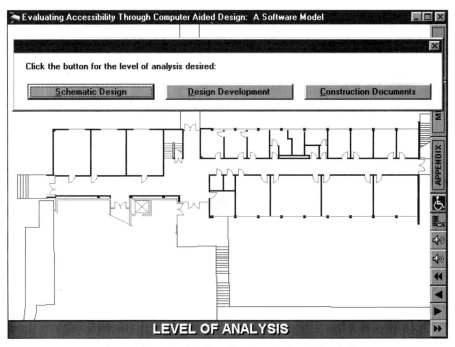

Figure 14.2. Graphic User Interface for level of analysis.

analysis, the scope of application, and the desired type of interface (Bermudez & Haley, 1994).

The rule-based system would then perform an analysis of the designated area (Figure 14.3) and present its conclusions in a summary list.

The designer could then activate referenced videos or animations that explain the relevant accessibility issues for each item on the summary list (Figure 14.4). There would also be hyperlinks to other relevant areas of information on the World Wide Web accessible through the Internet.

Once the designer has been presented with the results of the analysis, the reasoning of the rule-based system can be examined. The designer could identify the assumptions made in the rules of inference from any one or combination of the knowledge bases (VIKB, SVKB, and PhKB). The virtual user would assist the designer by illustrating the application and experience of these concepts and rules. The designer would thus participate in an interactive learning process with the assistance of the rule-based system. This can serve to improve the quality and understanding of the accessible environment during the design process.

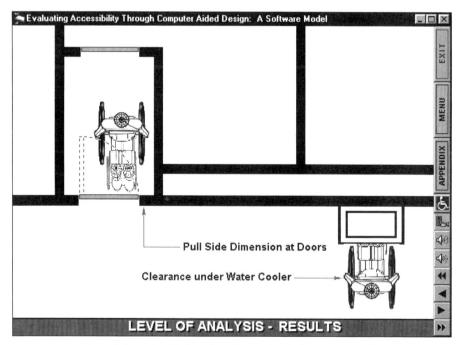

Figure 14.3. Graphic User Interface for level of analysis—results.

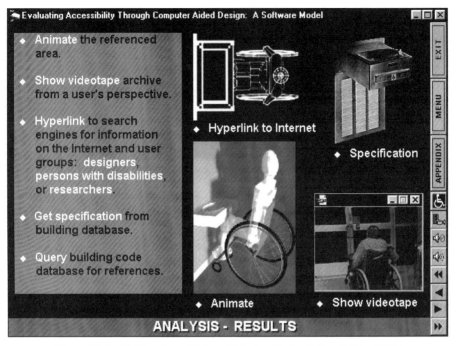

Figure 14.4. Multimedia and Internet interface for level of analysis—results.

PARTING WORDS

The Americans with Disabilities Act requires public building access for persons with disabilities in the United States. Dr. Walter Greenleaf of Greenleaf Medical Systems (1994) points out that most of us at some time in our life will at least temporarily experience some type of disability through illness, accident, or advanced age. Design solutions that create more accessible buildings will accommodate people who need access to buildings throughout their life and throughout their changing states of physical health.

The application of a rule-based system to analyze accessibility in buildings during the design stage can challenge the preconceived ideas of architectural design solutions and spark creativity by illuminating the nature of the design problem. The market for this type of rule-based system application is not necessarily restricted to the architectural profession. An accessibility analysis of a building or project can be used as an instrument by any of the following professionals to achieve alternate goals: occupational therapists to develop and test the impact of the environment on the progress of patients recovery, industrial medicine professionals to determine changes to the workplace to accommo-

date persons with disabilities, insurance underwriters to determine strategies to allow persons with disabilities to function within the workplace.

Beyond testing the issues of wheelchair accessibility, other forms of simulations to test accessibility for others (e.g., children, sight impairments) could be eventually incorporated into this theoretical model.

REFERENCES

ANSI A117-1 (1992). *American National Standards Institute accessible and usable buildings and facilities.* Falls Church, VA: Council of American Building Officials.

Bermudez, J., & Haley, M. (1994). Interfacing CAD representations and a knowledge-based system: A case study. In J. Pohl (Ed.). *Pre-conference Proceedings of Advances in Computer-Based Building Design Systems; 7th International Conference on Systems Research, Informatics & Cybernetics* (pp. 37-46). Baden-Baden, Germany: International Institute for Advanced Study in Systems Research and Cybernetics.

Coyne, R. D., Rosenman, M. A., Radford, A. D., & Gero, J. S. (1991). *Innovation and creativity in knowledge-based CAD: Expert systems in computer-aided design.* Amsterdam: Elsevier.

Ford, N. (1991). *Expert systems and artificial intelligence, an information manager's guide.* London: Library Association.

Greenleaf, W. (1994). Applications of Virtual Reality Technology to Therapy and Rehabilitation; Virtual Reality and Persons with Disabilities Conference, June 8-10, 1994, San Francisco, CA: Organized by the Center on Disabilities, California State University at Northridge San Francisco, CA.

Pohl, J., & Myers, L. (1993). A distributed cooperative model for architectural design. In G. Carrara and Y. Kalay (Eds.) *Symposium on Knowledge-Based Systems for Architectural Design; Knowledge-Based Computer Aided Architectural Design* (pp. 205-242). New York: Elsevier Science.

Steinfeld, E. (1991). Toward artificial users. In Y. Kalay (Ed.), *Principles of computer-aided design: Evaluating and predicting design performance* (pp. 337-338). New York: Wiley.

BIBLIOGRAPHY

Carrara, G., Kalay, Y. E., & Novembri, G. (1991). Computational framework for supporting creative architectural design. In Y. Kalay (Ed.), *Principles of computer-aided design: Evaluating and predicting design performance* (pp. 28-31). New York: Wiley.

Chan, C. S. (1990). Cognitive processes in architectural design problem solving. *Design Studies, 11*(2), 60-80.

Coyne, R. D., Rosenman, M. A., Radford, A. D., Balachandran, M., & Gero, J. S. (1989). *Knowledge-based design systems.* New York: Addison-Wesley.

Edmunds, R. A. (1988). *The Prentice-Hall guide to expert systems.* Englewood Cliffs, NJ: Prentice-Hall.

Mitchell, W. (1992). *The logic of architecture. Design, computation, and cognition.* Cambridge, MA: MIT Press.

Oxman, R. (1990). Prior knowledge in design: A dynamic knowledge-based model of design and creativity. *Design Studies, 11*(1), 17-28.

Schön, D. (1983). *The reflective practitioner.* New York: Basic Books.

Wilkie, G. (1993). *Object-oriented software engineering, the professional developer's guide.* New York: Addison-Wesley.

15

Wayfinding Performance by People with Visual Impairments

Gail Finkel

INTRODUCTION

People cannot be viewed in isolation of the environment in which they exist, and the environment must be seen in context with the people in it (Ittleson, 1973). Ability and the built environment are interconnected. Therefore, the effects of disability and the design of the environment are not separate issues.

Disability is defined as a limitation that substantially impedes human activities. The World Health Organization (1980) defined disability as a lack of ability within the range considered "normal" for a human being. The use of the word "normal" overlaid a negative connotation onto disability and implied that people with disabilities were inadequate or not normal. This is a logical extension of the traditional rehabilitation and medical model of disability that looks at the individual as having a "problem," which the professionals try to rectify. There are a number of defects with this approach.

First, the "normal" or perfect body type or ability is more unusual than this traditional view leads one to believe. With 43 million people in the United States and over 3 million people in Canada having permanent disabilities, clearly a large

Gail Finkel • Design Consulting & Research, Winnipeg, Manitoba, Canada R3L 0H3.

Enabling Environments: Measuring the Impact of Environment on Disability and Rehabilitation, edited by Edward Steinfeld and G. Scott Danford. Kluwer Academic/Plenum Publishers. 1999.

number of people deviate from this "normal" image. In addition to the 15% of the population having permanent disabilities, there are probably a like percentage of people in each country with temporary disabilities that are effected by environmental barriers. This includes conditions that result from recent surgery, broken bones, or arthritic joints. Furthermore, with the population in the United States and Canada aging, these numbers will be increasing dramatically in the near future. Therefore, the numbers of people fitting the definition of "normal" are not sufficient to set standards for the entire population.

Second, the independent-living movement promoted by people with disabilities has been working to alter traditional views by advocating a sociopolitical perspective of disability (Hahn, 1984). It charges that the responsibility for disability evolves from the environmental and social context, rather than from the individual. Although it is generally accepted that environments can handicap people with disabilities (ICIDH International Network, 1991), the use of the term "disability" has, in itself, far-reaching political and social implications. Disability, or not having ability, is a result of the handicapping conditions caused by others (DeJong, 1979). People using wheelchairs have many abilities, which are more readily exhibited when accessible environments allow them to maximize their potential. Limb weakness does not have to define the person, but in reality does so only through a lack of accessible alternatives. This perspective implies that architecture has a significant role to play in breaking down the barriers that limit individuals' ability to integrate and participate in community life.

Since disability does not create a homogeneous group, the issues raised are complex and difficult to clearly define. In terms of removing barriers in the built environment, the current cautious economic situation must be considered in tandem with ethical, legal, and moral considerations. To provide appropriate standards that allow most people access to community life, there need to be exhaustive discussions and research into what are disabling situations, acceptable methodologies, and the ethical questions regarding what type and level of disabilities to consider.

PURPOSE

With these issues as background, research was conducted to examine wayfinding in the built environment by people with visual impairments. Wayfinding is the process of moving from one location to another predetermined location and creates a foundation for information and behavioral responses within the built environment. Lynch (1973) stated, "[I]t is like a body of beliefs, or a set of social customs; it is an organizer of facts and possibilities" (p. 302). Accessibility for people with disabilities to and within buildings fundamentally includes successful wayfinding. Architecture must be seen as more than just the physical

structure and must include the functions of place, such as social and economic activities, with wayfinding communication as the facilitator of these activities.

Barrier-free design has tended to focus on the physical aspects of design, such as ramps and wider doorways. Although these dimensional requirements are critical to defining accessibility, it is not the only issue to be considered. This research into wayfinding brings attention to two other points of reference. These are the functional and psychological implications of design that are necessary to create truly accessible environments.

Functional accessibility refers to pragmatic issues, such as when a person with a visual impairment has difficulty locating the entrance to a particular building. In this situation, it is of little importance to that individual whether or not the door is wide enough. Accessible design and wayfinding information for people with visual impairments must go beyond a concern for the removal of physical barriers to include the removal of functional barriers (Smith-Kettlewell Eye Research Institute, 1991).

Questions of perception concerning accessibility define the psychological aspects. Accessibility becomes a reality only when people believe that the environment does not pose barriers. For instance, individuals with cognitive disabilities or who are frail may fear they will become disoriented in buildings with complex configurations, so they will avoid them, and those buildings become essentially inaccessible.

The decision to focus this study on people with visual impairments is the result of the little research and few design guidelines that attend to meeting their access needs. Specifically, little research has been done on the wayfinding of people with visual impairments in the built environment (Passini, 1984; Steinfeld, 1980). Early work that was done questioned whether or not people with visual impairments were capable of successful wayfinding or were able to understand spatial configuration (Casey, 1978; Cleaves & Royal, 1979; Fletcher, 1980).

Finding those approaches inappropriate, this research examines how effectively the built environment communicates wayfinding information to people with visual impairments, rather than focusing on their ability to adapt to design. This changes the question from one of individual responsibility for disabling conditions to one of environmental and social conditions that create disabling situations (Sands & Dunlap, 1991).

When the design of wayfinding information includes the needs of people with partial or no sight, the design will provide better information for all people (Canadian National Institute for the Blind, 1989; Sanford & Steinfeld, 1987). Understanding which cues are helpful to people with visual impairments will shift attention from designing just visual cues to include other sensory information. These other cues typically exist in the built environment but are not used by the design profession as an opportunity to provide more information. Cues can provide useful information for all navigators through an environment, whether

they have a visual impairment or not. The findings in this research could therefore be useful in defining universal design principles, which benefit all people.

Hypothesis

The initial research questions were: Are there differences in wayfinding ability between people with visual impairments and sighted people, and in what ways do these two groups differ in the relevant wayfinding information they use while navigating through public buildings? The research hypothesis was that, if a difference in the wayfinding ability between people with visual impairments and sighted people was identified, the deficiencies would be a result of architectural design factors. This point of departure focused on data that could then be applied to architectural solutions that enable, rather than limit, individuals' wayfinding abilities.

Objectives

There were four objectives. Objective one was to examine whether there was a difference in wayfinding ability between visually impaired and sighted people. The second objective was to determine which cues were used in wayfinding. Objective three was to examine what was understood of the overall configuration of a building after navigating through it. The fourth objective was to document the opinions of the participants on the accessibility of public buildings and useful wayfinding tools.

METHODOLOGY

The research design was based on work done by Passini and Proulx (1988), "Wayfinding Without Vision: An Experiment with Congenitally Totally Blind People." In that study there were 30 participants, 15 sighted and 15 congenitally blind who used white canes. With the addition of people who were assisted by guide dogs and people with low vision who required no mobility aids, our research study had a total of 60 participants. Both studies used the interior space of a complex building environment.

In the Passini and Proulx study there were three trials. The initial trial was a walk along a predetermined route that included two trips with the experimenter guiding the participant. On the third and last trip through, the participant led the experimenter. Our research employed only one preliminary guided walk. Both studies asked the participants to comment on the environment during the last walk through the route.

Passini and Proulx asked each subject to complete a cognitive mapping exercise to assess knowledge of the route. In this study, the mapping task was

replicated as a map reconstruction exercise. Both occurred immediately after the first task. In the last trial of the Passini and Proulx study, participants were asked four questions to test their understanding of the spatial configuration of the building just travelled. In this study, a structured interview elicited the participants' opinions and recommendations on accessibility and wayfinding design.

The study described here focused on the effect of mobility aids used by defining the subsamples by the orientation devices they used, such as white canes, guide dogs, or no device. There was an effort made to include people with visual impairments and the organizations that work with them in the planning stages of the project. As a result of this process, this research focused on issues important to people with visual impairments and emphasized documenting their opinions and experiences.

To summarize, the methodology in this study included three trials that collected both objective and subjective data. Test one was a journey along a predetermined route. The participants were led through the route once and then back to the starting point. This was immediately followed by the subjects leading the investigator through the route. When the participants led, they commented on what was familiar and assistive in making wayfinding decisions. Test two was a map-making exercise. The participants were asked to complete a tactile map of the route just travelled. Test three was an interview focusing on the experiences of people wayfinding through public buildings.

Subjects

Participants were identified by the mobility aids used during navigation rather than by age, sex, or onset of impairment. In terms of architectural implications, mobility aids are an important factor in wayfinding and understanding the surrounding environment. Therefore, to examine the interaction of the user who has a visual impairment with the architectural surroundings, groups were identified as people with low vision who use no mobility aids, people with white canes, people with guide dogs, and a control group of sighted people. All participants with visual impairments had 10% vision or less, the legal definition of blindness. Most previous research had used totally blind people with white canes. Less research has been done with people with low vision without aids, and no research has been done with people who use guide dogs.

There were a total of 60 participants, 15 in each of four subgroups. There were difficulties in obtaining a larger sample, due to timing and the size of the subgroups within the community. At the time this study was completed, there were approximately 24 people with guide dogs in this city. Another factor limiting sample size was that people with visual impairments who do not use mobility aids were difficult to identify because they do not generally use the services offered by organizations for people with visual impairments and do not necessarily identify themselves as visually impaired.

The participants were active individuals between the ages of 20-70, with a mean age range of 30-39. Selection of the participants with visual impairments occurred through the Canadian National Institute for the Blind, the Canadian Council for the Blind, and two consumer-run support groups for people with visual impairments. All participants were screened to ensure they were unfamiliar with the site used in this study and that they met the legal definition for blindness.

Site

The site chosen was the Medical School campus of the University of Manitoba, Winnipeg, Canada (Figure 15.1). This campus consists of a series of adjacent buildings built over many years (from the early 1900s to the 1980s) that are connected internally with entrances at slightly different levels. This site offered a variety of spatial experiences. Architectural components included several types of doors, corridors, stairways, and lobby spaces. The route included both grade and basement levels so that in only some locations were there views to the outside. Interior cues included various floor surfaces (from terrazzo to carpeting), several different types of signage, and other objects situated throughout the course. Other sensory cues included varying air temperature, smells, and sounds. These buildings are typical of many older complex institutional building configurations. It was the intention of this study to capture data in an actual setting that described common design issues, rather than in an artificial environment.

The predetermined course began at an entrance on the northwest corner of the site. The route continued on the main floor moving southeast through several connected buildings and required the participants to traverse stairs, ramps, and two lobby areas to an elevator that took them to the basement level. In the basement, the course was designed to have the participants return toward the northwest area of the site. The finish point was close to the start point, but one floor lower. The entire route was interior.

Procedure

The testing began when the investigator and participant arrived at the starting point, an entrance to the complex of buildings. Each participant was taken to the site individually. It took approximately 2 hours to complete the tests on site for each individual. The instructions specified that the participants would be guided to a destination, the finish point, and then back along the same route to the starting point (where they were presently standing). After this guided tour, they would then lead the way through the route.

The participants were allowed to ask questions about the surroundings while they were being guided. They were told that this experiment was not a test of their navigation skills, but rather an examination of the design features that

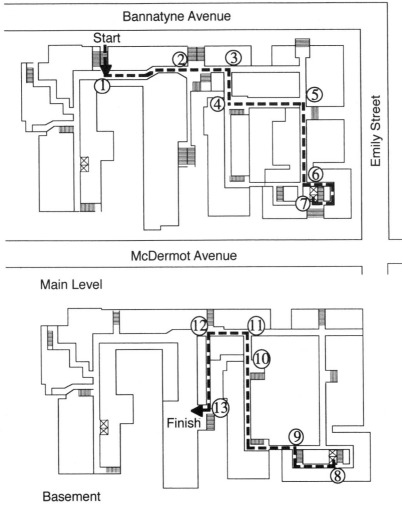

Figure 15.1. Site map with numbered decision points along the journey.

help or hinder wayfinding. They were also told that if they missed a turn, they would be told of their error and placed back on the route. Before the guided walk began, participants were encouraged to state their preferred method for being guided, which was used in all cases. The pace was set by the participant.

Immediately after the guided walk, each participant was asked to retrace the route without being guided. The start time was noted. While guiding themselves through the course, the participants were asked to explain why they were

making their particular decisions and what was familiar about the route as it was travelled. All comments were recorded. An error (a missed turn or wrong turn) was assessed after the participant had taken three steps off the predetermined route. At that point, they were informed of their error and directed onto the correct path. The place of each error was charted. Arriving at the destination, the finish time was noted.

As soon as the walk-through was completed, the participants were seated in the finish area and asked to complete a tactile map of the route. The purpose was to examine the participants' ability to understand the overall layout of the route. A 450 mm by 610 mm metal sheet was used as the base. Wood strips attached to a magnet were placed on the metal sheet to form the map. Wood strips were available in a variety of shapes, including rectangles representing the corridor, scaled stairs and ramps, a circle to represent the elevator, and triangles for the start and finish points. There were more pieces of each type than required to complete the map. It was assumed that the participants would have no experience in producing a map of this type. This proved to be accurate. There was no time limit.

To explore perceptions and beliefs about what makes wayfinding easier or more difficult, an interview was conducted immediately after the map-making exercise. There were a series of questions on the accessibility of the built environment starting with the buildings used in this study and then covering public buildings in general. Some questions focused on cues that are commonly used and suggestions for improving design. The questions were developed with the help of people with visual impairments and orientation and mobility instructors. There were questions on demographics, their visual impairment, mobility aids used, and their level and type of mobility training. There were open-ended and scaled questions. Open-ended questions were read to the participants and the answers noted by the investigator. The written answers were read back to the participants to ensure accuracy in recording. Scaled questions ranged from 1 to 5, with 1 signifying "not helpful at all" or "not accessible at all" and 5 representing "very helpful" or "very accessible." Interview questions were available in Braille, large print, and typical 10-point font. There was no time limit for the interview.

RESULTS

Analysis of data involved comparing the means of the subsamples with the one-way ANOVA test. Tests for significant differences between groups utilized the Scheffe F-test. Due to the small sample size, the level of significance was set at $p \leq .0051$, which is well below the conventional levels of .01 and .05 that are typically used.

In test one the participants with visual impairments took longer to complete the route than those who were sighted (Figure 15.2). The mean time for the entire sample was 8.2 minutes. The mean results per minute for the individual

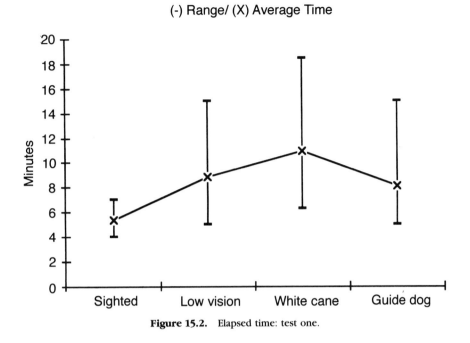

Figure 15.2. Elapsed time: test one.

groups were: sighted, 5.4; low vision, 8.9; participants with white canes, 11; participants using guide dogs, 8.

The relationship between the groups regarding the elapsed time to travel the predetermined course was not unexpected, but what was surprising was that the participants with low vision made virtually the same number of errors along the route as the sighted participants (Figure 15.3). Those who used mobility aids, white canes, and guide dogs made significantly more errors than those without aids. The mean number of errors of the entire sample was 2.9. The mean number of errors for the subgroups was: sighted, 1; low vision, 1.1; participants with white canes, 4.6; and participants using guide dogs, 4.7.

An examination of where the errors were made revealed a statistically significant difference at only 4 of the 13 decision points (Figure 15.4). A decision point was any place along the journey where the participants had to make a choice as to whether to continue straight or turn left or right. Where the most errors typically were made, there was only a visual reference cue with no redundancy of cues.

All participants used architectural cues predominantly (Figure 15.5). These cues included the placement of doors, windows, stairs, and elevators. They proved to be primary landmarks used to remember the route. Participants also used floor surface changes as landmarks. Changes in texture, color, pattern, and

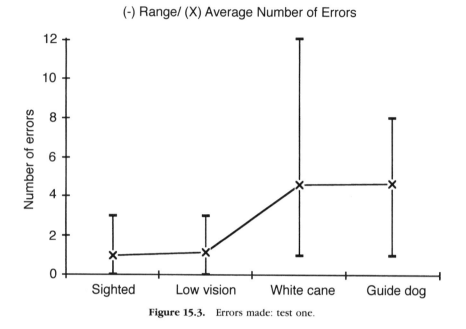

Figure 15.3. Errors made: test one.

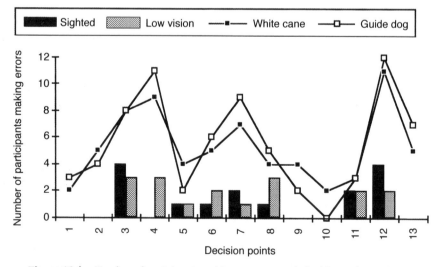

Figure 15.4. Number of participants making errors at each decision point: test one.

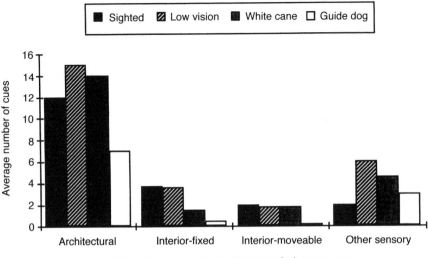

Figure 15.5. Type of cues used during wayfinding: test one.

sound quality were noted as factors that aided memory. Interior cues, both fixed and movable, were used more by the sighted participants than by the participants with visual impairments. Note that participants with guide dogs made fewer comments due to the commands they had to direct to their dog. Therefore, the total number of cues is skewed, but the relative number per category can be noted.

People with visual impairments relied on a broader range of cues to navigate through the built environment than the sighted group. The most commonly used cues after the architectural category for the participants with a visual impairment were those in the "other sensory" category (Table 15.1). These included sound, light/dark contrast, color contrast, lighting levels, smell and air pressure and temperature changes. Of these, sighted participants mentioned color contrast most often. Participants with low vision most frequently mentioned lighting levels. Participants with white canes relied on sound, and participants with guide dogs used smell.

The results of the tactile map exercise, test two, revealed that there was a decreasing ability between the groups to understand the overall spatial configuration of the building. The sighted participants scored highest, followed by the low vision participants, then the participants with white canes, and, finally, those with guide dogs (Figure 15.6). The map was evaluated by measuring the distance between the start and finish points. If the map was constructed accurately and to scale, the distance from the start to the finish point was 60 mm measured linearly. Within target range was determined to be 30–90 mm, linearly between the start

Table 15.1. "Other Sensory Cues" Reported: Test One

Category: other sensory cues	Sighted	Low vision	White cane	Guide dog
Lighting levels	8	35	12	12
Smell	0	8	2	22
Sound	6	25	28	0
Color contrast	9	25	10	4
Air pressure	1	2	14	3
Air temperature	0	0	4	3

and finish points. This distance was chosen because the length of one rectangular strip that signified the corridor was 30 mm. Therefore, accuracy was plus or minus one rectangular piece of wood. Moderate range was evaluated at more than 90 mm, but no more than 120 mm. The final category "outside of range/ illegible" was more than 120 mm, or if the map was incomplete and no accurate distance could be measured. Using these guidelines, all groups had at least some understanding of the spatial configuration of the buildings. As well, there was no statistical difference between the groups when comparing the total number of stairs, ramps, and corners placed on the map.

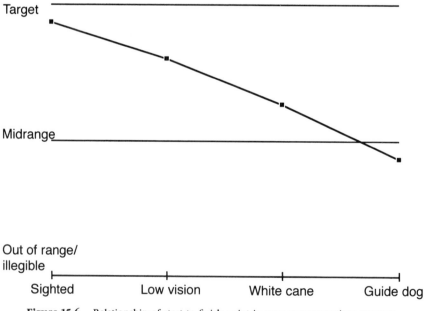

Figure 15.6. Relationship of start to finish point in map reconstruction: test two.

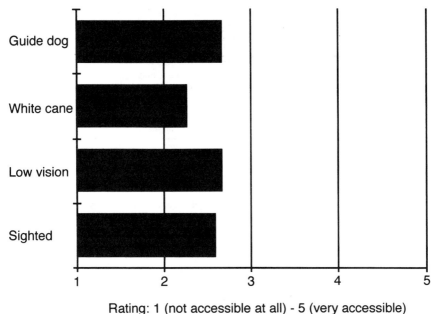

Rating: 1 (not accessible at all) - 5 (very accessible)

Figure 15.7. Average rating of the accessibility of public buildings: test three.

In test three, the interview, there was very little variation in the average rating between the groups on the question of accessibility of public buildings (Figure 15.7). A 1 was "not accessible at all" and a 5 was "very accessible." The average rating was below the midpoint on the 5-point scale. The averages for the entire sample were 2.3 for the buildings used in this study and 2.6 for public buildings in general. Although there were differences in time taken and number of errors made during the journey, all the subgroups felt that public buildings were less than moderately accessible.

In reasons given for this rating, 77% of the respondents commented on a lack of landmarks. The second most common concern, mentioned by 63% of the participants, was that spatial configurations were too complex. Of the participants with visual impairments, 78% mentioned difficulties with elevators: locating them, problems with the control panel, and a lack of audible cues. Ramps and stairs were mentioned as a hazard by 80% of the participants with low vision. The participants with low vision also commented more frequently (67%) on problems with inadequate lighting levels.

On questions related to helpful wayfinding tools, the highest rated (most helpful) was changes in floor surface (4.2 for the entire sample). Floor surfaces are a way to establish a landmark and also provide useful cues to delineate a path

Table 15.2. Ratings for Wayfinding Tools: Test Three

Wayfinding cues	Average score[a]	Wayfinding cues	Average score
Changes in floor texture	4.2	Handrails	3.6
Asking other people	4.0	Tactile maps	3.5
Floors	3.9	Narrow corridors	2.8
Tactile signs	3.7	Walls	2.8
Information phone	3.7	Open spaces	2.5
Sound	3.6	Braille maps	2.5

[a]1, not helpful; 5, very helpful.

through open spaces. The average ratings per group were: 3.3 for the sighted participants, 4.4 for those with low vision, 4.7 with white canes, and 4.4 with guide dogs.

The second most helpful tool was asking other people for directions. The average for the entire sample was 4.0. The sighted participants rated asking others a 4.0, the participants with low vision a 3.9, and the participants with white canes and guide dogs a 4.1. Although rated highly, there were problems associated with asking others for directions. The primary concern was that sighted people do not give very accurate directions. Secondarily, asking a stranger for directions inhibits feelings of self-reliance. A summary of rated questions appears in Table 15.2.

Participants were asked to suggest other cues that are helpful to wayfind indoors. The most frequently mentioned included landmarks, information telephones, lighting levels, and color contrast. Advice to designers when planning a new building focused on consulting people with disabilities, less complex building configurations, appropriate signage, and, for the participants with visual impairments, warning strips at stairs. The participants suggested that future research focus on safety issues and wayfinding in the exterior environment.

From these results several themes became apparent that should be considered during the design process (Table 15.3). It was not uncommon for an area that was given a low rating as a reason for creating difficulty in wayfinding to also be addressed in the question about wayfinding tools or suggestions for designers. As an example, the configuration and layout of buildings were cited in both. It is clear that the more complex a building is, as defined by the number of decisions an individual has to make to reach a desired location, the higher the probability that there will be difficulty wayfinding.

DISCUSSION

An important aspect of this research was collecting objective and subjective data. The objective data reinforced the notion that design plays a critical role in

Table 15.3. Summary of Responses to Open-Ended Questions: Test Three

	Sighted	Low vision	White cane	Guide dog
Other sensory cues	Color	Lighting	Sound	Smell
	Lighting	Sound	Air pressure	Lighting
	Sound	Color	Lighting	Color
Problems areas	Configuration	Vertical access	Configuration	Configuration
	Landmarks	Landmarks	Vertical access	Vertical access
	Vertical access	Configuration	Landmarks	Landmarks
		Lighting	Obstacles	Obstacles
Other useful tools	Landmarks	Color contrast	Smell	Smell
	Color contrast	Lighting	Signage	Air temperature
	Signage	Smell	Landmarks	Landmarks
	Lighting		Lighting	
			Air pressure	
Suggestions	Consult disabled	Consult disabled	Configuration	Warning strips
	Configuration	Lighting	Warning strips	Configuration
	Signage	Warning strips	Mark paths	Obstacles
		Configuration		

providing wayfinding cues and creating truly accessible environments. The predominance of architectural cues as the basis of remembering routes was clearly demonstrated. The minimal difference in errors made along the route by sighted and low vision participants compared to the participants using white canes and guide dogs suggests that design is based on visual cues with little redundancy using other senses. In examining the decision points that caused the most difficulty, this proved true.

In the map-reconstruction exercise, it was interesting that although people with visual impairments had more difficulty duplicating the spatial configuration of the route, they can understand the overall layout of the space as they move through it. Most participants understood that the finish point was in close proximity to the start point, but one floor lower. This result contradicts many early studies and theories proposed in the medical rehabilitation field, as well as in the design professions.

The objective data gathered through the commentary as the participants walked through the site and in the interview gave depth to the understanding of the process of wayfinding and the perceptions of people about the accessibility of the built environment. The result with potentially the most far-reaching implications was the response to whether the built environment was accessible. It validated the conjecture that by including the requirements of people with visual impairments, design will be improved for all people. Although the sighted participants made less errors and took less time to navigate through the route, their rating of the accessibility of public buildings was not significantly different from the other subgroups. From this one can surmise that sighted people, while

facing less obvious barriers in the environment, have less patience to accept the barriers they experience. Should this result be duplicated in other studies, it should serve as a red flag for designers.

It was useful to have the data collected through a number of different methods to verify the reliability of the information. Comments on which cues were remembered along the route during the walk through were often repeated in the interview such as in listing helpful wayfinding tools. For example, lighting levels were mentioned often during the route as cues that were helpful and repeated in the interview as useful cues. Participants were also asked in the interview questions about what made some buildings inaccessible. It was common for participants to mention difficulties when a particular type of cue is missing and to mention wanting this same cue in a question eliciting suggestions for better design. To illustrate this point, participants in all the subgroups frequently described a lack of landmarks as one problem area in finding their way in buildings. When asked an open-ended question to describe wayfinding cues they find helpful, participants again cited landmarks.

An outcome from collecting the subjective material was a conceptual model developed to aid in the design and evaluation of user-friendly environments and to determine strategies for improved accessibility. By attending to the comments people made on which cues aided remembering the route and the reasons why they remembered those particular cues, it became clear that symbolism and design features combine to create a language that people read and interpret. In this regard, the conceptual model proposed includes three key issues: the relationship among like components, the relationship among different components, and the symbolic value of the components (Figure 15.8). Each area must be assessed individually, a well as collectively, to determine the impact of the design on a navigator's ability to maneuver through the environment.

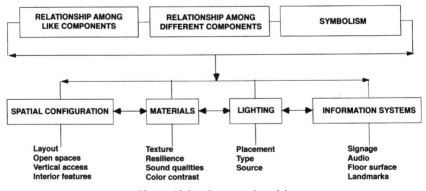

Figure 15.8. Conceptual model.

Relationships are critical in wayfinding because the process of navigation includes temporal and spatial sequencing. Often objects and places were remembered and read through their relationship with another place or object through adjacency, juxtaposition, and sequence. These relationships are determined by the similarities and differences between objects, as well as through positional factors. Symbolism is also important because the interpretation of an object is based on the relationship between the object and the individual's past experience. For example, darker areas of public buildings were interpreted by some individuals as private or unsafe and thus established a tendency not to travel in those directions.

Using this framework, there were four main design components identified in this study that provided the majority of information. These key components include spatial configuration, materials, lighting, and information systems. Spatial configuration considers the overall layout of a facility, the open spaces within the building, vertical access, and interior features. Materials include texture, resiliency, sound qualities, and color contrast. The lighting component addresses placement, type, and source (artificial or natural). And finally, the last component are information systems that are more than traditional signage. As shown from this research, this includes such items as audio cues, floor surface treatments, and landmarks.

All the components are interconnected and effect one another. For instance, the relationship among different sets of stairs, the relationship between the stairs and the surrounding floor surface, and the memory that is evoked from the aesthetics of those stairs combine to set the stage for remembering the route through a building. As a whole, these components provide either a coherent or a confused messaging system.

There was some concern regarding sampling error due to self-selection. To identify participants, notices were posted at the university and a government worksite and placed in bulletins sent to people with visual impairments, and letters were sent to organizations of and for people with visual impairments. Potential participants then contacted the researcher and if they met the eligibility criteria were selected to participate. This, as well as the limited sample size, may have influenced the validity of the study.

On the other hand, many appropriate individuals were involved in reviewing the methodology and procedures for this research. As well as contacting experts in the field, people with visual impairments and orientation and mobility instructors participated in the development of the research methodology, selection of the route, and interview questions. Once the entire procedure was established, the project was field tested by five people with visual impairments, some using white canes, some with guide dogs, and others with no aids. These steps ensured that the areas examined and the way in which they were approached were relevant to the issue under study.

After the research was completed and the final report written, the partici-

pants were invited to a presentation of the results to both respect the efforts of the participants and investigate the relevance and importance of the results. Most of the participants elected to come and the feedback was very positive. There was consensus that the results addressed the concerns of these individuals. The only results that were unexpected by the people with visual impairments were that people with low vision made a similar number of errors to the sighted group and that sighted people responded with similar themes to those with visual impairments in the interview. From this group of participants, there was enthusiasm to continue with more research regarding both the interior and exterior environments using a more active participatory approach. Since this project was completed, two research grants were applied for and managed by people with visual impairments with this researcher as consultant. The responses from the participants provided acknowledgment that the research reflected actual concerns, the methodology was appropriate, and the results were concurrent with their experiences.

To summarize, the data obtained in this research confirmed the original hypothesis. An examination of wayfinding by people with visual impairments clearly demonstrated that the design of the built environment effects performance. All people have the ability to find their way, but can be impaired by the design of the built environment. All people, whether disabled or not, want more accessibility in public buildings.

A typical lack of accessible cues poses obvious problems in wayfinding for people with visual impairments. In addition, sighted people also experienced frustrations by the lack of clear communication through the design of architectural features, although it was more difficult for a person with a visual impairment to recover missed cues. Effective measures to improve design for people with disabilities will also be helpful for people without disabilities. When this philosophical direction, a universal design approach, is adopted, disability may no longer be an outcome of environmental design.

REFERENCES

Canadian National Institute for the Blind. (1989). *Access needs of the blind and visually impaired travellers in transportation terminals: A study and design guidelines*. Ottawa, Canada: Transport Canada.

Casey, S. (1978). Cognitive mapping by the blind. *Journal of Visual Impairment & Blindness*, 72(8), 297–301.

Cleaves, W., & Royal, R. (1979). Spatial memory for configurations by congenitally blind, late blind, and sighted adults. *Journal of Visual Impairment & Blindness*, 73(11), 13–19.

DeJong, G. (1979). *The movement of independent living: Origins, ideology, and implications for disability research*. East Lansing: Michigan State University.

Fletcher, J. (1980). Spatial representations in blind children, 1: Development compared to sighted children. *Journal of Visual Impairment & Blindness*, 74(12), 381–385.

Hahn, H. (1984). Reconceptualizing disability: A political science perspective. *Rehabilitation Literature*, *45*(11-12), 362-365, 374.

ICIDH International Network. (1991, August). The handicaps creation process: How to use the conceptual model. *ICIDH International Network*, *4*(3).

Ittleson, W. (1973). Environment and perception and contemporary perceptual theory. In W. Ittleson (ed.), *Environment and cognition* (pp. 1-19). New York: Seminar Press.

Lynch, K. (1973). Some references to orientation. In R. Downs & D. Stea (Eds.), *Image and environment* (pp. 300-315). Chicago, IL: Aldine.

Passini, R. (1984). *Wayfinding in architecture*. New York: Van Nostrand Reinhold.

Passini, R., & Proulx, G. (1988). Wayfinding without vision: An experiment with congenitally totally blind people. *Environment and Behavior*, *20*(2), 227-252.

Sands, D., & Dunlap, W. (1991). A functional classification for independent living for persons with visual impairments. *Journal of Visual Impairment & Blindness*, *85*(2), 75-80.

Sanford, J., & Steinfeld, E. (1987). *Designing for orientation and safety*. Annual Research Conference of the AIA/ACSA Council on Architectural Research, Conference Proceedings. November 18-20, 1987, Boston.

Smith-Kettlewell Eye Research Institute. (1991). *Remote signage for the blind and visually impaired* (2nd ed.). San Francisco, CA: Author.

Statistics Canada. (1991). *Health and activity limitation survey*. Ottawa, Canada: Author.

Steinfeld, E. (1980, August). Designing barrier-free communications in buildings. *Architectural Record*, 51-57.

World Health Organization. (1980). *International classification of impairments, disability, and handicap*. Geneva: Author.

16

Postoccupancy Evaluation of Universally Accessible Multifamily Housing Units

Patricia L. Falta

INTRODUCTION

Background

Since 1981, Société Logique, a nonprofit housing corporation founded by persons with physical limitations, has been designing, building, and operating universally accessible multifamily housing units in Montréal, Québec. The founding members felt that the current practice of providing a certain number (or percentage) of specially adapted apartments in any one building did not offer a long-term solution to assuring that persons with disabilities have access to truly integrated housing. The existing approach had a narrow application since it focused on only one functional limitation—a wheelchair user—and the adapted features were not appropriate for able-bodied persons. Such a concept not only perpetuates the us-and-them syndrome but is also inefficient and uneconomical to administer and operate.

Patricia L. Falta • School of Architecture, Université de Montréal, Montréal, Québec, Canada H3C 3J7.

Enabling Environments: Measuring the Impact of Environment on Disability and Rehabilitation, edited by Edward Steinfeld and G. Scott Danford. Kluwer Academic/Plenum Publishers. 1999.

The members of Logique were convinced—and legislation such as the Fair Housing Amendments Act in the United States has proven them correct—that in the long run universally accessible units would have to be provided in all multifamily housing to respond adequately to the very varied needs of individuals and family groups who may have a functional limitation.

The objectives of their initiative were multiple:

1. To provide accessible and fully integrated rental housing for persons with physical or sensory limitations (whether they be children, single adults, or parents).
2. To develop standards for universally accessible housing that can be equally functional for persons with or without a disability.
3. To provide a viable alternative to specially adapted housing units.
4. To demonstrate that universally accessible housing can be built at the same cost as traditional nonaccessible housing.
5. To evaluate the functional performance and social effects of universally accessible design standards.
6. To use this experience to promote the feasibility and the desirability of governments and private enterprise to provide universally accessible housing.

Concept of Universal Access

The concept of access that is "universal" is defined by Logique as twofold:

1. All of the apartment units (one-, two-, and 3-bedroom) and all the common areas are equally accessible, functional, and adaptable
2. Persons of all ages, without any limitation or with any type of functional limitation, can be equally accommodated in any of the apartment units and in all the common areas.

Despite this "universality," and in order to avoid creating any sense of a "ghetto," a tenant mix for each building is established so that only 12% of all the residents have a physical, sensory, or intellectual limitation and that 15% of the residents are over 65 years of age. Single-parent and two-parent families are numerous, and single persons and couples also form part of the social mix.

Since this nonprofit housing is government supported, rentals are slightly below market value. Moreover, more than half of the residents (those on welfare or with a low income) receive an additional housing subsidy. Persons with severe physical limitations also receive at-home care services, provided either through an outreach program of a rehabilitation center or through a local community service center.

Design Standards for Universally Accessible Housing

Two of the founding members of Logique, Patricia L. Falta and Pierre Richard, are architects who use wheelchairs and whose specialty is barrier-free design. With their expertise and experience, they have developed and refined over time a series of standards that respect minimal but generally sufficient requirements for wheelchair users, as well as standards that respond to the needs of persons with other physical or sensory impairments. In other words, these standards are not for the usual type of "adapted" units associated with wheelchair users only, and, significantly, they do not entail the same additional construction costs that "adapted" units do (Falta & Kreiss, 1990).

It is important to emphasize that since the housing is fully subsidized and generally intended for low-income residents, the total area for each apartment unit allowed by the funding agency is minimal. Both the maximum square footage for each unit and the maximum construction cost per unit (which also has to include the costs for circulation and common areas) are set by the funding agency, Canada Mortgage and Housing Corporation (CMHC).

Barrier-free access and functionality are provided in all common areas such as entry, community room and kitchenette, laundry, elevator, corridors, outdoor spaces, and so on. Some of these basic access requirements are mandated by the National Building Code (NBC) of Canada, but the NBC does not deal with many of the specific details that Logique also incorporates. Thus, special care is taken to include power-assisted entry doors; intercommunication systems with low, large buttons and lettering; a voice simulator in the elevator; flashing alarm lights; and similar functional improvements.

It is in the units, however, that the concept of universal access really becomes apparent. Generic accessibility patterns have been developed and adapted for the areas that are most crucial in terms of wheelchair functioning: entry hall, corridors and doors, kitchen, and bathroom. These generic patterns include maneuvering space in front of all appliances in the kitchen and all fixtures in the bathroom (with a functional approach to each), maneuvering space at all doors and storage areas, appropriate heights of all controls, and ease of manipulation for controls and other moveable elements. The kitchen counter is located at 34.5 in. (a compromise between the "adapted" height of 32 in. and the standard of 36 in.) supplemented by lower, pull-out workboards in two locations.

The main design innovation is the inclusion of a variety of built-in provisions in all the apartment units that allow for easy and inexpensive future adaptation installations, when and where they are required. These adaptability features include not only such standards as wall reinforcement in the bathroom for the placement of grab-bars, but also such simple but very useful elements as electric outlets above apartment entry doors for connecting a possible power-assisted door-opener, an electric outlet in each unit connected to the building alarm

system for easy installation of visible or vibrating alarms in the unit, and removable storage modules under the kitchen sink.

An essential safety element required by the NBC is that emergency refuge areas be provided for persons who cannot evacuate on their own via stairs. Balconies can be considered an area of refuge if they are accessible with a minimal threshold height and if firefighters can reach them with their ladders (for this criteria the building height is usually six stories or less). In buildings that have no balconies, an area of refuge can be provided in the stairwell, a space that is considered to be safe from fire and smoke. Firefighters help evacuate persons with severe limitations from these locations.

Present Situation at Logique

The Société Logique now owns and operates five apartment buildings. It is particularly proud that their latest project—the Habitations Perras, designed by Pierre Richard with consultation by Patrician L. Falta and inaugurated in 1992—has been held well within the budget normally attributed by the federal funding agency to standard, nonaccessible units. In fact, although this building has the most complete universal access provisions, as well as a series of adaptation features, the construction cost for the building (which includes a large entry hall, community room, and gardens) was only 93% of the maximum allowable construction cost subsidy.

RESEARCH REGARDING FUNCTIONAL PERFORMANCE

Research Objectives

Despite positive but informal feedback that Logique has been getting over the years from the building residents, nevertheless the architects were interested in undertaking a more complete evaluation of the functional performance of the housing. They obtained funding in 1992 from CMHC for a research project to evaluate the postoccupancy performance of the accessible and adaptable features.

The objectives of the research were to evaluate the quality and extent of the functional performance of the projects' common areas and units in terms of the needs of persons with physical, sensory, and intellectual limitations, as well as of persons not normally considered "disabled" (including children). In other words, are the principles advocated in "universally accessible" housing equally valid for persons with and without obvious limitations? And what are the implications of such findings?

In addition to validating the functional adequacy of the design standards

related to persons with physical or sensory limitations, Logique also wanted to verify that such housing provides a better response to the needs of today's varied market. An important result of the demonstration and evaluation would be that these advantages can be accomplished within the market orientation and financial constraints of the housing industry.

Furthermore, the outcome of the research was to enable the architects at Logique to improve and refine their design specifications for universally accessible and adaptable housing. Therefore, the focus of the ensuing research was qualitative, rather than quantitative. Although some statistics have been produced, rather than relying solely on tabulated data most of the results have been analyzed in terms of direct response to individual situations and needs.

Three projects were studied (Figures 16.1–16.3 and Tables 16.1 and 16.2), buildings that are most representative in terms of Logique's design standards and tenant mix (*Critères de performance en accessibilité universelle*, 1994).

Universal Access Design Features in the Projects

The following specific design features incorporated into the public areas of the buildings have been evaluated:

1. Main entry
 * Driveway access ramped for access for both pedestrians and vehicles
 * Common ramped access allows a drop-off area for passengers in front of the door

Table 16.1. Characteristics of the Housing Projects

	Habitations Quesnel (1983): recycled school, three stories	Habitations St-Joseph (1988): new construction, four stories	Habitations Perras (1992): new construction, four stories
Services	Six steps and 1:12 ramp with drop-off at curb	Pedestrian and vehicle access ramped at 1:12	Pedestrian and vehicle access ramped at 1:20
	Communal space and laundry on main floor	Communal space and laundry in basement	Communal space and laundry on main floor
	Outdoor parking	Outdoor parking	Basement parking
Units	17 units, no balconies	42 units and balconies	44 units and balconies
1-bedroom	5, 648 ft^2 average	12, 542 ft^2 average	18, 595 ft^2 average
2-bedroom	6, 925 ft^2 average	21, 670 ft^2 average	14, 755 ft^2 average
3-bedroom	6, 1201 ft^2 average	9, 850 ft^2 average	12, 914 ft$_2$ average
Tenants	Approximate total: 40, 6 with limitations	Approximate total: 85, 14 with limitations	Approximate total: 105, 17 with limitations

Figure 16.1. Habitation Quesnel: 17 universally accessible housing units.

- Entrance is provided by wide, power-assisted doors without threshold
- Vestibule area is adequately deep to allow for maneuvering space between door-swings
- Intercom panel in vestibule is low, with large buttons and color-contrasted numerals
- Intercom system is connected to telephones in each apartment unit
- Postal boxes are set low, with several boxes large-format for braille mail
2. Interior parking in basement
 - Height of garage door and parking area sufficient to accommodate high van roofs
 - Several wide parking spaces to allow for wheelchair transfer
 - Level entry and a wide, power-assisted door to elevator vestibule

Figure 16.2. Habitation St-Joseph: 42 universally accessible housing units.

Figure 16.3. Habitation Perras: 44 universally accessible housing units.

3. Interior public circulation
 - Corridors widened to provide maneuvering space in front of doors
 - Walking surface slip-resistant, without carpet
 - Corridors well-lighted, with additional high lighting at doorways
 - Height of fire alarms accessible to seated and small persons
 - Visual, flashing alarms supplement the audible alarms in the corridors
 - Elevator call button height and location accessible to seated and small persons
 - Audible signals supplement visual lights to indicate cabin arrival
 - Elevator control panel low, with numerals/pictograms raised and color-contrasted
 - Braille numerals and in-cabin voice simulation for floor-arrival identification
 - Infrared connection in cabin for remote control operation
 - Garbage chute vestibule-accessible, with the chute trap door lowered
4. Communal room
 - Accessible public toilet
 - In the kitchenette, access to all appliances, space under sink, and lowered counters

The following design features have been incorporated into all of the apartment units:

1. Circulation within unit
 - Well-lit alcove outside entry door, with large, color-contrasted numbers above handle
 - Viewing holes in entry door at two heights
 - Maneuvering space inside the entry door and at end of corridors
 - All doors equally wide, with lever handles and no thresholds
 - Clear wall space at handle edge of doors, on inside and outside of doors
2. Controls and outlets
 - Rocker-type switches and electric outlets at reachable height, away from corners
 - Telephone outlets close to electric outlets
 - Electric control panel low for easy access
 - Electric outlet above entry door for possible installation of remote-control opener
 - Electric outlet connected to building alarm system for possible installation of visual and/or vibrating alarms in unit
3. Kitchen
 - Maneuvering space in front of all appliances and work areas
 - Counter height slightly less than standard, with high and deep toe space
 - Two pull-out work boards incorporated below counter for access to seated person

- Upper cabinets lower, with D-shaped handles on all doors and drawers
- Two full-height cabinets, one with electric outlet for possible installation of wall oven
- Sink with single-lever faucet and drainage trap set back at wall
- Removable module under sink for possible open knee space
- Electric outlets and light/fan controls at front of counter
- Pass-through opening at counter for transfers to dining area

4. Bathroom
 - Maneuvering space to access all fixtures (minimum 5 ft. in diameter)
 - Opening of door to outside if impeding on interior maneuvering space
 - Clear open space under lavatory counter, with mirror directly above counter
 - Open shelves on side wall of lavatory counter
 - Medicine cabinet located on wall beside door—low, accessible and lockable
 - Standard height toilet, at side of wall
 - Access to full length of bathtub
 - Wall reinforcement around toilet and bathtub for possible installation of grab bars
 - Single-lever faucets and hand-held shower

5. Windows
 - Tall format with low sill height
 - Lever-type opening and locking mechanism (sometimes sliding windows)

6. Balcony (accessible balcony accepted by code as valid refuge area in case of fire)
 - Outswinging door (sometimes patio door) with threshold maximum 1.5 in.
 - Maneuvering area on balcony

7. Storage
 - Closets with two height adjustments for rod and shelf
 - Lockers provided inside apartment unit, with individual hot water tank

RESEARCH METHODOLOGY

A questionnaire was developed, identifying the residential composition and functional limitations of the tenants, then focusing on the satisfaction with or difficulty with architectural and technical features incorporated in each building. Although the basic, generic design patterns are similar in all three buildings, the specific details do vary, since the access features and functional qualities have been improved in successive projects.

Table 16.2. Number of Respondents in Postoccupancy Evaluation

	Habitations Quesnel	Habitations St-Joseph	Habitations Perras
Respondents	11 households	25 households	31 households
Limitations	5 persons	13 persons	15 persons
(receive care)	(3 persons)	(8 persons)	(4 persons)

A total of 61 questions were ordered in a logical sequence, starting at the main entrance, passing through the common areas and into the apartment units, down to the smallest element.

A preliminary letter was sent to all residents in the 103 units of the three buildings, asking for their cooperation with the research. Tenants from 67 units responded positively (66% of all units), and all these units were evaluated. This included most units occupied by persons with functional limitations (33 units, or 50% of the sample). In total, residents with limitations accounted for 15% of all tenants, higher than the 12% ratio that Logique would prefer to maintain.

The questions followed a standardized protocol. Residents were asked if a feature was used, the difficulty or satisfaction of using it, and any additional comments regarding its functionality. Some questions were directed only to persons with a functional limitations (e.g., toilet use), but the majority were directed to all. The questionnaire was administered by the housing resources consultant from Logique who visited each unit, taking from ½ to 2½ hours to complete it.

Functional Performance Assessment

The results were analyzed separately for each building, and the responses were compiled to reflect the varying levels of functional limitations of the residents. For each design feature evaluated, a compilation sheet was created that identified the exact configuration and dimension in each building. Thus functional difficulties were directly related to the given situation, as well as to the limitation levels of the respondents.

Table 16.3 is a sample compilation of one of the assessed features.

Analysis of the Results Classified into Categories of Functional Performance

1. Features that are appreciated alike by persons with or without limitations, but where the design standards still fail to satisfy easy and safe access for some users, under certain conditions:

Example: Ramped entry

Table 16.3. Sample Compilation of Responses: Main Entrance Access Ramp Assessment[a]

	Quesnel	St-Joseph	Perras
Slope	1:12	1:12	Less than 1:20
Height of change of level	4"3"	3"0"	About 1'6"
Landings at change of direction or at the end	2	0	0
Handrails	On each side	On one side	None
Height of handrails	30½", 36"	31", 36"	NA
Landing at top of ramp (width by depth)	10' by 3'	10' by 5'	10' by 5'

User satisfaction

• The ramps are very much used by all the tenants despite the fact that they do present a certain level of difficulty for about 30% of the users.

Findings

• The 30% of the users who have difficulty with the ramps principally represent persons with disabilities and elderly persons. Only two persons with no disabilities mentioned having difficulty.
• The ramps are also used for bicycles, carriages, and strollers. When they are located in the axis of the normal pathway to the entrance, they aer used by all pedestrians.
• Several comments have been noted during the survey: the importance of the change in level or the critical height difference which the ramp has to cover; the absence of a level landing, allowing a rest area, in the sloped or ramped pathway; the absence of handrails on both sides; the steepness of the slope.

Proposed improvements

• The satisfaction factors identifed above should be evaluated in order to determine the maximum length, the maximum height to cover, and the rest landings required. A maximum change in level of 2' for the principle entrance of a building should be evaluated.
• The slope of 1:12 should be reevaluated.
• At the upper landing, if the entry to a ramp occurs in front of a staircase, the landing should be deeper than 3' (the existing at Quesnel).

[a]Translated from the original French by the author; reprinted by permission of Societé Logique Inc.

Although ramps were used by almost everybody (for shopping carts, strollers, bicycles), 30% of the users (mainly elderly persons or those with disabilities) found them difficult, particularly in winter.

2. Features that cause functional difficulties for some persons with limitations:
 Example: Intercommunication
 The telephone-connected system found a 94% user satisfaction rate, but only 74% were satisfied with the wall-panel system, since persons with mobility limitations found them not sufficiently flexible.

3. Features that cause difficulties for many users:
 Example: Windows
 About 50% of all users had difficulty opening sliding windows, while 25% had difficulty opening lever-operated swinging windows. The poor quality of the hardware seemed to be a major factor.

4. Features that increase facility of use for everybody:
 Example: Lever handles with returned ends
 One hundred percent of all residents were satisfied, since handles that curve back to the door do not catch clothing.
5. Features that are appreciated by many persons, especially those with physical limitations, but to which many others are quite indifferent:
 Example: Single-lever faucet
 About 60% of all users appreciated this facility, while the rest were indifferent to it.
6. Features that actually satisfy the able-bodied tenants more than those in wheelchairs:
 Example: Height of kitchen counters and cabinets
 Although 99% of all users were content with the lowered counters and cabinets, only 80% were really satisfied, since many wheelchair users would prefer both counters and upper cabinets even lower.
7. Features that allow for adaptation and are used often:
 Example: Wall reinforcement for grab bar installation
 Of the respondents with limitations, 40% had installed grab bars in the bathroom, generally at locations where wall reinforcement had been provided.
8. Features that allow for adaptation and are rarely used:
 Example: Replacement of stove by cook-top and wall-oven
 Only 5% of all respondents did this, perhaps because of cost implications or because they were not aware that the adaptation was available.

Of the respondents with functional limitations, 45% received some personal care in the home. Closer inspection of the data reveals that, generally, when persons with limitations were dissatisfied with a feature, it was often because of the severity of their disability. In many of these situations, only very specially designed features might compensate for their limitation, and in such cases it was more logical to use outside help than to devise extreme adaptations. Although such persons are included in the overall statistics, they are identified in the qualitative analysis and their satisfaction or difficulty is interpreted accordingly.

When persons without an identified limitation were dissatisfied with a feature, it was usually because of circumstances such as excessive height or aesthetic preferences. Surprisingly, many of the residents were not actually aware that they were living in "universally accessible" housing, and thus remained indifferent to some of the features, since they had not realized their specific functional purpose. Many parents with children, on the other hand, showed high satisfaction with features that facilitated childcare (e.g., better access to and easier use of bathtub faucet) or increased autonomy for their children (e.g., lower height of closet rods, equipment, and switches). Some of the tenants were not aware of the adaptability features provided, and therefore had not taken advantage of them.

One of the shortcomings of the postoccupancy evaluation is that at the time of the survey very few residents had visual or hearing limitations: Only one person who was deaf and two persons with intellectual limitations were interviewed, although several blind persons had been prior tenants. The high ratio of tenants with mobility impairments is due to the current socioeconomic situation in Montréal. Because there is presently a high vacancy rate in all rental housing, Logique is reluctant to refuse potential tenants who use wheelchairs, although it does not specifically seek them out. However, it is trying hard to avoid increasing the current ratio and thereby creating a "wheelchair ghetto."

EVALUATION OF FEATURES

Despite some limits in the variety of the available clientele, the survey was able to identify features that work very well, some that work reasonably well, and those that need improvement. Logique has already researched better technical and design specifications that have been incorporated into subsequent design guidelines.

This review does not dwell on all the details of the elements evaluated. General satisfaction was very high. Some specific features—whose evaluation gives a clear indication of what is useful or important—are identified here, since they have a direct bearing of what could and should always be considered under the label "universal."

Ramp

- A slope of 1:12 was considered too steep by various users.
- Handrails were required on both sides.
- A level landing was preferable every 20 ft.

Vestibule

- Size was very important, especially if postal boxes were located there.
- Location of power-assisted door-opening was important, and remote power-operation was essential for some tenants.
- Intercom-operated power-assist on door-opener would be useful.
- Intercom connected to telephone offered great flexibility.
- Visual information on the intercom was required in order to be useable by persons with hearing impairments.

Elevator

- Emergency telephone system, which was not functional for persons with hearing impairments or with severe mobility limitations, was not acceptable.
- Control buttons above 4'6" high were not easily operable.

Garbage chute

- Vestibule and chute doors were difficult to operate for some users.
- Some persons with severe mobility limitations could not use the chute at all.

Laundry room

- Maneuvering space was required between appliances and adjacent walls.
- Top-loading appliances were difficult to use by seated persons.

Doors

- Passage through doors was difficult without a clear space at the handle edge of the door.
- Door width was critical for wide, power-operated wheelchairs (minimum requirement is door 2'8" wide).

Kitchen

- Access to equipment for wheelchair users was difficult without a 5-ft. diameter maneuvering space.
- Open kitchens in L- or U-shape were preferred.
- Pass-through to the dining area was rarely utilized, but was appreciated for visual contact and daylight.
- Counter height was convenient for most able-bodied users, but almost a third of wheelchair users would prefer it lower.
- Space under the sink was good for wheelchair users, but otherwise was used for storage.
- Pull-out work-boards were used by all, for many activities.
- Cook-top and wall-oven combination was rarely found, but where the oven was installed, almost 50% of the wheelchair users found it too high.
- Toe space at lower counters was often insufficient.
- Electric outlets at the front of the counters were much appreciated.

Bathroom

- A 5-ft. diameter maneuvering space was essential for wheelchair users.
- The great majority of wheelchair users were satisfied with maneuvering space (even those with an attendant or using a lift).
- Toilet height was satisfactory (with the addition of a higher seat if necessary).
- Only one person would prefer a lateral transfer space beside the toilet.
- A lavatory in the counter with knee space underneath was preferred, with a removable storage module as optional.
- Height and location of medicine cabinet was important (with safety features for children).

- Grab bars were installed by 76% of mobility-impaired tenants, where wall reinforcement had been provided at the toilet and bathtub (as well as a few in other locations).
- Single-lever faucets were useful, but sometimes hard to operate.
- Hand-held shower with mounting pole was very useful.
- Location of bathtub faucets at the front was satisfactory.

Linen and clothes closets

- Closets located in a corner were hard to access.
- Two locations of rods and shelves were convenient, but still too high for a few.

Controls

- Lowered controls could be accessed by most users.
- Thermostat was still too high to be seen by 19% of wheelchair users.

Windows

- Lowered window sills were important.
- Operating systems (sliding or out-swinging) were difficult for a variety of users.

Balcony

- Majority of tenants used the balcony, but 6% had some maneuvering difficulty.
- The minimum dimension must allow for a 5-ft. maneuvering space.
- The sliding patio door caused some difficulty for wheelchair users.

Handles

- Lever and D-shaped handles facilitated use, but lever must curve toward door.
- One-hand locking operation was important.

Aesthetics

- The majority found no impact on aesthetics due to accessibility features.
- Open space under sink or lavatory could be unsightly when used for storage.

LIMITATIONS OF OBJECTIVES AND METHODOLOGY

The objectives of the research were focused on validating the universal qualities of the design criteria as developed and applied by Logique. Even within the scope of that limited objective, it must be recognized that the three buildings did not have identical design characteristics and that not all the access features

were exactly alike. Therefore, the compilation sheets provide an interesting comparison of what works under what specific circumstances. Since satisfaction and dissatisfaction levels have been directly related to each design detail, this facilitates future fine-tuning of the design standards.

In retrospect, it became clear during the analysis phase that the questionnaire was somewhat limited, particularly with respect to units occupied by two or more persons (58% of all units evaluated). The study did not identify clearly who exactly was using the different features, how they were using them, and to what extent they were being used. For instance, did a severely mobility-impaired person ever use the kitchen equipment, and if yes, what exactly did they do there and how often?

Thus, the reasons behind some findings are not known. The study unfortunately did not examine how people make use of the places and features provided and how they actually inhabit their units. For example, a question about toilet use was specifically asked of people with mobility impairments. We found that 19% of this group do not use the toilet at all (they use a urine bag and a rectal touch for bowel movements) and therefore have no need to access it. As a result, only one person in the whole sample preferred a lateral transfer space beside the toilet, while other users found the maneuvering space sufficient, even when they had help in the bathroom. This finding is important since it contradicts the standard belief that the more severely disabled a person is, the more maneuvering space they require.

Subsequent to our evaluation, a visit by a postoccupancy evaluation expert demonstrated that a study focusing on how people live and use the features provided could have offered additional valuable insights that might be quite different from the preconceived beliefs generally used in the design process. Logique has not undertaken such a study, which would be methodologically even more qualitative than the present evaluation. It could prove extremely fruitful, however, to demonstrate how residents take advantage of the environment offered, and what meaning and usefulness the various features actually have for them (Zeisel, 1981).

CONCLUSIONS

Validation of Universal Access Design Principles

Logique's premise that universal access in housing not only serves to integrate persons with physical and sensory limitations but also offers useful qualities for a large variety of other residents has been proven and justified. Equally important is the finding that persons with even severe physical limitations can function satisfactorily within an environment that is not specifically "adapted" in

the traditional sense but that respects their major constraints in terms of space and functional needs.

This is a major validation of the fact that very specific designs providing large areas and highly elaborate features are not essential to satisfy the housing requirements of persons with physical limitations. It shows that a little can go a long way. The design standards used in the evaluated buildings are in some situations the minimum necessary to provide access; in other situations they are a compromise between the conventional standards and what is considered as appropriately "adapted." Although not all residents are completely satisfied with every element, none of them are seriously limited in using the environment that is provided. This is an important advantage, since much traditional housing does not offer this functional potential.

The universal access design principles offer additional useful advantages, particularly to families and elderly persons. The concept easily accommodates diversity such as differences in stature (children and elderly persons tend to be smaller) and in strength (as in manipulation of controls). Easy-to-use controls (child-proofed) are selected whenever possible. An interesting finding was that features that facilitate an activity, although not essential, were widely appreciated by all. For instance, power-assisted openers at the main entry doors were almost universally used, even by very able-bodied persons. Similarly, the additional maneuvering space in kitchens was useful for accommodating several persons during cooking and clean-up.

The evaluation did not uncover any design features that hinder one group of users while helping another. Such elements as lever handles have no negative impact if they are properly designed. The architects at Logique fully believe that potential conflicts regarding functional satisfaction by different user groups (where they might exist) can be resolved by a thorough analysis of the various functional requirements and a resulting improvement in the design solution.

Aesthetic Considerations

Aesthetics and image play a very important role in consumer response and appreciation. Application of universal access design principles integrates the standards in a way that does not affect the aesthetics of the buildings, inside or outside. The fact that many residents did not realize that the buildings had special functional qualities proves this.

The buildings resemble the standard housing in the area, and the interiors compare to others in the same price range. Many visitors who have toured the buildings tend to be somewhat disappointed that they cannot "see" the difference. They are looking for something special, characteristics that can be identified. That, of course, is the exact opposite of the integrated, universal design idea. Logique tries to avoid even such common elements as ramps, since they tend to

be associated with disability access. A more understated approach is favored, one that provides uniform access and function for all residents, without visually demonstrating its specificity.

The only negative aesthetic reaction was to the open spaces under the sink and the lavatory, which can appear messy if used for storage. This has been resolved by improving the adaptability of these features: moveable storage modules are provided for insertion under the counter when knee space is not required.

Potential for Generalized Universal Access

Since the housing constructed by Logique is fully subsidized by government, the allowable costs and therefore the allowable square footage per unit are minimal. Logique has proven that, even within this constraint, universal access can be achieved. This is explained by the fact that design and equipment specifications are the same for all the units, and thus an economy of scale plays the same role here as it does in standard housing. In this context it is further important to note that market-driven housing is often more lavish both in square foot area and in the type and quality of equipment provided. It could therefore easily incorporate the basic requirements of universal design with no impact on cost.

Artificial barriers—often in the name of "interesting design"—sometimes hinder function and access uselessly: sunken living rooms are a good example. Other common elements such as thresholds have sometimes been overlooked as basic barriers and continue to be used. With increased awareness about the simple requirements of universal design, unnecessary barriers like these should not be difficult to eliminate.

Logique goes further, however, by incorporating built-in provisions for adaptations if and when they may be required. This aspect of universal design has not been given sufficient attention in the past. It could nevertheless provide a real breakthrough by allowing the type of housing flexibility that individuals will demand in the future. Such provisions are increasingly important since many of them focus on improved safety in terms of communication as well as in physical terms.

One important finding of the postoccupancy evaluation is that not all persons with physical limitations use their home environment in the same manner, that they have different levels of abilities and therefore do not require the same level of adaptations. The concept of adaptable features should be understood and developed on these intrinsic realities. Information about real consumer needs must be studied further and made available to designers and to the housing industry. Many design improvements have been incorporated into housing in the past 30 years because they made housing more functional and therefore more marketable. Adaptable features can continue to play this same vital role.

It is important to note that the elderly population is growing rapidly and will be demanding adaptable features to make their environment easier and safer to use. This is the largest demographic group that will benefit from universally accessible and adaptable housing, and they are already having a strong impact on what is provided. Recent focus group research carried out by CMHC has confirmed that seniors are very concerned with basic access, safety, and adaptability (Hickling, RBO Architects, and Société Logique, 1994). The federal agency has subsequently sponsored further research and development regarding the definition of standards that respond to such concerns.

Future for Universally Accessible Housing

The work carried out by Société Logique is similar to the objectives addressed by the Fair Housing Amendments Act in the United States, which requires basic access to all housing, with some adaptation provisions. Logique's experience proves that access and the accompanying adaptability can be achieved within the standard budget envelope since there is an economy of scale and no particular specialized features are provided. It has also proved that universal access is appreciated by all users and causes no difficulties for its able-bodied or disabled residents.

In support of this fact, Logique was very pleased that in 1992 Habitations Perras received an honorable mention for design and construction in the CMHC national competition Independence through Housing. This award recognizes that pleasant, liveable units with all the amenities have managed to integrate a wide variety of accessible and adaptable features in a most natural and unobtrusive manner. Since this has been accomplished at a competitive cost, it provides an excellent example for future development of universally accessible and functional housing.

In 1994 CMHC sponsored a second national competition—The Ideas Challenge—which addressed issues of energy conservation, healthy environments, and universal access. In this context housing developers, along with energy and access specialists, presented plans for housing that was to be constructed within the next 2 years. Logique was associated with one such Montréal developer: The team won the regional prize for its proposal, which included access and adaptability. Constructed in 1995, this privately developed, medium-cost 77-unit condominium is one example of the viability of urban, accessible housing.

Logique has recently prepared *Design Solutions for Accessible and Adaptable Housing* (Société Logique, Richard, & Falta, 1995), a series of guidelines for CMHC that are applicable to both single-family as well as multiunit housing construction. The findings of the postoccupancy evaluation on universal design criteria have thus been extended via the federal government to instruct and encourage private developers to pursue this goal.

It is high time that the housing requirements of persons with physical and sensory limitations be not considered as something special and costly. They can be easily accommodated in all housing, supplemented with simple adaptation provisions. Such an approach not only integrates this growing demographic groups but also serves the whole population by creating a safer and more usable habitat for everyone.

REFERENCES AND BIBLIOGRAPHY

*Accessible Housing Bulletin 1: Making housing more accessible to more Canadians. (1982a). Ottawa: Canadian Housing Design Council.

*Accessible Housing Bulletin 2: Setting your "sites" on good access. (1982b). Ottawa: Canadian Housing Design Council.

*Accessible Housing Bulletin 3: "Inside" information on good access. (1983). Ottawa: Canadian Housing Design Council.

*Barrier-free design: A national standard of Canada (CAN/CSA-B651-M90). (1990). Toronto: Canadian Standards Association. (revised 1995)

*Cost of accessible housing: An analysis of the estimated cost of compliance with the Fair Housing Accessibility Guidelines and ANSI A-117.1. (1993). Washington: U.S. Department of Housing and Urban Development, Office of Policy Development and Research.

Critères de performance en accessibilité universelle. (1994). Montréal: Société Logique.

*Eligible modifications for residential rehabilitation assistance program for disabled persons: A guide for RRAP delivery agents. (1990). Ottawa: Canada Mortgage and Housing Corporation. (revised 1991)

*Fair Housing Amendments Act: Adapt to a better design. (nd). Jackson Heights, Queens, NY: Eastern Paralyzed Veterans Association.

*Falta, L. P. (1984). Accessible housing costs (unpublished report). Ottawa: Canada Mortgage and Housing Corporation.

*Falta, L. P. (1983). Barrier-free design for disabled persons: Evaluation framework for assessing the quality of accessibility in public buildings. In Proceedings of the Fourteenth International Conference of the Environmental Design Research Association (pp. 198–214). Lincoln: University of Nebraska.

Falta, L. P., & Kreiss, S. (1990). Étude comparative des coûts de construction des logements adaptés et des logements universellement accessibles (unpublished report). Montréal: Société Logique.

*Habitations Perras: 44 unités de logement universellement accessibles. (1992). Montréal: Société Logique.

Hickling, RBO Architects, and Société Logique. (1994). Focus groups to examine barrier-free and adaptable housing design. Ottawa: Canada Mortgage and Housing Corporation.

*Housing Choices for Canadians with Disabilities (LNH 6620). (1992). Ottawa: Canada Mortgage and Housing Corporation.

*Kushner, C., Falta, P. L., & Aitkens, A. (1983). Making your home accessible: A disabled consumer's guide. Ottawa: Consumer and Corporate Affairs of Canada.

*Lifchez, R., & Winslow, B. (1977). Design for independent living: The environment and physically disabled people. New York: Whitney Library of Design.

*Maintaining seniors' independence: A guide to home adaptations. (1989). Ottawa: Canada Mortgage and Housing Corporation.

*Entries preceded by an asterisk are bibliographical and are not cited in text.

A modification checklist: Accessibility using RRAP for disabled persons. (1986). Ottawa: Canada Mortgage and Housing Corporation.

Open house: Guide. (nd). Ottawa: Canada Mortgage and Housing Corporation.

*Preiser, W., Rabinowitz, H., & White, E. (1988). *Post-occupancy evaluation.* New York: Van Nostrand Reinhold.

*Simon, A., Aitkens, A., et al. (1988). *Housing an aging population: Guidelines for development and design.* Ottawa: National Advisory Council on Aging.

Société Logique, Richard, P., & Falta, P. L. (1995). *Design solutions for accessible and adaptable housing: Performance criteria and architectural characteristics.* Ottawa: Canada Mortgage and Housing Corporation.

*Zeisel, J., Welch, P., & Demos, S. (1977). *Low-rise elevator housing for older people: Behavioral criteria for design.* Washington: U.S. Department of Housing and Urban Development, Office of Policy Development and Research.

*Zeisel, J., Welch, P., Epp, G., & Demos, S. (1983). *Mid-rise elevator housing for older people: Behavioral criteria for design.* Washington: U.S. Department of Housing and Urban Development, Office of Policy Development and Research.

Zeisel, J. (1981). *Inquiry by design.* Monterey, CA: Brooks-Cole.

17

Selecting Person– Environment Assessments

Barbara Acheson Cooper, Lori Letts, Patricia Rigby, Mary Law, Debra Stewart, and Susan Strong

INTRODUCTION

Rehabilitation practice is broadening not only to meet individual client needs but also to address group and community requirements. It now recognizes and emphasizes the influence of the environment on client function and treatment outcomes. This redirection in practice requires the use of trustworthy instruments of measure that address these person–environment relationships. The chapter presents a process that can be used to select and evaluate instruments for potential use in clinical practice and research. It also provides information on 41 assessments identified through a literature review and consultation with experts. Each assessment tool was rated according to construction, level of measurement, clinical utility, standardization, reliability and validity on 3-point scales. The instruments are listed by usefulness with social units of individual, family, and community and their usefulness identified based on four evaluation dimensions.

Barbara Acheson Cooper, Lori Letts, Mary Law, Debra Stewart, and Susan Strong • School of Rehabilitation Science, McMaster University, Hamilton, Ontario, Canada L85 4K1. Patricia Rigby • Department of Occupational Therapy, University of Toronto, Toronto, Ontario, Canada M5T 1W5.

Enabling Environments: Measuring the Impact of Environment on Disability and Rehabilitation, edited by Edward Steinfeld and G. Scott Danford. Kluwer Academic/Plenum Publishers. 1999.

Issues related to the clinical utility of these instruments in rehabilitation and research suggestions for future steps are also discussed.

Individuals of all ages with disabilities are choosing to live independently in the community. To facilitate this trend, the practice of rehabilitation has become more community-based and requires therapists to interact as much with groups as with individuals (Samsom, 1992). In this context, therapists are being called upon to help clients remain or locate in environments that are becoming increasingly more complex and multifaceted (Law et al., 1996). To meet these challenges, rehabilitation therapists have become aware of the influence that the environment has on the person and are required to evaluate clients, environments, and change accurately.

The purpose of this chapter is to present a process for assessing and selecting person–environment instruments suited to rehabilitation practice, to critique and summarize the instruments identified, and to propose a structure within which these can be organized. The first set of matrices serve a dual function: it categorizes the instruments by person cluster and environmental attribute and allows the assessments available for each of these areas to be reviewed and accessed quickly (Table 17.1). A second series of matrices (Appendices A–C) presents the critique of these measures by person category. These ideas are not limited to rehabilitation and may be of equal use to other disciplines.

METHODS

Selection of Environmental Assessments

Sixty-seven assessments and checklists that addressed environmental factors were identified by means of a broad literature review and consultation with local environmental and clinical experts in the field of rehabilitation. Those that were unpublished, did not focus on the environment or person–environment fit, or lacked a scoring method were eliminated, leaving 41 measures to assess further. Instruments using qualitative methods were not reviewed. Although the use of qualitative methodologies for environmental assessment is increasing and may be useful (Patton, 1990), these methods cannot be categorized as discrete instruments and require time and particular skills to use.

Categorization of Environmental Assessments

Two members of the team of rehabilitation therapists categorized the assessments; the remaining four members validated their decisions. The team identified three types of environmental assessments: those evaluating the accessibility of the setting, those identifying the environmental preferences of users, and those assessing the quality and type of use of the environment.

Accessibility or barrier-free design assessments identify the barriers to access and safety hazards that exist within environments, as in the Readily Achievable Checklist (Cronburg, Barnett, & Goldman, 1991) which focuses on the accessibility of public places to people in wheelchairs. Assessments of environmental preference examine the attributes of the environment that are preferred by respondents, and that influence their environmental choice, as shown by the Person-Environment Fit measure (Kahana, 1974), which collects information on the environmental preferences of older adults in order to identify the optimal housing choice for each person. Assessments of environmental use describe how environments are commonly used by individuals or groups. For example, the Life Stressors and Social Resources Inventory (Moos, Fenn, & Billings, 1988) allows people to describe their social environmental supports and stressors.

Classification

There are many ways to classify the environment. For example, Windley and Scheidt (1980) suggest ordering it by attribute (e.g., safety, accessibility), while Shalinsky (1986) and Knapper and associates (1986) organize it by variants of its physical (inanimate) and psychosocial (animate) characteristics. Classification by person and environment makes the task even more difficult. Transactive approaches that reflect the interwoven transactive person-environment relationship have recently been proposed by authors such as Hancock and Duhl (1985) and Livneh (1987). However, these classifications tend to be highly complex and do not lend themselves easily to categorization.

In our review of person-environmental assessments, we used a taxonomy that was clear and well articulated, comprehensive but not complex, and that provided an ecological framework appropriate to rehabilitation (Law, 1991). It is closest to the Healthy Cities Model proposed by Hancock and Duhl (1985) and considers the person as an individual or part of a larger group (family or community) and the environment from physical, social, cultural, and economic/institutional perspectives.

Most of the assessments we reviewed focused on the physical and social characteristics of the environment and were designed for use with individuals or communities, particularly the institutional community. Many of the instruments evaluated were found to have multiple uses and, therefore are listed in more than one category. The assessments are presented in three groups based on the social unit.

Evaluation of Psychometric Properties

In addition to reviewing psychometric properties, we also systematically examined the purpose, focus, and development of each measure. A standardized form and criteria described by Law (1987; Neurodevelopmental Clinical Research

Table 17.1. Environmental Assessments

Instrument title and author	Environmental attributes measured	Environmental application	Purpose—to determine:	Clinical utility	Instrument development	Psychometric testing
The Accessibility Checklist (Goltsman et al., 1992)	Physical	Community	Accessibility of buildings and outdoor facilities	• Survey checklists for a large number of physical spaces (e.g., playgrounds, retail areas) • Useful in consultation with other professionals	• Manual with clear instructions • Based on ADA, UFAS, California Building Code	• Content validity during scale construction • No reliability testing
Assessment of Home Environments (Yarrow et al., 1975)	Social Cultural	Family	The adequacy of the infant's early developmental environment at home (ages: newborn to 6 months)	• Structured observations • Limited instructions • Useful for early intervention	• Nominal data • Content not justified • No manual	• One interrater reliability study • No validity testing
Assessment Tool (Maltais et al., 1989)	Physical	Individual	Environmental barriers in a house, specific to functional limitations of an elderly person	• Structured questionnaire • Clear instructions • Useful to promote independence of clients in their homes	• Manual available • Nominal data • Norms available	• One interrater reliability study • One content validity study
Behavioral Environmental Assessment Technique (Whitehead et al., 1984)	Social	Community	How adults behave in or use institutional space	• Structured observations • Useful for institutional planning, evaluation of environmental modifications	• No manual	• One reliability study • One content validity study using factor analysis

Child Care Centre Accessibility Checklist (Metropolitan Toronto Community Services, 1990)	Physical	Community	Barrier-free accessibility of child care centers	• Direct observation and measurement of the environment • Clear instructions • Useful for determining physical accessibility	• Manual available • Nominal data • Norms: based on ANSI standards and Ontario building code	• Reliability unknown • Content validity determined based on instrument development
Classroom Environment Scale (Trickett & Moos, 1973)	Social	Individual Community	Aspects of classroom psychosocial environment salient to students and teachers	• Questionnaire • 3 forms, 90 items for each • Useful for consultation within a classroom	• Manual with clear instructions • Items selected based on theory and expert opinion • Nominal data • Norms available	• One reliability study: internal consistency • Content validity tested using factor analysis
Classroom Environment Index (Stern & Walker, 1971)	Social Cultural	Individual Community	A student's perception of the classroom environment	• Self-administered questionnaire • 300 true/false statements • Useful to describe classroom variables (e.g., achievement level) and student/environment fit	• Manual available • Item selection based upon experts, literature, and testing in schools • Norms available • Nominal data	• Internal consistency tested • Factor analysis and discriminative validity tested
Disability Rights Guide (Goldman, 1991)	Economic/ Institutional	Individual Community	Problems affecting persons with disabilities in accessing their community	• Self-report questionnaires address institutional barriers to accessibility • Useful for community planning, advocacy	• Questionnaires are contained within textbook • Contents based upon ADA • Nominal data	• Unknown reliability • Content validity based on instrument development

(continued)

Table 17.1. *(Continued)*

Instrument title and author	Environmental attributes measured	Environmental application	Purpose — to determine:	Clinical utility	Instrument development	Psychometric testing
Environmental Assessment Index (Poresky, 1987)	Physical Social	Family	The educational and developmental quality of the home environment for 3–11-year-old children living in rural communities	• Questionnaire, structured interview, and observations • Clear instructions • Useful for direct service, family education, program evaluation	• Manual available from author • Item selection based on literature review and expert opinion • Nominal data	• One reliability study: internal consistency • Validity: content validity with factor analysis; concurrent and predictive correlations
Environment Scale (Kannegieter, 1986)	Economic/ Institutional	Individual	• The characteristic of the clinical environment as perceived by the psychiatric client	• Structured interview • Useful for individual program planning, program evaluation	• Manual available from unpublished source • No norms • Nominal data • Comprehensive item selection	• Internal consistency and test–retest reliability established • Criterion and content validity testing underway
Environmental Competence Questionnaire (CMHC, 1982)	Physical Social	Individual Community	The competence of elderly persons living independently in their homes	• Questionnaire, structured interview • instructions not provided • Useful for direct service to adults with physical limitations	• No manual • Item selection appears adequate • Nominal data	Unknown reliability and validity

Instrument	Dimensions	Level	Focus	Format/Uses	Practical features	Reliability/Validity
Environmental Grid Description Assessment (Dunning, 1972)	Physical, Social, Cultural	Individual, Family	The individual's relationship with environmental space, people, and tasks	• Semistructured interview • No instructions • Useful as a client-centered assessment of occupational choice	• No manual • Item selection appears adequate	Unknown reliability and validity
Environment Preference Questionnaire (Kaplan, 1977)	Physical	Individual, Community	Individual differences in environmental preferences	• Questionnaire respondent can complete independently • Clear instructions • Useful in direct service	• Manual available from author • Item selection based on lit. review, expert opinion • Ordinal data	• Reliability: internal consistency • Content validity based on factor analysis
Environmental Response Inventory (McKechnie, 1974)	Social	Individual, Family, Community	Differences in the ways persons habitually interact with the environment	• Questionnaire can be completed independently • Clear instructions • Useful for career, lifestyle counseling, program planning	• Manual available • Item selection based on lit. review, limited by factor analysis • Ordinal data	• Reliability unknown • Content, construct, criterion validity established
Functional Requirements in the Physical Environment (United Nations, 1981)	Physical, Economic/Institutional	Community, Province/Country	Features of the built environment for accessibility by persons with physical, sensory and/or cognitive disability	• Checklist • Clear instructions • Useful for community consultation re: accessibility	• Manual available from UN • Item selection comprehensive • Nominal data	• Unknown reliability • Content validity based on instrument development

(continued)

Table 17.1. (*Continued*)

Instrument title and author	Environmental attributes measured	Environmental application	Purpose— to determine:	Clinical utility	Instrument development	Psychometric testing
Home Observation for Measurement of the Environment (Caldwell & Bradley, 1979)	Physical Social Cultural	Family	The adequacy of a child's early developmental environment at home (ages: newborn to 6 years)	• Structured observations and interview with parents • Clear instructions • Useful for consultation and family education	• Manual available • Item selection based on factor analysis • Nominal data	• Internal consistency and test–retest reliability tested, adequate statistical results • Content and construct validity established
Home Survey Checklist (Adaptive Environments Center, 1988)	Physical	Individual	Home safety and potential for independent function of elderly individuals' homes	• Questionnaire and observations in checklist format • Useful to structure modifications to home for an individual's needs	• Manual available • Content justified • Nominal data	• Unknown reliability • Content validity addressed during instrument development
Importance, Locus & Range of Activities Checklist (Hulicka et al., 1975)	Physical Social Cultural	Individual	An individual's perceived latitude of choice in ADL	• Interview with checklist • Clear instructions • Useful for client-centered program planning	• No manual available • Item selection process not well described • Ordinal data	• Test–retest reliability established • Construct and content validity tested

Infant-Toddler Environment Rating Scale (Harms et al., 1990)	Social	The quality of center-based child care for children up to 30 months of age	• Structured observation • Clear instructions • Useful for consultation, program planning	• Manual available • Item selection based on other scales • Ordinal data	• Interrater, test-retest and internal consistency established • Content and criterion validity established
Interpersonal Support Evaluation List (Cohen et al., 1985)	Social	Availability of social support for adults	• Self-report questionnaire • Clear, concise instructions • Useful for direct service, consultation	• Manual available from author • Item selection comprehensive • Nominal data	• Internal consistency and test–retest established • Concurrent and construct validity established
Life Stressors and Social Resources Inventory (Moos et al., 1988)	Physical Social Cultural	Common life stressors and social resources that influence well-being	• Semistructured interview • Clear instructions • Useful for direct service, consultation, and community planning	• Manual available • Item selection based on lit. review and expert opinion • Nominal data	• Internal consistency established • Content validity based on factor analysis
Modification Cheklist (CMHC, 1988)	Physical	Accessibility barriers of a house or apartment	• Checklist based on observations • Clear instructions • Useful for direct service	• Manual available • Item selection based on opinions of clinical experts, disabled persons, rehabilitation centers, architects, etc. • Nominal data	• Unknown reliability • Content validity based on instrument development

(continued)

Table 17.1. (*Continued*)

Instrument title and author	Environmental attributes measured	Environmental application	Purpose— to determine:	Clinical utility	Instrument development	Psychometric testing
Multilevel Assessment Instrument (Lawton et al., 1982)	Social	Individual	The well-being and behavioral competence of elderly at home and in community	• Structured interview • Limited instructions • Useful for comprehensive assessment of function in an environment	• No manual • Item selection based on literature review and expert opinion • Nominal data	• Internal consistency established • Content validity established
Multiphasic Environmental Assessment Procedure (Moos & Lemke, 1988)	Physical Economic/ Institutional Social	Community	The adequacy of sheltered care settings	• Structured questionnaire in five parts • Clear instructions • Useful for consultation in sheltered care settings	• Manual available • Item selection based on theory, lit. review, and experts • Ordinal and interval data • Norms available	• Internal consistency, interrater and test–retest reliability established • Content, construct validity established
Need Satisfaction of Activity Interview (Tickle & Yerxa, 1981)	Social	Individual	The individual's preferences for activities within his or her environment	• Interview • Clear instructions • Useful for direct service, program planning	• No manual; instructions available in published paper • Item selection comprehensive • Descriptive data	• One test–retest reliability study • Content test–retest study • Content validity based on factor analysis

Perceived Environment Constraint Index (Wolk & Telleen, 1976)	Economic/ Institutional	Individual Community	The level of personal autonomy allowed in a geriatric residential setting	• Self-report questionnaire • Clear instructions • Useful for institutional planning	• Instructions available in text • Item selection comprehensive • Ordinal data	• Unknown reliability • Content validity established
Person-Environment Fit (Kahana, 1974)	Physical Social Cultural Economic/ Institutional	Individual Community	Congruence between residential environment and elderly individual	• Self-report questionnaire • Limited instructions • Useful for long term care planning, consultation	• No manual • Item selection comprehensive • Nominal data	• Unknown reliability and validity
Person-Environment Fit Scale (Coulton, 1979)	Physical Social Cultural Economic/ Institutional	Individual Community	Person–environment fit	• Self-report questionnaire • Clear instructions • Useful for direct service, community consultation, and planning	• Manual available from author • Item selection based on lit. review and expert opinion • Ordinal data	• Internal consistency established • Content and construct validity established
Planner's Guide to Barrier-Free Meetings (Russell, 1980)	Physical	Community	Barrier-free accessibility of facilities for group meetings	• Checklist • Clear instructions • Useful for consultation re: accessibility	• Manual available • Item selection based on ANSI standards • Nominal data	• Unknown reliability • Content validity addressed in instrument development
Planning Barrier-Free Libraries (National Library Service, 1981)	Physical Economic/ Institutional	Community	Barrier-free accessibility of public libraries	• Checklist • Clear instructions • Useful for community consultation	• Manual available • Item selection based on ANSI standards, expert and consumer opinion • Nominal data	• Unknown feasibility • Content validity addressed in instrument development

(continued)

Table 17.1. (*Continued*)

Instrument title and author	Environmental attributes measured	Environmental application	Purpose— to determine:	Clinical utility	Instrument development	Psychometric testing
Play History (Takata, 1969; Behnke & Fetkovich, 1984)	Physical Social Cultural	Individual Family	A child's past and present play experiences and environmental opportunities	• Semistructured interview • Clear instructions • Useful for direct service	• No manual; instructives available from authors • Item selection based on lit. review • Ordinal data	• Interrater and test–retest reliability established • Content and concurrent validity tested
Quality of Life Interview (Lehman, 1988)	Social Individual	Satisfaction in 9 life domains	• Interview • Clear instructions • Useful in direct, client-centered service	• Manual available • Item selection based on literature review • Ordinal data	• Internal consistency and test–retest reliability tested • Construct validity established	
Readily Achievable Checklist (Cronburg et al., 1991)	Physical	Community	Barriers to accessibility	• Structured observations and measurements • Useful for planning public accessibility	• Manual available • Instructions and guidelines comprehensive	• Unknown reliability • Content validity addressed during instrument development
Safety Assessment of Function & the Environment for Rehabilitation (COTA, 1991)	Physical Social	Individual	The ability of the elderly person to function safely in his or her home	• Checklist using observations and interview • Clear instructions • Useful for community-based practice, discharge planning	• Manual available from author • Item selection based on lit. review, clinician and consumer opinion • Nominal data	• Internal consistency established • Content and construct validity tested

Instrument	Type	Level	Focus	Format	Development	Reliability/Validity
School-Quick Checklist (Ontario Ministry of Education, 1986)	Physical	Community	Accessibility barriers of schools; Modification requirements	• Checklist; observations • Clear instructions • Useful for school consultations	• Manual available • Item selection based on building code standards • Nominal data	• Unknown reliability • Content validity addressed in instrument development
Source Book (Kelly & Snell, 1989)	Physical	Individual	Environmental barriers in a house, specific to functional limitations of a physically disabled person	• Structured questionnaire, observations, and guidelines • Clear instructions • Useful for direct service, consultation	• Manual available • Item selection based on lit. review and expert opinion • Nominal data • Standards based on ANSI and CSA	• No reliability testing • Content validity addressed in instrument development
Tenant Interview (Howell, 1980)	Social	Community	Behavior preferences of adults living in congregate housing	• Structured interview • Clear instructions • Useful for program planning	• Manual available • Item selection based on lit. review and expert opinion • Nominal data	Unknown reliability and validity
Therapeutic Environment Guidelines (Chambers et al., 1988)	Economic/ Institutional	Community	Attributed of residential lodges for adults needing long-term care	• Checklist to use with observations and unstructured interview • Clear instructions • Useful for consultation	• No manual available • Item selection based on lit. review and expert opinions • Ordinal data	• Unknown reliability • Content validity based on instrument development

(continued)

Table 17.1. (*Continued*)

Instrument title and author	Environmental attributes measured	Environmental application	Purpose— to determine:	Clinical utility	Instrument development	Psychometric testing
United Cerebral Palsy: Initial Evaluation (Colvin & Korn, 1984)	Physical	Family	Physical barriers to the care of children with cerebral palsy within their own home environment	• Semistructured questionnaire using observations and interview • Clear instructions • Useful in community practice	• No manual available • Item selection based on ANSI standards • Nominal data	• Unknown reliability • Content validity addressed in instrument development
Work Environment Scale (Moos, 1981)	Social	Individual Community	Interpersonal environment of workplace as perceived by employers and staff	• Structured questionnaire • Clear instructions • Useful for direct service, workplace consultation	• Manual available • Item selection based on theory, lit. review, expert opinion • Nominal data	• Internal consistency and test–retest reliability established • Content validity based on factor analysis
Workplace Workbook (Mueller, 1990)	Physical	Individual	Environmental barriers in a workplace	• Structured observations and measurements for barrier-free accessibility • Useful for preparing the work environment for a person with a physical disability	• Manual available • Content justified • Nominal data	• Unknown reliability • Content validity addressed during instrument development

Unit [NCRU], 1991) was used. These criteria have been used to evaluate assessments of activities of daily living (Law & Letts, 1989), as well as neurodevelopmental assessments (Gowland et al., 1991). The form includes a review of the following areas: instrument construction, level of measurement, standardization, clinical utility, reliability, and validity. The criteria used to rate the instruments is further described in the following sections. For each instrument, a research team member familiar with the assessment completed the rating form. The completed rating forms were then checked by all members of the group, to ensure consistency and accuracy.

Instrument Construction

The evaluation of instrument construction examined the methods used to generate items in an instrument. A 3-point rating scale was used for this review. Instrument construction was judged to be excellent if the instrument included most relevant characteristics of the environmental attribute based on a comprehensive literature review, the views of clinical experts, and/or input of clients. Additionally, the developers needed to demonstrate clearly how the items had been generated and that they were comprehensive. Instrument construction was considered adequate if most of the relevant characteristics were included, even if the method of selecting items was sometimes unclear. A poor rating was assigned if the instrument included only a cursory sample of items.

Instrument construction was rated as either adequate or excellent for all of the environmental assessments reviewed, meaning that they covered the domain of the instrument in a comprehensive manner. Some instruments were clearly based on a specific theoretical construct (e.g., Moos & Lemke, 1988), a review of the literature (e.g., Takata, 1969), expert opinion (e.g., Stern & Walker, 1971), and consumer input (National Library Service, 1981). Others, particularly those focusing on barrier-free accessibility, developed items based on accessibility standards (e.g., Goltsman et al., 1992; Kelly & Snell, 1989).

Level of Measurement

Level of measurement determines the type and rigor of statistical analysis that can be performed on the data (Streiner & Norman, 1989). Therefore, the instruments were examined to identify whether they gathered nominal, ordinal, interval, or ratio data. The types of scores generated by each instrument were noted. Most instruments collected nominal or categorical data. Some gathered ordinal data, usually by means of a Likert scale for individual items; almost none collected interval or ratio data.

Judgments about the level of measurement associated with each instrument were not made, since the appropriateness of this factor depends on the purpose for which the instrument was designed. For example, the rehabilitation therapist assessing a client's ability to manage safely at home might consider using an instrument that renders nominal ratings of individual items; this would provide

sufficient and appropriate descriptive clinical information. However, if an instrument was selected for research purposes or program evaluation or if the results were to be compared to those provided by other measures, a tool that gathered interval or ratio data and generated summary scores would be preferable.

Standardization

The instruments were reviewed for standardization using the following criteria: the existence and availability of a manual to guide instrument completion and the availability of norms when appropriate. Manuals that describe the administration of the test clearly help ensure that the test will be used in a consistent manner, should ideally be readily available, and will include procedures for the administration, scoring, and interpretation of the instrument. Manuals were available for 28 of the 41 environmental assessments reviewed, although some had to be obtained directly from the author.

Norms may be useful for some environmental assessments. When assessing home settings of infants, norms allow the observer to compare the environment being assessed to a standard (Krauss & Jacobs, 1990). Where assessments were based on building specifications like the American National Standards Institute (ANSI) specifications, these minimal standards become the criteria by which to compare environments. In both of these examples, having a norm or standard for comparison is useful in guiding intervention. On the other hand, since all types of environments vary and responses to them are not homogenous, it is debatable whether the concept of a standard environment is possible, particularly when environmental use or preference is the focus of the assessment. Only five of the assessments reviewed had norms.

Clinical Utility

A number of factors contribute to the clinical utility of an instrument: the clarity and availability of instructions, the time required to administer the instrument, its cost, format (e.g., structured interview, self-report, observation), the requirements regarding qualifications to administer, and the value of the information provided.

Standardized and self-report instruments usually came with manuals or clear directions for administration; instructions for checklists and interview formats tended to be less comprehensive. The cost of the instruments was generally low. Most were available at no cost through public sources such as journals, books, and government offices and agencies, or for a small fee, usually less than $100. The formats of the instruments varied according to purpose, age group, and the type of environmental characteristic being evaluated. None of the instruments required special qualifications or training courses to administer. The instruments identified were multidisciplinary in origin and, therefore, unfamiliar to most

rehabilitation therapists. Additionally, their application in practice settings is only now being addressed by the authors of this chapter.

Reliability

The consistency of results provided by the instrument ascertains its reliability. Testing for this psychometric property considers the internal consistency of the instrument and agreement of outcomes when the test is administered at different times (test–retest); by the same person (intrarater), or by various individuals (interrater) (Law, 1987; Law et al., 1992). Three factors were considered when judging the reliability of instruments: the number of studies reported, the statistical analysis used, and the level of the coefficient of reliability reported (Law, 1987). Measures were rated as excellent when more than two rigorous and well-designed studies reporting on reliability were located, adequate when only one or two studies were found, and poor when no studies were available. The appropriateness of the statistical testing for the level of data generated was also examined. Reliability was judged in the same manner: excellent when the coefficient was greater than 0.80; adequate when it was between 0.60 and 0.79; and poor when it was lower than 0.60.

The amount of reliability testing reported on the instruments varied considerably, as many of the measures in common use have not been examined at all for this attribute. For example, both the Child Care Centre Accessibility Checklist (Metropolitan Toronto Community Services Department, 1991), and the Environment Response Inventory (McKechnie, 1977) are untested. In contrast, the Multiphasic Environmental Assessment Process (MEAP) (Moos & Lemke, 1988) has undergone extensive testing for all subscales, as have the Infant Toddler Environment Rating Scale (Harms, Cryer, & Clifford, 1990) and the Interpersonal Support Evaluation List (Cohen, Mermelstein, Kamarck, & Hoberman, 1985).

Validity

Validity examines whether or not an instrument is assessing what it is intended to measure. Validity testing explores different facets of this attribute: content, construct, and criterion validity (Law, 1987), as well as the responsiveness of the instrument to determine change (Kirshner & Guyatt, 1985). Criteria for the review of each type of validity include the number of validity studies undertaken and the results of those studies (Law, 1987; NCRU, 1991). Excellent ratings were assigned if more than two well-designed and rigorous validity studies had been completed. Adequate ratings were given if only one or two such studies had been completed. Poor ratings were given when no validation had been conducted. The type of validity evaluated and the results reported were also used to establish the rigor of the studies reviewed.

Content validity has been clearly established for almost all of the environ-

mental assessments reviewed, and in fact, most of the studies focused only on this aspect of validity testing. While this is an appropriate first step, further studies to explore construct and criterion validity should follow. Only two environmental assessments received excellent ratings because they had undergone more than two well-designed studies to evaluate content and construct validity (Caldwell & Bradley, 1979; Moos & Lemke, 1988). For the remaining environmental assessments, further research is needed to evaluate their construct and criterion validity. Also, for instruments that are intended to be used to evaluate change, the responsiveness of the instruments must be evaluated.

Assessments

The measures can be arranged into three categories: those that assessed attributes of the individual, those that dealt with family issues, and those that evaluated the concerns of larger groups in the community. These categories are set on the vertical axis of the matrices (Appendices A–C). Information in the cells of the horizontal axis of the matrices identifies the purpose of the instrument, its construction and level of measurement, and reports on the psychometric evaluation. A more detailed description of this material is provided in Law et al. (1992) and Letts et al. (1994).

Assessments of Use with Individuals

The review identified 25 instruments that could be used to evaluate the fit of the individual within different aspects of the environment. Most of these (22) address issues related to the physical and social environment; considerably fewer dealt with cultural, economic, and institutional concerns, although no area was left unaddressed. Appendix A summarizes the critical review of each of these instruments.

Assessments of Use with Families

The review identified 8 instruments that could be used to evaluate the fit of the family within different aspects of the environment. These also primarily address issues related to the physical and social environment. Appendix B summarizes the critical review of each of these instruments.

Assessments of Use with Communities

The review identified 24 instruments that could be used to evaluate the fit of the community within different aspects of the environment. Similarly, the majority (21) address the physical and/or social environment. Appendix C summarizes the critical review of each of these instruments.

Selection of Instruments of Measure

The review suggests that there are many instruments that can be used to assess the fit between clients and their environments. However, most of these have been designed by other disciplines and have not been previously used by rehabilitation therapists. As a consequence, their clinical utility in this field is not reported. Rather than wait until this information is available, the authors suggest that the instruments identified here are sufficiently generic to be tried in clinical practice.

To select an assessment, the first step is to decide which type is required. For example, if a postoccupancy evaluation of a school is being conducted to determine whether or not children with multiple disabilities are able to use the environment as intended, an assessment of use in combination with an accessibility assessment would be appropriate. The second step is to consider the category of client being served: individual, family, or community group. The final step is to review the information available on psychometric properties and to choose the instrument with the highest ratings.

CONCLUSION

A wide selection of person–environment assessments exist. The matrix structure makes it clear that there are gaps in the type of measures available, for example, there is a lack of cultural, economic/institutional, and macro-environmental measures. A review by six therapists determined that over 40 of these appear to have clinical value for rehabilitation. However, the clinical utility of these measures in practice is not yet reported. The review failed to establish whether these instruments are currently used by rehabilitation therapists, however, it is our belief that they are not.

The process of evaluation and categorization described in this chapter is clearly incomplete. It will be continually influenced by the development of new and more effective assessment tools, by the reporting of new information on the reliability and validity of existing instruments of measure; and by attitudinal and legislative changes that influence professional roles and the application of specific outcome measures. This raises several questions about responsibility: Who establishes the psychometric properties of measures, reviews their clinical utility for specific groups, maintains and updates their content, and makes them readily available to the public? The magnitude of the task argues for collaboration among disciplinary groups, for programmatic approaches to addressing the gaps in knowledge, and for the rigorous and conscientious dissemination of results of studies addressing these issues across disciplines.

Appendix A. Evaluation of Person–Environment Assessments of Use with Individuals

Instrument title and author	Purpose—to determine:	Instrument construction	Level of measurement	Standard-ization	Clinical utility	Reliability	Validity
Assessment Tool (Maltais et al., 1989)	Environmental barriers in a house, specific to functional limitations of older adults	+++	N	Yes*	+++	++	++
Classroom Environment Scale (Trickett & Moos, 1973)	Aspects of classroom psychosocial environment salient to students and teachers	+++	N	Yes*	+++	++	++
Classroom Environment Index (Stern & Walker, 1971)	A student's perception of the classroom environment	+++	N	Yes*	++	++	++
Disability Rights Guide (Goldman, 1991)	Problems affecting persons with disabilities in accessing their community	++	N	No	++	+	++
Environment Assessment Scale (Kannegieter, 1986)	Characteristics of clinical environment perceived by the psychiatric client	+++	N	Yes†	++	+++	++
Environmental Grid Description Assessment (Dunning, 1972)	Individual's relationship with environmental space, people and tasks	++	N	No	+	+	+
Environment Preference Questionnaire (Kaplan, 1977)	Individual differences in environmental preferences	+++	O	Yes†	++	++	++
Environment Response Inventory (McKechnie, 1974)	Differences in the ways persons habitually interact with the environment	+++	O	Yes	+++	+	++
Home Modification Workbook (Adaptive Environments Center, 1988)	Home safety and potential for independent function of elderly individuals' homes	++	N	Yes	++	+	++
Importance, Locus & Range of Activities Checklist (Hulicka et al., 1975)	An individual's perceived latitude of choice in activities of daily living	++	O	No	++	++	++
Interpersonal Support Evaluation List (Cohen et al., 1985)	Availability of social support for adults	++	N	Yes*	++	+++	++

Assessment	Description						
Life Stressors & Social Resources Inventory (Moos et al., 1988)	Common life stressors and social resources which influence wellbeing	+++	N	Yes*	+++	++	++
Modification Checklist (CMHC, 1988)	Accessibility barriers of a house or apartment	+++	N	Yes	+++	+	++
Multilevel Assessment Instrument (Lawton et al., 1982)	Well-being and behavioral competence of older adults at home and in community	+++	N	No	++	++	++
Need Satisfaction of Activity Interview (Tickle & Yerxa, 1981)	Individual's preferences for activities within his/her environment	+++	N	No	++	++	++
Perceived Environment Constraint Index (Wolk & Telleen, 1976)	Level of personal autonomy allowed in a geriatric residential setting	++	O	No	++	+	++
Person-Environment Fit (Kahana, 1974)	Congruence between residential environment and elderly individual	++	N	No	++	+	+
Person-Environment Fit Scale (Coulton, 1979)	Person-environment fit	+++	O	Yes†	+++	++	++
Play History (Takata, 1969; Behnke & Ketkovich, 1984)	A child's past and present play experiences and environmental opportunities	++	O	No	++	++	++
Quality of Life Interview (Lehman, 1988)	Satisfaction in 9 life domains	+++	O	Yes	+++	++	+++
SAFER (COTA, 1991; Oliver et al., 1993)	Ability of the older people to function safely in their homes	+++	N	Yes†	++	++	++
Source Book (Kelly & Snell, 1989)	Environmental barriers in a house, specific to functional limitations of a physically disabled person	+++	N	Yes	+++	+	++
Work Environment Scale (Moos, 1981)	Dimensions of relationships, personal development, system maintenance and change in the workplace as perceived by employers and staff	+++	N	Yes	+++	+++	++
Workplace Workbook (Mueller, 1990)	Environmental barriers in a workplace	++	N	Yes	+++	+	++

Legend: +++ = excellent, ++ = adequate, + = poor or absent; N = nominal, O = ordinal; * = norms available, † = available from author.

Appendix B. Evaluation of Person–Environment Assessments of Use with Families

Instrument title and author	Purpose—to determine:	Instrument construction	Level of measurement	Standard-ization	Clinical utility	Reliability	Validity
Assessment of Home Environment (Yarrow et al., 1975)	Adequacy of infant's early environment at home (ages: newborn to 6 months)	L++	N R	No	++	++	+
Environment Assessment Index (Poresky, 1987)	Educational and developmental quality of the home environment for children 3 to 11 years in rural communities	+++	N	Yes*	++	++	++
Environmental Grid Description Assessment (Dunning, 1972)	The individual's relationship with environmental space, people, and tasks	++	N	No	+	+	+
Environmental Response Inventory (McKechnie, 1974)	Differences in the ways persons habitually interact with the environment	+++	O	Yes	+++	+	++
Home Observation for Measurement of the Environment (HOME) (Caldwell & Bradley, 1979)	Adequacy of a child's early developmental environment at home (ages 0 to 6 years)	++	N	Yes	+++	+++	+++
Life Stressors & Social Resources Inventory (Moos et al., 1988)	Common life stressors and social resources which influence well-being	+++	N	Yes*	+++	++	++
Play History (Takata, 1969; Behnke & Ketkovich, 1984)	A child's past and present play experiences and environmental opportunities	++	O	No	++	++	++
United Cerebral Palsy: Initial Evaluation (Colvin & Korn, 1984)	Physical barriers to the care of children with cerebral palsy within their home environments	++	O	No	++	+	+

Legend: +++ = excellent, ++ = adequate, + = poor or absent; N = nominal, O = ordinal, R = ratio; * = norms available, † = available from author.

Appendix C. Evaluation of Person–Environment Assessments of Use with Communities

Instrument title and author	Purpose—to determine:	Instrument construction	Level of measurement	Standard-ization	Clinical utility	Reliability	Validity
The Accessibility Checklist (Goltsman et al., 1992)	Accessibility of buildings and outdoor facilities	++	N	Yes	++	+	++
Behavioral Environment Assessment Technique (Whitehead et al., 1984)	How adults behave in or use institutional space	++	N	No	++	++	++
Child Care Centre Accessibility Checklist (Metropolitan Toronto Community Services, 1991)	Barrier-free accessibility of child care centers	+++	No	Yes†	+++	+$	++
Classroom Environment Scale (Trickett & Moos, 1973)	Aspects of classroom psychosocial environment salient to students and teachers	+++	N	Yes*	+++	++	++
Classroom Environment Index (Stern & Walker, 1971)	A student's perception of the classroom environment	+++	N	Yes*	++	++	++
Disability Rights Guide (Goldman, 1991)	Problems affecting persons with disabilities in accessing their community	++	N	No	++	+	++
Environment Competence Questionnaire (CMHC, 1982)	The competence of elderly persons living independently in their homes	++	N	No	++	+	+
Environment Preference Questionnaire (Kaplan, 1977)	Individual differences in environmental preferences	+++	O	Yes†	++	++	++

(continued)

Appendix C. *(Continued)*

Instrument title and author	Purpose—to determine:	Instrument construction	Level of measurement	Standard-ization	Clinical utility	Reliability	Validity
Environment Response Inventory (McKechnie, 1974)	Differences in the ways persons habitually interact with the environment	+++	O	Yes	+++	+	++
Functional Requirements in the Physical Environment (United Nations, 1981)	Features of the built environment for accessibility by persons with physical, sensory, or cognitive disability	+++	N	Yes	+++	+	+
Infant-Toddler Environment Rating Scale (Harms et al., 1990)	Quality of center-based child care for children up to 30 months of age	++	O	Yes	+++	+++	++
Life Stressors & Social Resources Inventory (Moos et al., 1988)	Common life stressors and social resources which influence well-being	+++	N	Yes*	+++	++	++
Modification Checklist (CMHC, 1988)	Accessibility barriers of a house or apartment	+++	N	Yes	+++	+	++
Multiphasic Environmental Assessment Procedure (Moos & Lemke, 1988)	Adequacy of sheltered care settings	+++	O	Yes*	+++	+++	+++
Perceived Environment Constraint Index (Wolk & Teleen, 1976)	Accessibility of buildings and outdoor facilities	++	O	No	++	+	++

Assessment (Citation)	Description							
Person-Environment Fit (Kahana, 1974)	Congruence between residential environment and older individual	++	N	No	++	+	+	+
Person-Environment Fit Scale (Coulton, 1979)	Person–environment fit	+++	O	Yes†	+++	++	++	++
Planner's Guide to Barrier-Free Meetings (Russell, 1980)	Barrier-free accessibility of facilities for group meetings	++	N	Yes	++	+	+	+
Planning Barrier-Free Libraries (National Libaray Service, 1981)	Barrier-free accessibility of public libraries	+++	N	Yes	+++	+	+	+
Readily Available Checklist (Cronburg et al., 1991)	Barriers to accessibility	++	N	Yes	++	+	+	++
School-Quick Checklist (Ontarior Ministry of Education, 1986)	Accessibility of barriers of school; modification requirements	++	N	Yes	+++	+	+	++
Tenant Interview (Howell, 1980)	Behavioral preferences of adults living in congregate housing	+++	N	Yes	++	+	+	+
Therapeutic Community Guidelines (Chambers et al., 1988)	Attributes of residential lodges for adults needing long-term care	+++	O	No	++	+	+	++
Work Environment Scale (Moos, 1981)	Dimensions of relationships, personal development, system maintenance and change in the workplace as perceived by employers and staff	+++	N	Yes	+++	+++	+++	++

Legend: +++ = excellent, ++ = adequate, + = poor; N = nominal, O = ordinal; * = norms available, † = available from author.

REFERENCES

Adaptive Environments Center. (1988). *Home modification workbook*. Boston, MA: Author.

Behnke, C., & Fetkovich, M. (1984). Examining the reliability and validity of the play history. *American Journal of Occupational Therapy, 38*, 94–100.

Caldwell, B. M., & Bradley, R. H. (1979). *Home observation for measurement of the environment*. Little Rock: University of Arkansas.

Canada Mortgage and Housing Corporation (CMHC). (1982). *Environmental competence amongst independent elderly households*. Ottawa: Author.

Canada Mortgage and Housing Corporation. (1988). *A modification checklist: Accessibility for disabled persons using the Residential Rehabilitation Assistance Program (RRAP) for the disabled*. Ottawa: Author.

Chambers, L., Forchuk, C., Munroe-Blum, H., Woodcox, R. N., Moore, G., & Wigmore, D. (1988). The development of guidelines to promote a therapeutic environment in lodging homes. *Canada's Mental Health* (December), 14–18.

Cohen, S., Mermelstein, R., Kamarck, T., & Hoberman, H. M. (1985). Measuring the functional components of social support. In I. G. Sarason & B. R. Sarason (Eds.), *Social support: Theory, research and applications* (pp. 73–94). Boston, MA: Martinus Nijhoff.

Colvin, M. E., & Korn, T. L. (1984). Eliminating barriers to the disabled. *American Journal of Occupational Therapy, 38*, 748–753.

Community Occupational Therapists & Associates (COTA). (1991). *Safety Assessment of Function and the Environment for Rehabilitation (SAFER)*, Toronto, ON: Author.

Coulton, C. J. (1979). Developing an instrument to measure person-environment fit. *Journal of Social Service Research, 3*, 159–173.

Cronburg, J., Barnett, J., & Goldman, N. (1991). *Readily achievable checklist: A survey for accessibility*. Washington, DC: National Center for Access Unlimited.

Dunning, G. (1972). Environmental occupational therapy. *American Journal of Occupational Therapy, 26*, 292–298.

Goldman, C. D. (1991). *Disability rights guide: Practical solutions to problems affecting people with disabilities*. Lincoln, NB: Media Publishing.

Goltsman, S. M., Gilbert, T. A., & Wohlford, S. D. (1992). *The accessibility checklist: An evaluating system for buildings and outdoor settings*. Berkeley, CA: M.I.G. Communications.

Gowland, C., King, G., King, S., Law, M., Letts, L., MacKinnon, L., Rosenbaum, P., & Russell, D. (1991). *Review of selected measures in neurodevelopmental rehabilitation* (Research Report #91-2). Hamilton, ON: Neurodevelopmental Clinical Research Unit.

Harms, T., Cryer, D., & Clifford, R. M. (1990). *Infant/toddler environmental rating scale*. New York: Teacher's College Press.

Hancock, T., & Duhl, L. J. (1985). The mandala of health: A model of the human ecosystem. *Family and Community Health, 8*, 1–10.

Howell, S. C. (1980). *Tenant Interview*. Cambridge, MA: MIT Press.

Hulicka, I. M., Morganti, J. B., & Cataldo, J. F. (1975). Importance, locus and range of activities check list. *Experimental Aging Research, 1*, 27–39.

Kahana, E. (1974). Matching environments to needs of the aged: A conceptual scheme. In J. F. Gubrium (Ed.), *Late life: Communities and Environmental Policy* (pp. 201–214). Springfield, IL: Charles C Thomas.

Kannegieter, R. B. (1986). The development of the environment assessment scale. *Occupational Therapy in Mental Health, 6*, 67–83.

Kaplan, R. (1977). Patterns of environmental preference. *Environment and Behavior, 9*, 195–216.

Kelly, C., & Snell, K. (1989). *The source book: Architectural guidelines for barrier-free design*. Toronto ON: Barrier-Free Design Centre.

Kirshner, B., & Guyatt, G. (1985). A methodological framework for assessing health indices. *Journal of Chronic Diseases, 38*(1), 27–36.

Knapper, C., Lerner, S., & Bunting, T. (1986). Special groups and the environment: An introduction. *Environments, 18*(3), 1-5.

Krauss, M. W., & Jacobs, F. (1990). Family assessment: Purposes and techniques. In S. J. Meisels & J. P. Schondoff (Eds.), *Handbook of early childhood intervention* (pp. 303-325). Cambridge, MA: Harvard University Press.

Law, M. (1987). Measurement in occupational therapy: Scientific criteria for evaluation. *Canadian Journal of Occupational Therapy, 58,* 171-180.

Law, M. (1991). The Muriel Driver Lecture: The environment: a focus for occupational therapy. *Canadian Journal of Occupational Therapy, 58,* 171-179.

Law, M., & Letts, L. (1989). A critical review of scales of activities of daily living. *American Journal of Occupational Therapy, 43,* 522-528.

Law, M., Cooper, B., Letts, L., Rigby, P., Stewart, D., & Strong, S. (1992). *The environment: A critical review of person-environment relations and environmental assessment.* McMaster University, Hamilton, ON: Neurodevelopmental Clinical Research Unit.

Law, M., Cooper, B., Strong, S., Stewart, D., Rigby, P., & Letts, L. (1996). The person-environment-occupation model: A transactive approach to occupational performance. *The Canadian Journal of Occupational Therapy, 63*(1), 9-23.

Lawton, M. P., Moss, M., Fulcomer, M., & Kleban, M. H. (1982). A research and service oriented multilevel assessment instrument. *Journal of Gerontology, 37,* 91-99.

Lehman, A. F. (1988). A quality of life interview for the chronically mentally ill. *Evaluation and Program Planning, 11,* 51-62.

Letts, L., Law, M., Rigby, P., Cooper, B., Stewart, D., & Strong, S. (1994). Person-environment assessments in occupational therapy. *American Journal of Occupational Therapy, 48,* 608-618.

Livneh, H. (1987). Person-environment congruence: A rehabilitation perspective. *Rehabilitation Research, 10,* 3-19.

Maltais, D., Trickey, F., Robitaille, Y., & Rodriguez, L. (1989). *Maintaining seniors' independence: A guide to home adaptations.* Ottawa, ON: CMHC.

McKechnie, G. E. (1974). *Manual for the environmental response inventory.* Palo Alto, CA: Consulting Psychologists Press.

McKechnie, G. E. (1977). The environmental response inventory in application. *Environment and Behavior, 9,* 255-276.

Metropolitan Toronto Community Services Department, Children's Services Division. (1991). *Action for access.* Toronto ON: Author.

Moos, R. H. (1981). *Work environment scale manual.* Palo Alto, CA: Consulting Psychologists Press.

Moos, R. H., Fenn, C. B., & Billings, A. G. (1988). Life stressors and social resources: An integrated assessment approach. *Social Science and Medicine, 27,* 999-1002.

Moos, R. H., & Lemke, S. (1988). *Multiphasic environmental assessment procedure.* Palo Alto, CA: Social Ecology Laboratory.

Mueller, J. (1990). *The workplace workbook: An illustrated guide to job accommodation and assistive technology.* Washington, DC: Dole Foundation.

National Library Service for the Blind and Physically Handicapped. (1981). *Planning barrier-free libraries: A guide for renovation and construction of libraries serving blind and physically handicapped readers.* Washington, DC: Library of Congress.

Neurodevelopmental Clinical Research Unit. (1991). *Guidelines for reviewing clinical measures.* Hamilton, ON: Author.

Oliver, R., Blathwayt, J., Brackley, C., & Tamaki, T. (1993). Development of the Safety Assessment of Function and the Environment for Rehabilitation (SAFER) tool. *Canadian Journal of Occupational Therapy, 60,* 78-82.

Ontario Ministry of Education. (1986). *Designing for the physically disabled.* Toronto, ON: Author.

Patton, M. Q. (1990). *Qualitative evaluation and research methods* (2nd ed.). Newbury Park, CA: Sage.

Poresky, R. H. (1987). Environmental assessment index: Reliability, stability, and validity of the long and short forms. *Educational and Psychological Measurement, 47,* 969-975.

Russell, H. (1980). *The Planner's Guide to Barrier Free Meetings*. Raleigh, NC: Barrier Free Environments.

Samson, L. (1992). Consultancy issues concerning accessibility. In E. G. Jaffe and C. F. Epstein (Eds.), *Occupational therapy consultation: Theory, principles and practice* (pp. 385-394). New York: Mosby.

Shalinsky, W. (1986). Disabled persons and their environments. *Environments, 17*(1), 1-8.

Stern, G. G., & Walker, W. J. (1971). *Classroom Environment Index*. Syracuse, NY: Evaluation Research Associates.

Streiner, D. L., & Norman, G. R. (1989). *Health measurement scales: A practical guide to their development and use*. Oxford: Oxford University Press.

Takata, N. (1969). The play history. *American Journal of Occupational Therapy, 23*, 314-318.

Tickle, L. S., & Yerxa, E. J. (1981). Need satisfaction of older persons living in the community and in institutions. *American Journal of Occupational Therapy, 35*, 650-655.

Trickett, E. J., & Moos, R. H. (1973). The social environment of junior high & high school classrooms. *Journal of Educational Psychology, 65*, 93-102.

United Nations Centre for Human Settlements. (1981). *Designing with care: A guide to adaptation of the built environment for disabled persons* (Joint project of the Swedish Development Authority, The United Nations and the United Centre for Human Settlements). New York: United Nations.

Windley, L., & Scheidt, R. (1980). Person-environment dialectics: Implications for functioning in old age. In L. Poon (Ed.), *Aging in the 1980's: Psychological Issues* (pp. 407-423). New York: Academic Press.

Whitehead, C. C., Polsky, R. H., Crookshank, C., & Fik, E. (1984). Objective and subjective evaluation of psychiatric ward redesign. *American Journal of Psychiatry, 141*, 639-644.

Wolk, S., & Telleen, S. (1976). Psychological & social correlates of life satisfaction as a function of residential constraint. *Journal of Gerontology, 31*, 89-98.

Yarrow, L. J., Rubenstein, J. L., & Pederson, F. A. (1975). *Infant and environment: Early cognitive and motivational development*. New York: Wiley.

Index

Aberrant Behavior Checklist, 268
Ability, normal range of, 331–332
Access Board, 47–48
Accessibility, *see also* Accessible design;
 Universal design
 acceptable level of, 12
 as civil right, 50
 functional, definition of, 333
 international symbol for, 297, 298
 perception of, 333
 variability of, 298
Accessibility Checklist, The, 376, 395
Accessibility movement, beginning of,
 303
Accessible design
 civil rights legislation for, 2
 computer-aided, building code compli-
 ance of, rule-based assessment of,
 319–330
 precedents for, 322–323
 rationale for, 321–322
 virtual building inspector simulation in,
 319–320, 325–326, 328
 virtual user simulation in, 320, 323–
 324, 326, 328
 differentiated from accessible design,
 8
 norms for, 8–9, 11–12, 18, 20–21, 25
 relationship to observed task perfor-
 mance, 18
 traditional approaches in, 35–36, 37
 universal: *see* Universal design
Accommodation, environmental, 112–113
Activities, differentiated from actones and
 tasks, 144–145

Activities of daily living (ADLs)
 A Day's Journey Through Life® (game/
 simulation), evaluation of, 208–
 209, 211–231
 benefits of, 230
 caregivers' involvement in, 215
 comparison with conventional assess-
 ment techniques, 219–224, 229
 gameboard of, 215, 216
 gaming history background of, 213–214
 home setting of, 215
 quantitative approach of, 219–229
 rounds of play in, 216–219, 220
 videotaping use in, 215
 physical barriers to, 211–212
Actones, 144
Adjusted goodness of fit test, 288n
Affordances, 142, 148
Aging, of the population, 89
Allen, Layman, 214
Alzheimer's disease patients: *see* Dementia
 patients
American Institute of Architects, 185
American National Standards Institute
 (ANSI), 184, 185, 203, 303, 314,
 388
Americans with Disabilities Act, 2, 271, 293
 Accessibility Guidelines of, 47–48, 184,
 185, 187, 188–189, 203, 326
 environmental simulation software and,
 312
 public building access requirement of, 329
 reasonable accommodation requirement
 of, 12, 13, 298
Analysis of variance (ANOVA), 287

401